Julia
Margaret
Cameron's Women

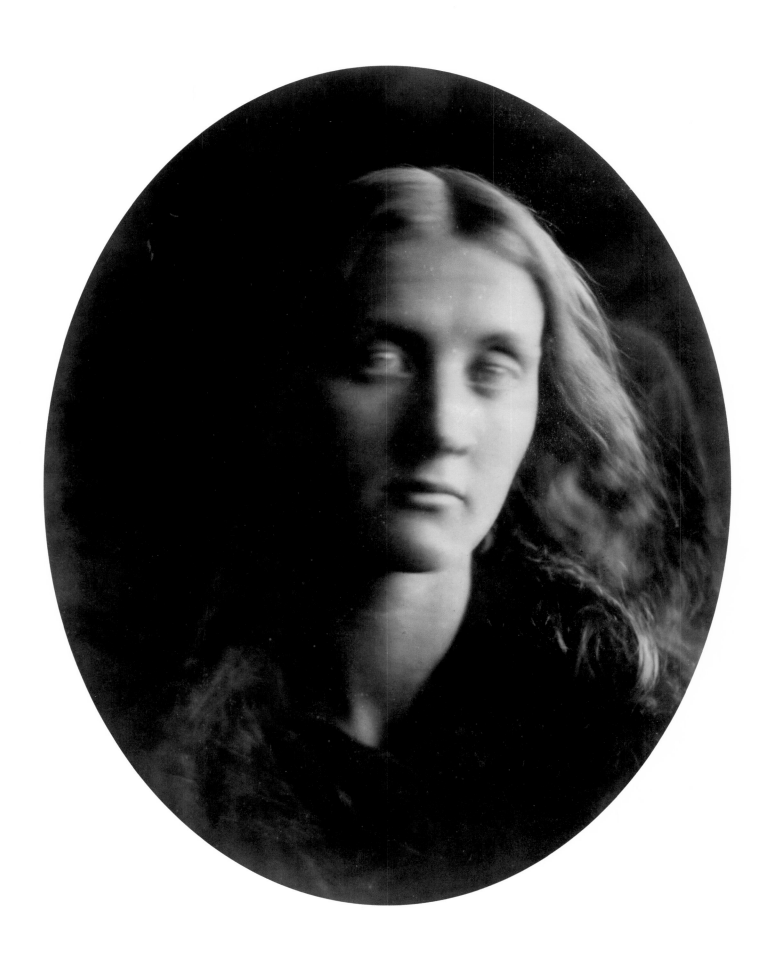

Julia Margaret Cameron's Women

by Sylvia Wolf

with
contributions by
Stephanie Lipscomb,
Debra N. Mancoff,
and
Phyllis Rose

The Art Institute
of Chicago

Yale University
Press,
New Haven and
London

This book was published in conjunction with the exhibition "Julia Margaret Cameron's Women," organized by The Art Institute of Chicago.

Exhibition dates:
The Art Institute of Chicago
19 September 1998–10 January 1999

The Museum of Modern Art, New York
27 January–4 May 1999

San Francisco Museum of Modern Art
27 August–30 November 1999

This book and the exhibition it accompanied were made possible by American Airlines and the National Endowment for the Arts.

Produced by the Publications Department of
The Art Institute of Chicago:
Susan F. Rossen, Executive Director

Edited by Margherita Andreotti, Associate Editor for Scholarly Publications

Production by Amanda Freymann, Associate Director of Publications – Production

Designed and typeset by studio blue, Chicago
Separations by Martin Senn, Philomont, Virginia
Printed by Meridian Printing, East Greenwich, Rhode Island
Bound by Acme Bookbinding Company, Charlestown, Massachusetts

Clothbound edition distributed by Yale University Press, New Haven and London

ISBN 0-300-07781-5
(clothbound edition)

ISBN 0-86559-169-5
(paperbound edition)

For photography credits, see page 243.

First Edition

Library of Congress Cataloging-in-Publication Data
Wolf, Sylvia. 1957–
Julia Margaret Cameron's Women / Sylvia Wolf: contributions by Stephanie Lipscomb, Debra N. Mancoff, and Phyllis Rose. – 1st ed.
p. cm.
"Published in conjunction with the exhibition, Julia Margaret Cameron's Women...exhibition dates, Art Institute of Chicago, 19 September 1998–10 January 1999; The Museum of Modern Art, New York, 27 January–4 May 1999; San Francisco Museum of Modern Art, 27 August–30 November 1999" –
Includes index.
ISBN 0-300-07781-5 (hardcover). – ISBN 0-86559-169-5 (pbk).
1. Photography of women – Exhibitions. 2. Cameron, Julia Margaret Pattle, 1815–1879 – Exhibitions. I. Cameron, Julia Margaret Pattle, 1815–1879. II. Lipscomb, Stephanie. III. Mancoff, Debra N., 1950–. IV. Rose, Phyllis, 1942– . V. Art Institute of Chicago. VI. Museum of Modern Art (New York, N.Y.) VII. San Francisco Museum of Modern Art. VIII. Title.
TR681.W6W64 1998
770'.92–dc21

98-34245
CIP

Front cover
Julia Margaret Cameron
Julia Jackson, 1867
Albumen silver print from wet-collodion glass negative
27.6 x 22 cm
The Art Institute of Chicago, Harriott A. Fox Endowment, 1968.227
(also reproduced as plate 57)

Back cover
Julia Margaret Cameron
Mrs. Herbert Duckworth, 1867
Albumen silver print from wet-collodion glass negative
27.6 x 23.8 cm
Rochester, New York, George Eastman House, International Museum of Photography and Film, 81:1124:0007
(also reproduced as plate 58)

Frontispiece
Julia Margaret Cameron
Julia Jackson, 1867
Albumen silver print from wet-collodion glass negative
24.8 x 19.8 cm
The Art Institute of Chicago, Mary and Leigh Block Endowment, 1998.301

Table of Contents

Preface

From the time Julia Margaret Cameron's photographs were first exhibited in 1864, her works have aroused admiration and debate. Many were quick to praise her penetrating portraits of "famous men and fair women," to use Virginia Woolf's phrase, while others criticized Cameron for her radical departure from traditional photographic technique. Over the years, Cameron has become recognized as a great portraitist and one of photography's pioneers. Her art has been the subject of more exhibitions and publications than that of almost any other nineteenth-century photographer, and stories of her life are peppered with fiction and myth — one of the signs of an artist of true stature and allure. That we still find relevance, beauty, and new ideas in Cameron's photographs proves their lasting power.

In spite of Cameron's notoriety, there is still much to be learned about her career and her oeuvre. Little-known prints and documents are continuing to come to light, yielding new insights into her work. From the outset, this exhibition had two goals. One was to examine an under-recognized aspect of a well-known artist's career — to take Cameron's portraits of women apart from her photographs of men and look at them for what they convey about their maker and her time. In this respect, the exhibition follows the long-standing art-historical tradition of studying an aspect of an artist's career in an effort to better understand the whole. Our other aim was to assemble the highest-quality prints available in an exhibition that would be a connoisseur's delight. To this end, the exhibition's curator, Sylvia Wolf, reviewed hundreds of prints in six countries, often returning to the same collection three or four times. She researched letters to and from Cameron, and examined family papers and publications of the period. I am grateful to her for the enthusiasm, high standards, and dedication she brought to this project. The resulting exhibition and catalogue integrate personal, photographic, and social history, and provide new information about many aspects of Cameron's career. The exhibition also offers the public some of the finest representations of Cameron's art.

Artistic excellence was a critical criterion in the selection of Cameron's prints for this exhibition. Individual prints from the same negative may be distinctly different either because of the artist's intention or because of the passage of time; thus each of Cameron's photographs is unique. It is with heartfelt thanks, therefore, that we acknowledge all those who made their exquisite photographs available to this exhibition. The extraordinary generosity of these lenders has allowed us to bring together stellar prints from the many important collections of Cameron's art.

Our commitment to this exhibition would not have been possible without the corporate support of American Airlines and a generous grant from the National Endowment for the Arts. Finally, we are pleased to acknowledge the enthusiastic cooperation of The Museum of Modern Art, New York, and the San Francisco Museum of Modern Art. By joining us in the presentation of *Julia Margaret Cameron's Women*, they have insured that these extraordinary photographs would reach the broadest possible audience.

James N. Wood
Director and President

Introduction and Acknowledgments

My interest in Julia Margaret Cameron's portraits of women grew out of research for a children's book I wrote in 1994 on five women photographers. Although I had long admired Cameron's photographs, this was the first time I had a chance to concentrate on her career, and I was surprised to find that her life and art were even more captivating than I had imagined. After the children's book was printed, Cameron's portraits of women continued to intrigue me. They seemed different from her photographs of men — more complex and enigmatic somehow. My work on this project began when I started wondering if there truly was a unique quality to Cameron's portraits of women. After three years of looking at hundreds of Cameron's prints, the conclusion I have come to is a resounding "yes." This book and the exhibition it accompanies are designed to look at how and to speculate on why.

In conducting research for *Julia Margaret Cameron's Women*, a number of questions arose about the relationship of her photographs to her life and to the social climate of the period, which I have attempted to address here, both through my own texts and those of others. I have been fortunate that several scholars of Victorian art and literature have been willing to lend their expertise to this endeavor. In the introductory essay to this book, which is aimed especially at the general reader, Phyllis Rose has combined a broad and sensitive understanding of the era with her own personal response to Cameron's art. In my essay, I have attempted to place Cameron's photographs in the context of her life and time. And Debra N.

Mancoff, in her essay on Cameron's illustrations for Tennyson's *Idylls*, has contributed greatly to an understanding of an aspect of Cameron's work that is particularly difficult for modern viewers to appreciate. In an appendix to this book, Mancoff has also written detailed and illuminating entries on the less familiar subjects treated by Cameron in the pictures in this exhibition. These subjects, while popular in Victorian times, are in many cases almost unknown to audiences today. Unknown to us for different reasons have been the identities of many of Cameron's female sitters. Although Cameron often inscribed the names of her male subjects below their portraits, she mostly gave titles drawn from literary, religious, or classical sources to her portraits of women. Stephanie Lipscomb has researched the lives of these women and provided biographical entries on those who posed for the photographs in this exhibition. Finally, in an extended note on Cameron's process and sales, I have offered some reflections on the commercial side of the artist's production.

From the very start of this project, the pictures have been my point of departure. I am grateful, therefore, to those who gave me access to their photographs and agreed to lend works to this exhibition: Adam Fuss; Charles Isaacs Photographs, Inc.; the Estate of Beaumont and Nancy Newhall, courtesy of David Scheinbaum and Janet Russek; Marjorie and Leonard Vernon; Paul Walter; and Jane and Michael Wilson. I am equally indebted to my colleagues and friends at lending institutions. At the George Eastman House, Rochester, New York, I am grateful to Therese Mulligan. Roy Flukinger of the Harry Ransom Humanities Research Center, University

of Texas at Austin, is thanked for providing unrestricted access to Cameron photographs from the Helmut Gernsheim Collection. Weston J. Naef of The J. Paul Getty Museum, Los Angeles, has extended his long-standing commitment to the study of Cameron's art with his generous loan to this exhibition. I am grateful to Maria Morris Hambourg of The Metropolitan Museum of Art, New York, for her willingness to part with cherished new acquisitions. At the National Gallery of Art, Washington, D.C., Sarah Greenough graciously made a rare Cameron portrait of Julia Jackson available to the exhibition. Amanda Nevill at the National Museum of Photography, Film & Television, Bradford, England, has generously parted with several exquisite works from the rarely seen Herschel album. Pam Roberts of The Royal Photographic Society, Bath, England, is heartily thanked for sharing information and prints from the Society's vast collection of works by Cameron. I am also deeply indebted to Mark Haworth-Booth at the Victoria and Albert Museum, London, for his previous scholarship on Victorian photography and for his special efforts on behalf of this project. My endeavor to secure the highest-quality prints for this exhibition was greatly facilitated by the commitment of the two other institutions presenting this show: The Museum of Modern Art, New York, and the San Francisco Museum of Modern Art. For sharing my enthusiasm for Cameron's art and for bringing this exhibition to a broader audience, I am especially grateful to Peter Galassi, Chief Curator of the Department of Photography at The Museum of Modern Art, and to Sandra S. Phillips, Curator of Photography at the San Francisco Museum of Modern Art.

Thanks go, too, to the staffs of lending institutions and participating venues, in particular: James A. Conlin, Heidi Halton, Janice Madhu, Grant B. Romer, Becky Simmons, and Joseph Struble at the George Eastman House; Debra R. Armstrong-Morgan, Barbara Brown, David Coleman, Kelly George, and John Wright at the Harry Ransom Humanities Research Center; Marc Harnly, Sally Hibbard, Anne Lyden, and Ernie Mack at The J. Paul Getty Museum; Catherine Bindman, John Crooks, Malcolm Daniel, Predrag Dimitrijevic,

Nora Kennedy, Laura Muir, and Trine L. Vanderwall at The Metropolitan Museum of Art; Darsie Alexander, John Alexander, and the staff of the Department of Photography of The Museum of Modern Art; Lisa Mariam, Constance McCabe, Hugh Phibbs, and Julia Thompson at the National Gallery of Art; Robert Cox, Paul Goodman, Brian Liddy, and Philippa Wright at the National Museum of Photography, Film & Television; Debbie Ireland at The Royal Photographic Society; Barbara Levine and Douglas R. Nickel at the San Francisco Museum of Modern Art; and Martin Barnes, Charlotte Cotton, Addie Elliott, Janet Skidmore, Timothy Stevens, and David Wright at the Victoria and Albert Museum.

In addition to the lenders to this exhibition, a number of other individuals deserve thanks for allowing me to study Cameron photographs in their possession: Jane Corkin, The Right Honorable The Earl of Crawford and Balcarres, Stephen Daiter, James Danziger, Susan Ferris, Howard Greenberg, Betty and Lester Guttman, Manfred and Hanna Heiting, Scott Kraft, Hans P. Kraus, Jr., Noel and Harriet Levine, Michael Mattis and Judith Hochberg, Russell Maylone, Jay McDonald, Laurence Miller, Jill Quasha, William Rubel, Richard and Ellen Sandor, and Thomas Walther. Special thanks are due to Robin Vousden and Nadja Berri of the Anthony d'Offay Gallery, London, and to Cameron's descendants, Charles and Sandra Norman, and Angelica Garnett.

I have benefited immeasurably from the writings of those who have studied Cameron's work, including, in chronological order, Peter Henry Emerson, Virginia Woolf and Roger Fry, Helmut Gernsheim, Brian Hill, Anita Ventura Mozley, Colin Ford, Dave Oliphant et al., Graham Ovenden and Lord David Cecil, Mike Weaver, Weston J. Naef, Amanda Hopkinson, Joanne Lukitsh, Therese Mulligan, Elizabeth P. Richardson, Pam Roberts, Lindsay Smith, April Watson, Carol Armstrong, Carol Mavor, R. Derek Wood, Violet Hamilton, and Julian Cox. These and additional scholars are acknowledged in the bibliographic references throughout this book.

Many other individuals facilitated my research or contributed to my thinking during work on this book: Pierre Apraxine, Gordon Baldwin, Neal Benezra, Laurel Bradley, Stephen Crook,

Verna Curtis, Diana Davis, Tracy C. Davis, Kenneth Dunn, Lucy Flint-Gohlke, Philippe Garner, Sue Gates, Sophie Grossiord, Beth Ann Guynn, Anne Hammond, Colin Harris, Willis Hartshorn, Anne E. Havinga, Virginia Heckert, Françoise Heilbrun, Robert Hershkowitz, Karen V. Kukil, Olivia Lahs-Gonzales, Karen Lanzoni, Jean-Claude Lemagny, Mary Davis MacNaughton, Vera Magyar, Ursula Mayr-Harting, Sheila McKenzie, Sarah McNear Wardropper, Philip Milito, Martha Mock, Octavio Olvera, Terence Pepper, Harold Perkin, Joan Perkin, Jeff Rankin, Mary Sampson, Anne Sievers, Raghubir Singh, Catharina Slautterback, Charles Stainback, Will Stapp, Stephanie Stepanek, Maia-Mari Sutnik, Carol Vernon, and Sandi Wisenberg.

At every point in the preparation and execution of this project, the staff of The Art Institute of Chicago has provided invaluable guidance and assistance. I am grateful first of all for the enthusiastic support and wise counsel of David Travis, Curator of Photography. Equally critical to this project, and to all Photography Department activities, are the extraordinary eye and knowledgeable appreciation of photography of Director and President James N. Wood. Teri J. Edelstein, Deputy Director, provided invaluable guidance and perspective throughout preparations for the exhibition. I am also sincerely grateful for the support of Dorothy Schroeder, Assistant Director for Exhibitions and Budgets. For sharing in my study of Cameron's art and career, and for ensuring the care of prints lent to the exhibition, I am deeply indebted to Douglas Severson, Conservator of Photographs, and to Sylvie Penichon, Andrew W. Mellon Fellow in Photograph Conservation. Colin Westerbeck, Associate Curator of Photography, gave consistent collegial support. For applying a keen aesthetic eye to the presentation of photographs for this exhibition, I am grateful to James Iska, Preparator, and to his assistant Christine Laning. Collection Manager and Research Assistant Kristin Merrill was ever-present throughout the project, as was Lisa D'Acquisto, Department Secretary, both of whom regularly went above and beyond the call of duty to provide much-needed support and good cheer. Sincere thanks go as well to Christine Prentice and Martha Schneider for their volunteer assistance.

In the Art Institute's Department of Museum Registration, I am grateful to Mary Mulhern, who orchestrated the many complex registrarial tasks related to the exhibition and its tour. Thanks also go to Mary Solt, Sally-Ann Felgenhauer, Fran Baas, Dorothy Pesch, John Molini, Walter Andersons, and Michael Kaysen. For their efforts in securing the necessary funding for this exhibition, I am deeply indebted to Karin Victoria, Meredith Miller Hayes and her predecessor Greg Cameron, as well as to Edward W. Horner, Jr., Christine O'Neill Singer, Jennifer Harris, and Miriam Braganza. The staff of the Art Institute's Ryerson Library provided critical support throughout my research. In particular, Natalia Lonchyna, former Reference Librarian, quickly and thoroughly tracked down countless sources. Thanks also go to Executive Director Jack Perry Brown, Mary Woolever, Susan Perry, and Matt Crawford. For organizing a wide range of public programs to accompany the exhibition, I am grateful to Clare Kunny, Mary Sue Glosser, and Kirsten Buick of the Department of Museum Education, as well as to Ronne Hartfield, Robert W. Eskridge, and Irene Backus. For bringing news of the exhibition and book to a broad audience, my gratitude goes to Eileen Harakal, Kathleen H. Cardoza, and John Hindman of the Department of Public Affairs. Countless other colleagues and friends in the museum have aided this project with their efforts or their words of encouragement. I extend my deep appreciation to Judith Barter, Sanna Evans, Donna Forrest, Laura Giles, John Mancini, Mark Pascale, Mollie Riess, Kevin Sharp, Kirk Vuillemont, and Frank Zuccari.

The quality of this publication is due to the efforts of many individuals. I am grateful to the friends and colleagues who read early drafts of this book and to those who clarified difficult points of Cameron's process and technique. Special thanks go to Douglas Severson, James N. Reilly, Grant B. Romer, Douglas Munson, Richard Bolton, Debra N. Mancoff, Larry J. Schaaf, and Rudolf Kingslake. In the Art Institute's Publications Department, I am grateful to Executive Director Susan F. Rossen for supporting this publication from the beginning. Margherita Andreotti, Associate Editor for Scholarly Publications, guided all editorial aspects of the book's contents with a steadfast commitment to art appreciation and an extraordinary gift for the organization of information and ideas. Every page of this book

has been enhanced by her perseverance, intelligence, and grace. Amanda Freymann, Associate Director of Publications – Production, applied her seasoned eye and aesthetic sensitivity to the artful production of this book. Her commitment to translating Cameron's work to the printed page is evident throughout. Others who were helpful in the Art Institute's Publications Department include Sarah Guernsey, Stacey Hendricks, Katherine Irvin, Simone Juter, Laura Kozitka, Bryan Miller, Britt Salvesen, and Robert Sharp. For a design that is as lively and timeless as Cameron's art, I am indebted to the staff of studio blue, Chicago, especially to Cheryl Towler Weese and to the uncompromising vision of Katherine Fredrickson, along with JoEllen Kames, Todd Nossek, Matt Simpson, and Gail Wiener. For the high-quality reproduction of many works in the exhibition, I am grateful to Greg Williams, as well as to Alan B. Newman, Christopher Gallagher, Iris Wong, and Anne Morse of the Art Institute's Department of Imaging and Technical Services. Martin Senn lent his extraordinary skill and artistry to the difficult task of making color separations of Cameron's art. I am deeply grateful to Daniel Frank and the staff of Meridian Printing Company for replicating the delicate color and tonality of Cameron's original prints with remarkable fidelity. Thanks go, too, to John Nicoll at Yale University Press for becoming a partner in the publication of the book.

Special recognition is due to the following individuals, who were exceptionally generous during my research over the past three years. In their responses to my many inquiries, each one gave above and beyond what a colleague might expect, and in so doing, each became a guardian angel to the project and a valued friend. Julian Cox has been a staunch advocate of this exhibition and book. Violet Hamilton shared information and ideas with a graciousness that sets the model of true collegial generosity. Roger Taylor challenged me with his curiosity and his encyclopedic knowledge of nineteenth-century photography and British social history. His tough-minded criticism and invaluable leads challenged me to raise the level of my texts with each review. Mike Weaver applied his keen intelligence and cumulative knowledge about Cameron's career to all sections of this book. The more I learned about Cameron and her time, the more I appreciated the depth and substance of his own writings on the subject. Stephanie Lipscomb, Special Projects Assistant, is the person with whom I have shared every aspect of this project since its inception. As primary researcher, contributing author, and administrator of the exhibition's tour, she has had an immeasurable impact on this exhibition and book. As intellectual partner and much-needed sounding board, she has also given me the pleasure of her talent and support.

Several people not directly connected with this project also deserve recognition. I would like to acknowledge Abby Levine, Joseph Boyd, and Kathy Tucker at Albert Whitman & Co. for working with me on the children's book from which this project evolved. The long-standing support of Jodie Ireland and Elisa Lapine has greatly enhanced every aspect of this exhibition and book. I am particularly grateful to Duane Schuler for seeing the beauty and mystery of Cameron's photographs from the start, and for sharing in my discovery of their meaning. Lastly, though Cameron is not alive to be thanked, it is her art that has mobilized the efforts of all those who have contributed to this project. For the power of her photographs, and for what I have learned from their study, my appreciation is deep and long-lasting.

Sylvia Wolf
Associate Curator of Photography

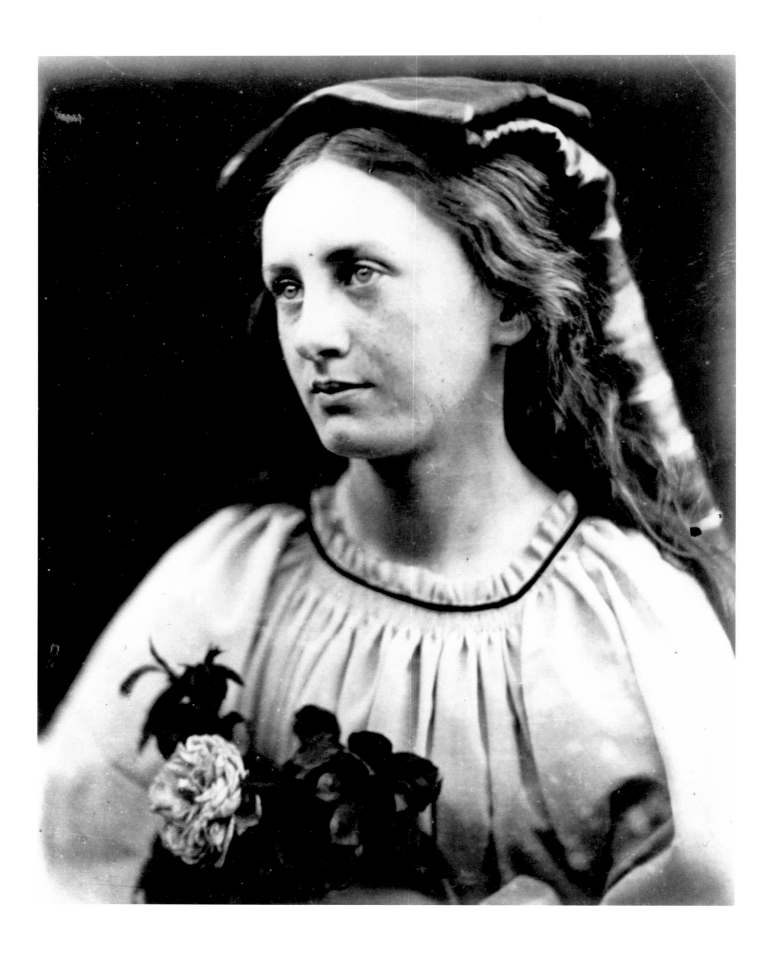

Phyllis
Rose

Milkmaid Madonnas: An Appreciation of Cameron's Portraits of Women

"Mrs. Cameron is making endless Madonnas and May Queens and Foolish Virgins and Wise Virgins and I know not what besides," Emily Tennyson, the poet's wife, reported to Edward Lear, the author and illustrator, of her neighbor and their mutual friend, the photographer. "It really is wonderful how she puts her spirit into people."[1]

On the Isle of Wight, nineteenth-century England's equivalent of Martha's Vineyard, where artists lived to get away from bustle and ended up bringing bustle in their wake, Julia Margaret Cameron, in one of the greatest outpourings of creativity in the history of art, went about for a decade discovering beauty in her family and friends and the working men and women around her, hauling people into her "studio," a converted hen coop, and making of their bodily forms immortal images.

It was the immortal within them she responded to. She had little interest in sociological data, details of clothing, tools of trades. When she looked at a domestic servant with a mop and bucket, her imagination erased the mop and bucket, covered the homespun clothing with swaths of drapery, and saw the woman as the current exemplar of some timeless, enduring type – a youthful May Queen or noble Madonna, a suffering Ophelia, a sinning Guinevere, a sainted wife, devoted daughter, grieving mother, or wild-spirited wood nymph.

For her mental store of archetypal personae she drew on eclectic sources: the Old Testament, the New Testament, Greek mythology, Renaissance painting, and the classics of English literature – Shakespeare, Milton, Keats, Shelley, Byron, and Coleridge. She had the words of the Romantic poets in her head as we might have the lyrics of songs by the Beatles. Many of the most popular

figure 1 Julia Margaret Cameron
The Contadina, 1866
Albumen print
33.1 x 27 cm
Bradford, England,
National Museum of
Photography, Film
& Television,
Herschel Album, no. 87

13

writers of the day were her friends, including Coventry Patmore, who, in singing the praises of "The Angel in the House," codified the Victorian ideal of domesticity, and Alfred Tennyson, who, among other achievements, gave new life to the heroines of Arthurian legend.

She had received no formal education, which was typical for women of her time. Yet she was better read than many of us with graduate degrees. If we cannot reproduce her literary culture, if our minds' mansions are furnished, instead of with stanzas by Milton and Shakespeare, with episodes of favorite television shows, can we understand or fully respond to her photographs?

Every now and then a creative artist is inspired by other art which may be unfamiliar to readers or viewers. James Joyce, for example, based the structure and many episodes of *Ulysses* on Homer's *Odyssey*. An acquaintance with the story of Odysseus's wanderings may or may not enrich a reading of *Ulysses*, but the older work's greatest contribution to Joyce's epic, I would suggest, lies in enabling him to write it in the first place. It powered his imagination. It allowed him to see the life of ordinary people like Leopold Bloom, in an ignoble time like the turn of the century, in a provincial city like Dublin, as connected to enduring patterns of human life and therefore as material for art.

Cameron also had to see the eternal in the everyday in order to be stimulated. She needed to see the Madonna in the milkmaid, the Lancelot in the farmhand. But what she needed in order to create and what we need in order to enjoy are different. In some cases her photographs could have been numbered, for all the difference their ostensible subject makes to this viewer — those of Coleridge's "Christabel" or Milton's "Sweet Liberty," of Sappho, Pomona, and Daphne, for example.

Indeed, the more literal illustrations of texts — the ones in which women wear theatrical costumes or act out specific situations, as in the pictures for Tennyson's *Idylls* (see figure 2) — seem to me the least successful of Cameron's works, resembling the tableaux vivants of Victorian after-dinner entertainment, just as her beautiful women look less beautiful the more the details of their dress are articulated. They become dated. They lose their universality. Cameron was right to make her models take their hair down and wrap themselves in shawls and turbans. It eternalizes their beauty, the way nudity might, if nudity were an option.

Packed inside the modern baggage I bring to Cameron's photographs is an inappropriate curiosity about her models, a curiosity she usually deflects by giving her works mythological or literary titles. I'd really like to know more, for example, about May Prinsep, who poses for one of my favorite Cameron photographs. She was a young relative of Cameron's, as were many of her

sitters. An orphan by the time she was a teenager, she was adopted by Cameron's sister Sarah Prinsep and her husband, Thoby, who made their London home a haven for artists. May married a man named Andrew Hichens and was widowed, then married Hallam Tennyson, the poet's eldest son. She must have been a cultivated, intelligent, resilient, and likeable person, but we would not know that from Cameron's photographs of her. For some reason, the spirit Cameron saw in her clamoring for expression was Italian. She posed May Prinsep for Italian peasants and Renaissance ladies (see figure 1). Little of what we would call May's personality comes through in these images.

Clothing, occupation, class, personality — all these things are transitory and accidental; they did not interest Cameron. She refused to be influenced by mere circumstance, such as whether a female model happened to be a great lady or a servant, English or Italian, bubbly or depressed. Her eye was fastened firmly on the Ideal, and her out-of-focus technique exactly rendered her attitude to the details of daily life. She didn't *like* to see things sharply. "When focussing and coming to something which, to my eye, was very beautiful, I stopped there instead of screwing on the lens to the more definite focus which all other photographers insist upon," she wrote in her account of her career, *Annals of My Glass House*.[2] In that sense, her style was, in her own words, "a fluke." But what *is* style except an embodiment of the way an artist sees, the distinctive angle, distance, and focus at which the world looks right to her?

Cameron's response to beauty, eradicating class as it did, was so extreme as to constitute an almost political statement. Her tableaux are parables of radical democracy, or, seen from a slightly different angle, real-life fairy tales: in Cameron's glass house, Cinderella is always becoming a princess. Her parlor maid, Mary Hillier, was so often released from household drudgery to pose as the Virgin that she was known locally as Mary Madonna.

Cameron's photographs made other people see the treasures she saw within people, too, regardless of the accident of their birth. For example, Mary Ryan had been the daughter of an Irish beggar. Mrs. Cameron took her in and

figure 2 Julia Margaret Cameron
King Arthur Wounded
Lying in the Barge
Albumen print
33.9 x 29 cm
From *Illustrations to*
Tennyson's "Idylls of the King"
Vol. 2, May 1875
Rochester, New York,
George Eastman House,
International Museum
of Photography and Film,
GEH 28940

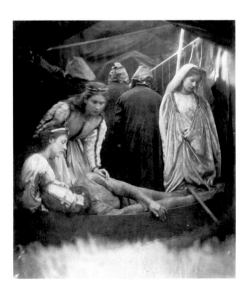

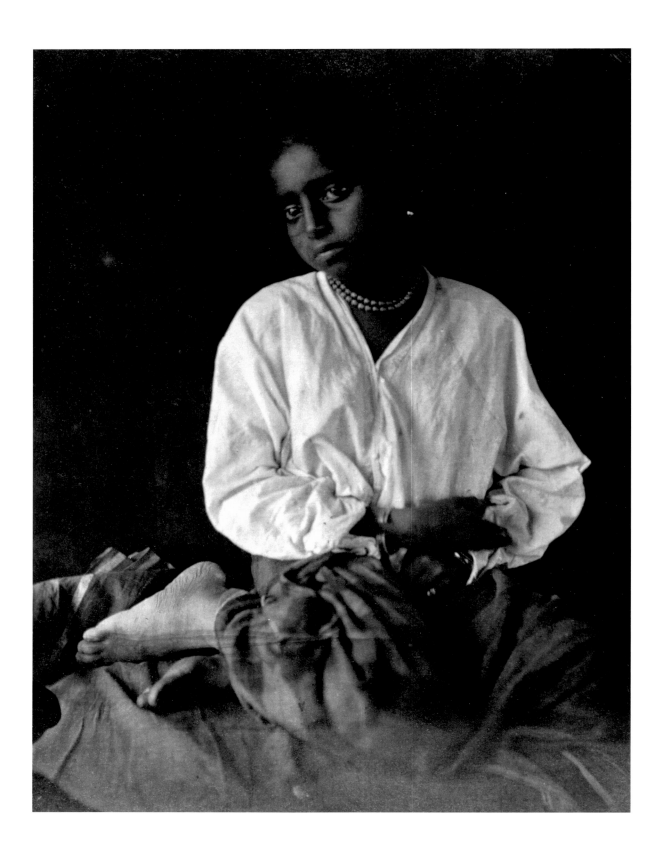

figure 3 Julia Margaret Cameron
 Cingalese Girl, 1875
 Albumen print
 25.1 x 18.7 cm
 Los Angeles,
 The J. Paul Getty Museum,
 86.XM.636.2

raised her along with her own children. Henry Cotton, a young gentleman, fell in love with Mary after seeing one of Cameron's pictures of her and sought permission to court her. Eventually, he married her. She became Lady Cotton. They lived happily ever after.

Today we can't help but notice that, for Cameron, this ideal world of Arthurian ladies and Shakespearean heroines was not populated by women of color. When, late in life, she returned to the East, where she had spent much of her earlier life, her husband being an important colonial administrator, she did little photography. Partly this was because of the difficulty of getting chemical supplies, partly because the heat increased all the technical problems. But it seems also to be the case that the people of Sri Lanka did not have the same effect on her imagination as did the people – gentry and peasantry alike – of the Isle of Wight. The few photographs that exist of the people of Kalutara (see figure 3), the fishing village where the Camerons lived out their days in tropical beauty, are strikingly different from the English ones. The poverty of these people is essential, not accidental. The circumstances of their life define them in a way they do not define the young maidens of the Isle of Wight, who can turn into princesses at the wave of the photographer's wand. The dramas of her mind were performed by white actresses.

Cameron's women do not smile. Their poses embody sorrow, resignation, composure, solemnity, and love, determined love, love which will have a hard time of it. Compare them to the subjects of contemporary fine-art portraits, like Richard Avedon's and Irving Penn's, and you may notice that, however different the styles of Avedon and Penn, both artists tend to capture their sitters in moments of unrepentant, sometimes even antisocial self-assertion (see figure 4).[3] Their subjects seem to say, "This is who I am. Want to make something of it?" At the other end of the ladder of contemporary portrait photography, commercial studios strive to generate images of women that say, "I'm fun. I'm friendly. I'm enjoying life and will help you enjoy it, too." When such college-yearbook or engagement photographs are used to show the faces of

figure 4 Irving Penn
Three Girls, One Reclining,
Dahomey, 1967
Platinum palladium print
57.5 x 53 cm
The Art Institute
of Chicago, 1996.275

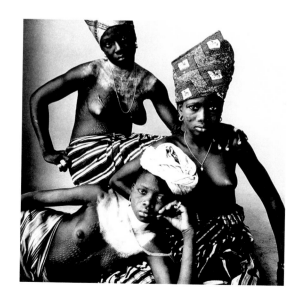

the victims of a disaster, the absurdity of the smiling face convention is all the more apparent. If Cameron's portraits of women convey a message, it's "I'm ready for the worst. I have resources that can be brought to bear on the tragedies I know lie ahead of me, that lie ahead of every woman who lives and loves other creatures who are mortal."

And the tragedies did lie ahead. Julia Jackson, Cameron's niece and her favorite model, had three years of happy marriage and then her beloved young husband suddenly dropped dead. When she remarried, she inherited a stepdaughter who was schizophrenic. Mrs. Cameron herself had to endure the greatest tragedy a parent can face – the death of a child. In fact, she endured it twice: a son died in infancy and her only daughter, Julia Norman, died in childbirth.

Everywhere you look in these Victorian lives, you see sudden and early death, sickness, disaster. You also see incredible kindness and flexibility. Orphans seem to move with ease from one family to another. Women remarry and raise other women's children. Death did the job divorce does now in cutting down the timeline of family groups, but without the cynicism divorce brings in its wake. In fact, with quite the opposite, a certain amount of justified sentimentality. Wives were treasured as saints and mothers as Madonnas. Children dead young were angels.

These metaphors are the stuff of Cameron's imagination, producing great works like *The Dream*, *The Kiss of Peace*, and *Mary Mother*, but also some I find silly, as when she stuck wings on children to make them angels (see figure 5). Children seem particularly resistant to her posing. They insist on being themselves, not embodiments of something else, and they are always more mischievous and more complex than the roles they are asked to play in Cameron's studio (see figure 6).

The archetypal figures Cameron was drawn to tap into the tragic strain in life. What is the Madonna but a woman who loves her son and will lose him, who will grieve forever? Ophelia is a woman whose lover rejects her and whose father is killed; she is driven mad by these twin griefs. Nothing good is in store for these women. They may have happy moments, but the pain they will suffer will be greater than any happiness. Their faces demonstrate a self-containment, a hoarding of energy which can be available as active love when it is needed, as it certainly will be.

The image I like so much for which May Prinsep was the model is *Beatrice*, plate 24 which may serve as an example of Cameron's response to the tragic. It does not depict Dante's beloved, although nothing in the picture itself makes that clear. We know from other sources that the subject is Beatrice Cenci, a young woman who lived in sixteenth-century Rome, whose father, a debauched and

figure 5 Julia Margaret Cameron
Angel of the Nativity, 1872
Albumen print
32.7 x 24.3 cm
Los Angeles,
The J. Paul Getty Museum,
84.XM.443.3

figure 6 Julia Margaret Cameron
Paul and Virginia, 1865
Albumen print
25.4 x 19.9 cm
Los Angeles,
The J. Paul Getty Museum,
84.X2.186.3

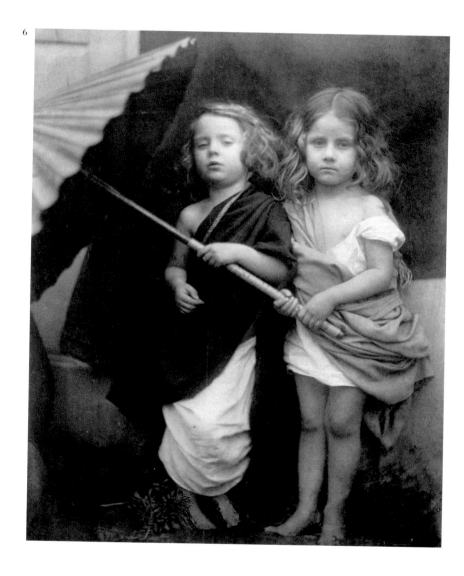

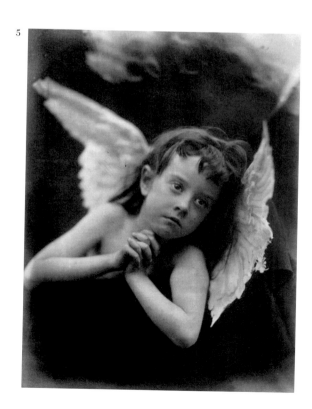

vicious nobleman, conceived a sexual passion for her and abused her for years. Beatrice plotted with her stepmother and brother to have the brute killed. Assassins did the deed. But the conspirators confessed to their crime under torture and were punished for it by death. Shelley wrote a poetic drama based on this story, called *The Cenci*, and Beatrice was a popular subject for Victorian history painters and sculptors.[4] We think of the Victorians as prudish and prissy, but even today's tabloids would have a hard time matching, for prurience and violence, this story of incestuous lust and parricide, which so appealed to Cameron that she came back to the subject again and again.

Whatever need we have for tragic narratives (and I believe it is a need as much as an appetite) can be satisfied now by magazines, memoirs, nonfiction narratives, TV docudramas, and the evening news, which make completely explicit what Victorian art could only allude to. Our visual art doesn't have to do that work. We are freed for formalism, free to react to *Beatrice*, for example, as a tonal composition, a work whose beauty depends on the interplay of light and dark as well as on the lines created by the unbound hair and by the turban. Nonetheless, at least some of the photograph's appeal resides in the woman's expression – the sad composure, the avoidance of contact with the viewer, as though she knows she has emotional business of her own to attend to and isn't interested in making new friends. I would suggest that that element, the emotional resonance which transcends the formal, the depth, is what comes through from Cameron's fascination with the Cenci narrative. Cameron's Beatrice seems to know and accept the horrible fate that lies ahead of her. Whether or not we know the generative story, something enters the work of art that stimulates a dimension beyond the formal in our response.

Religion offered Cameron a specific response to the sorrows of life and an aid in supporting those sorrows. Christian love seemed to her and her friends the only possible response to the cruelties of nature, "nature," in Tennyson's words, "red in tooth and claw."[5] Whereas we distrust refinement and perhaps romanticize the natural, the Victorians, who had not read Freud, assumed that the goal of life was to transcend nature, to "work out the beast," as Tennyson put it.[6] And whereas we tend to consider every disaster as an outrage, for Cameron's generation disaster was a predictable part of life and one's charitable response the only thing that could be controlled. So the families are fluid. Orphans are adopted. Cameron puts in a lifetime as wife and mother before picking up her camera, and then does not aim at realism but at giving exquisite form to the powers of the spirit.

That Cameron's favorite niece and model was Virginia Woolf's mother, Julia Jackson, provides a neat yardstick for cultural change: two generations to go from an age of idealism to an age of irony, from Tennyson to T. S. Eliot, from

high Victorian to thoroughly modernist. Woolf made affectionate fun of her great-aunt in a play called *Freshwater*, which she wrote for private performance, and, as proprietor of the Hogarth Press, she published a selection of Cameron's photographs under the title *Victorian Photographs of Famous Men and Fair Women* (1926). Her prefatory essay depicts a dynamo who had more or less wasted herself for many years in ditsy hospitality until the gift of a camera turned her into an artist, enforcing on her random energies a sorely needed discipline. She is, in Woolf's telling, almost an allegorical figure of Talent, with whom Woolf herself clearly identifies, as opposed to the other six Pattle sisters (including her own grandmother), who incarnate a Beauty that interests her less.

At about the same time Woolf was mythologizing her matrilineage in the guise of a biographical essay about her great-aunt, she was also writing *To the Lighthouse*, her great novel about a Famous Victorian Man and the Fair Woman who enables him to achieve demi-greatness. Julia Jackson, Woolf's mother, was her model, as she was Cameron's. Jackson appears in *To the Lighthouse* as the secular Madonna Mrs. Ramsay. The novel, with its somewhat skeptical view of this Madonna, does not perpetuate the loving approval of Cameron's photographs. In Woolf's view, the womanly women and the manly men of the Victorian hothouse were equally forced, unnatural growths.

We may well share Woolf's skepticism about a neat division between women, who are reservoirs of spiritual strength, and men, who are reservoirs of genius. But some of her irony about Cameron and her Victorian values seems misplaced. Like other artists of the early twentieth century, Woolf was in creative rebellion against a parental culture which to her seemed stuffy and stifling. But if we look with unprejudiced eyes at the literary culture of Julia Margaret Cameron, it hardly looks stifling. Quite the opposite. The rich, eclectic, thoroughly Victorian mixture of literary and pictorial images stored in Cameron's mind stimulated her to dense achievement, hundreds of works in a career of little over ten years, as the Madonnas and May Queens, the Wise Virgins and Foolish Virgins, the wood nymphs and angels in her mind were brought forth through darkness and light onto paper. And if we look, as this exhibition asks us to do, at the photographs of the fair women without the famous men, what we see is how splendidly the women stand on their own.

1 Quoted by Colin Ford in CF, p. 127, note to pl. 44.
2 Quoted in CF, p. 17.
3 See also, for example, Avedon's portrait of June Leaf (Richard Avedon, *Avedon: Photographs, 1947–1977*, New York, 1978, pl. 162).
4 Harriet Hosmer's version, for example, was shown at the Royal Academy Summer Exhibition in London in 1857, where Cameron is likely to have seen it. See CF, p. 137, note to pl. 83.
5 Alfred Tennyson, *In Memoriam A.H.H.*, 56.15.
6 Ibid., 118.27.

Sylvia
Wolf

Julia Margaret Cameron's Women

In July of 1877, a year and a half before she died, Julia Margaret Cameron wrote a letter to her friend Sir Henry Taylor, in response to the publication of a five-volume edition of his literary works. Cameron's personality had changed little since she had read Taylor's first book, the dramatic poem *Philip van Artevelde*, some forty years before. Certainly her commanding nature had not weakened, nor had her intellectual curiosity diminished. And her exuberant enthusiasm for the achievements of her friends remained high. The person Taylor described as one "who lives upon superlatives as her daily bread" did not disappoint him here.[1] Like most of Cameron's letters, this one is written in a stream-of-consciousness style, her large handwriting sprawling across the page with little or no punctuation to temper her zeal. "You are standing on a hill the height of which is perceived by the greatness of the men who surround you as friends," she wrote, "to say nothing of the women!! They seem to me to be the salt of the Earth — the men great thro' genius the women thro' Love — that which women are born for!"[2]

Age sixty-two when she wrote this letter, Cameron was in a good position to comment on Victorian women's experience and the characteristics of male achievement. As a wife, mother, sister, and devout Christian, she knew love on a variety of levels. For forty years, she had been married to a man to whom she was deeply devoted. She had raised eleven children: five of her own, five orphaned relatives, and one foster child. She had maintained strong ties with her six sisters, and she was an ardent believer in God. Cameron also knew genius on personal terms. Among her friends and acquaintances were many of the great luminaries of the mid-nineteenth century.

figure 1 Anonymous
*Portrait of Julia Margaret
Cameron*, c. 1868
Albumen print
45.7 x 25.4 cm
Bradford, England, National
Museum of Photography,
Film & Television

That she held what may seem to us a simplistic view of male and female traits — men are great through genius and women through love — is in keeping with Victorian attitudes toward the sexes. In fact, so commonplace was this belief that we might take Cameron's words at face value if we had only her letters with which to interpret her views. But Cameron was a portrait photographer. During her career, she photographed dozens of what Virginia Woolf later called "famous men and fair women."[3] Her photographs of men are indeed inspired by her reverence for the male intellect. Her portraits of women, however, tell a different story.

On the faces of Cameron's female subjects, we read languor, melancholy, defiance, and desire. Love is there too, but only as one of many complex emotions Cameron attributed to women. While much of the energy in Cameron's portraits of famous men derives from her appreciation of the mind and spirit of her subjects, her portraits of women reflect a broader inquiry into human nature and into the expressive possibilities of photography. On the one hand, they offer Victorian viewers many possible models of feminine behavior and they reveal the ideals against which women of her day were measured. On the other, they display Cameron's unbridled love of photography. It is in her portraits of women that she gave herself the most room for artistic experimentation and that she displays the greatest range.

A look at Cameron's photographs of women, apart from her pictures of men, allows us to study a section of the artist's career in an effort to better understand the whole. A focus on this aspect of her work also reveals the photographer's complex relationship to her time. In the mid-nineteenth century, British society experienced large-scale technological, economic, and social change, which challenged many accepted definitions, those of gender roles included. Cameron's portraits of women, in particular, exhibit the depth to which she was responsive to the shifting values of the period. Because Cameron's own development suggests why some of her pictures look the way they do, a brief overview of her personal history is useful, as is a discussion of social factors and photographic history as they relate to Cameron's art. But first and foremost, Cameron's photographs are the storytellers here. Ultimately her pictures, not her words, best communicate her ideas. As D. H. Lawrence knew, it is in their art that artists leave their message. "Never trust the artist," he warned, "trust the tale."[4]

The tale, in this case, is told by many hundreds of negatives and countless prints made over the eleven years of Cameron's peak productivity.[5] Between the years of 1864 and 1875, she photographed some of the era's greatest personalities: among them, social critic Thomas Carlyle, astronomer Sir John Herschel, theorist of evolution Charles Darwin, painter George Frederic Watts,

poets Robert Browning and Henry Wadsworth Longfellow, as well as Poet Laureate Alfred Tennyson. She also made hundreds of pictures of women. The majority of her photographs were of women, in fact.

Cameron exhibited her photographs in Paris, Berlin, and London, sometimes by invitation, sometimes in a gallery she rented for the display and sale of her work. She won medals for her portraits and, during her most fertile period, she reported that her prints sold as fast as she could make them.[6] By the time she died in 1879 at the age of sixty-three, Cameron's photographs were in public art collections, including those of the British Museum and of the South Kensington Museum (this group of works is now in London's Victoria and Albert Museum). They were in the private hands of novelist George Eliot and illustrator Gustave Doré, as well as of Queen Victoria and her daughter the Crown Princess of Prussia.[7] The French poet and novelist Victor Hugo owned over twenty-five of Cameron's photographs, which he had received from her as a gift, and at which he had exclaimed, "No one has ever captured the rays of the sun as you have. I throw myself at your feet."[8]

For a Victorian woman to have the kind of artistic aspirations Cameron had was uncommon. That she began her career at age forty-eight — late middle age by Victorian standards — makes her achievement all the more remarkable.[9] A few social factors worked in her favor. While the nineteenth century was a time of codified behavior and clearly defined social restrictions, eccentricity flourished, particularly when it was played out in the name of artistic endeavor or scientific discovery. One had to know the rules in order to circulate in polite society, but the rules could be broken. Cameron was allowed her transgressions in part because she frequented the world of intellectuals, where curious and lively behavior was in no short supply, and in part because she came from a privileged family background, albeit an unusual one.

Cameron's Early Years and the Beginnings of Photography

Born Julia Margaret Pattle on June 11, 1815, in Calcutta, Cameron was the fourth of ten children of James Pattle, an official of the East India Company, and Adeline de l'Etang, the daughter of French aristocrats.[10] At age three, she was taken to Versailles, France, where she and her sisters lived with their maternal grandmother.[11] (The hot climate of India was perilous to children, prompting many British parents to send their sons and daughters abroad for their early education.) In the 1820s and 1830s, a girl's education consisted mainly of developing her social skills. Included were lessons in dancing, the art of conversation, music, and foreign languages (Cameron knew German and French, and had some understanding of Italian). In between their lessons, the Pattle sisters played in the great gardens of the Palace of Versailles, the

former residence of Louis XIV. The gardens extended for miles and included wooded areas, reflecting pools, fountains, and statues of Greek gods and goddesses. It was a perfect place for playing make-believe, for daydreaming of fairies, saints, and elves, and for a young girl's imagination to flourish. Little else is known of Cameron's early years, except that she finished her education abroad and returned to Calcutta in 1834.

Cameron was twenty-two when Queen Victoria – four years Cameron's junior – ascended to the throne in 1837, marking the beginning of the Victorian era. The year before, Cameron had been introduced to her husband-to-be, Charles Hay Cameron, a jurist who had been a member of the Council of India. Julia and Charles met while both were convalescing on the Cape of Good Hope, a popular spot for English subjects suffering from ailments contracted in India (Julia may have been recovering from a bout of bronchitis and Charles from kidney trouble, chronic problems both battled throughout their adult lives). Their twenty-year age difference was not unusual for the period. Many older men, particularly widowers like Charles, married younger women. Most importantly, Julia and Charles were a good match from a social standpoint, and in 1838, two years after they met, the couple was married in Calcutta.

At the Cape, Cameron also met the person who would become her mentor in photography, the astronomer Sir John Herschel (figures 2 and 9) and his wife, Lady Margaret. Cameron knew Herschel by reputation. Well known for his own celestial observations, he came from a family of astronomers: his paternal aunt Caroline Herschel was a respected astronomer;[12] and his father, Sir William Herschel, discovered Uranus. Sir John had come to the Cape to survey the skies of the southern hemisphere.[13] When he and Cameron met in 1836, photography was in its nascent stages. Herschel's friend William Henry Fox Talbot had achieved his very first success with photography in Britain the year before, though he would not exhibit his early photographs, which he called "photogenic drawings," or announce them to the world until January 31, 1839.

After Cameron went back to Calcutta in 1836 and the Herschels returned to England in 1838, they kept in touch. It was through her friendship with Herschel that Cameron had early knowledge of photography. Herschel, for whom light was the medium by which he observed celestial phenomena, was immediately captivated by the idea of photography when he learned of Talbot's invention in 1839. In fact, it took only the suggestion of the medium for the astronomer to develop his own photographic process independently of Talbot's experiments.[14] Herschel, who once declared, "*Light* was my first love!" is also credited with being the first to use the word "photography" (from the Greek, meaning "writing with light"). And he was the first to under-

stand that the chemical "hypo" would remove any remaining light-sensitive particles on photographic film or paper after exposure, and by doing so fix the image. When Cameron spoke of men great through genius, Herschel was high on her list.

Herschel sent Cameron the first photographs she saw, which she acknowledged in a letter she wrote to him some twenty years later: "you were my first Teacher and to you I owe all the first experience and insights which were given to me when you sent me in India a score of years ago – the first specimens of Talbotype of photographs coloured by the juices of plants."[15] Though photography made a strong impression on Cameron from the very beginning, it would be over two decades before she would become a photographer herself. During the intervening years, she gave birth to five boys and one girl (one boy died in infancy). In India the Camerons became distinguished members of British colonial society, in part because of Charles's work with Thomas Babington Macaulay on developing an Indian penal code, and in part because Julia Margaret took on the task of overseeing Governor Hardinge's social obligations in the absence of his wife, who maintained permanent residence in Britain.

As the equivalent of the governor's social secretary, Cameron developed a reputation as a lively and spirited hostess, an indication that the charisma she used to solicit models for her photographs in later years was fully developed in her youth. At the governor's parties, Cameron would have undoubtedly heard news of the progress of photographic technology. During the 1840s, while the Camerons lived in India, the medium advanced in two formats in two countries. The British invention, Talbot's paper-negative process, with its subtle gradations of tone and its grainy texture, lent itself to landscape photography.[16] The French daguerreotype was instead best suited to portraiture. Small and jewellike in its color and precision, it gave a highly detailed depiction of a sitter (see figure 2). Prized for their realism, daguerreotype portraits became extremely popular in Europe and, by the late 1840s, had become

figure 2 John Jabez Edwin Mayall
Sir John Frederick
William Herschel, c. 1848
Daguerreotype
7.3 x 6 cm
London, National
Portrait Gallery

commonplace in middle- and upper-class homes in Britain and France. "I daresay you have seen plenty of the French Daguerreotype specimens," Herschel wrote to Cameron in June of 1841, acknowledging this fervor for the medium and assuming it had made its way to the colonies.[17]

The impact of photography was immediate, and the popular enthusiasm it aroused was as widespread as that for other forms of technology. In Britain, the 1840s and 1850s were a time of achievement and prosperity. Victorians were proud of their nation's technological prowess and the bright future it promised. At the same time, the machine age bred ambition, greed, and fear of the erosion of spiritual and moral values. In 1843 social critic Thomas Carlyle published *Past and Present*, a comparison between the nobility of spirit and social order of the Middle Ages and the moral decay he saw rising from the materialistic bent of modern Britain. In 1848 Karl Marx and Friedrich Engels published their *Communist Manifesto* (the English translation appeared in 1850), criticizing the impact of industrialization on society and calling for widespread social change. Such was the atmosphere – one charged with optimism and uncertainty – when Charles Cameron retired in 1848, at age fifty-three, and the Cameron family moved back to England.

In the years immediately following their return, Julia Margaret Cameron, then in her mid-thirties, spent a great deal of time with one of her sisters, Sarah Prinsep, particularly after 1850, when Sarah and her husband, Thoby Prinsep, moved from Chesterfield Street to London's Kensington neighborhood. In the Prinseps' new home, called Little Holland House, Sarah hosted a salon that drew many of London's most prominent politicians, writers, and artists. At these salons, Cameron met several of the famous people who would become her friends and photographic subjects when she became a photographer. Among the topics of discussion at these gatherings were art, technology, and current events. Of particular interest to this group would certainly have been the Great Exhibition of the Works of Industry of All Nations, which opened in London's Hyde Park in 1851.

With displays ranging from the electric telegraph to false teeth, the first World's Fair was designed to be a forum for all the nations of the world to compete on the stage of technology and innovation. In little over five months, over six million visitors attended the fair – an average of forty-three thousand people a day.[18] The fair was housed in the Crystal Palace, which was in itself an engineering and architectural feat. Built of glass and steel, its main area was 1,851 feet long and 456 feet wide. Under a roof tall enough to accommodate full-grown trees, an entire world of art and technology was contained by a structure that in itself was a testament to the achievements of the great minds of the nineteenth century – to men who were great through genius.

Though there is no direct evidence of Cameron's attendance at the Great Exhibition, it is hard to imagine that she did not visit the fair, given her interests and her friends, and the fact that it was the social event of the decade.[19] For anyone with even a passing interest in photography, there was much to see there. On the second floor, in the section on Philosophical Instruments, photographs and cameras were displayed along with other devices that measured the world, including barometers, microscopes, bell jars, and telescopes.[20] Photographs in this section, which were made by commercial practitioners, documented people, places, or things. By contrast, images that were more suggestive of ideas and emotions were on view in the Fine Arts Court downstairs.[21] The placement of the more descriptive photographs upstairs and the expressive photographs on the main floor anticipated a debate over the distinction between commercial and art photography that would develop and intensify as the decade progressed. When she became a photographer, Cameron responded to the debate by taking great pains to distinguish her work as high art, not the work of a technician who used the camera as a recording device.

Apart from the Great Exhibition, British photographic achievement in the 1850s was marked by the landscape photographs of Francis Frith, Robert Macpherson, and Francis Bedford; by the genres pictures of Oscar G. Rejlander and Henry Peach Robinson; and by the portraits of Lewis Carroll. Roger Fenton became well known for his pictures of the Crimean War, although he also made photographs of distant lands and portraits of the royal family.[22] Lady Clementina Hawarden took up photography in 1857. Starting in 1859, she made hundreds of photographs of her daughters in their home in South Kensington, London (see figure 3), and exhibited them to a receptive audience in 1863 and 1864.[23] Also beginning in the 1850s, countless women created family albums for private enjoyment that contained photographs of loved ones or of famous people, often collaged with personal items or surrounded by artful illustrations (see figure 4).[24]

For public consumption, photographs appeared in several exhibitions in the 1850s. In December 1852, the first serious exhibition devoted solely to photography was hosted by the Royal Society of Arts. It presented 783 works and was promoted by an independent group of photographers who went on to found the Photographic Society of London in 1853 (of which Cameron would become a member eleven years later). The Photographic Institution on Bond Street was the first commercial gallery to sell photographs as works of art.[25] And in 1857, the Manchester Art Treasures Exhibition, patronized by Prince Albert himself, showed off the gems of British art—the best paintings, sculptures, and photographs from both public and private collections.[26]

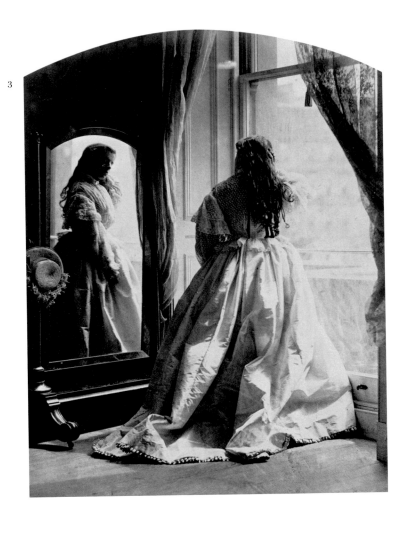

3

4

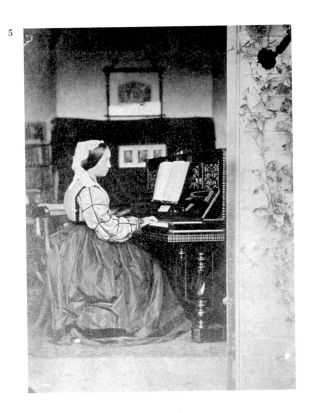

5

figure 3 Lady Clementina Hawarden
*Clementina Maude
in Fancy Dress*, c. 1862–63
Albumen print
17.6 x 13.2 cm
From *Lewis Carroll's Album
"Professional and other
Photographs"*
The University of Texas at
Austin, Harry Ransom
Humanities Research Center,
Gernsheim Collection

figure 4 Anonymous
Untitled, 1870s
Photo-collage of albumen
prints and watercolor
24 x 31 cm
The Art Institute of Chicago,
Henry Foundation Fund,
1997.221

figure 5 Attributed to
Oscar G. Rejlander
*Julia Margaret Cameron
at Her Piano*, 1863/65
Albumen print
15.5 x 11 cm
Los Alamos, New Mexico,
Michael Mattis and Judith
Hochberg Collection

No concrete evidence of Cameron's participation in the world of art photo-graphy in the 1850s assists us in determining the extent of her exposure to the medium during her late thirties and early forties. Much of that time she spent moving: the Camerons changed residence four times in twelve years before settling in Freshwater, on the Isle of Wight, in 1860. We do know, however, that, as a parent, Cameron was a consumer of photography and, like most parents, enjoyed sharing photographs of her children with family and friends.[27] On more than one occasion, Cameron posed for the camera herself. A photographer (thought to be Oscar G. Rejlander) visited the Camerons' home between 1863 and 1865, as documented in pictures of Cameron and her family (see figure 5). The photographs are staged, and tell more about Victorian life and pastimes than they do about the sitters. Even so, they confirm that in the very beginning of her career Cameron participated in the medium as a model and had an opportunity to witness an accomplished photographer in action, both under the dark cloth and perhaps even in the darkroom.

Breaking with Tradition

Cameron may have experimented with photography in 1860, three years earlier than was previously believed, but it was not until 1863, when she was given a camera by her daughter and son-in-law, Julia and Charles Norman, that she started photographing in earnest.[28] Originally Cameron saw photog-raphy as an educational tool. "When I started Photography," she wrote to Herschel, "I hoped it might help me in the education of one of my boys."[29] Cameron may have been referring to the Victorian idea that science was an ideal recreation for boys because it developed their skills of observation and analysis and it got them outdoors (photography, botany, astronomy, and chem-istry were all counted among these "rational recreations").[30] Here Cameron was most likely writing about Henry Herschel Hay, her youngest son, who was twelve at the time and who would go on to be a photographer himself.

From the start, Cameron knew she wanted to make portraits. Though she had lived in different countries and seen varied landscapes, it was not the natural world that interested her, but the world within. When she began taking pho-tographs, portrait photography was a burgeoning commercial enterprise. By 1864 daguerreotypes had given way to *cartes-de-visite*, 3½-by-2¼-inch albu-men prints mounted on cardboard, which were easily and cheaply produced. Because they were affordable, many middle- and upper-class Victorians had *cartes-de-visite* made for distribution to family and friends. They also collected *carte* portraits of famous people (see figure 6), including royalty and many of the men Cameron would later photograph. In the peak year of 1866, millions of *cartes-de-visite* were made in Britain alone, evidence that the public's

appetite for photographic portraiture was well under way by the time Cameron took up photography.[31]

In a style adopted from portrait painting, sitters for a *carte-de-visite* portrait wore their best clothes and were posed turned slightly to the side. Cameras were placed at a distance and lighting was spread evenly to clarify details in the sitters' features and dress. The result was a small and descriptive formal portrait. Of these popular photographs, Cameron's friend the author Anne Isabella Thackeray wrote, "People like clear, hard outlines, and have a fancy to see themselves and their friends as if through opera-glasses, all complete, with the buttons, etc., nicely defined."[32]

From Cameron's own writings, we know that she neither liked the way these conventional portraits looked, nor the way they were seen: as documents, not personal expressions; as the work of a tradesman, not an artist. Cameron also felt they did little to elevate the spirit. Like many other artists of the period, she believed that her art had moral value. Photography was not just a means of registering a likeness, but a format for enhancing moral rectitude and humane behavior. Jane Carlyle, the wife of Thomas Carlyle, concurred:

Blessed be the inventor of photography. I set him above even the inventor of chloroform. It has given more positive pleasure to poor suffering humanity than anything that has cast up in my time or like to. This art, by which even the poor can possess themselves of tolerable likenesses of their absent dear ones! and mustn't it be acting favourably on the morality of the country? I assure you I have often gone into my own room in the devil's own humour, ready to swear at things in general and some things in particular, and my eyes, resting, by chance, on one of my photographs of long ago places or people, a crowd of gentle thought has rushed into my heart, driven the devil out as clean as ever so much holy water and priestly exorcism could have done.[33]

Though Jane Carlyle was talking about the kinds of portraits Cameron rebelled against, both women shared a passionate belief in the redemptive value of the medium. The idea that art contributed to moral betterment was part of a mid-nineteenth-century vision of high culture. At a time when

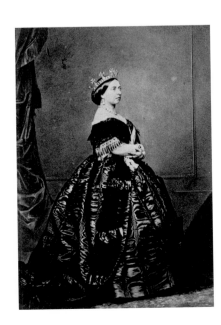

figure 6 Charles Clifford
Queen Victoria, "The Regal Portrait of Her Majesty,"
November 14, 1861
Albumen print
8.9 x 5.7 cm
Windsor Castle, England,
Royal Archives

religious principles were challenged by technological advances and scientific discoveries, this vision allowed for a displacement of spiritual values from religion to literature and art.

To Cameron's eye, the photographs being made in the 1850s and 1860s were flat-footed and uninspired, unworthy of the distinction of high art. When it came time for her to take photographs, she was determined that hers would be different and, from the very beginning, they were. A picture she made in the first few months of her career of her husband, Charles (figure 7), was a radical break from anything that had been done before. With his head large in the frame and his clothes and surroundings obscured by soft focus, the image shows Cameron to be more interested in creating an expressive interpretation of her subject than a highly detailed formal portrait. Even an early experiment like this one displays the mark of an artist with a strong personal vision who was determined to enlist the medium in the service of her ideas. This, however, was easier said than done.

The process Cameron used — wet-collodion glass negatives printed on albumen paper — though common for the period, was messy and volatile (for a detailed description of Cameron's process, see "Mrs. Cameron's Photographs, Priced Catalogue: A Note on Her Sales and Process" in this book). It required time, space, and working with toxic solutions. Cameron wrote in her short autobiography about print frames scattered in her yard, and about photographic chemicals staining her clothes, table linens, and fingernails. She also acknowledged her family's tolerance of the mess and their hearty support of her work, recognizing that from the start she was assisted in her efforts by their indulgence and love.[34]

Cameron's aesthetic arose from a combination of chance and design. During the first two years of her career, she made 9-by-11-inch plates and utilized a lens with a short focal length. This yielded an image in which only one shallow plane would be in sharp focus and the rest of the image would fall off into progressive blurriness. For example, a sitter's eye might be in focus, but her nose, hair, or garment would not. Cameron's exposures could take up to seven minutes. A model's breathing or slight body movement were, therefore, recorded as motion on film, further adding to the diffusion of the image. Cameron herself once remarked that the soft-focus characteristic of her work was achieved at first by accident. Had she been dissatisfied with the result, she could have changed cameras or photographed her subjects differently. But Cameron immediately recognized the artistic value of the error. When she graduated to a larger camera in 1866, with 15-by-12-inch plates and a lens with a long focal length, she had more options, but by then the selective focus of her early pictures had become part of her creative vision.[35]

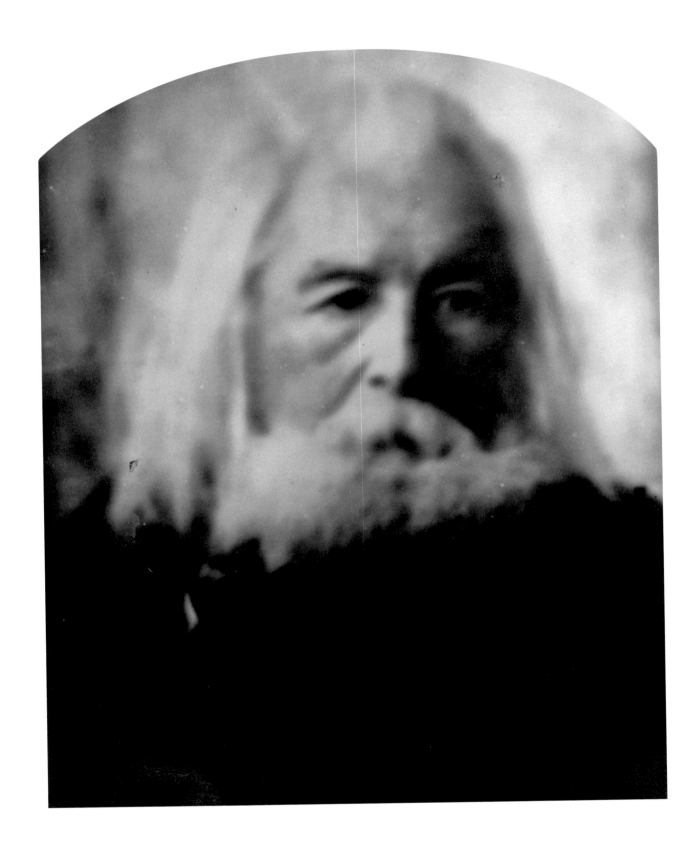

figure 7 Julia Margaret Cameron
Charles Hay Cameron, 1864
Albumen print
18.3 x 15.2 cm
Rochester, New York,
George Eastman House,
International Museum of
Photography and Film,
71:0109:0013

A photograph taken in 1866, titled *Christabel*, illustrates the close-up, soft- plate 21
focus characteristics that were Cameron's signature. In it, Cameron's niece
May Prinsep, a high-browed young woman, is positioned low and to the
right in the frame, a corona of light behind her. "Christabel" is the title of an
unfinished ballad published in 1816 by Samuel Taylor Coleridge. In the
poem, a virtuous maiden is placed under a spell by an evil sorceress, who
shares her bed and gains favor with her widowed father. Although the out-
come of the story is uncertain, for the poem is unfinished, Christabel's loss
of innocence is clearly the result of both treachery and her own trusting
nature. The Christabel Cameron portrayed is not the naive, duped maiden,
but a woman both languid and sensual. The photograph has an intimate
feeling to it, as though Prinsep has dropped her social poise altogether. With
a droopy-eyed gaze and unpinned hair, she makes no pretense at formality.
(Victorian women let their hair down only in the privacy of their bedcham-
bers.)[36] When Cameron sent this photograph to Herschel along with a batch
of others for his critique, his response was mixed: "Christabel is a little too
indistinct to my mind, but a fine head." He felt that *Mountain Nymph Sweet* plate 4
Liberty was a greater success.[37] What may have bothered Herschel is that
Christabel is decidedly human; there is nothing heroic or idealized about her,
nothing that speaks of a woman who was great through love. Instead, Prinsep
looks at the camera the way one looks in the mirror, with a distinct lack of
self-consciousness, as though she is alone at her dressing table, weary and
unimpressed with what she sees.

Compared to conventional portraits of the time, a photograph like this was a
dramatic departure in its candor, its simplicity of composition, and its lack of
reference to any period or style. For this, Cameron met with disdain and
belittlement from many of her fellow photographers, though painters and poets
praised these very same traits. To the bad press, Cameron responded with
aloofness and a hint of disdain: "The Photographic Society of London in their
Journal would have dispirited me very much had I not valued that criticism
at its worth. It was unsparing and too manifestly unjust for me to attend to."[38]
Cameron's loudest response to her critics came in the form of the photo-
graphs themselves. Defiant in the face of criticism, she became all the more
determined to make photographs that she claimed would "startle the world."[39]

Cameron was able to break with photographic tradition in part because she
came to the medium later in life, when she neither needed to conform to what
her elders were doing, nor impress anyone with her youthful enthusiasm. Her
age gave her patience and mature commitment. It also gave her an urgency
to do something that was truly her own. Because Cameron came from a back-
ground devoted to literature, religion, and painting, these were her primary

sources of inspiration. She was mostly influenced, as were many artists of
her day, by early Renaissance painters from Giotto (c. 1266–1337) to Perugino plate 46
(c. 1450–1523). Her friend George Frederic Watts, a well-known allegorical
painter active from the 1840s to the 1870s, advised her on composition and
symbolism. Cameron's sensibilities were also informed by the paintings of
the Pre-Raphaelite Brotherhood, in particular by their penchant for depicting
mournful women with long flowing hair, who were often unlucky in love. plate 25
The Brotherhood dispersed in 1853 – ten years before Cameron began pho-
tographing – and yet their effect on British art was felt well into the end of
the century. Cameron incorporated some of the formal characteristics favored
by the Pre-Raphaelites, but ultimately surpassed them in the range of expres-
sion she attributed to women.

In photography, Cameron was influenced by the genre pictures of Rejlander
and the portraits of Royal Academy members in costume made by David Wilkie
Wynfield (see figure 8).[40] Both men assisted Cameron in her early experi-
ments with photography. Though she was born within five years of some of the
master photographers of the mid-nineteenth century – Nègre, Nadar, and
Fenton, to name a few – by the time Cameron began photographing in 1863,
most of these photographers had already made the works they became known
for and had moved on to other things. Moreover, there is no evidence in her
writings or her pictures to suggest that she was influenced by their work.

Cameron was quite specific, however, about the impact on her photography
of her friend Sir John Herschel. Not only did he respond to problems she had
with photographic chemicals, but also, and more importantly, he provided
enthusiastic support for her art at a tender time in her creative development.
Within a year of making her first successful photograph, Cameron asked
Herschel to pose – her wish to make a portrait of the astronomer a signal of
both her confidence in her abilities and her desire to share her passion for
photography with her mentor. For three years, Cameron tried to entice Sir
John and Lady Herschel to Freshwater, where she had set up a studio in a
glass-roofed chicken coop and a darkroom in the coal house. But Sir John's
failing health and reclusive nature kept the Herschels at home. Not to be
dissuaded, Cameron arranged through correspondence with Lady Herschel
to bring her camera equipment and chemicals by train to the Herschels'
home in Collingwood, where her famous portraits of Herschel were made.

Cameron's wish to photograph Herschel came first and foremost out of rever-
ence and respect, though the astronomer's age was undoubtedly a factor in
her sense of urgency in making a portrait. When she finally took his picture in
1867, Herschel was seventy-five years old. In photographing him, Cameron
filled the frame with Herschel's head (figure 9). His face appears lined and

8

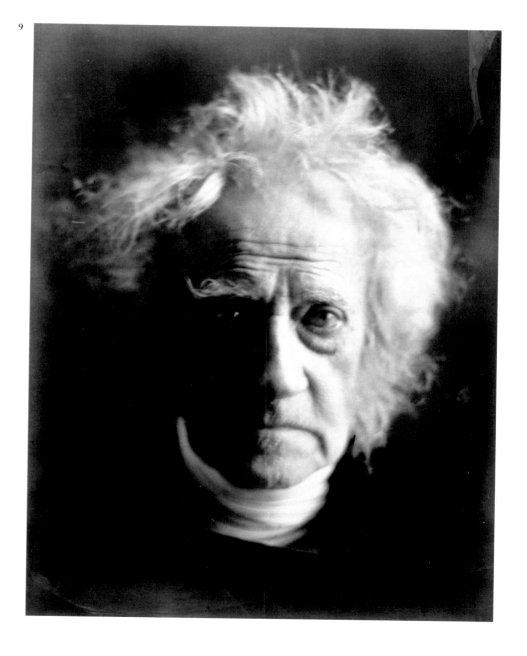

figure 8 David Wilkie Wynfield
 Simeon Solomon, c. 1870
 Albumen print
 20.2 x 15.1 cm
 London,
 Royal Academy of Arts,
 Photographic Collection

figure 9 Julia Margaret Cameron
 Portrait of
 J. F. W. Herschel, 1867
 Albumen print
 35.9 x 27.7 cm
 London, Michael and Jane
 Wilson Collection, 93:4916

9

baggy, his eyes moist with age. Stubble grows on his chin, and stray hairs on his right eyebrow catch the light. In some ways, the astronomer looks more like a hermit than a famous scientist. Lit primarily from the side, the furrow in Herschel's brow is accentuated, giving him an inquisitive and sensitive, though slightly startled, look. At the same time, Herschel's white, woolly hair (recently washed and left uncombed at Cameron's request) is ablaze with light, as though illumination comes from within. A picture like this points out that it is not who Cameron's sitters were, but how she photographed them, that made her photographs powerful then and makes them compelling still. With his fly-away hair and unwavering stare, Herschel's intensity is as palpable to modern viewers as it was 130 years ago — it is of little consequence that the astronomer is largely unknown to audiences today.

Several years after Cameron photographed Herschel, she wrote about this portrait sitting in her autobiographical account of her photographic career: "my illustrious and revered as well as beloved friend, Sir John Herschel...was to me as a Teacher and High Priest. From my earliest girlhood I had loved and honoured him, and it was after a friendship of 31 years' duration that the high task of giving his portrait to the nation was allotted to me."[41] The way Cameron worded this makes it sound as if she was picked by an outside authority to do an official state portrait of the astronomer, when in truth Cameron designated herself as the single photographer capable of capturing Herschel's spirit for posterity.[42] Written when she was fifty-eight years old, these are the words of an artist who knows her abilities. They also trace Cameron's attitude toward famous men over thirty years time — from girlish fascination to full-blown hero worship.

Herschel was not the only one Cameron held in such high regard: all the men she knew of intellectual stature were the subject of her reverence. She both photographed and spoke adoringly of her friend and neighbor Alfred Tennyson and of Sir Henry Taylor (figure 10), for whom she had a particularly acute affection. Her account of photographing philosopher and social historian Thomas Carlyle can be applied to all her male subjects: "When I have had such men before my camera my whole soul has endeavoured to do its duty towards them in recording faithfully the greatness of the inner as well as the features of the outer man.... The photograph thus taken has been almost the embodiment of a prayer."[43] The process of photographing famous men was for Cameron not merely a creative act, but a religious experience — the creation of a beautiful head a devotional offering.

Cameron's adoration of great men is in keeping with the Victorian glorification of the male intellect. Like many others of her time, Cameron felt it was her moral responsibility as an artist to raise human consciousness

figure 10 Julia Margaret Cameron
Sir Henry Taylor,
October 13, 1867
Albumen print
34.3 x 27.4 cm
The University of Texas
at Austin, Harry Ransom
Humanities Research Center,
Gernsheim Collection,
964:0037:0105

figure 11 Julia Margaret Cameron
Our May, 1870
Albumen print
34.9 x 28 cm
Boston Athenaeum,
C.5.4 Pri.m.1870

through the creation of beauty and the preservation of high ideals. By photographing famous men in a style distinctly her own, Cameron exercised a voice equal to and conversant with theirs, and she aligned herself with their greatness. She also knew that if she used her medium to make an expressive picture of her sitter, not just record a likeness, she would create a new identity for her subject – a photographic identity – which would in turn create an identity for herself as its maker. It is significant that, in almost every case, Cameron maintained her male sitters' names as titles of her photographs. Rather than equate them with historical or classical figures, she used photography to create a pantheon of godly geniuses of her own time. Not so with her portraits of women.

Models of Femininity

To start with, the female sitters Cameron photographed were not famous. Cameron could very well have found women of stature or of note had she wished, but genius or intellectual accomplishment were not what she looked for in her female models. Instead, Cameron sought faces that were the embodiment of her ideas about femininity. She found them among her friends, her family, and her household staff – young, beautiful women, whom she portrayed as saints, Madonnas, and figures from poetry and mythology (the most notable exception, her niece Julia Jackson, will be discussed later).

Cameron's points of reference for photographing women came from her own experience and from the way women were portrayed in art and literature. In life, upper-class women were preoccupied with the religious training of their children (the actual child care was entrusted to a nanny) and with overseeing household activities and staff. In 1861, for example, Cameron's home was run by a staff of six, including a manservant, a cook, a governess, and three maids.[44] Philanthropic pursuits and caring for the sick were part of the generosity, selflessness, and nobility of spirit so highly esteemed in women. (Cameron fulfilled this role admirably by initiating the raising of some 10,000 pounds for relief of the Irish Potato Famine in 1845.)[45] And, with the advent of the Penny Post in 1840, women maintained correspondence with family and friends.

Representations of Victorian women in art and literature range from the specific to the ideal, as two of Cameron's photographs show. An image made in 1870 is a domestic genre picture of the kind that was common in painting (figure 11). In it, Cameron's niece May Prinsep is well appointed in finery, her hair appropriately contained in a bun. She sits at a writing table in a high-backed wooden chair, her head bent over a letter. A candle burning close to its base and positioned in front of a clock is a reference to transience and time

passed more than it is a source of light, for the photograph is illuminated evenly with a kind of display lighting utilized in genre pictures to ensure that all the symbols were clearly seen. The most prominent symbols here are the Bible on Prinsep's lap, the empty bird cage nearby, and the bird perched on the tabletop. The Bible represents female piety and virtue, the cage symbolizes both woman's nurturing nature and her containment, and the bird identifies May Prinsep with a delicate pet.

In contrast is a photograph Cameron made in 1867 of her housemaid Mary Hillier as a woman looking mournfully into the distance. Hillier is posed plate 1 against a black backdrop, her head and hair filling the frame; and she is cloaked in black velvet, a device Cameron often used to obscure details in her sitters' clothing and eliminate any references to class, era, or style. The trappings of daily life, so prominent in the photograph of May Prinsep, are nowhere to be seen. This photograph is about a general state of melancholy, not a specific domestic activity. Cameron alternately left the image untitled or applied a line from a Tennyson poem, "Call, I follow, I follow, let me die."[46] While the woman's despair inspires sympathy, there is a measure of erotic allure to this photograph. Hillier's heavily-lidded eyes, her full lips that droop ever so slightly at the edges, her exposed neck, and her hair — unpinned and flowing behind her with a looseness that is both literal and metaphoric — signal sensuality and abandon. Ennobled by her suffering, Hillier is enticing. She is also in a world of her own. A tragic heroine, she is both languorous and aloof, inviting and unapproachable.

While neither of these photographs gives an accurate depiction of the lives of actual Victorian women, both contain elements of what mid-century Victorians needed or wanted women to be. The fact that Cameron made both of these photographs tells us that she had a far keener sense of the paradoxes facing women of her time than her letter to Henry Taylor, quoted earlier, suggests. Some of this Cameron knew from her own experience. By the time Cameron began photographing in 1863, she had seen a number of changes affect the lives of middle- and upper-class women. Romantic love, for example, underwent a significant shift during her lifetime. When Cameron married Charles in 1838, it was common for partners to be matched based on social standing. But by the 1860s and 1870s, arranged marriages increasingly gave way to marriages formed by love and attraction. Men wooed the women they desired, and women sought the men of their dreams. With little real-life experience relating to the opposite sex, both men and women modeled their hopes after characters from literature and legend — the men as idealized as the women. Courtship was a confusing and titillating affair. Handbooks on proper social conduct encouraged women to be cool, aloof, detached, and men to be appropri-

ate in their conduct at all times. As a result, both partners often experienced smoldering ardor and agonizing love sickness. This suppression of feeling in real life encouraged a spilling over of sentiment into the arts and letters, as evidenced by the dramatic rise in romantic poetry starting in the 1840s, and in submissions to the Royal Academy of paintings depicting courtship.[47]

As romantic love became a thriving subject, a visual language of signs and symbols was developed to describe or allude to passion and longing. A garden, for example, signaled at once pastoral beauty and erotic potential. It symbolized the inner sanctum, where a young woman's virtue was isolated and protected from the outside world by ivy-covered walls. At the same time, a garden offered privacy and the opportunity for illicit love. Under the shadow of a leafy tree or in a remote corner or gazebo, lovers could meet. An image of a woman in a garden, therefore, delivered a tantalizing combination of virginal unavailability and sexual suggestion. It also made reference to Eve in the garden of Eden, which added innocence, temptation, and sin to the possible readings.

Following a tendency common to painters of her day, Cameron depicted romantic love through poetic allusion. Lines from Shakespeare and Tennyson were among her sources of inspiration. A photograph Cameron made, related to Tennyson's poem "The Gardener's Daughter," portrays the moment when the poem's narrator, a young man drawn to the garden by tales of the beautiful maiden within, first sees the gardener's daughter and is awed by her loveliness. Viewed from afar, the young woman is unaware of her observer as she repairs a fallen branch on a rose bush. In her photograph, Cameron illustrated Tennyson's lines:

... One arm aloft —
Gown'd in pure white that fitted to the shape —
Holding the bush, to fix it back, she stood,
A single stream of all her soft brown hair
Pour'd on one side;...[48]

Cameron's housemaid Mary Ryan is indeed shown from a distance as she tends to a rose bush. In Tennyson's poem, the narrator is a painter, and his first glimpse of the gardener's daughter is described in vivid formal and spatial detail. In Cameron's photograph, the moment is eloquently described with light. Slightly soft in focus, with a sumptuous gray tone, the image is a picture of delicacy and tranquillity. Everything is touched by a gentle breeze that blows the vines, their motion reading as a dreamy blur. Even the walkway is sublime, the stones softened by the sun. The world beyond the ivy-covered archway is out of focus, as though a scrim has been dropped to diffuse the contours of a reality too harsh. Here the gardener's daughter may not be

protected from the voyeuristic eye of an ardent admirer, but she is alone with her thoughts, lost in private reverie, safe in a world that is distinctly her own.

By contrast, the woman in another Cameron photograph, also inspired by a line from a Tennyson poem, strains against her garden fence.[49] In *Passion Flower at the Gate* (figure 12), a young woman in everyday dress – again with her hair down, though this time wearing a wedding ring – gazes longingly beyond the confines of her yard. Her chin on her arm and her wistful look imply a long wait. In the Victorian language of flowers, a passion flower symbolized belief or susceptibility. In Victorian garden iconography, photographs that included fences or gates made reference to women enclosed, cloistered from the temptation of men and the aggression of the outside world. By their very form, the spikes of this fence suggest a threat to the model's virtue. At the same time, they keep her in, her virtue intact.

In their differences, these two pictures imply that Cameron had complex attitudes toward courtship and love. The first image is an ethereal and idealistic rendering, infused with pastoral beauty. The second has greater urgency and immediacy. Though our first reading of this picture is that the young bride awaits her husband's return, we may also interpret it as expressing not just love, but a desire for release from the confines of home. Whatever the interpretation, both photographs allude to female virtue, a potent topic for Victorians.

Virtue was addressed in books and articles in popular magazines, which were designed to convey what was expected of a middle- and upper-class woman in love and in marriage. In Isabella Beeton's *Book of Household Management* (1861), for example, a woman was described as a model of virtue: "she was a formidable leader with a responsibility to teach, nurse, and above all exemplify to her servants the proper morality, charity, cleanliness, frugality, and self-sacrifice."[50] John Ruskin, in his 1865 essay *Of Queens' Gardens*, asserted that "woman's power is for rule, not for battle – and her sweet intellect is not for invention or creation, but for sweet ordering, arrangement, and decision.... This is the true nature of home – it is the place of Peace: the shelter, not only from all injury, but from all terror, doubt, and division."[51] Ruskin's words give evidence of the very real fear many Victorians felt before the uncertainties of the outside world. They also communicate a commonly held belief, akin to that expressed in Cameron's words to Henry Taylor: while men of great minds were looked to for invention and creation, women ruled through love.

The Victorians' strongest model of femininity was, of course, their queen, a woman who literally had the power to rule, and who held conservative views on the rights and prerogatives of women. Queen Victoria's domestic values are reflected in one of the most famous mandates for proper female conduct,

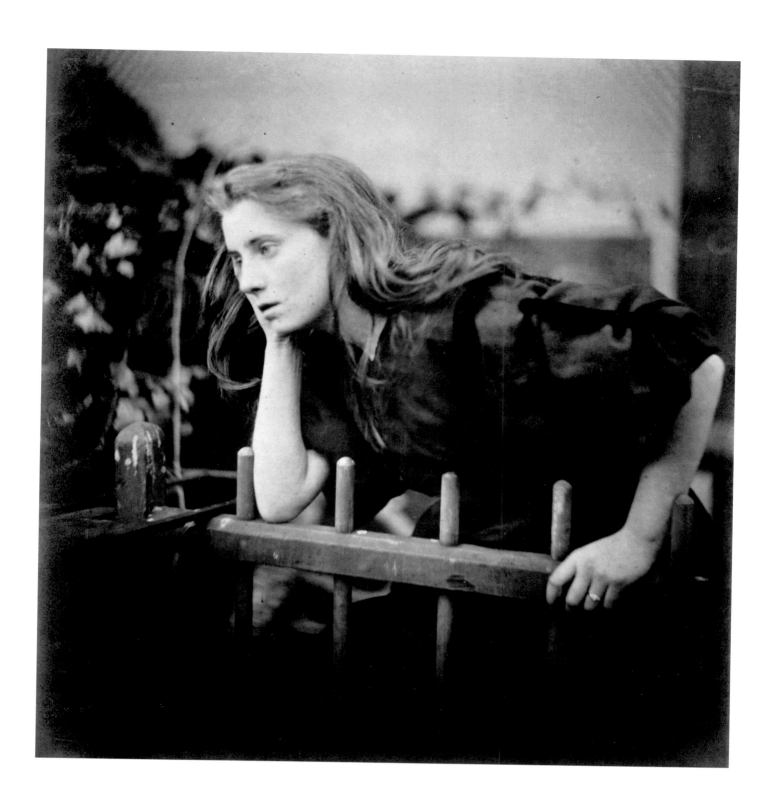

figure 12 Julia Margaret Cameron
 The Passion Flower
 at the Gate, 1867
 Albumen print
 28.6 x 27.1 cm
 Boston, Museum of Fine Arts,
 Lucy Dalbiac Luard Fund,
 1991.550

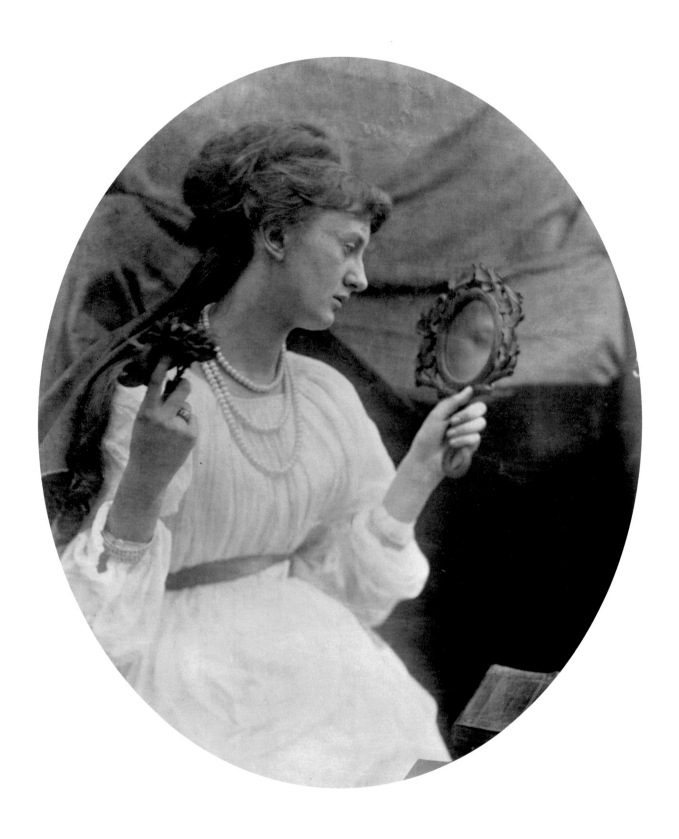

figure 13 Julia Margaret Cameron
 May Prinsep, October 1870
 Albumen print
 31 x 25.1 cm
 The University of Texas
 at Austin, Harry Ransom
 Humanities Research Center,
 Gernsheim Collection,
 964:0037:0039

Coventry Patmore's poem "The Angel in the House," which was published in four installments from 1856 to 1862. In it, women are cast as beings of high moral fiber, as guardian angels, who create a safe haven from the troubling issues of the day. They are gentle and humble, they love without ambition, and the more childlike they are, the greater their appeal:

...she grows
More infantine, auroral, mild,
And still the more she lives and knows
The lovelier she's express'd a child.[52]

In 1871 Cameron and her son Henry Herschel Hay, now age twenty and a photographer himself, made a photograph of Emily Peacock as *The Angel in the House*.[53] With her coarse curly hair in a bun, her eyes dark and deep, her head upturned, as if she were looking to the heavens or perhaps listening in subservience, Peacock looks delicate and ethereal. To modern eyes, the collar of her garment has a bedroom-slipper fuzziness about it, which evokes the image of a woman padding softly through the house with a hush and a whisper. Her shoulders slump and there is a hint of a furrow in her brow that makes her seem burdened, fragile, like one more in need of care than able to dispense it.

plate 2

This photograph points to the contradiction in Patmore's vision of womanhood. When Patmore began writing his poem in the mid-1850s, it voiced both a critique of male aggression and a fear many Victorians had about decaying social and moral values. It also gave women impossible shoes to fill. The contradictory image of woman as frail and vulnerable, malleable and childlike, and at the same time strong enough to protect men from the coarseness of their natures and from the outside world, is one that Victorian women were measured against. By the time the Camerons made *The Angel in the House* fifteen years later, the climate was changing. In 1870 John Stuart Mill lobbied for women's suffrage in his book *The Subjection of Women*, which was widely debated in intellectual circles. Though his ideas would take fifty-eight years to be realized (British women were not given full suffrage until 1928), Mill posed a serious challenge to conservative views of women.[54] With this in mind, another of Cameron's photographs – this one of May Prinsep gazing at herself in a hand-mirror, her reflection a disembodied eye – may be seen not simply as an allegorical subject or a vanity pose, but as a contemplation and questioning of woman's identity (figure 13).

Cameron came of age among the kinds of beliefs about Victorian womanhood that were outlined in Patmore's "Angel in the House," and yet her own life and character were far from Patmore's ideal – a factor that no doubt contributed to the paradoxical images we see among her portraits of women. A spirited

and ambitious woman, Cameron was intellectually engaged with the ideas of her time, not cloistered in her house, childlike and adoring. Proficient in languages since youth, she published in 1847 an English translation of the poem "Lenore" by the eighteenth-century German poet Gottfried August Bürger.[55] She was a member of the Arundel Society, an organization with a large and impressive membership, which promoted a knowledge of art through the creation, publication, and sale of copies of famous works.[56] Cameron wrote poetry (though she was an astute enough judge of literature to see the limitations of her own abilities), and she was up-to-date on world events.[57] The Great Chicago Fire of 1871, for example, elicited Cameron's deep sadness, the tragedy real to her though it was thousands of miles from her home on the Isle of Wight.[58]

A proper upper-middle-class woman, Cameron fulfilled her duties as wife and mother. She also managed more than simple domestic activities, sometimes assuming the patriarchal role in her own household. Cameron's letters signal that she had a strong command of financial matters, including knowledge about the family's real estate holdings in Ceylon, about annuities, and about which child would get what percentage of the proceeds when property was sold.[59] For a Victorian woman to be privy to that kind of information in detail was uncommon; estate and inheritance affairs were ordinarily the domain of a woman's husband or father. The same could be said of home remodeling, and yet in 1872 Cameron initiated the renovation of the family residence in Freshwater, overseeing the knocking down of walls, the installation of windows, and the building of two porches, with an eye toward making part of her home attractive to renters.[60] She also took on primary responsibility for the education of her sons. In a letter of 1868 to Henry Cole of the South Kensington Museum, she thanked him for lending her rooms in the museum for portrait sessions, as these sessions advanced the sale of her work and "a woman with sons to educate cannot live on fame alone!"[61]

If Cameron's husband, Charles, is often absent in her accounts of household affairs, it may be because throughout much of his later life he was bedridden with chronic kidney problems or with the opium drops that were the only means of easing his pain. When he is mentioned, it is in news of his health that Cameron sends in letters to friends and relatives. These passages are marked by a tenderness that underscores her reverence for her husband, not as a man who was great through genius (for though well educated, Charles was not known for remarkable achievement), but as a person for whom she felt love, devotion, and respect. Of significance to her art is the autonomy Cameron enjoyed in part because of her husband's poor health, but largely because of the respect he, in turn, had for her.

In spite of his illness, Charles would have been informed and concerned about the financial strain on the family's resources that started in the late 1850s. With the decline of their coffee plantations in Ceylon and the economic inflation of the 1860s, the Camerons were in distinct financial distress by the time Cameron took up photography in 1863.[62] In an effort to earn money through the sale of her photographs, Cameron established a relationship with one of Bond Street's leading art galleries, P. & D. Colnaghi and Co. of London. Her pick of venue is revealing. By allying herself with a well-established gallery, specializing in fine-art prints and drawings, Cameron asserted that her photographic portraiture was high art and not the work of the commercial trade. She also revealed her determination to make a commercial success of her photography (her commercial activities are further discussed in this book in "*Mrs. Cameron's Photographs, Priced Catalogue:* A Note on Her Sales and Process").

For a middle- or upper-class woman to make money was rare. A woman in Cameron's circle did not ordinarily handle money beyond day to day household transactions. She had a sum attached to her in the form of a dowry, but this and any material possessions she owned passed to her husband upon marriage, at which time she became his legal property.[63] If a woman remained single, her father or another male relative became her financial caretaker. A Victorian woman's economic prospects, therefore, were largely defined by her association with a man. This is one of the reasons why female characters in art and literature who faced the loss or betrayal of a man were treated with sympathy by the Victorians. Ophelia, for example, the young maiden in Shakespeare's play *Hamlet*, who faced the loss of both her father and her lover, was one of the Victorians' favorite heroines.[64]

Cameron's Expressive Range: From the Theatrical to a "Reserve of Power"

Ophelia captivated Cameron's imagination enough to inspire at least two depictions. In one, the model is dressed in a heavy black velvet cloak and a straw hat garnished with flowers. Her eyes are slightly milky, like a cat's-eye marble, an effect caused by motion during the exposure. In the play, Ophelia is driven insane with grief over the murder of her father by her beloved Hamlet and by Hamlet's subsequent denial of his love for her. In her madness she wanders in a field to pick flowers, then falls into a nearby stream. Too delusional to realize the danger she is in, Ophelia sings absentmindedly and is buoyed on the surface momentarily by the air under her skirts:

plate 15

...but long it could not be
Till that her garments, heavy with their drink,
Pulled the poor wretch from her melodious lay
To muddy death.[65]

14

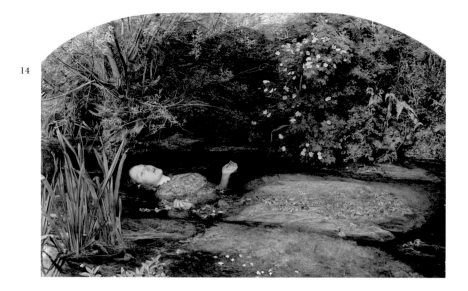

15

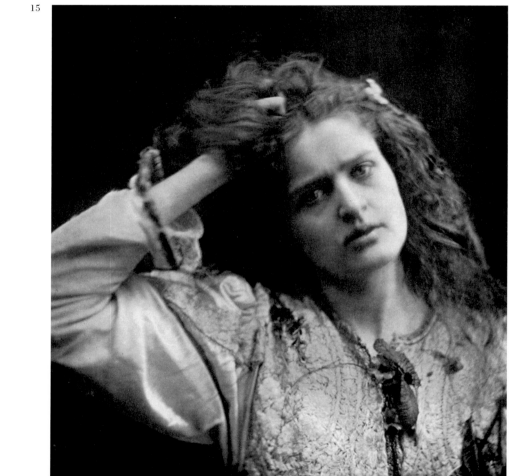

figure 14 John Everett Millais
 Ophelia, 1851–52
 Oil on canvas
 76.2 x 111.8 cm
 London, Tate Gallery

figure 15 Julia Margaret Cameron
 Untitled (Ophelia), 1870/75
 Albumen print
 35.3 x 27.7 cm
 Los Angeles,
 The J. Paul Getty Museum,
 84.XM.349.15

Most paintings and drawings of Ophelia in British art pay close attention to descriptive details in the drama – in particular, the types of flowers Ophelia carried. In a painting of 1851–52 by Pre-Raphaelite artist John Everett Millais (figure 14), each one of the flowers on the canvas signifies some aspect of the story and was painstakingly painted from nature over a period of four months (the figure was added in the winter months by posing a model in a tub in Millais's studio).[66] Cameron could have emulated this Pre-Raphaelite tendency to exactitude. Certainly the camera gave her an apparatus with which to transcribe a subject directly from nature. But Cameron had long before concluded that there was more art to the characterization of a subject than to its photographic illustration.

In another of her renditions of Ophelia, for example, nothing in the picture alerts viewers to its subject. The sitter is draped in a black cloak. She is lit from above right, so that her nose and high forehead form a delicate silhouette. This model could be portraying any number of characters in literature or art. (Cameron appears to have sometimes had a title in mind when she began photographing, and at other times titled a work later in response to the way a picture looked.) Once the title of this photograph is read, we become aware that the white rosebuds at the sitter's neck – both closed, the outer petals wilting – allude to Ophelia's life cut short before its flowering. In this image a certain spontaneity in the pose is suggested by the model's slightly open mouth and by the turn of her head, as though – true to the story – she is distracted by a spirit of her own imagining. And yet her look, though absorbed, is not that of the crazed maiden in the play. This Ophelia exhibits an existential distress more akin to Hamlet's than to the tragic heroine Shakespeare portrayed. She is not a woman who is great through love or even love lost. The power of Cameron's Ophelia is her questioning look, one that is modern and in keeping with the emotional tenor of Cameron's time.

plate 16

Less evocative is a picture of Emily Peacock strung with flowers, pulling her hair and looking at the camera in obvious dismay (figure 15). This may be a third version of Ophelia, though it is untitled. As another portrayal of a woman in the grip of despair, it is an example of Cameron's interpretive range and her willingness to experiment with a single subject or theme. In its explicit emphasis on the dramatic, this photograph also recalls one of the Victorians' favorite pastimes. Called "amateur theatricals," these were plays or enactments of poems staged in the home for the entertainment of family and friends. Playacting held strong appeal for the Victorians, as it provided a form for the free expression of emotion not deemed appropriate for everyday social intercourse. Even the queen orchestrated elaborate tableaux with family and guests of the royal court. Cameron and her children hosted theatrical

evenings on numerous occasions, spending days or weeks in rehearsal, preparing announcements, and printing programs for the event.[67]

The Victorians' passion for playacting made its way into art and literature. Henry Peach Robinson and Oscar G. Rejlander led the way in photography through staged scenes or collages called "tableaux vivants." Robinson, Cameron's most serious rival for notoriety and sales, made a composite panoramic view in 1862 called *Bringing Home the May* (figure 16). In 1866 Cameron made a picture on the same subject entitled *May Day*. The emphasis in Robinson's picture is on the landscape of the May Day ritual. Using several negatives, he combined images of women and children in a solemn scene with an overgrowth of vegetation that makes the activity look more like a weeding expedition than a gathering of flowers. Cameron, too, leaned toward exaggeration in her May Day photograph.

plate 19

Packed with five figures and a profusion of flowers, the image is tightly composed, with slight vignetting to emphasize the circular composition rotating around the central figure. The photograph is obviously staged. No effort has been made to conceal that the setting for her picture was indoors (patterned wallpaper in the upper right corner gives this away). It must have been difficult for Cameron to get all five models to do what she wanted and to hold the pose for the length of the exposure. Nevertheless, the zombielike state with which each sitter maintains her position makes this a somber occasion, not the joyful one the picture's title suggests. Even Mary Hillier (upper left), who resembles a heralding angel with puffed white sleeves and a hat behind her head that looks like a pair of wings, seems stunned as she holds a bundle of flowers and vines stiffly aloft. A tangle of leaves, twigs, and berries in the foreground and wilting flowers strung around the models' necks, or tucked behind their ears, add an element of disorder and decay that is

16

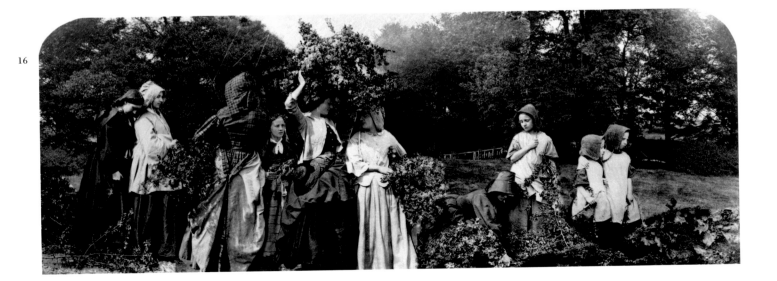

reminiscent of the *vanitas* theme in Dutch still-life painting – everything a bit ripe and overdone, as a reminder of mortality. What should be a photograph about fertility and abundance, about budding youth and potential, has instead a frozen sadness to it. This theatrical excess is precisely what makes the picture strangely powerful and touching.

Although some of her photographs are decidedly staged, Cameron was aware of the pitfalls of overdramatization. In a letter to Mrs. Sidney Frances Bateman, in praise of her daughter's subtle acting ability on the professional stage, Cameron wrote about the famous opera singer Maria Malibran: "Madame Malibran who was one of the stars of my early days had the gift of making reality of life, stronger in her simplicity of acting, than *dramatic* effect!! I very much appreciate this reserve of power in everything – in painting, in poetry, in acting. It does not *seize* hold of the public but it takes hold I hope."[68] Cameron did not always achieve this "reserve of power" in her own work. Among her more delightful extremes is a picture variously called *The Rosebud Garden of Girls* and *Too Late! Too Late!* (figure 17), both titles inspired by Tennyson poems.[69] There is a kind of campy pleasure to be had from the heightened sense of drama in this picture and from the display of earnest effort on the part of both the models and the photographer.

The most successful of Cameron's narrative pictures are ones in which there is no need to illustrate the story because the tale is one her audience already knows. Educated upper-class British viewers of the 1860s and 1870s shared a common vocabulary and understanding of pictorial conventions (what William Butler Yeats referred to as the "spiritus mundi," the body of literary

figure 16 Henry Peach Robinson
Bringing Home the May, 1862
Albumen print
from nine separate
wet-collodion negatives
38.7 x 99.8 cm
Bath, England,
The Royal Photographic
Society Collection, 6997

figure 17 Julia Margaret Cameron
The Rosebud Garden of Girls,
1868
Carbon print
33.8 x 28.1 cm
The University of Texas
at Austin, Harry Ransom
Humanities Research Center,
Gernsheim Collection,
964:0037:0092

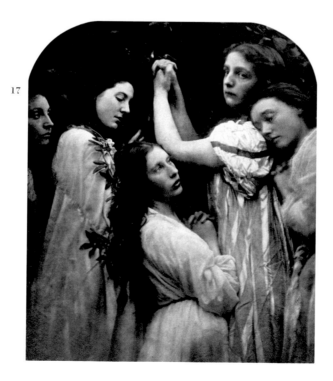

17

and visual knowledge acquired through a classical education). Just as they knew that a white rose symbolized innocent love and an apple alluded to Adam and Eve, they knew that a figure in white robes was a reference to the classical world. In the late 1860s, Cameron made a number of photographs of women from Greek mythology – gods and goddesses had indeed been a part of her visual memory from her girlhood days at Versailles. Mary Hillier posed for at least three renditions of the Greek poetess Sappho (see figure 18), who resided on the island of Lesbos and whose verses expressed friendship and passionate love, often between women. Painter and model Marie Spartali portrayed Hypatia, a great beauty and powerful orator, who belonged to the fifth-century Neoplatonic school of philosophy and was dismembered by a Christian mob. May Prinsep posed as Zoe, the heroine of the Greek War of Independence of 1822. And Emily Peacock was Egeria, the wife of and advisor to the king of Rome in the seventh century B.C. (figure 19). All of these characters were strong and articulate women, whether defending their home-land and beliefs, or voicing the expressions of the human heart. Within Cameron's own work, these images expanded the range of possible models for female behavior, and, in so doing, complemented the passive childlike view of women expressed in photographs such as *The Angel in the House*.

plate 34

plate 3

In one of her most famous photographs, Cameron posed Alice Liddell as Pomona, the Roman goddess of fruits and trees. Pomona was a popular figure who had appeared through the ages in the works of painters, including Titian, and writers, such as Ovid and Milton. She was variously portrayed as a fertility figure, or a woman who refused all advances, as Summer or Autumn, and sometimes – because she was the guardian of a sacred orchard – she was asso-ciated with Eve. Cameron's Pomona is photographed with a shallow depth of field. The soft-focus leaves in the foreground create a frame around her so that she protrudes from the vines like a figure from classical relief sculpture. With a square jaw, boyish bangs, highly-arched eyebrows, and a hand perched on her hip, this Pomona looks strong and willful, saucy and direct. No hot-house flower, she is someone to be reckoned with. The personality of the sitter is largely responsible for this. Unlike many of Cameron's sitters, Alice Liddell had a forceful presence that transcended the role she played for the camera. It is easy to see why Lewis Carroll found Liddell a compelling character and muse for his *Alice's Adventures in Wonderland*.

plate 18

This image and others on classical themes tell us that Cameron joined in the nationwide look to the classical past, which was fueled during the nineteenth century in part by nostalgia and in part by new archaeological discoveries. In 1812 the British ambassador to the Ottoman Empire, Lord Elgin, brought to England sculptures from the Greek Parthenon and sold them in 1816 to the

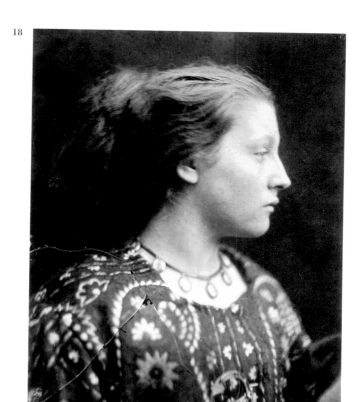

figure 18 Julia Margaret Cameron
Sappho, 1866
Albumen print
35 x 26.8 cm
London, Michael and
Jane Wilson
Collection, 84:1004

figure 19 Julia Margaret Cameron
Egeria, 1870/75
Albumen print
38.4 x 30.4 cm
London, Victoria
and Albert Museum,
34-1939

19

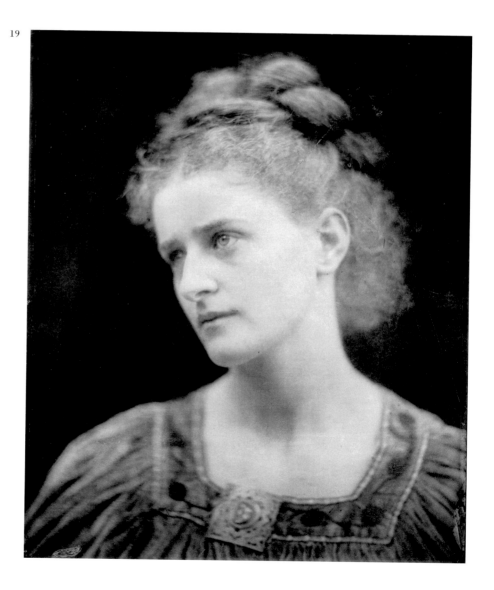

20

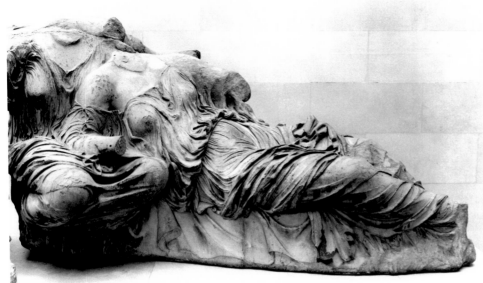

21

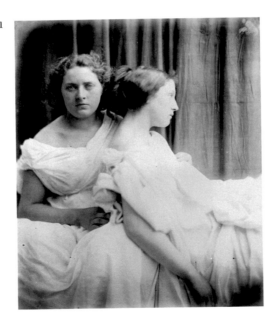

22

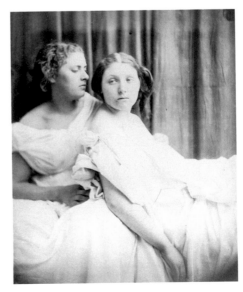

British Museum. Their classical beauty and suggestion of a nobler, more heroic time were infinitely appealing to a society undergoing dramatic change. So popular were the Elgin Marbles that, throughout the nineteenth century, they were widely copied and published. In fact, Cameron is reported to have once made a gift to the Tennysons of wallpaper based on these classical marbles. And John Ruskin, upon visiting Little Holland House, compared two of Cameron's sisters to the Greek carvings: "two, certainly, of the most beautiful women in the grand sense – Elgin marbles with dark eyes – that you could find in modern life."[70]

In 1867 Cameron made two photographs based on one of the marbles, a sculptural fragment that had once been under the cornice of the Parthenon's east pediment (figure 20). The fragment's two female figures are headless, leaving their mythological identity forever in question and leaving Cameron free to interpret them at will. In one photograph, Cyllena Wilson and Mary Ryan seem to be sharing a secret (figure 22). In the other, Wilson returns our gaze with pale eyes and a directness that belies all modesty and social decorum (figure 21). Wilson, the daughter of a missionary, had been orphaned at a young age and adopted by Cameron. Here she appears thoroughly comfortable with Cameron's housemaid, Mary Ryan – the social codes that regulated interaction between the classes having been forfeited for this sitting.[71] Both of these photographs are faithful to the pose of the marble fragment in which one figure reclines against the other, but that is where the similarities between Cameron's work and the Elgin Marbles cease.

To begin with, there is no idealization in the posture of Cameron's sitters, even if they are wearing Grecian garb. With bored and tired expressions on their faces, Wilson and Ryan are not noble icons of godly grace, but two models slouching in sheets. Even the drapery looks frumpy, the fabric bunched and twisted rather than wet and revealing of the human form as in the Elgin Marbles and in all classical figurative sculpture. While Cameron was most likely trying in earnest to make an artful illustration of the marble fragment, the pictures themselves imply another narrative. They hint at a skepticism toward the prevalent zeal for classicism and they infer an ambivalence, or perhaps a discomfort, at projecting the idea of classical perfection on contemporary women. In fact, the two women in these pictures are so decidedly self-conscious that we remain unsure if Cameron made these dispassionate views of classicism on purpose, or if she failed here in her efforts to achieve a "reserve of power." In that ambiguity lies the power of these pictures.

Educated Victorians who saw these photographs would recognize their subject, having viewed the Elgin Marbles at the British Museum or having seen them in reproduction. Likewise, sophisticated European travelers to Rome

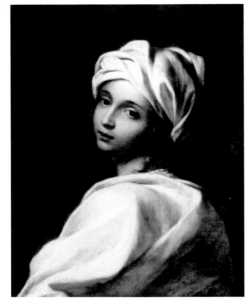

figure 23 After Guido Reni?
Beatrice Cenci, early 1600s
Oil on canvas
64.1 x 49.5 cm
Rome, Galleria nazionale
d'arte antica, Palazzo Corsini
[Photo: Barbara Novak,
*Nature and Culture: American
Landscape and Painting,
1825–1875*, New York, 1980,
fig. 106]

figure 24 Julia Margaret Cameron
Beatrice, March 1866
Albumen print
35.5 x 28.1 cm
London, Victoria
and Albert Museum,
944-1913

figure 25 Julia Margaret Cameron
A Study of the Beatrice Cenci,
September 1870
Albumen print
33.3 x 27.2 cm
Bath, England,
The Royal Photographic
Society Collection, 2301/4

24

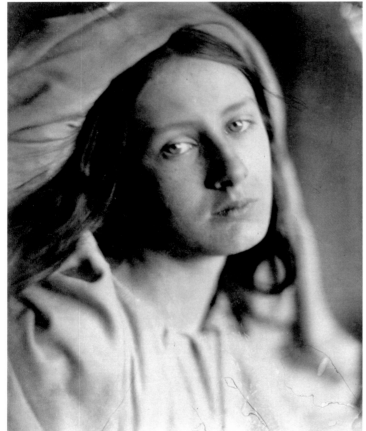

25

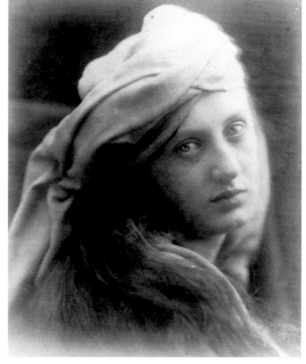

would have visited the Palazzo Barberini and seen the well-known painting (once thought to be by Guido Reni) of the sixteenth-century Roman girl Beatrice Cenci (figure 23).[72] Cameron did not travel to Rome, but she knew of the painting, if not from a reproduction courtesy of the Arundel Society or from her friend Anne Isabella Thackeray, who had seen it, then from the countless treatments of the tale in the 1860s. Earlier in the century, the story of the Cencis was dramatized by Percy Bysshe Shelley in a play published in 1819 that was repeatedly reprinted during the Victorian era. Stendhal was so taken by the painting that he researched the tale and recounted it in 1837 in what became one of his *Italian Chronicles*.[73] Nathaniel Hawthorne wrote about it in 1860 in his novel *The Marble Faun*. And both Charles Dickens and Herman Melville were captivated by the painting, the former calling it "a picture almost impossible to be forgotten," the latter describing it as "the sweetest, most touching, but most awful of all feminine heads."[74] The story of the Cencis, in short, is as follows.

Sixteen-year-old Beatrice Cenci, raped and brutally abused by her father for years, conspired with her brothers and stepmother to kill him. The family hired assassins, but when it came time to stab the elder Cenci in his drug-induced sleep, the killers faltered, and only with Beatrice's prompting did they complete the job. The assassins were ultimately caught, they confessed, and implicated Beatrice, her brothers, and her stepmother, who were all arrested and tried. As Beatrice's abuse at the hand of her father was detailed in her trial, she became heavily favored by public sympathy, but she was nevertheless found guilty of murder and hanged on Saturday, September 11, 1599.

Cameron made at least five interpretations of Beatrice Cenci, using two models over a period of five years. In all of them, the sitters are draped in a Middle-Eastern style shawl reminiscent of the one in the Barberini painting. By the somber looks on her models' faces, it appears that Cameron depicted the period after Cenci's sentence and before her death. Three pictures are

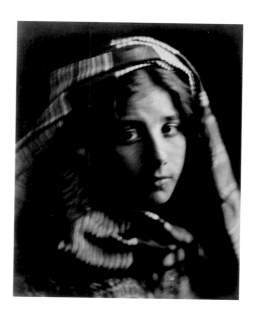

figure 26 Julia Margaret Cameron
A Study of the Cenci, 1868
Albumen print
30.9 x 25.5 cm
Paris, La Maison de
Victor Hugo

of May Prinsep photographed from the side, her head turned to the camera plate 24 as though she is caught in mid-thought (figures 24 and 25). In another two photographs, ten-year-old Katie Keown is a younger Cenci, her face exhibiting the soft contours of youth and her eyes as velvety as the centers of black-eyed Susans (figure 26). plate 23

While Beatrice Cenci's tale is a violent one, she is depicted in both the Barberini painting and in Cameron's photographs as a gentle, sympathetic character. Neither demure nor showing anguish, she appears sad but clear-eyed, self-possessed, and accepting of her fate. To the Victorians, a story like Cenci's provided an outlet for the emotional drama that in real life was so stringently restrained. It also allowed viewers to consider moral questions through art rather than religion. For the most part, religious images did not figure prominently in British art of the 1860s and 1870s. Instead, moral messages were conveyed through myth, literary allusion, or domestic narratives. That Cenci took action against abuse, and took responsibility for those actions, made her both dangerous and noble, an alluring combination of traits with which to tell a moral tale.

The Sacred and the Sensual

Tragic heroines, like Beatrice Cenci and other women who bore extraordinary burdens of grief and loss, held a particular appeal for the Victorians. Cameron, for whom being a mother and being a Christian were intertwined, chose the Madonna as the focus of many of her images. The Madonna's appeal is not surprising. Cameron took up photography when her children were leaving home. "We are *for the first time in twenty six years*, left quite alone without *one* child under our roof and my heart bleeds for the want of the lifelong food of an object to caress and *to do for*," she wrote to Herschel at the time.[75] As Cameron moved from parenting to photography, she exchanged one creative act for another, a shift that was not without its own sadness and loss.

Cameron made dozens of photographs of the Madonna, her treatment of the Virgin roughly divided between images of Mary of this world and pictures of Mary divine (see figure 27). In the first years of her career, she made a series of photographs called *The Fruits of the Spirit*.[76] With titles such as *Faith*, *Long-Suffering*, and *Love* (figure 28), this series presents Cameron's parlor maid Mary Hillier as an earthbound Madonna, loosely wrapped in a humble shawl, with one or two children in poses that emphasize the Virgin's maternal characteristics. In most of the pictures, the children look tired and restless, or, as in *Goodness*, coy and solicitous. The lighting in the photographs is plate 43 usually flat and Cameron's use of space lacks drama. The pictures are straightforward — nothing in them signals that this woman is the Mother of

27

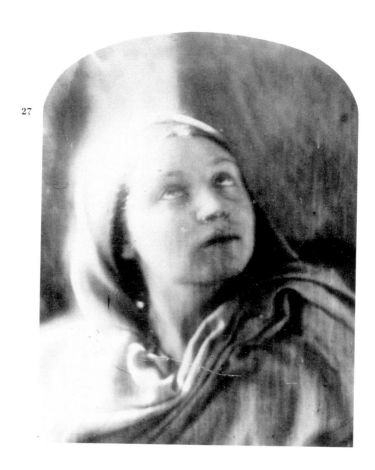

figure 27 Julia Margaret Cameron
*Mary Hillier
as a Madonna Study*, 1864/65
Albumen print
20.1 x 14.9 cm
Bath, England,
The Royal Photographic
Society Collection, 025552

figure 28 Julia Margaret Cameron 28
Love, 1864
Albumen print
25.3 x 20.1 cm
Bradford, England,
National Museum of
Photography, Film
& Television,
Herschel Album, pl. 43

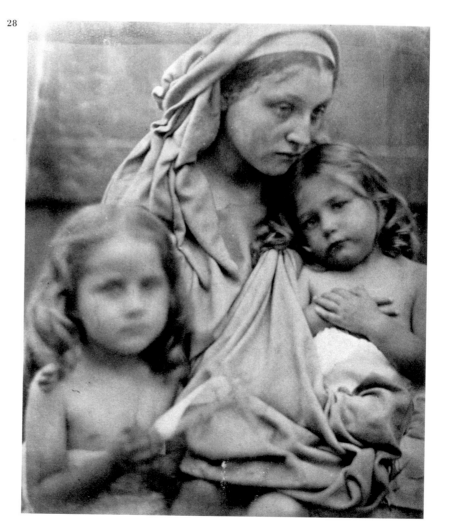

God. In marked contrast is a portrayal of the same sitter with a light, slightly textured, fabric shawl encircling her face and shoulders. With her head tilted down and light spilling over her from the right, Hillier looks like a Madonna of the school of Raphael. There is no mistaking this as a rendering of the Virgin Mother. The fluid drape of the fabric and the alabaster tonality of her skin give the picture a sculptural beauty that makes Hillier appear truly divine.

plate 44

The Virgin Mary is a compelling and complex character for any believer, particularly a woman of the mid-nineteenth century. On the one hand, she was the ideal of femininity – gentle, nurturing, compassionate. If ever there was a woman who was great through love, it is the Madonna. On the other hand, as both mother and virgin, she presented a paradox. Because her virtue was reconciled with her motherhood through divine intervention, a method not available to other mortals, she represented an unattainable realm for women. The Catholic Church's own ambivalence about the Virgin Mary is characterized by the fact that it was not until 1854 that Pope Pius IX proposed the dogma of the Immaculate Conception, which recognized Mary as the only mortal in the history of Christianity to have been born without original sin. (This is the true meaning of Immaculate Conception. It is not a reference to Mary's virgin conception of Christ, as one might imagine.)[77] The point of the dogma is not an esoteric one for theologians or believers. Original sin is at the basis of Christianity. Around it revolve all the religion's beliefs and rituals, from baptism to confession to redemption. If Mary is without original sin, she is not simply a mortal who has been blessed, but she is both human and divine, unique in her purity, and, as such, all the more daunting as a model of feminine grace.

Still, Cameron was a champion of the Virgin, if her pictures tell us correctly. Cameron's devotion, though, must have been tested by the ideas of her time, starting with the work of one of her photographic subjects, Charles Darwin. With the publication in 1859 of his *On the Origin of the Species*, it must have been increasingly difficult to reconcile Darwin's theories of evolution with faith in an all-knowing being and immaculate conception. Darwin himself did not believe his theories precluded religious faith, but others did. Many found fodder with which to challenge the authority of the Bible in his theories and in the growing understanding of the earth's evolutionary cycles – especially through new geological research. Doubt about the existence or knowability of a god was ultimately given a name in 1869, when the scientist Thomas Henry Huxley coined the term "agnosticism."[78]

At the other end of the spectrum, Cardinal John Henry Newman, a former preacher of the Church of England who had converted to Catholicism in 1845,

62

published his autobiography, *Apologia Pro Vita Sua*, in 1864. In it he explained his need for a return to ritual and his role in the Tractarian Movement of the 1830s and 1840s, which called for a restoration of High Church principles. The impact of the movement was not merely clerical. The Tractarian Movement generated a widespread revival of medieval myths in art and literature (among them, a treatment of the Arthurian legend by Alfred Tennyson, for which Cameron provided photographs; see Debra N. Mancoff's essay "Legend 'From Life': Cameron's Illustrations to Tennyson's *Idylls of the King*" in this book).

Closer to home, Cameron's husband, Charles, was only one of several people she loved who did not share her beliefs.[79] Even so, Cameron held fast to her faith. Indeed, her photographs confirm that her commitment to religious principles was strong. If pictures in which she illustrates Christian values — *The Fruits of the Spirit* series, for example — appear somewhat flat and didactic, they nevertheless demonstrate Cameron's earnest efforts to express her religious belief. They also show her desire to communicate using the iconography of the art of the past, not the language of commercial photography of the present.

Cameron's most glorious pictures on religious themes are ones in which her love of beauty is combined with her love of God. Unlike her contemporary, the art historian Anna Jameson, who took "the poetical and not the religious view of Art," Cameron subscribed to both.[80] The photograph *The Angel at the Tomb*, for example, takes as its subject the angel who was in attendance at the moment of Christ's Resurrection. In the Scriptures, the angel is a man. In this photograph, the angel is Cameron's maid Mary Hillier. Decidedly feminine, her profile is cut by a light from above that accentuates the delicate contour of her brow, nose, and chin. Hillier's hair is the dominant feature of the picture. Rendered in soft contrast and orange-colored tones, her cascade of kinky waves dissolves to cotton softness at the bottom of the frame. With a sheet wrapped around her shoulders and carelessly pinned just below the sternum, Hillier is slightly disheveled, a woman in dishabille. In fact, she looks more like Mary Magdalen, the penitent prostitute who was the first mortal Christ chose to present himself to upon his Resurrection.[81] Whether Cameron intended this picture to represent the Magdalen or Christ's attendant, the picture is of a woman who seems to be at once a heavenly figure and someone of flesh and blood — she is both melancholy and angelic, sensual and divine.

plate 47

A photograph like this one, while addressing a religious subject, reveals Cameron's love of photography. It displays a pure delectation in the effects of light on skin, hair, and drapery, and it shows how a portrait can transcend the specifics of the real world and get at something below the surface. Cameron's pictures were not just a point of departure for a message she wanted to convey about spiritual values and art: she made beautiful photographs. In that regard,

she was a modern artist, devoted to the formal properties of her medium and to what photography suggests that no other art can.

Another picture of exquisite beauty is *The Wild Flower*, titled after a line from plate 22 the William Blake ballad "Auguries of Innocence," published in 1863:

To see a World in a Grain of Sand
And a Heaven in a Wild Flower...[82]

Here Mary Ryan's face is slightly turned to the side and it glows. (Cameron often draped fabric over the windows of the rooms in which she photographed to diffuse sunlight and imbue her sitters with an almost supernatural luminescence.)[83] Ryan's hair fans to the sides as though parting to expose her face. Both model and photographer appear to collaborate in making a picture about the pleasure of looking. Viewers are invited to gaze at the model's beauty without self-consciousness, a liberty discouraged in real life. Similarly, in a photograph of the painter and model Marie Spartali, her head turned to the side plate 10 and her hair in a bun to expose the nape of her neck, Cameron seems to revel in the sensuality of soft, youthful skin.

That there is an erotic allure to these and to several others of Cameron's photographs implies that, though devoutly religious and proper in social conduct, Cameron was not a prude. Indeed both she and her husband believed sensuality and sexual desire to be normal impulses, part of being human. In a letter to her son Hardinge, Cameron wrote, "a life that has not known the purer sanctifying influences of love filtering lust is a life that has not yet had developed in it the God as *exalting* and intensifying the human nature and animal side of man and woman which animal side I do not at all despise. It is the rich soil that bears the golden fruit but if good seed is not sown in that soil it then degenerates into a dung heap does it not?"[84]

Cameron's acknowledgment of the animal side of both woman and man is notable, as is her theological framework: love and religious devotion make sex morally correct. Stereotypically, the Victorians are associated with sexual repression and prudery, in spite of decades of study showing them to be far more sexualized than previously believed. We tend to envision Victorian women as chaste and unyielding, and in fact there were legitimate reasons why a woman of the nineteenth century might have reservations about sex.[85] To start with, premarital sex was uncommon between men and women of the middle and upper classes, so couples did not know if they were physically compatible until they were married, and many matches proved disappointing. Morever, physical intimacy was not discussed between women of polite society. A lack of knowledge about sex thus added to a woman's uncertainty about the subject. Because contraception was limited, there was also a very real link

between sex and pregnancy. The high incidence of complications or death in childbirth and the high rate of infant mortality meant that sex could have both physically and emotionally painful consequences. Cameron, for example, lost a son in infancy and her only daughter, Julia, died giving birth in 1873, leaving behind a husband and six children.[86]

In spite of the above, several of Cameron's photographs display sensuality and erotic suggestion. In *Christabel*, for example, May Prinsep's lack of decorum and her drowsy gaze imply a kind of post-coital languor. And *Zoe* addresses the camera with a sultry, come-hither look. The postures in these pictures, while inappropriate for the drawing room, gave expression to very real human emotions. They also give evidence that Cameron recognized the value of an integrated life, one in which multiple and varied impulses coexist.

plate 21

plate 3

Apart from photographs that call sexuality to mind, many of Cameron's images address intimacy between women. In the absence of open and casual social relations with men, platonic friendships between women provided comfort, closeness, and a realm of shared experiences that was private and uniquely their own.[87] In fact kinship between women could be so powerful that sisters and sometimes friends lived and traveled together even after one or both of them married. In Cameron's art, the subject of friendship and physical closeness between women may be seen in the context of her own experience. Growing up with her grandmother and her sisters, Cameron's identity was formed in the company of women, with no father or brothers to dote on or conform for. This is reflected in several of her photographs, which display a poignant empathy and tenderness between women.

The photograph *The Kiss of Peace*, for example, shows a woman with lips and cheek ever-so-gently posed on the brow of a girl. The fact that one model looks older than the other invests the picture with maternal or perhaps sisterly connotations. Cameron may have also made this picture in response to the

plate 51

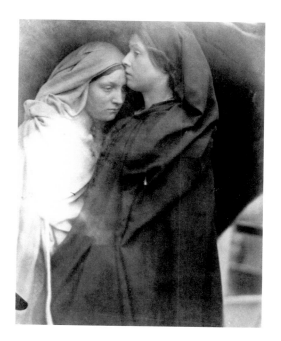

figure 29 Julia Margaret Cameron
Untitled, 1864
Albumen print
25.3 x 19.9 cm
London, Victoria
and Albert Museum,
347-1981

church-service ritual of kissing one's neighbor in a gesture of peace.[88] Variants of the picture – stilted images in which the models are dressed in veils and robes – develop the possible references to the biblical salutation of Mary to Elizabeth (figure 29). Arguments for a more intimate interpretation of these images must be weighed against the fact that Cameron belonged to the pre-Freudian age, when relationships between parents and children, friends and family, were not charged with an awareness of subconscious motivations.[89] Innocence and the beauty of youth may also be the subject of *The Kiss of Peace*. Cameron so idealized beauty in young women that she is reported to have once said, "No woman should ever allow herself to be photographed between the ages of eighteen and eighty."[90] In picking her sitters, Cameron did indeed look to youth. She also repeatedly enlisted a model of similar type. Mary Hillier, Mary Ryan, and May Prinsep, for example, all have oval faces with soulful eyes and full lips. In fact they look enough alike in Cameron's photographs that viewers often confuse the three. Exceptions to this type include Emily Peacock, the delicate, fair-haired beauty who posed for *The Angel in the House*; the husky, big-boned Agnes Mangles who posed for *Mariana*; and Cyllena Wilson, whose ample features slope so gently that she appears to have no jaw or cheekbones, only uninterrupted curves and skin as smooth as heavy cream.

plate 2

plate 11

plate 37

Every now and then, Cameron photographed mature women. One image, simply titled *The Sibyl*, is a portrait of a seated woman in a dark toga, leaning on a lectern, looking more like a weary caryatid than a sage or a prophet (figure 30). A particularly lovely photograph is of Lady Elcho, the Countess of Wemyss, posed in the garden of Little Holland House (figure 31) in a picture that is variously titled *Cumean Sibyl* or *A Dantesque Vision*. These, however, are the exceptions to the norm. Cameron's appreciation for youthful beauty was matched by her comfort in the company of young women, perhaps because around them she could be her unabashedly enthusiastic self. One of her best friends, the spirited author Anne Isabella Thackeray, was more than twenty years her junior. And the woman Cameron had a particular fondness for was her sister Maria's daughter, Julia Jackson. Like Cameron's portraits of famous men, photographs of Jackson are nearly always titled with her name, but unlike the men, no single portrait is intended to stand for who she is.

Portraits of Julia Jackson

What is known about Julia Jackson comes mostly from the accounts of others, since few letters and no diaries by her seem to exist. With blue eyes set under hooded lids, an aquiline nose, and delicately curled lips, "Julia's beauty was conspicuous from her childhood and … as she grew up she was admired by all who had eyes to see," so wrote her second husband, Leslie Stephen, after

figure 30 Julia Margaret Cameron
 The Sibyl, 1864
 Albumen print
 26.9 x 21.7 cm
 Bath, England,
 The Royal Photographic
 Society Collection, 2223

figure 31 Julia Margaret Cameron
 Lady Elcho as Cumean Sibyl,
 May 1865
 Albumen print
 25.2 x 20 cm
 London, Victoria
 and Albert Museum,
 45-139

30

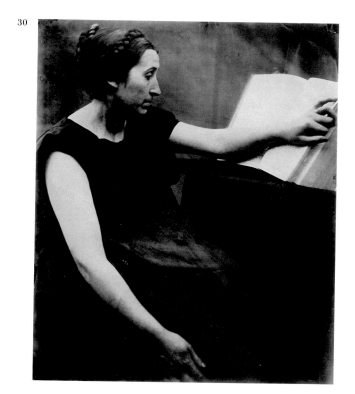

31

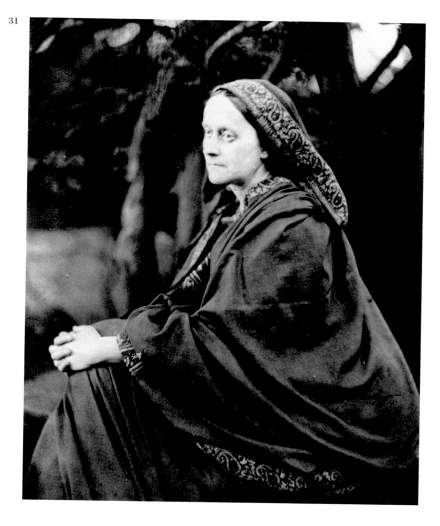

Jackson's death in 1895.[91] Stephen was not alone in recognizing Jackson's allure. When no older than ten, she was asked to pose for the sculptor Carlo Marochetti's monument at Carisbrooke to Princess Elizabeth, daughter of Charles I. In her early thirties, she posed for Edward Burne-Jones's painting of *The Annunciation* (figure 32). Even Jackson's daughter Virginia Woolf was haunted by her mother's charm. More than thirty years after Jackson's death, Woolf cast her as Mrs. Ramsay in the book *To the Lighthouse*: "One wanted fifty pairs of eyes to see with.... Fifty pairs of eyes were not enough to get round that one woman with."[92]

While Jackson's magnetism attracted many, it was a source of utter fascination for her aunt. Cameron devoted dozens of photographs to Julia Jackson over a period of ten years (this at a time when a middle- or upper-class Victorian would have a portrait taken only two or three times in a lifetime). In one of her earliest pictures, made in 1864 when her niece was eighteen years old, Jackson is demure, clothed in a simple dress, her hair in a snood, her head tilted to the side. Her eyes, slightly protruding and catching the light, are focused on something past the camera. Technically imperfect, this image is imprecise and unclear, but even the filmy, gauzelike haze created by irregu- plate 52
larities in the collodion emulsion contributes to this misty and picturesque evocation of gentleness and youth.

A full-length portrait of Jackson (figure 33), taken around the same time by another photographer (perhaps Rejlander), is more descriptive, showing a woman with a tiny waist and swan neck, with a posture that seems fluid and lithesome, even in the formal standing pose of a studio portrait. In her late teens when this picture was made, Jackson was in her prime and was the object of many men's affections. She captivated two Pre-Raphaelite artists, the sculptor Thomas Woolner and the painter Holman Hunt, both of whom proposed marriage and were declined. At age twenty-one, Jackson ultimately accepted the proposal of barrister Herbert Duckworth, a modest, sweet-tempered country gentleman. The wedding was set for May 4, 1867.

During the month before the wedding, Cameron made numerous photographs of Jackson, ranging in style and emotional tone. That Cameron took particular interest in Jackson at that time is easy to understand, given her affection for her favorite niece and given the meaning of the coming event. A marriage was the single most important social and religious ritual in a Victorian woman's life. Although the age of consent for women was twelve years old for much of the Victorian era, a woman's wedding day was the day on which she truly passed from youth to womanhood. Further evidence of the seriousness of the occasion are two somber photographs Cameron made of other brides-to-be.

32

figure 32 Edward Burne-Jones
The Annunciation, 1876–79
Oil on canvas
98 x 44 cm
Port Sunlight, England,
Lady Lever Art Gallery

figure 33 Possibly Oscar G. Rejlander
Julia Jackson, c. 1865
Albumen print
19.7 x 14.5 cm
Northampton, Massachusetts,
Smith College, William
Allan Nielson Library,
Mortimer Rare Book Room,
Leslie Stephen's Photograph
Album, pl. 33c

33

One is a portrait of Annie Chinery on the day of her marriage to Cameron's son Ewen (figure 34). The other is of the sixteen-year-old actress Ellen Terry (figure 35), betrothed to Cameron's friend, forty-seven-year-old painter George Frederic Watts. Cameron's decision to photograph Terry enacting the sentiment "sadness" lends a bittersweet touch to a time of joy.

In one of the photographs Cameron took of her niece in the weeks before her wedding, Jackson looks down and past the camera, her head large and off center in the frame. Strong light enters from the right, accentuating the contour of her right eye, the curve of her lips, and the porous texture of her skin. Her hair is pulled away from her face and hangs behind her back. This is one of the least sensational of Cameron's pictures of Jackson and one of the most intimate — an earnest picture, simple in the tenderness with which the photographer considers the pensive sitter and the comfort with which the sitter receives the gaze. Cameron's inscription, "My favorite Picture of all my works. My niece Julia," reflects her recognition that it is indeed a special photograph. She alternatively titled the picture *La Santa Julia*, giving it a religious appeal. But unlike her religious pictures, in which the sitters portray biblical characters, this photograph retains Jackson's name, giving this mortal a saintly status.

plate 56

Quite the opposite is an imposing frontal view of her niece that Cameron also made in April of 1867 (figure 36). Here Jackson is powerful. With eyes wide, she stares at the camera in a manner that is both confrontational and distinctly modern. The light entering from the right is raking and dramatic. There is nothing sentimental or even poetic about this photograph. Jackson looks hypnotized, numb, defiant. Cameron made at least two negatives from this one sitting: the one mentioned above, and another in which Julia's eyes are open wider than in the first (figure 38). While both frontal views of Jackson are mysterious in themselves, there is also a mystery behind their making. It was

plate 57

figure 34 Julia Margaret Cameron
The Bride, 1869
Albumen print
32.5 x 25 cm
Bath, England,
The Royal Photographic
Society Collection, 2286/1

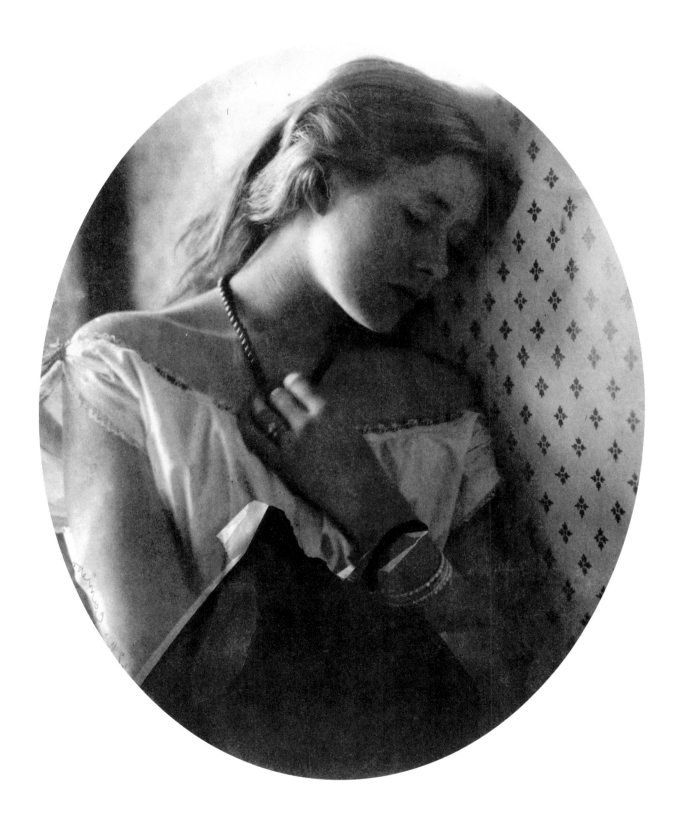

figure 35 Julia Margaret Cameron
Sadness, 1864
Albumen print
22.1 x 17.5 cm
Los Angeles,
The J. Paul Getty Museum,
84.XZ.186.52

36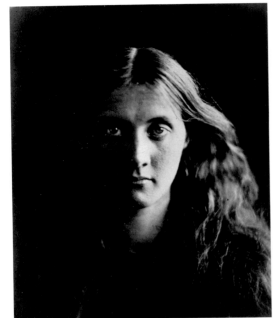

37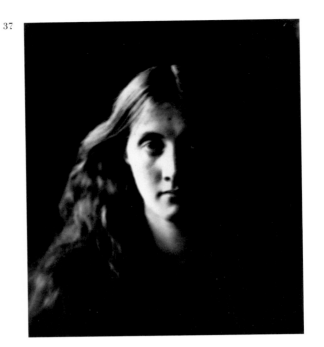

38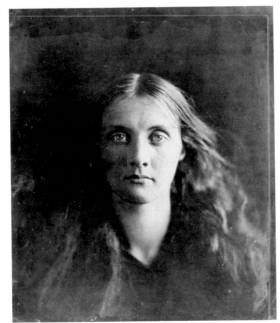

39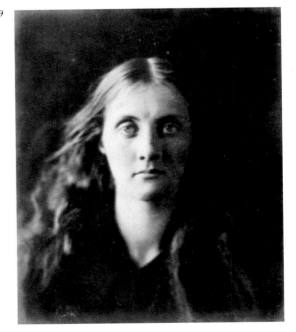

figure 36 Julia Margaret Cameron
Julia Jackson, 1867
Albumen print
27.6 x 22 cm
The Art Institute of Chicago,
Harriott A. Fox Endowment,
1968.227
(also reproduced as pl. 57)

figure 37 Julia Margaret Cameron
Mrs. Herbert Duckworth, 1867
Albumen print
27.6 x 23.8 cm
Rochester, New York,
George Eastman House,
International Museum of
Photography and Film,
81:1124:0007
(also reproduced as pl. 58)

figure 38 Julia Margaret Cameron
Julia Jackson, 1867
Albumen print
39 x 33.8 cm
London, Victoria
and Albert Museum,
361-1981

figure 39 Julia Margaret Cameron
Julia Jackson as "Stella," 1867
Albumen print
29 x 24 cm
Paris, La Maison de
Victor Hugo

40
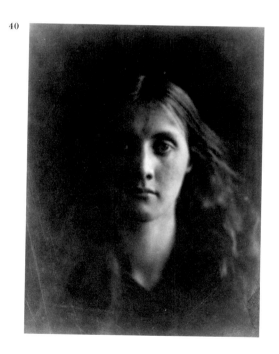

41
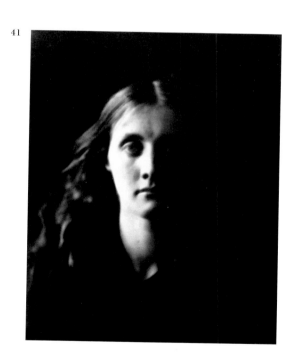

figure 40 Julia Margaret Cameron
Julia Jackson, 1867
Albumen print
27.4 x 20.6 cm
New York,
The Metropolitan Museum
of Art, Purchase,
Joseph Pulitzer Bequest,
1996.99.2
(also reproduced as pl. 59)

figure 41 Julia Margaret Cameron
Stella, 1867
Albumen print
29.2 x 22.8 cm
The University of Texas
at Austin, Harry Ransom
Humanities Research Center,
Gernsheim Collection,
964:0037:0133

common for Cameron to crop an image by trimming the final print, but no image reversal or flopping of a negative has been noted before, except here.

With each of these two negatives, Cameron appears to have reversed the images and made several variations. In the case of the first negative, she did it once. In the original orientation (figure 36), light streams from the viewer's right. (We know this is the original orientation because when the emulsion side of the paper and the emulsion side of the negative are placed in contact, as they should be, the image will be rendered in sharp detail, as it is here.) Jackson's pores and the oils on her face are visible, and strands of her hair are in sharp focus. In the reversed image (figure 37), the light enters from our left and Julia's face is rendered in softer focus, her skin smooth and uniform in tonality. Careful examination shows that the blemishes characteristic of all collodion negatives — the pits, bubbles, fingerprints, or scratches — are exactly reversed on the two prints. Therefore, Cameron most likely flopped the negative in the print frame. (She also may have made a copy negative of the original to produce the reversed image, but the copy process adds blemishes, and no additional blemishes are visible here.)

With the second negative from that sitting (figure 38), Cameron appears to have made three reversals: a reversal of the original orientation (figure 39), then a reversal of the reversal (figure 40), and then yet another reversal plate 59 (figure 41). Again, telltale blemishes confirm that each variation was generated from the same original negative. More than one example exists of almost all orientations and each of these prints is signed in Cameron's hand, suggesting that the reversals were done by design. Some prints are titled *Julia Jackson*, some *Mrs. Herbert Duckworth*, and some, of the second negative only, are titled *Stella* after "Astrophel and Stella," a sequence of 108 sonnnets and 11 songs by Sir Philip Sidney, written about 1582 and published in 1591. Cameron's obsessive reworking of the same two negatives is an indication of her fascination with her subject and with the fruits of that one sitting. But why so many variations? Perhaps Cameron felt the original two orientations were too harsh: they are definitely tougher and more imposing than most of her compositions. The reversals, by contrast, are softer and more mysterious. One is ghostlike (figure 40), the soft focus making Julia look like a specter, plate 59 her disembodied head emerging from the dark. Or perhaps Cameron saw the different interpretations as equally valid, and Jackson's character as complex enough to accommodate them all.

Jackson was, in fact, an unusually malleable subject. Though Cameron consistently photographed her as herself, from picture to picture Jackson rarely looks the same. It is hard to believe, for example, that the profile head of Jackson that has become one of Cameron's most celebrated images was taken

in the same month as the frontal heads discussed above. In the profile por- plate 61
trait, Jackson looks like a different woman, or at least a woman at a different
time in her life. In this distinctly formal pose, head held high, she appears a
woman of noble bearing. Strong side light dramatizes the tendons in her neck
and favors her with a glow that cuts her profile out of the black backdrop.
This woman is sure of herself and regal, not young and confrontational. All of
the words written about her seem faint in comparison with the stalwart grace
and elegance of this portrait. And yet a turn of the head, a shift in depth
of field, and slight motion produce a decidedly more uncertain and aged figure,
reminding us of the degree to which Cameron could control how her pho- plate 60
tographs looked.

The act of posing for her aunt just weeks before her wedding must have
appealed to Jackson, for there are several photographs made in April of 1867.
Having a picture taken is a way of recording one's identity, of fixing one's
likeness at a particular time in life. That Cameron consistently signed prints
of these images with Julia Jackson's married name, Mrs. Herbert Duckworth,
reflects Cameron's pride in her niece's union, the value she placed on a
woman's status as a wife, and her attitude toward the reading of the photo-
graph: it should be read in the present, even if the negative was made when
Jackson was still single.

By all accounts, Julia Jackson and Herbert Duckworth were happy together
(see figure 42). They bore two children in the first three years of their marriage.
Julia was carrying a third when Herbert died suddenly of a seizure in
September 1870, leaving her a widow at age twenty-four. Jackson's grief at her
husband's death shook her faith and left her in a state of utter despair, which
lasted for years. A photograph Cameron made two years after Duckworth's
death shows Jackson leaner in the face, the fullness of youth gone. Still in plate 62
mourning, she wears a dark dress with a simple ruffle at the neck and a white
Puritan-style cap. Peering out from an ivy-covered wall, her skin is luminous
and radiant. Her eyes, however, are vacant — the pupils mere pinpoints.
Consumed by grief, Jackson was all the more beautiful, for now she embodied
the characteristics of a tragic heroine that so appealed to the Victorians.
Cameron was profoundly moved by her niece's mourning, and her sympathy
shows in her photographs.[93] Here was the face of real tragedy, not an artist's
rendering of a model looking sad. A stanza from a poem Cameron wrote three
years later could have been written about this portrait of her widowed niece:

A mouth where silence seems to gather strength
From lips so gently closed, that almost say,
"Ask not my story, lest you hear at length
Of sorrows where sweet hope has lost its way."[94]

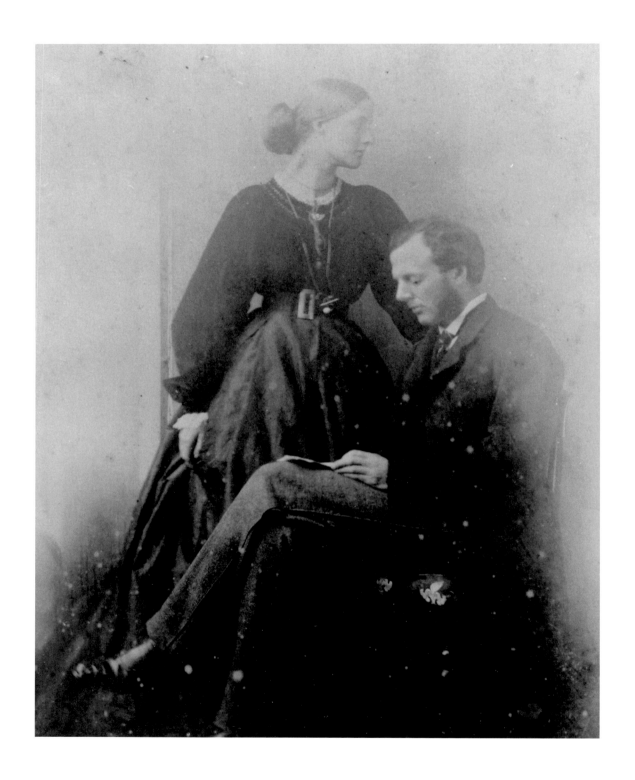

figure 42 Possibly Oscar G. Rejlander
Julia and Herbert Duckworth,
1867/70
Albumen print
19.7 x 14.5 cm
Northampton, Massachusetts,
Smith College, William
Allan Neilson Library,
Mortimer Rare Book Room,
Leslie Stephen's Photograph
Album, pl. 33a

A picture like this is all the more poignant given the fact that in the nine-
teenth century death and grief were not merely romantic notions, but ever-
present realities in a woman's life. Disease, the death of children, and
widowhood visited almost every home.[95] When in 1861 Prince Albert died of
typhoid and the Queen, aged forty-three, went into a ten-year grieving period,
the cult of mourning that was already a feature of Victorian art and literature
rose to a high pitch. (Cameron's photograph *The Dream*, from Milton's poem plate 33
"On His Deceased Wife," can be seen in this context.)[96] The Victorians found
nobility in death and grief, perhaps out of a need to find redeeming value in
something over which they had no control. They saw beauty in suffering,
and thus believed that images of suffering in art and literature could touch the
soul and humble the heart.

One of Cameron's last portraits of Julia Jackson, titled *"She walks in beauty,"*
after a line from Byron's *Hebrew Melodies* (1815), was taken in 1874, the year
before Julia Margaret and Charles Cameron moved to Ceylon to live out
their final years. Here Jackson is positioned against an ivy-covered garden plate 63
wall and is dressed in finery, her hair tucked under a stylish hat. With one
hand she holds her skirt in a gesture that is partly demure and partly coquet-
tish. With the other she extends a gold chain, with a dramatic flair that draws
attention to the decorative accessory. Everything about the image – from the
clothes to the setting to the pose – signals that this is a formal portrait of a
fashionable woman: the kind of photograph one might expect from a com-
mercial portrait studio. And yet Jackson's face is empty of emotion. Move-
ment during the exposure has rendered her eyes glazed and unfocused, and
has given her skin a pale, bloodless tonality.

Unlike earlier portraits Cameron made of her niece, this one is taken from a
distance, and appropriately so, as that was the world Jackson had created for
herself. For years she shut off all emotions and moved through life in a dead-
ened state. At one point she considered the convent life, but settled instead
on caring for the sick. Nursing was not unknown to Jackson. Her father had
been a physician and she had tended her mother through several illnesses.
Now, with her own heart ailing, she approached aiding the sick with the force
of one clinging to a life raft. Indeed, she called her life a "shipwreck" after
Duckworth's death.[97]

Julia Jackson did love again, and in 1878, at age thirty-two, she married Leslie
Stephen, a dour and humorless man, himself a widower. The Stephens had
four children, two boys and two girls. One of their daughters grew up to be
the painter Vanessa Bell and the other the writer Virginia Woolf. When
the Stephens married, Cameron was living in Ceylon and did not attend the
wedding, most likely because it took place in the winter months when the trip

to London by sea would have been treacherous. She did visit in the spring of that year. Nine months later, on January 26, 1879, Cameron died in Ceylon at age sixty-three. Her husband, Charles, outlived her by little more than a year. Julia Jackson died sixteen years later, at age forty-nine, her life's sorrows and the raising of seven children showing in her angular features and thinning head of gray hair (figure 43).

Even after death, Jackson elicited awe. Over thirty years later, in 1928, an actress and family friend named Elizabeth Robins told Virginia Woolf, "I remember your mother [as] the most beautiful Madonna and at the same time the most complete woman of the world. She would suddenly say something so unexpected from that Madonna face, one thought it vicious."[98] This may be the crux of Jackson's allure and the trait to which Cameron responded most. If doing what was unexpected, if being at once devilish and sublime was a definition of a "complete woman of the world," then Cameron may have recognized something of herself in her favorite niece. Certainly, both women were witty, charming, and tough. They were adored and unpredictable, and they held sway over others: Jackson did it with beauty and spirit, Cameron did it with spirit and photography. But there was more to Cameron's fascination with Jackson than that.

First of all, Jackson was among a younger generation of women that Cameron looked to with hope and sympathy. Far more than the men she portrayed, who stood for the old order and the supremacy of the male intellect, the young women Cameron photographed — even when cast as tragic heroines — were multi-faceted, resilient, sensual, and strong. They were complex human beings, Julia Jackson the most enigmatic of them all. No angel in the house or fading flower from romantic poetry was she. Nor was Jackson typecast as a

figure 43 Anonymous
Julia Stephen, 1880s
Albumen print
8.3 x 5.7 cm
Northampton, Massachusetts,
Smith College, William
Allan Neilson Library,
Mortimer Rare Book Room,
Leslie Stephen's Photograph
Album, pl. 36a

member of a sisterhood of women who was born with an innate capacity for nurturing which made her "great thro' love." Instead, in the dozens of photographs Cameron took of Jackson over ten years time, she remains elusive and full of mystery. In fact, the more Cameron photographed her niece, the less we know about Julia Jackson and the more Cameron herself is on display.

In the very range of postures and moods Cameron created with Jackson, she affirmed her sensitivity to the shifting roles of women in Victorian society. When she portrayed Jackson as a stark, wide-eyed maiden and an elegant woman of noble bearing – all in one month – Cameron defied the impulse to generalize female behavior and insisted on a variety of roles for her niece. A complex character herself, Cameron was driven by old-fashioned values and modern ambition. Indeed, in her life and in her art, she was the embodiment of the paradoxical time in which she lived. That, ultimately, is what makes her pictures so powerful. For while a good portrait artist will skillfully transcribe the outer features of her subjects, a great one gets at the inner characteristics of her sitters, and through them at an evocation of their time.

All of Cameron's portraits – of men and women alike – reveal her sympathy for humanity and her love of photography, but her portraits of women in particular reflect the questioning of identity that is a defining characteristic of the modern era. With this in mind, Cameron's pictures of female subjects may be seen as a composite portrait of sorts, no single image telling us about the whole of Victorian women's experience, but different and sometimes contradictory portraits showing the many facets of a changing world. To achieve this, it took a woman who was great through more than love. It took an artist with an exalted sense of her mission, someone with a single-minded purpose, with ego and detachment, who mastered her medium and made her sitters her own. It took one who was great through love *and* through genius. A poem Cameron wrote in 1867 in praise of a portrait painting best describes her own abilities. For as an intelligent and worldly woman, a pioneer photographer, and an insightful chronicler of the tenor of her time, Cameron was indeed one in whom "Genius and love have each fulfilled their part, / And both unite with force and equal grace."[99]

1 Taylor to Cameron, June 23, 1875
 (University of Oxford, Bodleian
 Library, Special Collections,
 MS English letters [hereafter BLSC],
 d.19, ff.108–09). Henry Taylor
 is not well known today, but in the
 mid-1800s he was highly regarded
 as an author and colonial magistrate.
 For more information on Taylor,
 see the entry on *Rosalba* in the
 Appendix to this book.
2 Cameron to Taylor, July 1, 1877
 (BLSC, d.13, ff.70–87).
3 Virginia Woolf and Roger Fry,
 *Victorian Photographs of Famous
 Men and Fair Women by Julia
 Margaret Cameron*, London, 1926.
4 D. H. Lawrence, *Studies in Classic
 American Literature*, London, 1924,
 p. 90: "Never trust the artist. Trust
 the tale. The proper function of
 a critic is to save the tale from the
 artist who created it."
5 For the purposes of this essay, I have
 limited my discussion to the years
 Cameron photographed in England.
 After she moved to Ceylon in 1875,
 she made a dozen or so images of
 Sinhalese women and men, but she
 did not work with the same frequency
 as in England. While these images
 are compelling, the fact that
 Cameron used natives as models
 suggests additional readings beyond
 those addressed in this essay.
 For further discussion of these
 photographs, see: Jeff Rosen,
 "Cameron's Photographic Double
 Takes," in Julie F. Codell and Dianne
 Sachko Macleod, eds., *Orientalism
 Transposed: The Impact of the
 Colonies on British Culture*, London,
 1998; Joanne Lukitsh, "'Simply
 Pictures of Peasants': Artistry,
 Authorship, and Ideology in Julia
 Margaret Cameron's Photographs in
 Sri Lanka, 1875–1879," *Yale Journal
 of Criticism* 9, 2 (1996), pp. 283–308;
 and Lori Cavagnaro, "Julia Margaret
 Cameron: Focusing on the Orient,"
 in Dave Oliphant, ed., *Gendered
 Territory: Photographs of Women by
 Julia Margaret Cameron*, Austin,
 Tex., 1996.
6 Cameron to Herschel, January 28,
 1866 (London, The Royal Society,
 Herschel Correspondence [here-
 after RS:HS], 5.162).
7 Queen Victoria bought five of
 Cameron's photographs: a portrait
 of Tennyson, one of Taylor, two
 photographs of children, and *Whisper
 of the Muse*, featuring the painter
 George Frederic Watts. See Frances
 Dimond and Roger Taylor, *Crown
 and Camera: The Royal Family and
 Photography, 1842–1910*, Middlesex,
 England, 1987, p. 154.

8 HG1975, p. 67 (for full citations, see Bibliographic Abbreviations). The photographs Victor Hugo referred to are currently housed at the Maison de Victor Hugo in Paris and are reproduced in Jean-Marie Bruson, *Hommage de Julia Margaret Cameron à Victor Hugo*, exh. cat., Paris, Ville de Paris et Maison de Victor Hugo, 1980.

9 Though it was uncommon for Victorian women to embark on a career, Cameron was not unique. Female writers of the Victorian era include Elizabeth Barrett Browning, Mary Braddon, Charlotte and Emily Brontë, Lady Eastlake (née Elizabeth Rigby), Elizabeth Gaskell, Anna Jameson, and Anne Thackeray. In art, Sophie Anderson, Lady Butler (née Elizabeth Thompson), Jessica and Edith Hayllar, Emily Osborn, Elizabeth Siddal, Rebecca Solomon, and Mrs. E. M. Ward exhibited frequently at the Royal Academy. See Susan P. Casteras, *The Substance or the Shadow: Images of Victorian Womanhood*, exh. cat., New Haven, Yale Center for British Art, 1982, p. 23. See also Jan Marsh and Pamela Gerrish Nunn, *Pre-Raphaelite Women Artists*, Manchester, 1997.

10 Cameron was one of nine daughters, two of whom, and a son, died young. Biographical information on Cameron can be found in AH, BH, CF, HG1975, and JL. Among recent publications, also useful are VH, JC, and *For My Best Beloved Sister Mia: An Album of Photographs by Julia Margaret Cameron*, exh. cat., Albuquerque, University of New Mexico Art Museum, 1994–96.

11 In a letter to Herschel of March 21, 1860 (RS:HS, 5.155), Cameron marveled at the fact that she was a grandmother while her own grandmother was still alive (when she wrote this letter, Cameron was forty-five and her grandmother was ninety-six). She was most likely referring to her maternal grandmother, Thérèse Joseph Blin de Grincourt, which would have made Madame de Grincourt fifty-four when Cameron arrived in France in 1818.

12 Caroline Herschel observed nebulae in 1783 and, between 1786 and 1797, she discovered eight comets. See DNB, vol. 9, 1973, p. 712.

13 For Herschel's astronomical discoveries and observations, see DNB, vol. 9, 1973, p. 716. For additional information about Herschel's time at the Cape, see David S. Evans, ed., *Herschel at the Cape: Diaries and Correspondence of Sir John Herschel, 1834–1838*, Austin, Tex., and London, 1969.

14 See Larry J. Schaaf, *Out of the Shadows: Herschel, Talbot, and the Invention of Photography*, New Haven and London, 1992, pp. 45–74; and idem, *Tracings of Light: Sir John Herschel and the Camera Lucida*, San Francisco, 1989. Herschel was passionate about the new medium. He once begged his wife's indulgence in his fervor for photography: "Don't be enraged against my poor photography. You cannot grasp by what links *this* department of science holds me captive – I see it sliding out of my hands while I have been *dallying* with the stars. *Light* was my first love! In an evil hour I quitted her for those brute and heavy bodies which tumbling along thro' ether, startle her from her deep recesses and drive her trembling and sensitive into our view" (Herschel to Lady Margaret Herschel, 1841; University of Texas at Austin, Harry Ransom Humanities Research Center, Herschel Collection [hereafter HRHRC], L0539). I am grateful to Larry Schaaf for his careful reading of my text on Herschel and Talbot, and for his enlightening remarks.

15 Cameron to Herschel, December 31, 1864, quoted in CF, p. 141. Herschel used dyes extracted from flowers as color filters in his experiments (see Schaaf 1992 [note 14], p. 34).

16 A notable exception was the Scottish team of Hill and Adamson, who made salted paper portraits of clerics, artists, and laborers.

17 Herschel to Cameron, June 1841 (Los Angeles, Getty Research Institute, Research Library, Cameron Family Papers, c. 1800–1940, no. 850858).

18 The fair was open from May 1 to October 11, 1851.

19 I am especially indebted here to Roger Taylor for the countless references on social history and the Great Exhibition that he shared from his extensive library and his vast knowledge of the period.

20 One of the organizing principles of the fair was to show a product next to its means of production. Daguerreotypes, for example, were exhibited next to daguerreotype cameras.

21 A group of picturesque landscape calotypes by Samuel Buckle were so admired for their "great delicacy of tint and exquisite cleanness of execution" that they were awarded a medal and were acquired by Prince Albert. See Mark Haworth-Booth, *The Golden Age of British Photography, 1839–1900*, Millerton, N. Y., 1984, p. 48. Other medal winners were Antoine Claudet and the photographers Ross and Thompson of Edinburgh. The Scottish portrait team of Hill and Adamson showed in the Fine Arts Court. Talbot did not exhibit.

22 French photography in the 1850s was characterized by the portrait work of Parisian photographer Nadar, and the landscapes and cityscapes of painters-turned-photographers Edouard Baldus, Gustave Le Gray, Henri Le Secq, Charles Marville, and Charles Nègre.

23 In fact, Lewis Carroll favored Hawarden's work over Cameron's. In response to an exhibition in 1864, he wrote in his diary, "I did *not* admire Mrs. Cameron's large heads, taken out of focus. The best of the life ones were Lady Hawarden's" (diary entry of June 23, 1864, quoted in Helmut Gernsheim, *Lewis Carroll: Photographer*, New York, 1969, p. 57). Hawarden's career came to an end when she died of pneumonia in 1865 at age forty-three. The largest number of her photographs (over 700) are in the photography collection of the Victoria and Albert Museum in London.

24 In the 1860s, Cameron made several albums of her own photographs and presented them to family and friends. Cameron's photographs, unlike those in other Victorian albums, are not collaged or elaborately painted. They are meant to be seen as works of art in themselves. Cameron's albums in public collections include: one for Sir John Herschel, now at the National Museum of Photography, Film & Television, Bradford, England; one for George Frederic Watts, now at the George Eastman House, Rochester, New York; one for Sir Henry Taylor, now in the Special Collections, Bodleian Library, University of Oxford; and one for Anne Isabella Thackeray, now in the Gernsheim Collection, University of Texas at Austin. At least four other albums are known to exist in private collections.

25 Grace Seiberling, *Amateurs, Photography and the Mid-Victorian Imagination*, Chicago, 1986, pp. 75–76.

26 Lord Overstone, a friend of Charles Cameron since their Eton College days and a commissioner of the Great Exhibition of 1851, was an important lender of his own extensive art collection to the Manchester exhibition. The Camerons may have thus attended the show as guests of Overstone, though no evidence has been found to confirm this. The Manchester exhibition included 597 photographs among a total of 5,711 objects. For a visual guide to the exhibition, see *Photographs of the "Gems of the Art Treasures Exhibition,"* Manchester, 1857.

27 In 1858 Cameron sent Herschel a picture of her son Henry Herschel Hay, Herschel's god-child, with the remark that it was a "Photograph likeness *most faithful* and to all eyes most beautiful" (Cameron to Herschel, January 1858, RS:HS, 5.153). We know from her own work, still a few years away, that to Cameron "most faithful" did not always mean precise. A year earlier, in 1857, Cameron wrote to her daughter, Julia, of two portrait sittings at the Photographic Institution (Cameron to Julia Cameron, July 3 and August 12, 1857, Maidstone, England, Kent County Archives, Norman Papers). For citations from these letters, see Joanne M. Lukitsh, "'To Secure for Photography the Character and Uses of High Art': The Photography of Julia Margaret Cameron, 1864–1879," Ph.D. diss., University of Chicago, 1987, pp. 13–14.

28 Mike Weaver remarked, "She may have begun to make family pictures herself as early as 1860 because there is an inscription in the MacTier album in her own hand 'from Life year 60 printed by me J.M.C.'" See Mike Weaver, "Julia Margaret Cameron: The Stamp of Divinity," in Mike Weaver, ed., *British Photography in the Nineteenth Century*, Cambridge, 1989, p. 154.

29 Cameron to Herschel, January 28, 1866, RS:HS, 5.162.

30 See for example, John Henry Pepper, *The Boy's Play Book of Science*, London, 1860, pp. 138–48, esp. ch. 11, sections on "The Art of Photography" and "Photographic Manipulations."

31 Lukitsh (note 27), p. 128. Also see William C. Darrah, *Cartes de Visite in Nineteenth-Century Photography*, Gettysburg, Pa., 1981.

32 Anne Isabella Thackeray, *Toilers and Spinsters, and Other Essays*, London, 1874, p. 227.

33 Quoted in CF, p. 117.

34 Julia Margaret Cameron, "Annals of My Glass House," written in 1874 and published in *Photographic Journal* (July 1927), pp. 296–301; reprinted in MW1986.

35 There are at least two theories of what might have caused the soft focus in Cameron's early prints. Cameron herself wrote in "Annals of My Glass House" (note 34) that she might not have screwed the lens on tightly, and that she stopped when she saw something beautiful on the ground glass of the camera before the image was in sharp focus. Emerson wrote in *Sun Artists*, cited below, that he had examined Cameron's equipment with his friend the lensmaker T. R. Dallmeyer. Emerson added that this early lens did not allow Cameron to see an image in focus on the ground glass of the camera, even when focus had been achieved, further supporting the idea that her early soft-focus pictures were made by accident. But he, too, noted that when she moved on to new equipment she selected the Dallmeyer Rapid Rectilinear Lens, which worked at a large aperture and a shallow depth field. See Peter Henry Emerson, "Mrs. Julia Margaret Cameron," in *Sun Artists*, ed. by W. Arthur Boord, London, 1891, reprinted New York, 1973, pp. 36–37. The issue of focus in Cameron's photographs has been widely discussed. Two essays devoted solely to the subject are: Lindsay Smith, "The Politics of Focus: Feminism and Photography Theory," in *New Feminist Discourses*, ed. by Isobel Armstrong, London and New York, 1992, pp. 238–62; and idem, "Further Thoughts on 'The Politics of Focus,'" in Oliphant (note 5).

36 See Elisabeth G. Gitter, "The Power of Women's Hair in the Victorian Imagination," *Publications of the Modern Language Association of America* 99, 5 (1985), pp. 936–54.

37 About *Mountain Nymph Sweet Liberty*, Herschel wrote, "She is absolutely alive and thrusting out her head into the air" (Herschel to Cameron, reprinted in "Annals of My Glass House" [note 34]).

38 From "Annals of My Glass House"
 (note 34). For a detailed account of
 critical response to Cameron's
 art, see Pam Roberts, "Julia Margaret
 Cameron: A Triumph over
 Criticism," in *The Portrait in
 Photography*, ed. by Graham Clarke,
 London, 1992, pp. 47–70.

39 Cameron to Henry Cole, February
 21, 1866 (London, Victoria and
 Albert Museum, National Art
 Library [hereafter NAL], Cole corre-
 spondence, Box 8).

40 Cameron acknowledged Wynfield's
 instruction in a letter to Herschel of
 February 26, 1864: "I have had
 one lesson from the great Amateur
 Photographer Mr. Wynfield & I con-
 sult him in correspondence whenev-
 er I am in difficulty" (RS:HS, 5.159).

41 From "Annals of My Glass House"
 (note 34).

42 Evidence of her conviction that her
 portrait was the truest likeness
 of Herschel (and Herschel's agree-
 ment) is a letter from Herschel to
 James Samuelson denying
 Samuelson permission to photo-
 graph the astronomer: "Allow me to
 explain the circumstances in which I
 am placed in respect of photographs
 of my unworthy features. My excel-
 lent friend Mrs. Cameron has taken
 extreme pains about some large ones
 which in fact are really extraordinary
 productions *as* photographs and
 I stand under a promise to her not
 to sit for one to any other artist-
 photographer" (Herschel to James
 Samuelson, May 1868, RS:HS, 68.5).

43 From "Annals of My Glass House"
 (note 34).

44 Census information for 1861 was
 found at the Family Records Centre,
 Myddleton Street, Finsbury, East
 Central London. I owe thanks to
 Roger Taylor, Will Stapp, and
 Stephanie Lipscomb for research
 on Cameron's census status.

45 Emerson (note 35), p. 34. Presum-
 ably, Emerson was using the amount
 in pound value of 1891, the year
 his essay was published. This impres-
 sive amount reflects Cameron's
 philanthropic commitment and her
 formidable powers of persuasion.

46 This is a line from the Tennyson
 poem "Lancelot and Elaine" from
 Idylls of the King.

47 See Casteras (note 9); and Erna
 Olafson Hellerstein, Leslie Parker
 Hume, and Karen M. Offen, eds.,
 *Victorian Women, A Documentary
 Account of Women's Lives in
 Nineteenth-Century England, France,
 and the United States*, Stanford,
 Calif., 1981.

48 "The Gardener's Daughter," from
 The Poems and Plays of Tennyson,
 New York, 1938, p. 135, lines
 130–34.

49 The photograph's title is from the
 poem "Maud": "There has fallen
 a splendid tear / From the passion
 flower at the gate."

50 Quoted in Casteras (note 9), p. 30.

51 Ibid., p. 23.

52 Reprinted in Martha Vicinus, ed.,
 *A Widening Sphere: Changing Roles
 of Victorian Women*, Bloomington,
 Ind., 1977, p. 148.

53 This picture is dated and titled in
 Cameron's hand, but her son Henry
 Herschel Hay provided it with his
 signature. Most likely the two made
 the photograph together.

54 In Britain, married women received
 the vote for local elections in 1918.
 That same year, women landowners
 over thirty years old were granted
 the vote for parliamentary elections,
 but it was not until 1928 that all
 British women over the age of twen-
 ty-one could vote.

55 Written in 1773, the poem was trans-
 lated by Cameron as "Leonora" and
 published, with illustrations by
 Daniel Maclise, in London in 1847.

56 See MW1986, p. 38.

57 Her poem "On a Portrait," dated
 September 1875, was published in
 Macmillan's Magazine 33 (Feb.
 1876), p. 372. See MW1984, p. 158.

58 Cameron to Henry Herschel Hay
 Cameron, October 19, 1871: "Here
 we see the utter destruction of a
 whole city, a city of uncommon luxu-
 ry and refinement prodigious wealth
 of the City, every thing of the Past,
 present and unrealized Future, all
 sacrificed thro' the carelessness
 of one Boy entering one stable with
 a light" (MW1986, p. 65).

59 Ibid.

60 Cameron to Emily "Pinkie" Ritchie,
 September 17, 1872 (HRHRC,
 Gernsheim Collection Letters).

61 Cameron to Henry Cole, April 7,
 1868 (NAL, Cole correspondence,
 Box 8).

62 Mike Weaver (MW1986) was the first
 to suggest that Cameron's photogra-
 phy was motivated not merely by a
 dilettante's passion, but also by an
 economic purpose. Using grocery
 bills and letters, Weaver illustrated
 the family's financial need and
 Cameron's efforts to earn money
 through her photography. For

 information on domestic expenses
 and inflation in mid-century
 England, see J. A. Banks, *Prosperity
 and Parenthood: A Study of Family
 Planning among the Victorian Middle
 Classes*, London, 1954.

63 Charles Cameron, for example,
 is reputed to have received ten thou-
 sand pounds upon his marriage to
 Julia Margaret Pattle. See MW1984,
 p. 14. In conversation, Weaver
 remarked that the amount given
 was based on the value of the
 pound when his book was published
 in 1984.

64 For a discussion of Ophelia's mad-
 ness and the treatment of this sub-
 ject in Victorian art and literature,
 see Elaine Showalter, *The Female
 Malady: Women, Madness, and
 English Culture, 1830–1980*, New
 York, 1985, pp. 90–92.

65 William Shakespeare, *Hamlet*, in
 The Works of William Shakespeare,
 New York, 1938, p. 704.

66 Malcolm Warner, *The Victorians:
 British Painting, 1837–1901*, exh.
 cat., Washington, D.C., The National
 Gallery of Art, 1996, pp. 68–69.

67 For more on Victorian photography
 and amateur theatricals, see
 Malcolm R. Daniel, "Darkroom vs.
 Greenroom: Victorian Art
 Photography and Popular Theatrical
 Entertainment," *Image* 33, 1–2
 (Fall 1990), pp. 13–20.

68 Cameron to Mrs. Sidney Frances
 Bateman, December 8, 1873
 (HRHRC, The Bateman Theater
 Record and Scrap Book, Mackenzie,
 Compton Archives). Maria-Felicia
 Malibran (née Garcia, 1808–1836)
 was a Spanish mezzo-soprano whose
 powerful voice and range were so
 extraordinary that Vincenzo Bellini
 and Gaetano Donizetti adapted
 music just for her. Cameron would
 have heard Madame Malibran in
 Paris between 1828 and 1832, when
 she sang alternately in Paris and
 London. Cameron was between age
 thirteen and seventeen at that time,
 and living with her grandmother
 and sisters in Versailles. Madame
 Malibran's premature death in a rid-
 ing accident, while pregnant, at age
 twenty-eight, made her a tragic
 heroine to writers and poets of the
 nineteenth century.

69 The Tennyson poems that inspired
 these titles were "Maud" and
 "Guinevere." Cameron must have
 liked this image very much, for she
 had several copies of the image
 made into carbon prints, at least ten
 of which are in the collection of
 the Royal Photographic Society,
 Bath, England.

70 Ruskin to Margaret Bell, April 3/4, 1859, quoted in CF, p. 129.

71 For more on these two sitters, see Stephanie Lipscomb's "Sitters' Biographies" in this book.

72 See D. Stephen Pepper, *Guido Reni: A Complete Catalogue of His Works*, Oxford, 1984, p. 304.

73 Stendhal, *Chroniques italiennes*, Paris, 1977, pp. 239–68.

74 Charles Dickens, *Pictures from Italy*, London, 1846; and Herman Melville, *Pierre*, New York, 1852; both cited in *Guido Reni, 1575–1642*, exh. cat., Bologna, Museo civico archeologico, Pinacoteca nazionale, 1988, pp. 341–43.

75 Cameron to Herschel, January 28, 1866 (RS:HS, 5.162). See Carol Armstrong, "Cupid's Pencil of Light: Julia Margaret Cameron and the Maternalization of Photography," *October* 76 (1996).

76 Mike Weaver wrote: "This phrase comes from the fifth chapter of the Epistle to the Galatians in the New Testament. The context is the wickedness of the flesh in terms of sex and violence...:'But the fruit of the Spirit is love, joy, peace, long suffering, gentleness, goodness, faith, meekness, temperance: against such there is no law'" (MW1986, p. 29).

77 The dogma was proposed in 1854 and ratified four years later after the Virgin appeared eighteen times to a fourteen-year-old girl named Bernadette in a cave at Lourdes. When the girl asked the vision her name, she replied "Immaculate Conception." For a social, cultural, and historical survey of the Virgin Mary, see Marina Warner, *Alone of All Her Sex: The Myth and the Cult of the Virgin Mary*, New York, 1983. See also Carol Mavor, "To Make Mary: Julia Margaret Cameron's Photographs of Altered Madonnas," in *Pleasures Taken: Performances of Sexuality and Loss in Victorian Photographs*, Durham, N.C., 1995, pp. 43–70.

78 Warner (note 66), p. 26.

79 Charles's salvation was of great concern to Cameron, as seen in a touching prayer of devotion she wrote in 1838, while pregnant with her first son: "my only grief has been that his faith is not yet fixed on the Saviour[,] the Rock of Ages in whom I trust and to whom I make my prayer. If it be then Thy will that I should die in Childbirth my last prayer is that Thou shouldst grant me in death the blessing I have so earnestly desired in life and enlighten his mind so as to enable him to see more clearly and to believe more fully spiritual things" (written July 8, 1838, printed in MW1986, p. 62). Weaver wrote of Cameron's religious affiliation: "Mrs. Cameron was probably a Tractarian, but not a Catholic—what we would today call an Anglo-Catholic" (MW1986, p. 26).

80 Anna Jameson, *Sacred and Legendary Art*, vol. 1, New York, 1970, reprinted from the edition of 1896, p. 15.

81 For a discussion of *The Angel at the Tomb* as Mary Magdalen, see MW1986, pp. 39–50, and MW1984, pp. 17–26.

82 For the history of the publication of this poem, see Geoffrey Keynes, *A Bibliography of William Blake*, New York, 1921, pp. 43–46.

83 See CF, p. 116.

84 MW1986, p. 31. Also see Charles Cameron, *On the Sublime and Beautiful, and on Duelling*, London, 1833.

85 The following are only two among numerous publications on this subject: Michel Foucault, *The History of Sexuality*, vol. 1, tr. by Robert Hurley, New York, 1978; and Jeffrey Weeks, *Sex, Politics and Society: The Regulation of Sexuality since 1800*, London and New York, 2d ed., 1989.

86 For a compelling study of sex, contraception, and women's rights in nineteenth-century British society, see J. A. and Olive Banks, *Feminism and Family Planning in Victorian England*, New York, 1964. Also see "'That Damned Morality': Sex in Victorian Ideology," in Jeffrey Weeks (note 85). For a discussion of Victorian marriages and a characterization of five individual unions of famous Victorians, see Phyllis Rose, *Parallel Lives: Five Victorian Marriages*, New York, 1983.

87 In a letter to Herschel, for example, Cameron wrote of how she longed to talk to Lady Herschel about motherhood and its "sacred tie of sympathy" (Cameron to Herschel, May 24, 1847, RS:HS, 5.150).

88 See MW1986, pp. 39–50, and MW1984, pp. 17–26.

89 Martha Vicinus, in a chapter on women's colleges in her book *Independent Women: Work and Community for Single Women, 1850–1920*, Chicago, 1985, wrote that it was common asexual behavior among women of higher classes to embrace or to write one another in loving terms. I am grateful to Linda K. Hughes and Debra N. Mancoff for directing me to sources on the subject of Victorian female friendship.

90 Hester Thackeray Fuller, *Three Freshwater Friends: Tennyson, Watts and Mrs. Cameron*, Newport, England, 1933, p. 36.

91 Sir Leslie Stephen, *Mausoleum Book*, Oxford, 1977, p. 28.

92 Lily Brascoe, describing Mrs. Ramsay. See Virginia Woolf, *To the Lighthouse*, London, 1927; 1st Harvest ed., 1989, p. 198.

93 In a letter she wrote to her sister Maria (Mia), Jackson's mother, some years later, Cameron recounted a conversation she had had with Jackson, in which Jackson prayed for death: "her sweet large blue eyes growing larger with swimming tears. Oh Aunt Julia don't talk in that way to me only pray God that I may die soon. That is what I most want" (Cameron to Maria Pattle Jackson, February 6, 1878; The New York Public Library, Astor, Lenox and Tilden Foundations, Berg Collection of English and American Literature [m.b. Stephen, L.], folder no. 73B6609).

94 From "On a Portrait" (note 57).

95 Since many women married men
 who were markedly older than
 themselves, women often became
 widows at an early age.

96 Jonathan Goldberg and Stephen
 Orgel, eds., *John Milton*, The Oxford
 Poetry Library, Oxford, 1994, p. 58,
 sonnet 19. In the poem, the author
 thinks he saw his "late espoused
 saint" in a dream. Though Milton
 wrote these lines around 1658, over
 two hundred years before Cameron's
 photograph was made, the Victorians
 would have been moved by his
 poignant expression of loss and
 longing.

97 Diane F. Gillespie and Elizabeth
 Steele, *Julia Duckworth Stephen:
 Stories for Children, Essays for
 Adults*, Syracuse, 1987, p. 7. Jackson
 ultimately became so experienced at
 nursing that years later, in 1883,
 she published a book on the subject;
 see Julia Stephen, *Notes from Sick
 Rooms*, London, 1883. Jackson also
 wrote children's stories between
 1880 and 1884 that may be found in
 the publication by Gillespie and
 Steele cited above.

98 Elizabeth Robins to Virginia Woolf,
 May, 4, 1928, in *The Diary of Virginia
 Woolf*, ed. by Anne Olivier Bell and
 Andrew McNeillie, 5 vols., London,
 1977–84, vol. 3, p. 183.

99 From "On a Portrait" (note 57).

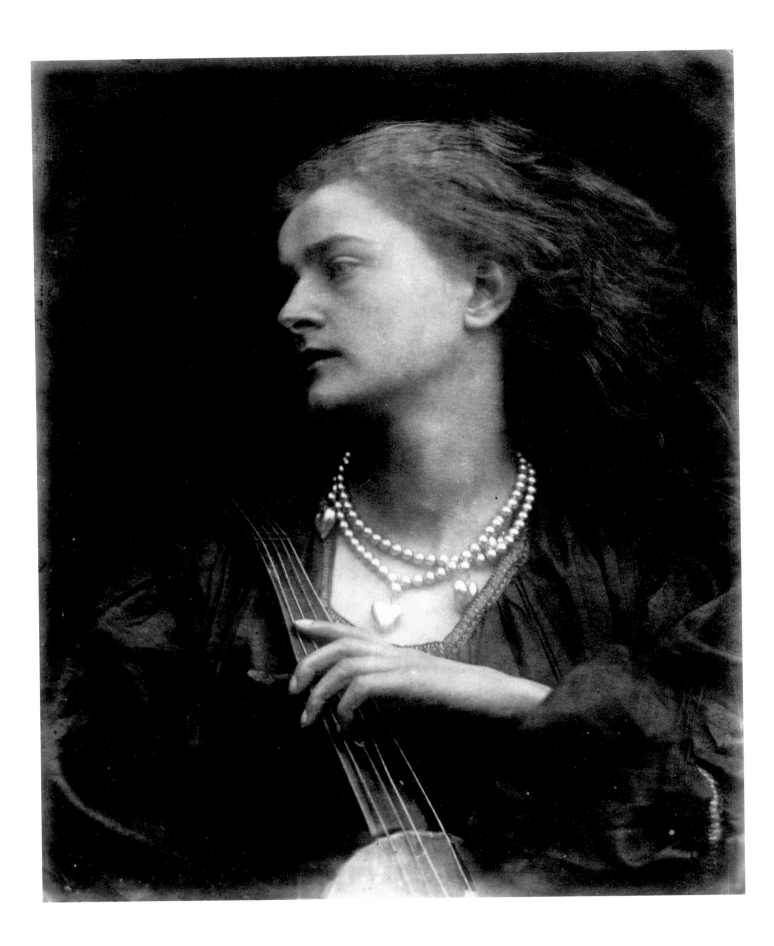

Debra N.
Mancoff

Legend "From Life": Cameron's Illustrations to Tennyson's "Idylls of the King"

On November 29, 1874, Julia Margaret Cameron wrote to her friend Sir Edward Ryan, the retired chief justice of Bengal, to share some exciting news:

About three months ago Alfred Tennyson walked into my room saying, "Will you think it a trouble to illustrate my Idylls for me?" I answered laughingly, "Now you know Alfred that I know that it is immortality to me to be bound up with you that altho' I bully you I have a corner of worship for you in my heart" and so I *consented*.[1]

In the course of her letter, written in her usual enthusiastic and expansive style, Cameron described the project. Tennyson, her long-time friend and present neighbor in Freshwater, on the Isle of Wight, was seeing to the last details of a cabinet edition of his collected poems to be published in twelve volumes by Henry S. King of London. Quarto sized and modestly bound, the series was also affordably priced. Both the publisher and the poet wanted to enrich each volume with a simple, wood-engraved frontispiece. Tennyson thought that Cameron might make some photographs, to serve as models for the engraver's designs.

Cameron instantly rose to the challenge. She selected her models from her family and household, as well as from local residents and visitors to Freshwater. She constructed some of the costumes and rented others, and, within a span of three months, she made 180 negatives to produce twelve photographs she deemed acceptable. (This is the number she reported to Ryan; in other descriptions the number is as high as 245.) As she confessed to Ryan in the letter of November 29, all her "zeal and energy" were invested in this "high task," but the use of her work, although it was just as planned, disappointed

figure 1 Julia Margaret Cameron
And Enid Sang
Albumen print
35.4 x 28 cm
From *Illustrations to
Tennyson's "Idylls of the King"*
Vol. 1, Dec. 1874–Jan. 1875
New York, The Metropolitan
Museum of Art,
David Hunter McAlpin Fund,
1952 (52.524.3.3)

her: "My beautiful large photographs are reduced to cabinet size for his people's edition and the first Illustration is transferred to Wood-cut and appears now today when *1200* copies are issued."[2]

Firm in her conviction that her photographs deserved a better venue, she announced plans to publish them herself. Although they would be available for individual purchase, in her letter to Ryan she also described an album suitable for a "beautiful Xmas gift book or a Wedding gift book," featuring twelve photographic illustrations of Tennyson's Arthurian poems. Cameron chose not to reproduce Tennyson's text with her illustrations. Instead, she included only brief extracts from his poems, lithographed in her own hand-writing on the page preceding each print. Introduced by a frontispiece portrait of the poet, the suite of photographs would appear as "a handsome half morocco volume priced six guineas [i.e., one hundred and twenty-six shillings]," for as she told Ryan in her letter, "I could not make it under for it to pay at all." While the original endeavor was undertaken purely for friendship, Cameron hoped to see a profit with this volume, which appeared under the title *Illustrations to Tennyson's "Idylls of the King."* Her desire that Ryan help promote her project was thinly veiled in the letter of November 29, but in later correspondence, she bluntly urged him to use his influence with the editors of London's most popular news-paper to promote her work: "I am sure if it is favourably noticed in the *Times* I shall make a success of it after all."[3]

The volume of photographs appeared before the public in late December 1874–early January 1875, under the imprint of Tennyson's publisher Henry S. King. Critical response was modest but supportive; reviews of Cameron's *Illustrations to Tennyson's "Idylls of the King"* appeared in the London *Times* and the *Morning Post*.[4] Although it is impossible to ascertain whether or not she turned the profits she sought, Cameron produced a second volume of photographs under the same title later that year in May.[5] Despite the reference to the *Idylls* in the title of the second album, the photographs in this volume drew their subject from a range of Tennyson's most popular poems, including "The May Queen," "The Princess," and "Maud," with just three subjects from his Arthuriad.[6] Cameron never attempted another venture on this scale; five months after the publication of the second volume, she and her husband returned to their estate in Ceylon, and the new demands on her time detracted from her involvement with photography. Although Cameron did not reflect upon her Tennyson albums in her later correspondence, she must have been well aware of her unprecedented achievement. No one before her had attempted to bring the Arthurian legend to life through photography. And, more importantly, no other illustrator had ever pleased Tennyson.[7]

Despite the photographer's efforts and the poet's endorsement, Cameron's *Illustrations to Tennyson's "Idylls of the King"* have not fared well in the critical history of her work. While the press notices attracted by her active promotion of the project were positive, they were few in number; and, shortly after the *Illustrations* appeared, they seem to have been forgotten. There appears to be no evidence that subsequent photographers emulated her experiment, and, by the turn of the century, changed aesthetic standards and revised conventions for subject matter made the ensemble seem hopelessly out of date. To younger generations, her unrestrained dramatic engagement and passionate emotional interpretation seemed staged – even histrionic – prompting critics Roger Fry and Virginia Woolf to judge the *Illustrations* as inferior to her portraits. They called her dramatic groups "failures from an aesthetic standpoint."[8] Helmut Gernsheim, in his pioneering monograph on Cameron published in 1948, dismissed these works as little more than a photographic equivalent of "the amateur theatricals at Dimbola [the Cameron home]," and he introduced his discussion of the *Illustrations* with an admonition: "We must try not to laugh, but we must weep over her misspent labors and her and Tennyson's mistaken notion that photography could compete in such a task with artists like Gustave Doré."[9]

The imaginative premise and the sentimental nature of Cameron's *Illustrations* clearly make twentieth-century audiences uncomfortable. Some writers have simply dismissed them as "high camp," while others have questioned the motives behind their creation, claiming, "It is indeed hard to believe that some of [Cameron's] Tennysonian *tableaux* ... are meant seriously, rather than being satires on the subject-matter."[10] In recent scholarship, the matter of aesthetics and sentiment has been either set aside or subsumed into a search for deeper cultural meaning, perhaps to redeem the *Illustrations* or reposition them in Cameron's now respected place in the history of photography. The *Illustrations* have proved a rich source for identifying an emergent feminist vision, for the negotiation of gender roles in a changing society, and for the complex interaction of text and image as a marketable commodity.[11] But, as valuable as these new readings are to our recognition of Cameron's work, it is often difficult to reconcile the issues that ignite contemporary interest with the actual concerns of Cameron's life and world. Perhaps *we* are imposing a context that would have been alien to Cameron's motivation for making her *Illustrations to Tennyson's "Idylls"* and, in so doing, we may be missing a more sympathetic way to read them.

Reflection upon the moment and circumstance of the production of the *Illustrations* reveals three significant factors that intersected to shape Cameron's interpretation. First, Victorian culture had revived the saga of the

medieval hero King Arthur; the legend enjoyed a relevance and popularity unparalleled since the Middle Ages. Secondly, Tennyson was acknowledged to be the premier poet of the Arthurian Revival; his position as Poet Laureate and the wide reception of his *Idylls of the King* made him the interpreter of the legend for his generation. And finally, Tennyson and Cameron were close friends; they shared a social circle, ethical and political views, and a belief that aesthetic expression in the arts was inextricably bound to moral content.

Upon close examination, each of these factors proves more complex than previously acknowledged. The popularity of the Arthurian legend can be traced back to the dawn of the Victorian era, but by 1874, through many retellings and reinterpretations, the legend had grown and changed. Tennyson deservedly held the dominant position among poets engaged in the subject, but modern readers and critics rarely remember that the form of the *Idylls* known today did not exist until 1885. In 1874 readers knew the *Idylls* not as a singular epic with an overarching symbolic message, but as a collection of works that portrayed legendary characters as distinct individuals, subject to the same human frailties and desires as the readers themselves. The nature of Tennyson's and Cameron's friendship, moreover, bound them together in a shared interpretative vision. Just as Cameron often signed her negatives "From Life," Tennyson sought to instill an authentic vitality into his legend. This was the basis for their shared vision. And by taking these factors into consideration, we replace the imposed context for one that is genuinely inherent and, in that way, approach the *Illustrations* with kinder vision and fairer judgment.

In the early 1830s, shortly after completing his degree at Cambridge, Tennyson stunned the literary world with an audacious announcement: He intended to write a new version of the Arthurian legend for his own generation. The legend had waned in popularity since the Middle Ages, but in recent decades, the heightened interest in national medieval culture, associated with the Gothic Revival, sparked new interest in the saga of the mythic king. In the years 1816–17, no fewer than three editions of Sir Thomas Malory's *La Morte Darthur* (1469–70) appeared on the market; it had been out of print since 1634. But few writers approached the legend, and those who did, including Thomas Warton, Sir Walter Scott, Robert Southey, and William Wordsworth, preferred to edit medieval text or used only a single episode from the lengthy saga as a subject.[12] Since Malory's day, no poet had succeeded in presenting the complete legend in contemporary language or giving it the relevance of contemporary life. Little wonder that Tennyson's contemporaries greeted his grand plans with skepticism. Greater and more experienced writers had failed to revitalize the legend. How could a young, untested poet achieve the goal they could not attain?

But Tennyson did succeed. He worked on his drafts for almost a decade, and in 1842, four Arthurian works appeared as part of a two-volume collection, *Poems*. These included: "The Lady of Shalott," "Sir Lancelot and Queen Guinevere," "Sir Galahad," and "Morte d'Arthur." The collection drew critical acclaim, and although the Arthurian poems were among those most highly praised, years passed before Tennyson was ready to present more of the legend to the public. During this time, he demonstrated his artistic scope and power, reflective in "Locksley Hall" (1842), lyric in "The Princess" (1847), elegiac in "In Memoriam" (1850). Through his work he earned strong popular support and gained royal recognition; in 1850, at the death of Wordsworth, he was appointed Poet Laureate. But the Arthurian legend held sway over his imagination and ambitions, and after a series of journeys to Arthurian sites – Glastonbury, Camelford, Tintagel – he returned to the subject.

In 1859, four poems – "Enid," "Vivien," "Elaine," and "Guinevere" – were published under the title *Idylls of the King*. Ten years later, Tennyson gave the public four more Arthurian poems, publishing "The Coming of Arthur," "The Holy Grail," "Pelleas and Ettarre," and "The Passing of Arthur" (an expansion of the 1842 "Morte d'Arthur") in the collection *"The Holy Grail" and Other Poems*. "The Last Tournament" followed in 1871, and, in 1872, he published "Gareth and Lynette." "Balin and Balan" was written in 1872, but did not appear until 1885. In the following year, Tennyson split the poem "Enid" into "The Marriage of Geraint" and "Geraint and Enid." With twelve poems complete, he set them in their present order, describing the life cycle of Arthur's society in tandem with the cycle of the seasons. He framed the poems with a "Dedication" to Prince Albert, written at the Prince's death in 1861, and the epilogue "To the Queen," written in 1872. As late as 1891, the year before his death, Tennyson revised and inserted individual lines.[13] In his youth, he had stated that his Arthuriad would occupy him for twenty years; in the end it was the project of a lifetime.

The publishing history of Tennyson's Arthuriad provides an essential, yet often ignored, context for Cameron's *Illustrations to Tennyson's "Idylls of the King."* Literary scholar Linda K. Hughes wisely observed that there is a "crucial difference between Victorian and late-twentieth-century encounters with the *Idylls*. For Victorian audiences, *Idylls of the King* meant from the start a human-centered, accessible, vivid set of stories."[14] Tennyson's choice of the term *idyll*, as opposed to terms like *epic* or *lyric*, defines the poems' true nature. Since classical times, an idyll referred to a short work, featuring a simple and peaceful pastoral tale. But, in Tennyson's day, the term shed the customary rural setting and took on an intimate nuance. To Victorian readers, an idyll presented a glimpse of life, most often domestic, seen, in the words of

Mike Weaver, as a "pictured moment."[15] Tennyson's early Arthurian poems and his first 1859 installment of the *Idylls* conformed to this characterization, and his readers welcomed the intimacy and individuality of his portraits of an innocent Elaine, a faithful Enid, a depraved Vivien, and a troubled and tragic Guinevere.

Critics of the 1859 *Idylls* hailed them for their deep human interest and understanding, a perfect fulfillment of the intimate and domestic poetic form. The *Saturday Review* compared Tennyson's evocation of character favorably to that in his earlier poems, concluding, "His fabulous knights and ladies are not only true men and women, but sharing in the highest interests of genuine human life." The critic in *Bentley's Quarterly Review* praised Tennyson's ability to "enliven" the most grand and distant subject "with touches of human feeling, life, and pathos; he will certainly bring it somehow or other within the compass of our sympathies."[16] Reviewers also noticed that the 1859 *Idylls* focused on women. According to the *Examiner*, although in "each of them King Arthur's knights are the adventurers.... each is inscribed with a woman's name and has a woman's heart for centre of its action."[17] Through the quarter-century history of the serial publication of the *Idylls*, the 1859 poems set a standard for both critical acclaim and vivid human portrayal. No subsequent work by Tennyson would be as warmly received.[18] And these were the *Idylls* that most influenced Cameron's interpretation. Of the fifteen Arthurian subjects she treated in the two volumes of her photographs, ten are based on the four poems of the first 1859 edition of Tennyson's *Idylls of the King*.[19]

Tennyson's vivid accounts of life in Arthur's court readily inspired visual interpretation.[20] But, by the time Cameron undertook her work, Tennyson had earned a reputation for difficulty with his illustrators. In 1855, when Edward Moxon, his publisher at the time, was planning an illustrated edition of the *Poems*, Tennyson helped select the artists and made it a point to visit as many as he could to "give them his views of what the illustrations ought to be."[21] When the volume appeared two years later, he expressed shock at the visual liberties taken by the artists. William Holman Hunt recalled that Tennyson took issue with his aesthetic decision to depict the Lady of Shalott with wild, wind-blown hair, her body entangled in the threads of her broken web (figure 2). "I didn't say her hair was blown about like that," the poet complained, "I did not say [the web] floated round and round her." When Hunt defended his interpretation, Tennyson retorted, "I think the illustrator should always adhere to the words of the poet!"[22] When Gustave Doré illustrated the first four *Idylls* for Edward Moxon's publication of 1868, he was spared visits from the poet, but he wasn't safe from his barbs. As early as 1867, Tennyson expressed dismay in a letter to his friend Francis Palgrave:

"I liked the first four... but the rest not so well; one I hate.... On the whole I am against illustrators, except one could do with them as old Mr. Rogers did, have them to breakfast twice a week and explain your own view to them over and over again."[23] Tennyson's insistence on the literal translation of word into image may well account for the rather slim selection of illustrated editions of the *Idylls* produced in his lifetime.[24]

When Tennyson approached Cameron with his request that she illustrate the *Idylls*, he must have been well aware that he had chosen an artist with strong opinions and a clear point of view. They had been good friends since the very early 1850s, and their bond deepened when the Cameron family moved to Freshwater in 1869. The older of Tennyson's two sons, Hallam, remembered Cameron as "one of the most benevolent human beings, always thinking of something for the good or the pleasure of others."[25] The poet and the photographer spent many hours together, deep in conversation, walking the shore for their mutual health. While Tennyson had little patience for his friend's excessive enthusiasm – Hallam claimed her "wildly romantic ideas and performances used to call forth growls of amused dissatisfaction from him" – what has been preserved of their correspondence reveals the depth of his respect for her.[26] And that is clearly why he invited her to illustrate his *Idylls*.[27]

Prior to her work on the *Illustrations*, Cameron showed no more interest in the Arthurian legend than any other well-read woman of her generation. In 1857, she did view a group of murals in progress, based on the legend and painted by a group of artists led by Dante Gabriel Rossetti in the Oxford Union Debating Hall, but her visit was prompted by her nephew Valentine Prinsep's participation as one of the painters, rather than curiosity about the Arthurian images.[28] During the following year, Tennyson was a regular visitor to Little Holland House, the home of Valentine's parents, Sarah (Cameron's sister) and Thoby Prinsep. He often gave readings of works in progress as evening entertainment. It is very likely that Cameron attended on occasion; it is known

figure 2 William Holman Hunt
The Lady of Shalott
Wood engraving
9.5 x 8.3 cm
From Alfred Tennyson, *Poems*,
London, 1857
Chicago, The Newberry
Library

that Tennyson read "Pelleas and Ettarre" to her on June 28, 1859. She, in turn, gave him an appropriate gift within a month of the *Idylls* publication: the new three-volume edition of Malory's *La Morte Darthur*, set in modern language by Thomas Wright.

Cameron's encounter with the Arthurian legend typified that of most of her generation; Tennyson's vision and words guided her understanding. And in telling the legend to a new audience, Tennyson conformed to a venerable tradition. He recast the legend in the image of his generation. Appearing to construct a window on the mythic past, Tennyson, in fact, held up a mirror to the present, reflecting modern ethics in medieval guise. This was the key to the deep humanity that readers recognized in the first four *Idylls*; in the vivid portraits of mythic characters, they saw embodied their own identities and desires; in the men, and particularly the women, of the *Idylls*, they saw reflected their own dreams and disappointments.

While Cameron drew her narrative inspiration from Tennyson, her illustrations never reflected a slavish translation of word into image. In photographing her characters — creating mythic women "From Life" — she added the depth of her own sympathy, emotion, and experience. Nowhere is this more evident than in her two portraits of Enid (figures 1 and 3), the patient wife of Geraint, Prince of Devon. Tennyson based his poem on a tale that can be traced through the French romance tradition (Chrétien de Troyes's *Eric et Enide* of c. 1180) to ancient Welsh roots. According to the story, misunderstanding a rumor in the court, Geraint accused Enid of infidelity, and he forced her to join him on a rough adventure to test her devotion. Through every trial, Enid proved her constancy, and ultimately she dispelled her husband's fears and regained his trust. Tennyson celebrated Enid as a self-sacrificing — therefore ideal — wife, but Cameron saw in Enid a strength based in compassion and a dignity born of forgiveness.

figure 3 Julia Margaret Cameron
Enid
Albumen print
34.2 x 26.7 cm
From *Illustrations to Tennyson's "Idylls of the King"*
Vol. 1, Dec. 1874–Jan. 1875
New York, The Metropolitan Museum of Art,
David Hunter McAlpin Fund,
1952 (52.524.3.2)

4

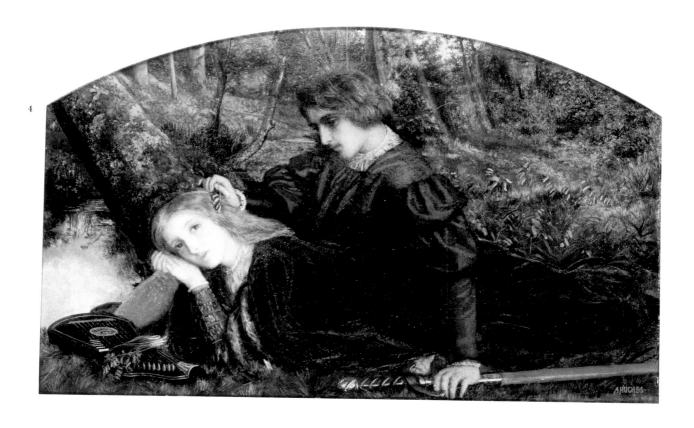

5

figure 4 Arthur Hughes
The Brave Geraint, 1863
Oil on canvas
22.9 x 35.6 cm
Private collection

figure 5 Gustave Doré
He Turn'd His Face
Engraving
24.1 x 17.8 cm
From Alfred Tennyson,
Idylls of the King.
London, 1868
Chicago, The Newberry
Library

Cameron's choice to portray Enid alone departed from the preferred convention in painting and illustration of depicting her at her husband's side. Whether appearing as the object of his obsessive adoration, as seen in Arthur Hughes's painting *The Brave Geraint* (figure 4), or seeking aid for his near fatal wounds, as in Doré's illustration *He Turn'd His Face* (figure 5), Enid's existence gains significance only through his presence. By situating Enid in her own space, Cameron focused on Enid's own thoughts and responses to her trials, and thereby endowed her with her own identity. In *Enid* (figure 3) we see the heroine's anguished resolve as she obediently follows her furious husband's orders to retrieve the tattered garments she wore when they met, "a faded silk, / A faded mantle and a faded veil" (Tennyson "The Marriage of Geraint," lines 134–35), and to prepare for a journey, the purpose of which she did not understand. In his poem, Tennyson tells the reader that her thoughts stray to the moment when Geraint first saw her in her impoverished home in that modest gown, but Cameron adds nuance to the moment, using Enid's weary gestures and withdrawn, downward glance to expose the pang of lost happiness in her recollection. *And Enid Sang* (figure 1) again evokes the couple's first meeting, when she charmed Geraint with a song about the whims of Fortune. But she, too, was the victim of this fickle goddess, first in the dire straits of her family, but then again in the transformation of her husband's affection into obsession. Cameron presents Enid as a conflicted figure, proud but wistful, singing knowingly of fate, while accepting what it offers. But the image draws on the broad context of the poem, rather than on a single incident; readers of the *Idylls* would know that Enid returned Geraint to his senses with her voice. Her cry for help, defying his order of silence, dispels his deluded anger, stirs him to protect her, and reunites them in love strengthened with newfound trust.

Vivien was the *femme fatale* of Tennyson's legend. Of all Guinevere's ladies, she was "the wiliest and the worst" (Tennyson, "Guinevere," line 29). Tennyson based her on Malory's Nimuë, whose beauty caught Merlin's eye; he hounded her relentlessly, until her only means to protect her innocence was to turn his magic against him. In Tennyson's telling, it was Vivien who pursued Merlin.[29] Hungry for power, she stalked Merlin into the woods and seduced him into sharing his secrets. Then she paralyzed him with his own spells. Victorian artists portrayed Vivien as dangerous and degenerate. In his painting *The Beguiling of Merlin* (figure 6), Edward Burne-Jones showed the sorceress reveling in her triumph. As statuesque as an Amazon, she rivets her gaze on her victim, like a snake eyeing its prey. Tennyson cast Vivien as the incarnation of the serpent in Eden, destroying Merlin to engender Arthur's fall. Finding Merlin at rest in the woods, she "writhed toward him" (Tennyson, "Merlin and Vivien," line 237), and when she embraced him, her "arm clung

figure 6 Edward Burne-Jones
The Beguiling of Merlin,
1874–76
Oil on canvas
185.4 x 110.5 cm
Port Sunlight, England,
Lady Lever Art Gallery

figure 7 Gustave Doré
Merlin and Vivien Repose
Engraving
24.1 x 17.8 cm
From Alfred Tennyson,
Idylls of the King,
London, 1868
Chicago, The Newberry
Library

7

6

97

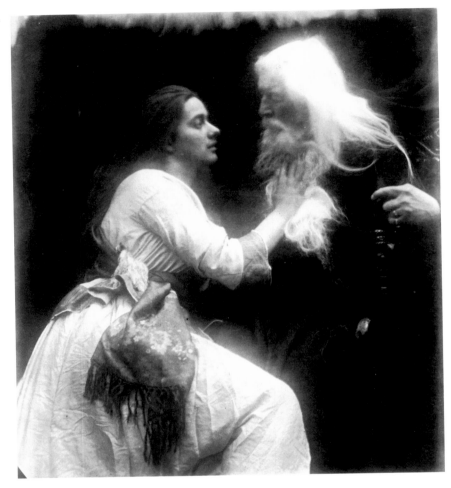

figure 8 Julia Margaret Cameron
Vivien and Merlin
Albumen print
31.9 x 28 cm
From *Illustrations to
Tennyson's "Idylls of the King"*
Vol. 1, Dec. 1874–Jan. 1875
New York, The Metropolitan
Museum of Art,
David Hunter McAlpin Fund,
1952 (52.524.3.4)

figure 9 Julia Margaret Cameron
Vivien and Merlin,
September 1874
Albumen print
31 x 26.6 cm
From *Illustrations to
Tennyson's "Idylls of the King"*
Vol. 1, Dec. 1874–Jan. 1875
Los Angeles,
The J. Paul Getty Museum,
84.XO.732.1.1.6

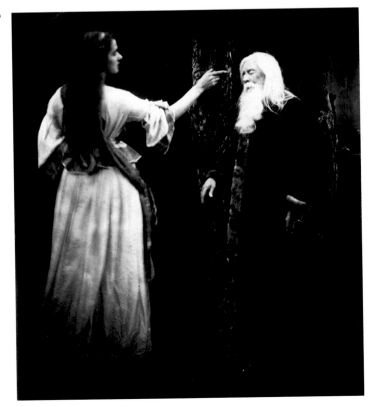

like a snake" (line 240). Doré used the analogy of the snake in his image *Merlin and Vivien Repose* (figure 7). Lithe and pliant, Vivien drapes her body across Merlin's lap, gazing in his eyes with false desire.

In her two photographs of Merlin and Vivien, Cameron fell short of this serpentine sensuality. In the first image (figure 8), Vivien perches on Merlin's lap, gazing in his eyes and stroking his beard. In the second (figure 9), she points her finger as she casts her spell, and Merlin succumbs. There is little sexual tension between the seductress and the mage; the gestures seem devoid of passion. Certainly, prevailing decorum restricted the models' actions, but the awkwardness can also be attributed to the length of time required for the exposures, making spontaneous movement impossible to hold. Agnes Mangles, who posed as Vivien, recalled an additional problem: Cameron's husband Charles, with his craggy face and trailing white hair and beard, made an ideal model for the aged Merlin, but his tendency to laugh throughout the sessions ruined a number of negatives.[30]

Many lively anecdotes chart Cameron's avid pursuit of perfect models. The character of Lancelot, Arthur's finest knight, whose "great and guilty love .../ Had marr'd his face and mark'd it ere his time" (Tennyson, "Lancelot and Elaine," lines 244 and 246), proved the greatest challenge. Cameron's first choices included men who were famous both for their good looks and accomplishments: the bibliophile and author Alexander Lindsay, 25th Earl of Crawford, and the painter John Everett Millais; it is not known, however, if she actually invited them to sit for her. While visiting the home of theologian William George Ward with Tennyson, she saw a man, half hidden in shadow, staring into the fire. She exclaimed, "Alfred, I have found Sir Lancelot! I want a face well worn with evil passion." Much to her embarrassment, the well-worn face belonged to Herbert Vaughan, the Roman Catholic Bishop of Salford.[31] Beneath the comic aspect of Cameron seeing her mythic sinner in a man of the cloth is another key to her artistic vision. Like the Pre-Raphaelites, Cameron sought "characteristic models," real figures who shared traits and experiences with the mythic or literary types they were meant to impersonate. As William Michael Rossetti wrote in his essay "Pre-Raphaelitism" of 1851, a Pre-Raphaelite artist gives priority to "truth" and seeks, after that, "scrupulous fidelity." In this quest, the artist must "search diligently for the best attainable model; whom when obtained, he must render in form, character, expression, and sentiment, as conformably as possible with his conception, but as truly as possible also to the fact before him."[32] Similarly, phrenology guided Victorian artists, again notably the Pre-Raphaelites, to choose particular individuals as models.[33] However, as a photographer, Cameron had limited ability to alter her sitters' appearance, and she was forced to find models who looked the part they were pressed into playing. This issue of inherent

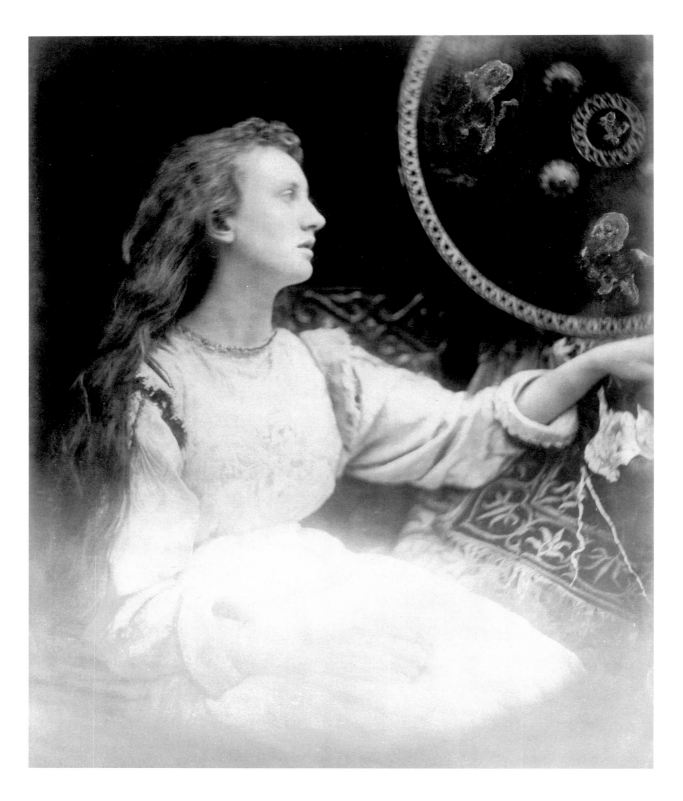

figure 10 Julia Margaret Cameron
Elaine, the Lily Maid of Astolat
Albumen print
34.3 x 28.4 cm
From *Illustrations to
Tennyson's "Idylls of the King"*
Vol. 1, Dec. 1874–Jan. 1875
New York, The Metropolitan
Museum of Art,
David Hunter McAlpin Fund,
1952 (52.524.3.6)

character shaping external appearance mattered to her; when she reflected on the difficulty of portraying Vivien, she worried that although the model looked "lissome and graceful and piquante," she was "a sweet girl," perhaps "not wicked eno'."[34]

The reviewer for the *Morning Post* lauded Cameron for her choice of sitters and recognized the importance of model selection in Cameron's artistry. These were "no mere models in the ordinary acceptation of the word, but men and women of peculiar types, combining with fine *physique* high mental culture as well, and abundantly imbued with the poetic spirit of the themes they co-operate in illustrating."[35] Cameron's great success with the appealing portraits of Elaine (see figure 10) in the first volume of the *Illustrations* reveals precisely what the reviewer meant as "types." May Prinsep, Cameron's niece, sat for the innocent girl on the brink of womanhood, who died from unrequited love. Publisher C. Kegan Paul praised Prinsep's winsome Elaine as "all ease and life, but life fading, love and despair." He further observed that "Miss Prinsep must be a great actress, as you are a great artist to be able to put such pathos into her face, now that her life is not like Elaine's, but crowned and happy."[36] Paul was referring to Prinsep's recent marriage, but Cameron's interpretation saw beyond incident to essence. Prinsep shared with Elaine the moment of transformation – girl into woman – and this is the poignancy Cameron captured in her portrait. A characteristic model served to incarnate a type rather than represent an example. The viewer would look through the tangible appearance of May Prinsep – a lovely, innocent, yet nubile young woman – to comprehend the symbolic traits of the soul of Elaine. A good model was transparent, neither too expressive nor too individualized. Burne-Jones warned against an overly explicit characterization of mythic subjects. Countering criticism of the restraint with which he had imbued the grieving queens in his painting *The Sleep of Arthur in Avalon* (1881–98; Museo de Arte, Ponce, Puerto Rico), he wryly commented: "A little more expression and they would be neither queens nor mysteries nor symbols, but just...Augusta, Esmeralda, and Dolores, considerably overcome by a recent domestic bereavement."[37]

figure 11 Dante Gabriel Rossetti
*Lancelot's Vision
of the Sangrael*, 1857
Watercolor over black chalk
71.1 x 106.7 cm
University of Oxford,
Ashmolean Museum

figure 12 William Morris
 Queen Guinevere, 1858
 Oil on canvas
 71.8 x 50.2 cm
 London, Tate Gallery

figure 13 Gustave Doré
 *The Parting of Arthur
 and Guinevere*
 Engraving
 24.1 x 17.8 cm
 From Alfred Tennyson,
 Idylls of the King,
 London, 1868
 Chicago, The Newberry
 Library

12

13

Artistic restraint gave Cameron's two photographs of Guinevere the dignity, plates 39, 40 nobility, and grand tragedy associated with the legendary queen. While the Victorians regarded Vivien as degenerate, they saw Guinevere as flawed, her life ruined by an inability to submit her passion to her duty. The complexity in her character made her difficult to portray. In his study for the mural he painted in the Oxford Union Debating Hall, Dante Gabriel Rossetti presented her as a type of Eve, tempting Lancelot from under the shade of an apple tree (figure 11). William Morris used her to pay tribute to his future wife Jane Burden, in a melancholy portrait seen only by family and friends (figure 12). The subject of Guinevere sprawled on the floor at Arthur's feet, begging his forgiveness, also had a definite appeal for Victorian artists. This scene appears late in Tennyson's poem and was his own invention. Doré included it in his illustrations of the *Idylls* (figure 13); Cameron considered it as well, but she left it out of her final selection.[38]

The photographs she did select reveal her deep response to Guinevere's conflicted emotions, and her progress, not to sin but toward redemption. *The Parting of Lancelot and Guinevere* conveys the pain she feels as she tells plate 39 Lancelot to leave her, sacrificing her heart's desire in the hope of avoiding her husband's disgrace: "O Lancelot, get thee hence to thine own land, / For if thou tarry we shall meet again, / And if we meet again some evil chance / Will make the smouldering scandal break and blaze / Before the people and our lord the King" (Tennyson, "Guinevere," lines 86–91). Cameron's queen rests her head on her devoted knight's shoulder for the last time. She closes her eyes, as if to fix the tender moment in her memory. The restraint of their gestures — the clasped hands, Lancelot's gentle kiss, Guinevere's silent sorrow — gives the scene a poignancy unparalleled in more passionate interpretations.[39]

It is human sorrow — deep, wounding, and genuine — that lends dignity and humanity to Cameron's tragic queen, as seen in the photograph *The "little* plate 40 *Novice" and Queen Guinevere in "the Holy House of Almesbury."* For the poem "Guinevere," Tennyson invented a scene to portray the Queen in her anguish. After leaving Lancelot, she took refuge from the court in a nearby convent at Almesbury. Although she hid her identity, she could not disguise her noble demeanor, and to see to her company and comfort, the nuns assigned a young novice to wait upon her in her chambers. Although the girl's lovelorn songs and endless questions about court life led Guinevere to wonder whether the novice had been sent to torment her, she soon recognized that the girl spoke out of her curiosity and her innocence. Guinevere sought to silence her companion by telling her that the ways of the world turned upon events she could not understand: "'O little maid, shut in by nunnery walls, / What canst thou know of Kings and Tables Round'" (lines 225–26), but the girl did not relent, tearing away at her like the voice of conscience. So Guinevere retreated into

her own memories, where pleasure and pain were inseparable. Cameron conveyed Guinevere's complex emotions in her simple double portrait. As the girl chatters on in her innocence, Guinevere endures her grief and guilt with dignity and reserve. Her strength, like her sorrow, sprang from a source unknown to the novice. Guinevere was forged by life's experience.

In the poem "Aurora Leigh," Elizabeth Barrett Browning observed, "all actual heroes are essential men, / And all men possible heroes."[40] Bridging the boundary between the human and the mythic, Tennyson's early *Idylls* brought the Arthurian legend to Victorian England. Responding to Tennyson's interpretation, Cameron conceived her *Illustrations* in the same spirit, transforming the mythic characters into "essential" men and women. But her photographs transcend the simple notion of illustrating a narrative through a construction of associated imagery. Using sentiment, insight, and empathy, Cameron's photographs must be regarded as responsive inventions upon Tennyson's *Idylls* rather than mere illustrations of them. Her subject choices reflect her desire to explore the emotions of men and women, whether they reside in nineteenth-century Britain or Arthur's mythic Camelot. She did not need to tell the legend; Tennyson had done that to her satisfaction for their generation. She was instead responding as an artist through her medium, creating a visual set of "pictured moments." Domestic and intimate — idylls in the Victorian sense of the term — Cameron's *Illustrations* gave a tangible human dimension to the mythic world. While she did not inscribe her *Illustrations* with her characteristic phrase "From Life," no other description is as appropriate, for in her *Illustrations* Cameron recognized the life in the legend, and, in so doing, she forged legend from life.

I am grateful to Linda K. Hughes of Texas Christian University, Fort Worth — whose own work on Tennyson's *Idylls of the King* suggested the departure point for this essay — for her insightful and enthusiastic encouragement of my inquiry.

1 As quoted in Joanne Lukitsh, "Julia Margaret Cameron's Photographic Illustrations to Alfred Tennyson's *Idylls of the King*," in *Arthurian Literature VII*, ed. by Richard Barber, Woodbridge, Suffolk, 1987, p. 147.
2 When the cabinet edition appeared as a completed set in 1875, only three of Cameron's images were used: *King Arthur*, for vol. 6; *Elaine*, for vol. 7; and *Maud*, for vol. 9. Of these, only the first two are based on poems from the *Idylls*.
3 Cameron to Ryan, December 4, 1874, as quoted in Lukitsh (note 1), p. 149. In this same letter, Cameron inferred that it was Tennyson who was disappointed with the modest engravings in the cabinet editions and that he first suggested the idea of featuring the photographs in a gift book: "He himself said to me, 'Why don't you bring them out at their actual size in a big volume at your own risk' and I resolved to do so at once."
4 See "Mrs. Cameron's New Photography," *Morning Post*, Jan. 11, 1875, and "Poetry and Photography," *Times*, Feb. 1, 1875. The *Morning Post* review is reprinted in full in HG1975, p. 48. Both reviews are unsigned; Lukitsh (note 1), p. 155, asserted that "both reviews also read as if they had been written by Cameron." It is evident that Cameron supplied the writers with personal and anecdotal information, but this was common practice at the time.

5 Historians differ about the profits earned by the project. Charles W. Millard, in "Julia Margaret Cameron and Tennyson's *Idylls of the King*," *Harvard Library Bulletin* 21 (Apr. 1973), p. 373, described it as a commercial failure. Gernsheim stressed the expense of making the volume, as Cameron often did in her letters (HG1975, pp. 45–46). Lukitsh (note 1), p. 156, observed that it is simply not known if the volumes were profitable.

6 Cameron did produce a third volume, with a mixed selection of photographs from the previous two, but it was originally owned by her friend Lady Ritchie and may well be unique (see HG1975, p. 49). A miniature edition also appeared in 1875, with twenty-two photographs selected from the original albums. The edition lacks a title page; it features no publisher's name or date. But the small size of the prints (4³⁄₄ x 3¹⁄₂ in., as opposed to the original 12 x 10 in. format) and the inexpensive binding suggest it was meant to be a popular and affordable edition. Gernsheim claimed there was no demand for it (HG1975, p. 50).

7 In a letter enclosed with an advanced copy of the *Illustrations*, Cameron wrote, "Our great Laureate Alfred Tennyson himself is very much pleased with this ideal representation of his idylls" (as quoted in HG1975, p. 48).

8 Virginia Woolf and Roger Fry, *Victorian Photographs of Famous Men and Fair Women by Julia Margaret Cameron*, London, 1926, p. 12. Woolf was the daughter of Julia Jackson and thus Cameron's grandniece.

9 HG1948, p. 42. In the first edition of Gernsheim's monograph, published in 1948, the *Illustrations* were not even reproduced.

10 See BH, p. 122; and A. N. Wilson, *Eminent Victorians*, New York, 1989, p. 222.

11 See, for example, JL, p. 30; Jennifer Pearson Yamashiro, "Idylls in Conflict: Victorian Representations of Gender in Julia Margaret Cameron's Illustrations of Tennyson's *Idylls of the King*," in Dave Oliphant, ed., *Gendered Territory: Photographs of Women by Julia Margaret Cameron*, Austin, Tex., 1996, pp. 97–98; and Victoria C. Olsen, "Idylls of Real Life," *Victorian Poetry* 33 (Autumn–Winter 1995), p. 371, respectively.

12 For a full discussion of the literary history of the Arthurian legend from the end of the Middle Ages to the dawn of the Arthurian Revival, see James Douglas Merriman, *The Flower of Kings: A Study of the Arthurian Legend in England between 1485 and 1835*, Lawrence, Kans., 1973.

13 For a thorough publication history of the *Idylls of the King*, see Kathleen Tillotson, "Tennyson's Serial Poem," in Geoffrey Tillotson and Kathleen Tillotson, *Mid-Victorian Studies*, London, 1965, pp. 80–109. Although the number of poems and the present structure of the *Idylls* was set in 1885, a later change further modified our comprehension. The line "Ideal manhood closed in real man," seen by most interpreters as essential to the reading of the whole, was not inserted until 1891, the year before Tennyson's death.

14 Linda K. Hughes, "Tennyson's Urban Arthurians: Victorian Audiences and the 'City Built to Music,'" in Valerie M. Lagorio and Mildred Leake Day, eds., *King Arthur through the Ages*, 2 vols., New York, 1990, vol. 2, p. 48.

15 See Mike Weaver (MW1984, p. 67). As examples of the domestic nature of this use of the form, Weaver cited Tennyson's "The Gardener's Daughter," while Hughes (note 14), p. 46, pointed to the domestic novel by Mary Russell Mitford, *Our Village* (1824), which served as the inspiration for Tennyson's poem "The Miller's Daughter." Curiously, Tennyson's *Idylls of the King* has reshaped our contemporary comprehension of the term *idyll*. In *Webster's New World Dictionary*, 3d college ed., ed. by V. Neifeldt and D. B. Guralnik, New York, 1988, the third definition of *idyll* describes it as "a narrative poem somewhat like a short epic [Tennyson's *Idylls of the King*]."

16 *Saturday Review*, July 16, 1859, p. 76; and *Bentley's Quarterly Review* (Oct. 1859), p. 162. This is in marked contrast to a recent description of Tennyson's characters as "stiff" and "paper-doll." See Yamashiro (note 11), p. 99.

17 *Examiner*, July 16, 1859, p. 452. *Blackwood's Edinburgh Magazine* (Oct. 1859), p. 610, stressed the importance of women to the characterization of the popular — and essential — male characters in the legend: "Arthur, Lancelot, and Merlin — the king, the warrior, and the sage of the poem — are represented to us, not so much in council or in action as in their dealings with, and in the effect they produce on, Guinevere, Elaine, and Vivien." See Hughes (note 14), pp. 44–48, for a cogent overview of critical response to the 1859 *Idylls*.

18 Our current view of the *Idylls*, as an epic view of the rise and inevitable fall of a mythic society, developed only after Tennyson consolidated his individual poems into a cycle, but the first indication of the completed poem's metaphysical themes and symbolic patterns was evident in the publication of Tennyson's *The Holy Grail and Other Poems* in 1869. Hughes (note 14), p. 48, however, emphasized that Tennyson's original readers carried the intimate interpretation of the first set of poems forward, seeing in the *Idylls* "affirmations of humanity and the individual, a framework which remained intact as they encountered subsequent parts."

19 Volume one (December 1874–January 1875) of Julia Margaret Cameron's *Illustrations to Tennyson's "Idylls of the King"* contains the following subjects: *Gareth and Lynette; Enid; And Enid Sang; Vivien and Merlin; Vivien and Merlin; Elaine, the Lily Maid of Astolat; Elaine; Sir Galahad and the Nun; The Parting of Sir Lancelot and Queen Guinevere; The Little Novice and the Queen; King Arthur;* and *The Passing of Arthur.* Volume two (May 1875) of this same publication includes: *The May Queen; The May Queen and Robin; The May Queen; The Princess; O Hark, O Hear; Tears from the Depths; Mariana in the Moated Grange; King Cophetua and the Beggar Maid; Elaine; The Corpse of Elaine in the Palace of King Arthur; King Arthur Wounded Lying in the Barge;* and *Maud – the Passion Flower at the Gate.* The above list of subjects is based on the copies of the *Illustrations* in the collection of the International Museum of Photography and Film, George Eastman House, Rochester, New York, cited in Lukitsh (note 1), p. 157. It should be noted that not all copies of Cameron's *Illustrations* contain the same prints.

20 For a full account of the role Tennyson's poems played in the imagery of the Arthurian Revival, see Debra N. Mancoff, *The Arthurian Revival in Victorian Art*, New York, 1990, esp. chs. 5–8.

105

21 Hallam Tennyson, *Alfred, Lord Tennyson: A Memoir by His Son*, 2 vols., London, 1897, vol. 1, p. 420.

22 William Holman Hunt, *Pre-Raphaelitism and the Pre-Raphaelite Brotherhood*, 2 vols., London, 1913, vol. 2, pp. 123–25.

23 Tennyson to Palgrave, March 23, 1867, as quoted in H. Tennyson (note 21), vol. 2, p. 43. "Old Mr. Rogers" was Samuel Rogers (1763–1855), a poet known for his breakfast salons, in which he brought together members of the literary and the arts communities. His memoirs, published the year after his death, were titled *Recollections of the Table Talk of Samuel Rogers*.

24 Weaver aptly noted that this period, particularly the 1860s and 1870s, was "the greatest period of Victorian book illustration" (MW1984, p. 67). Among those who did illustrate the *Idylls* at an early stage were: Paolo Priolo, who produced a suite of sixteen outline drawings for prints, published in 1862 without text by the Art Union; Amy Butts, who made sixteen etchings in 1863, dedicated to the Laureate with his permission; and George DuMaurier's satire, "A Legend of Camelot," spoofing Tennyson, the Pre-Raphaelites, and the Arthurian Revival in a series published in *Punch* (Mar. 1866). For further discussion, see MW1984, pp. 67–69, and Mancoff (note 20), pp. 256–57.

25 H. Tennyson (note 21), vol. 2, p. 84.

26 Ibid., vol. 2, pp. 86.

27 Most scholars have inferred that Tennyson's request was nothing more than an invitation indulging an eccentric neighbor, which was hardly the case. Charles Millard (note 5), p. 188, dismissed this, but with an inference even more disturbing, saying Tennyson's choice was "not simply accommodating an old and close friend but following the path of least resistance by selecting the artist close at hand." This unfortunately perpetuates William Gaunt's opinion that Tennyson's "indifference to the arts was entire" (William Gaunt, *The Pre-Raphaelite Dream*, New York, 1966, p. 101). Tennyson's avid interference with his illustrators easily refutes Gaunt's claim, and Tennyson's long and close association with Cameron, to whom he closed letters with "God bless

you, dear Julia Cameron" (as quoted in H. Tennyson [note 21], vol. 1, p. 372), suggests that Millard's explanation is too simple.

28 For a full account of the Oxford Union Murals Project, see Mancoff (note 20), pp. 156–60. See MW1984, pp. 57–58, for Cameron's familiarity with the legend before the *Illustrations*.

29 Valentine Prinsep claimed that Burne-Jones, distraught at the way Tennyson "modernized and altered the character while preserving the ancient name" in his Arthurian poem, convinced Tennyson to call his sorceress Vivien. Georgiana Burne-Jones, *Memorials of Edward Burne-Jones*, 2 vols., London, 1906, vol. 1, p. 182.

30 She recorded: "As to Mr. Cameron being an admirable representation of the patriarch there could not be a shadow of a doubt – but would he laugh? The point was soon settled; laugh he did, and that most heartily." She then commented on the results: "With all the latitude which Mrs. Cameron allowed herself in the way of 'out of focus' and 'sketchiness,' Merlin had moved far too much, there were at least fifty Merlins to be seen" ("A Reminiscence of Mrs. Cameron" by a Lady Amateur, *Photographic News* [Jan. 1886], as quoted in HG1975, pp. 42–43).

31 This anecdote is recorded in Wilfred Ward's *Aubrey de Vere: A Memoir* (1904), as quoted in HG1975, p. 45. According to this account, Cameron laughed off her mistake, telling the Bishop, "I shall write to your Pope about it."

32 The essay originally appeared in the Pre-Raphaelite journal *The Germ*. See Rossetti, "Pre-Raphaelitism," in James Sambrook, ed., *Pre-Raphaelitism*, Chicago, 1974, p. 67.

33 For a thorough discussion of the thriving interest in phrenology among Victorian artists, see Julie F. Codell, "The Dilemma of the Artist in Millais's *Lorenzo and Isabella*: Phrenology, the Gaze and the Social Discourse," *Art History* 14 (Mar. 1991), pp. 58–59.

34 Cameron to Sir Edward Ryan, Dec. 6, 1874, as quoted in HG1975, p. 47. It is worth observing that, given Tennyson's portrayal of Vivien as a vicious and degraded woman, even Cameron would hesitate to have a fully characteristic model of that type in her studio.

35 *Morning Post*, Jan. 11, 1875, as quoted in HG1975, p. 49.

36 C. Kegan Paul to Cameron, Oct. 30, 1874, as quoted in HG1975, p. 44. Paul worked for Henry S. King, the publisher of Cameron's *Illustrations*.

37 As quoted in G. Burne-Jones (note 29), vol. 2, p. 141.

38 Gernsheim (HG1975, p. 43) offered this anecdote to suggest that Cameron was experimenting with this subject: "One day the 'Guinevere' was found by a friend looking rather exhausted, and on inquiry whether this was the result of a long walk she answered with a smile, 'Oh no. I have not been for a walking, I have been lying on the floor for the last two hours, clutching the porter's ankle.'" The "porter" was William Warder, a porter from Yarmouth pier who sat for Cameron's portraits of King Arthur.

39 Cameron's contemporaries seemed to prefer to set the scene in a fuller narrative. Rossetti, for example, in *Sir Lancelot in the Queen's Chamber* (1857; Birmingham Museum and Art Gallery, England), depicted the moment when Mordred and his cohorts interrupt their farewell, showing Lancelot prepared for a battle, while Doré showed the parting lovers riding out of Camelot, exchanging farewells before they pursue their separate destinations and destinies. The image of the embrace gained popularity at the turn of the century in illustrated editions of the *Idylls*. It also gained in passion, as seen in Eleanor Fortiscue Brickdale's *The Sombre Close of That Voluptuous Day*, in "*Idylls of the King*" *by Alfred Lord Tennyson*, London, n.d. (1911); and Florence Harrison's *It Was Their Last Hour*, in *Tennyson's "Guinevere" and Other Poems*, London, 1912.

40 Elizabeth Barrett Browning, *Aurora Leigh*, New York, 1857, 5th bk., p. 169, 11.151–52.

Plates

1 "Call, I follow, I follow,
let me die!"
1867

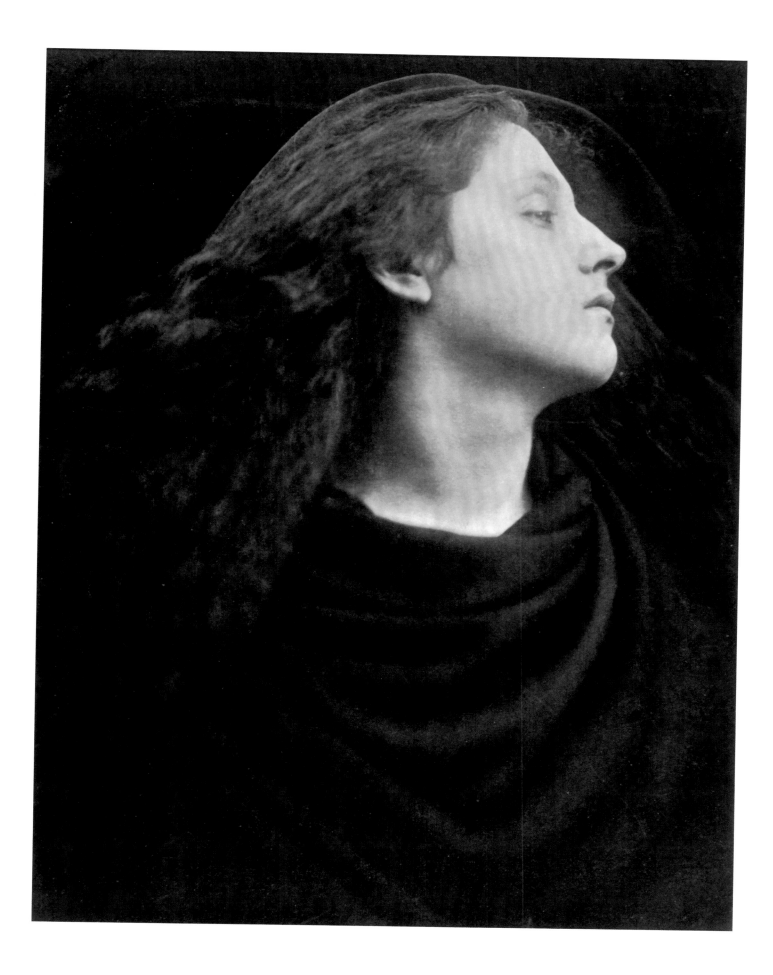

2 The Angel in the House
1871

3 Zoe, Maid of Athens
1866/70

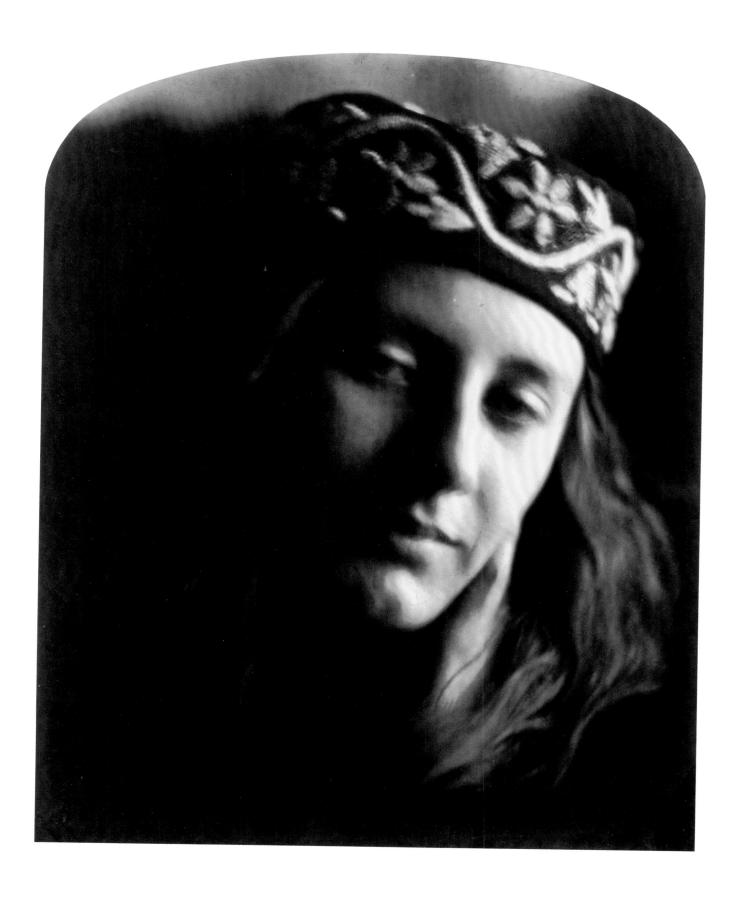

4 The Mountain Nymph
Sweet Liberty
1866

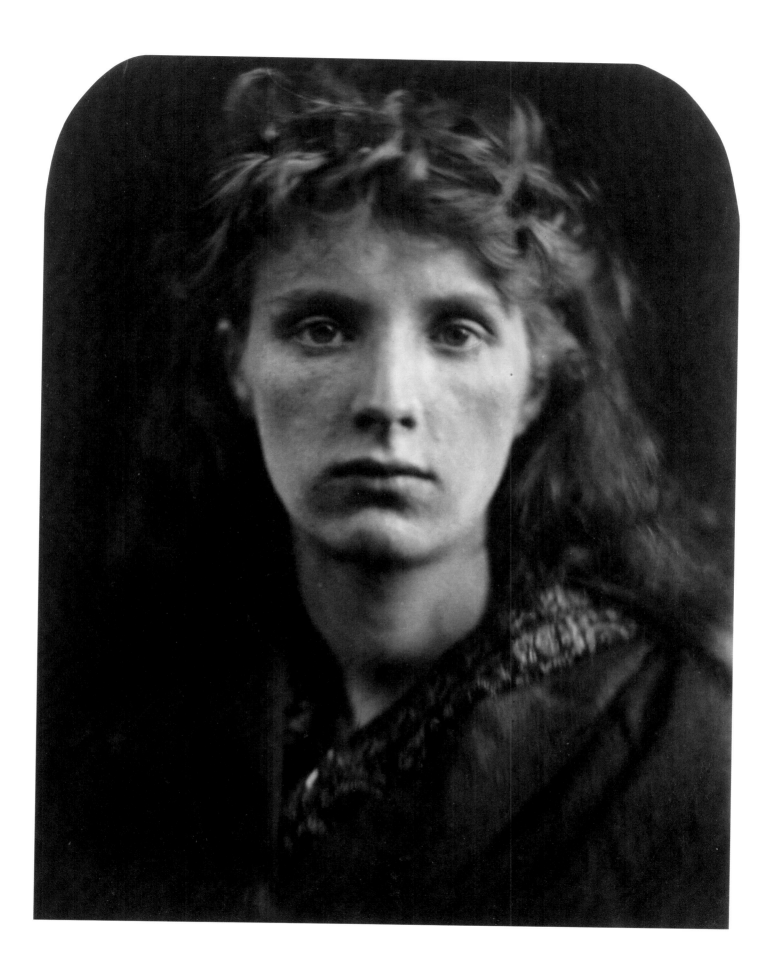

5 The Echo
1868

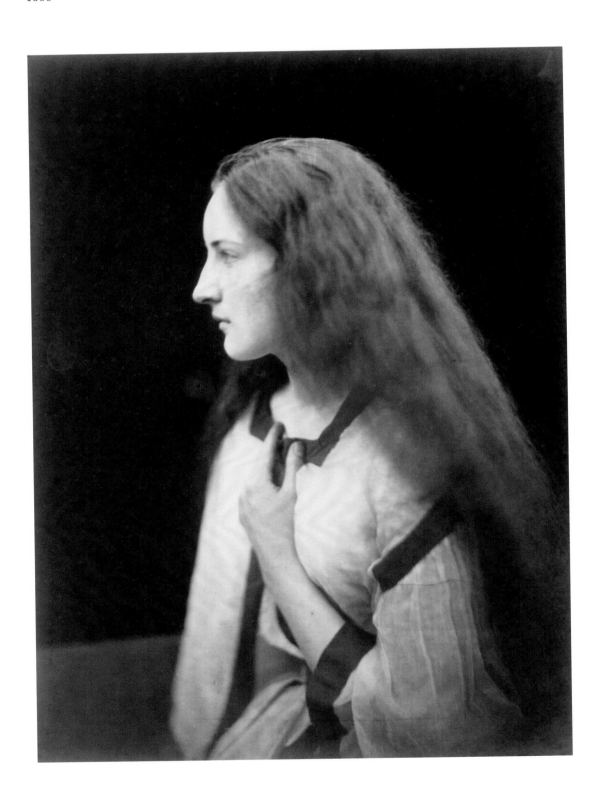

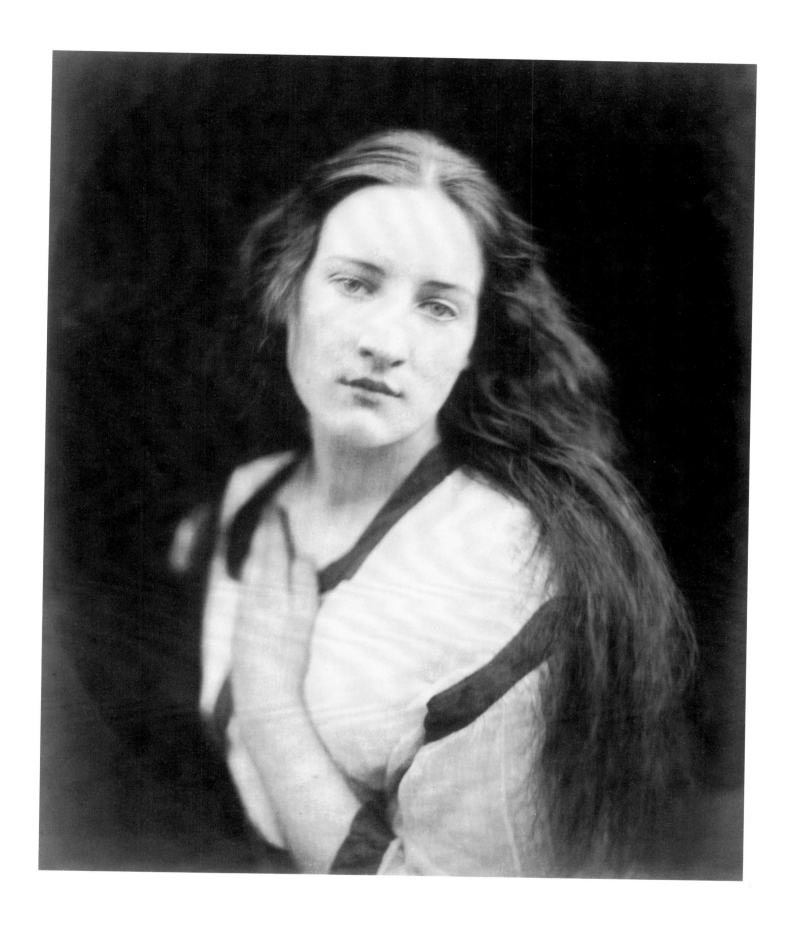

6 The Echo
1868

7 Daphne
1866/68

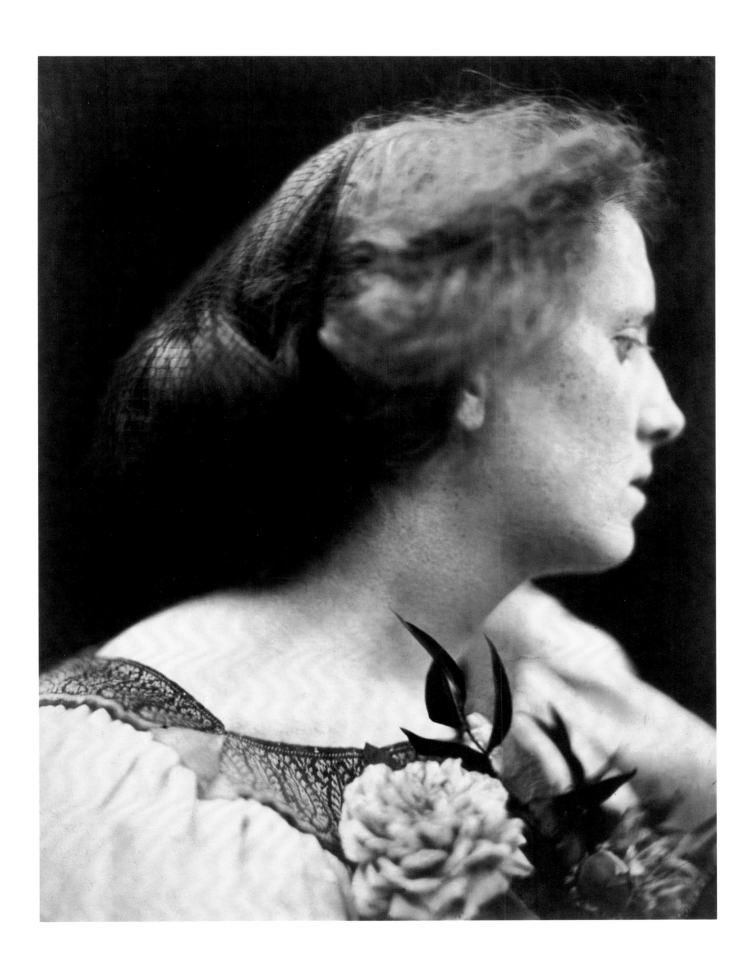

8 Mrs. Herbert Fisher
1864

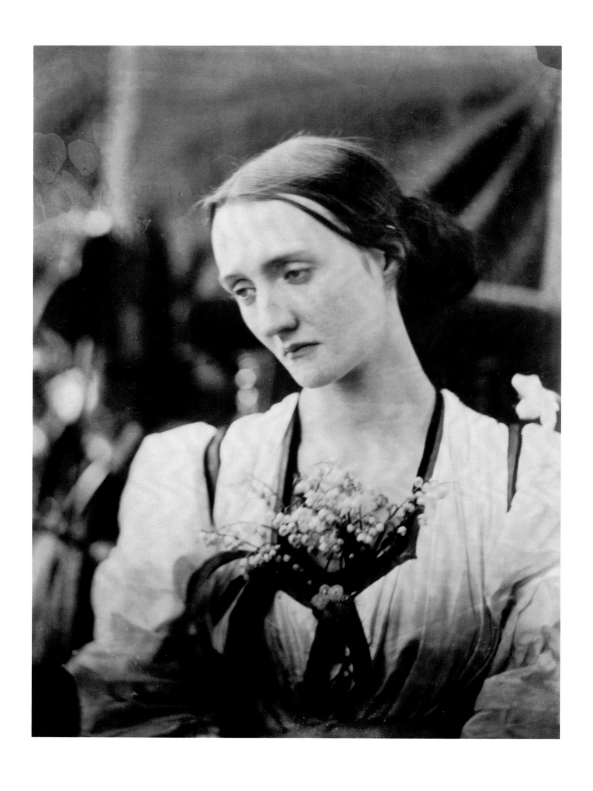

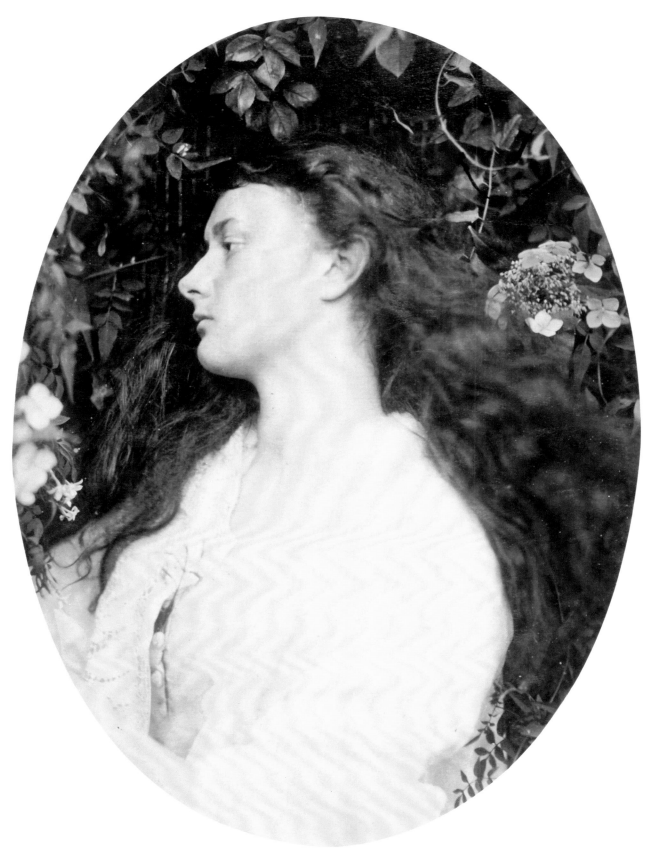

9 Alethea
1872

10 Marie Spartali

1868

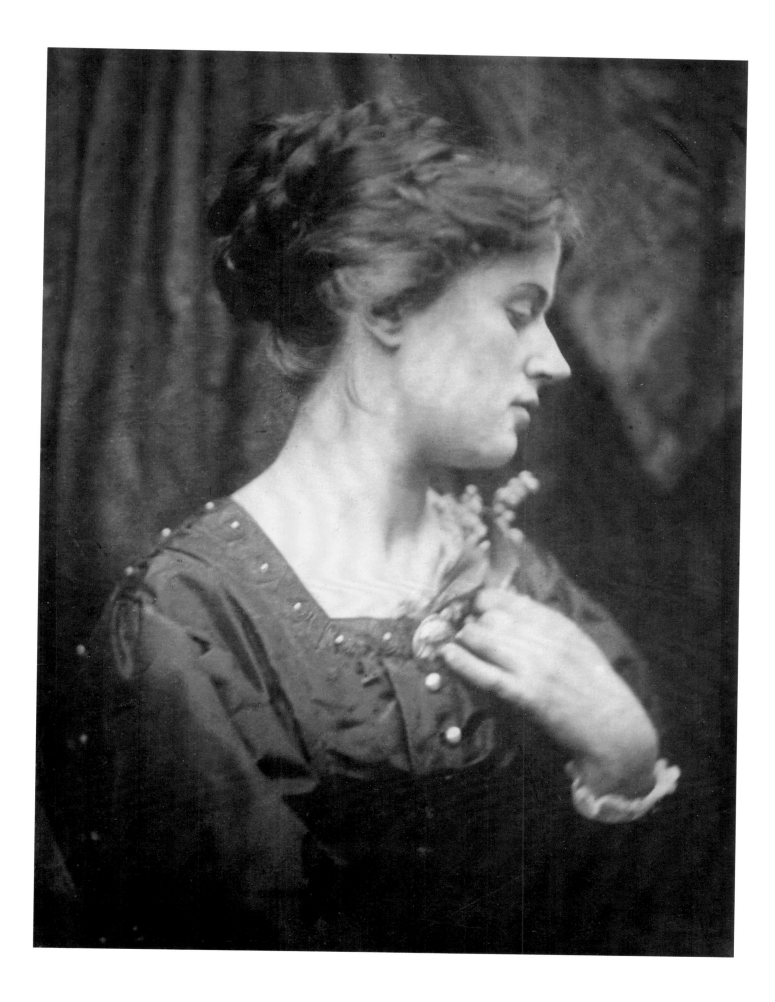

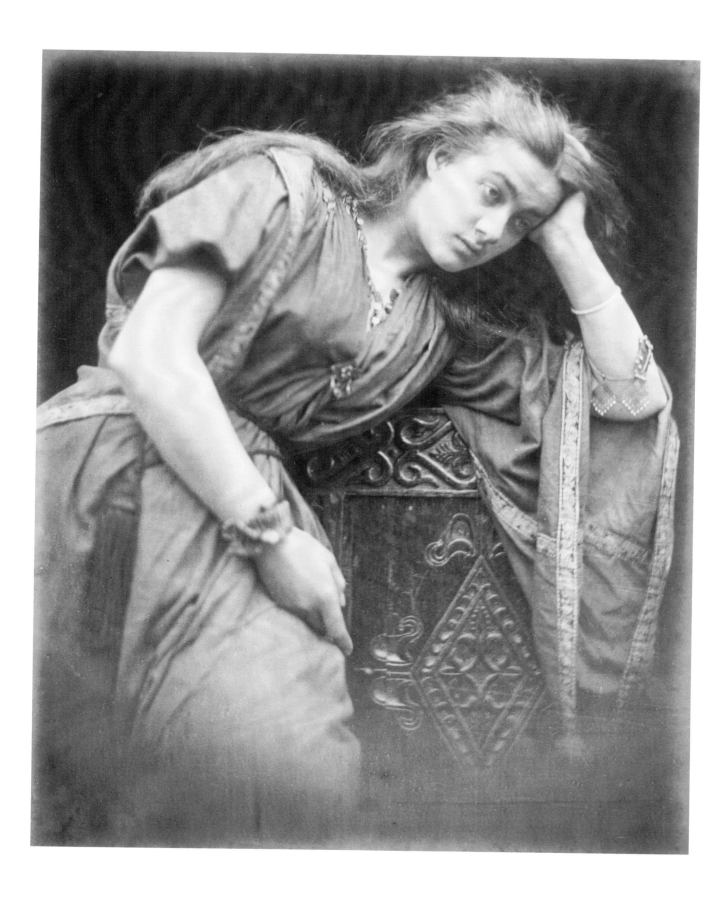

12 Rosalba

1867

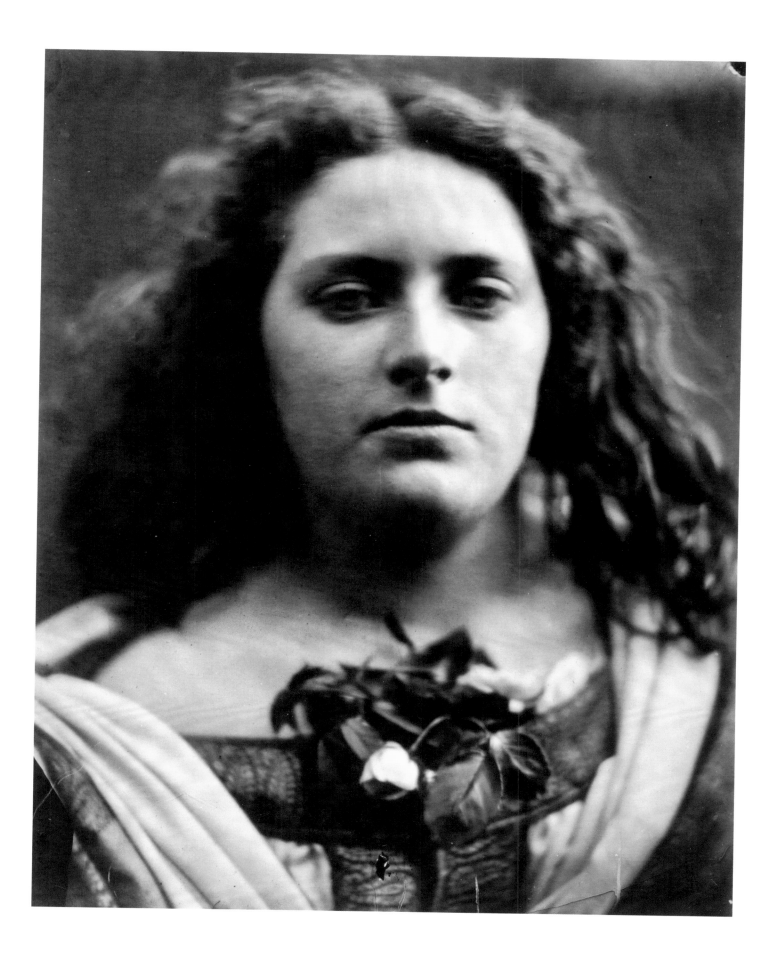

13 Summer Days

April 1866

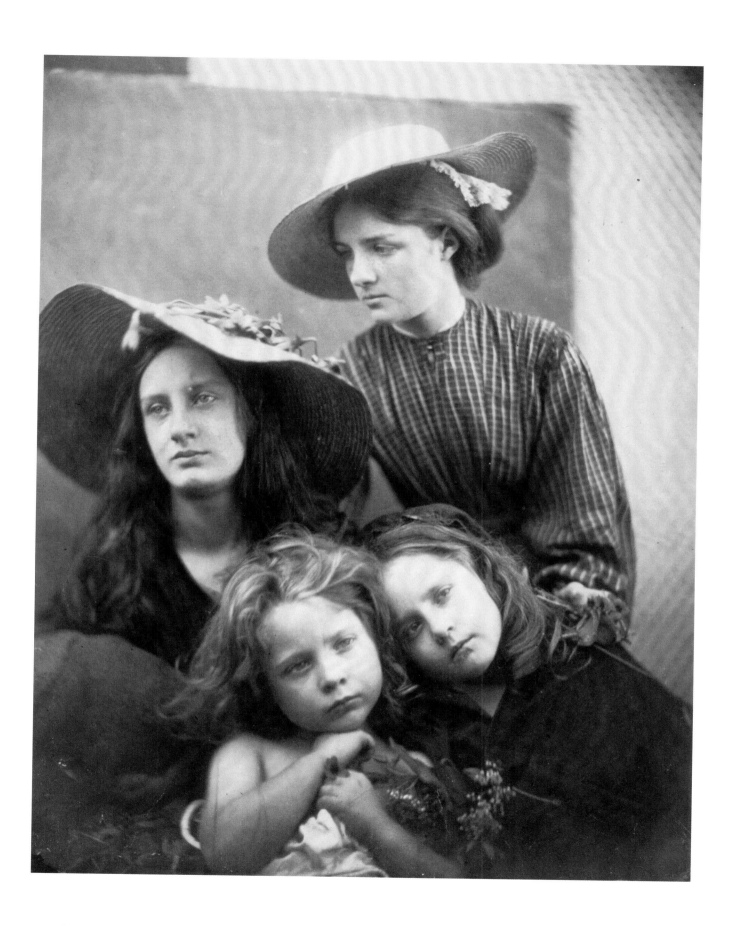

14 "For I'm to be Queen
 of the May, Mother,
 I'm to be Queen of the May"
 May 1, 1875

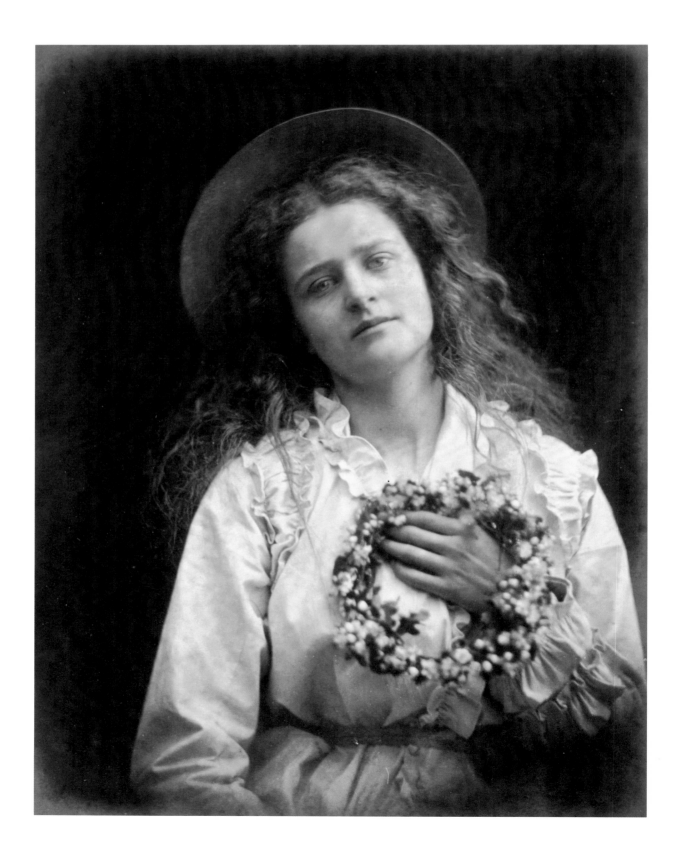

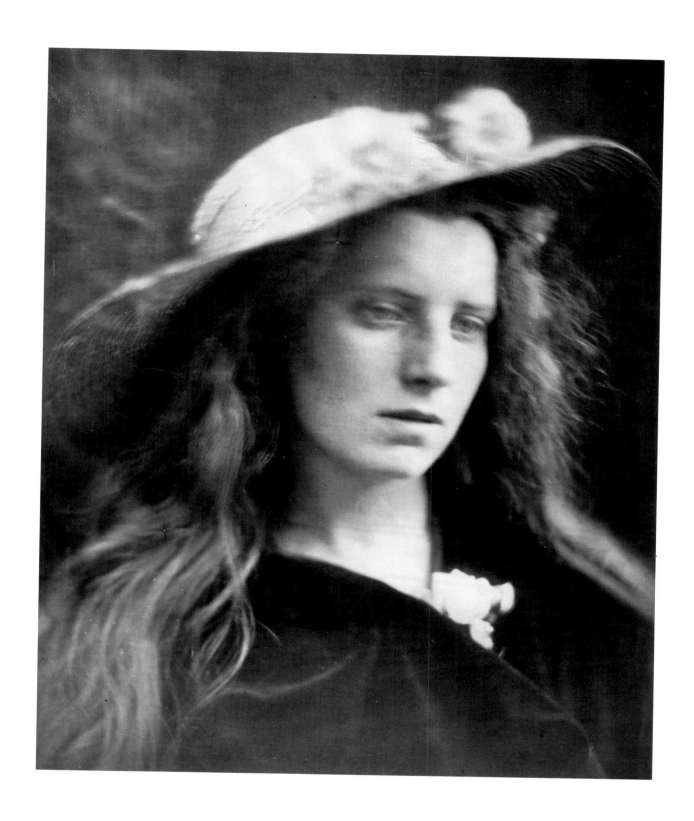

15 Ophelia, Study No. 2
1867

16 Ophelia
1867

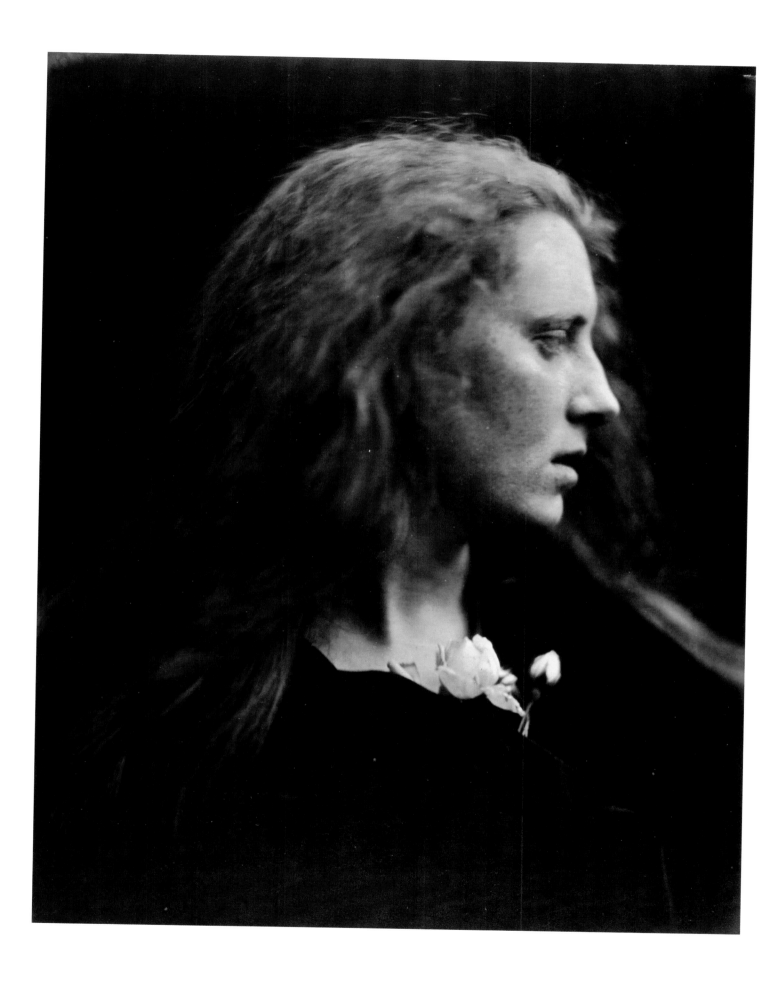

17 The Gardener's Daughter
1867

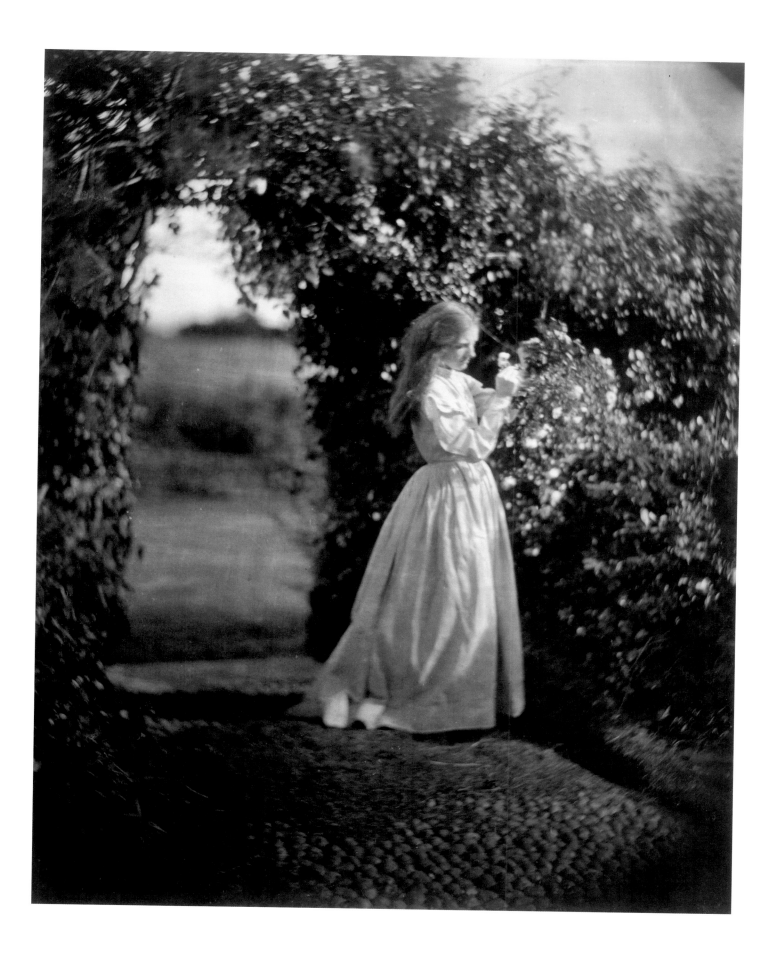

18 Pomona
1872

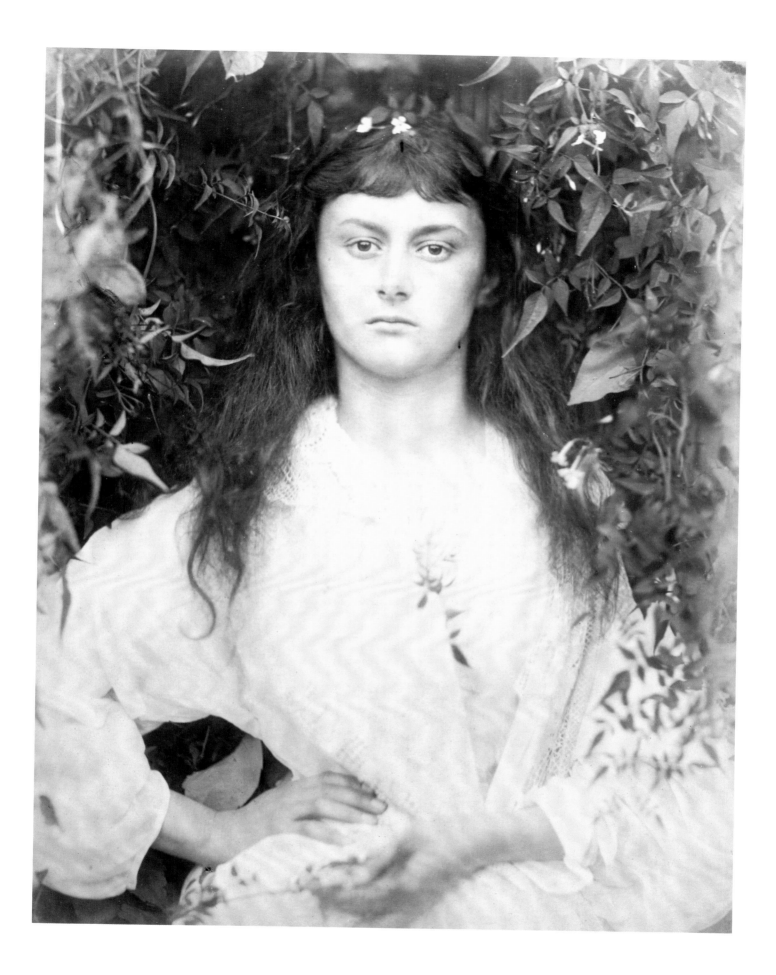

19 May Day
 1866

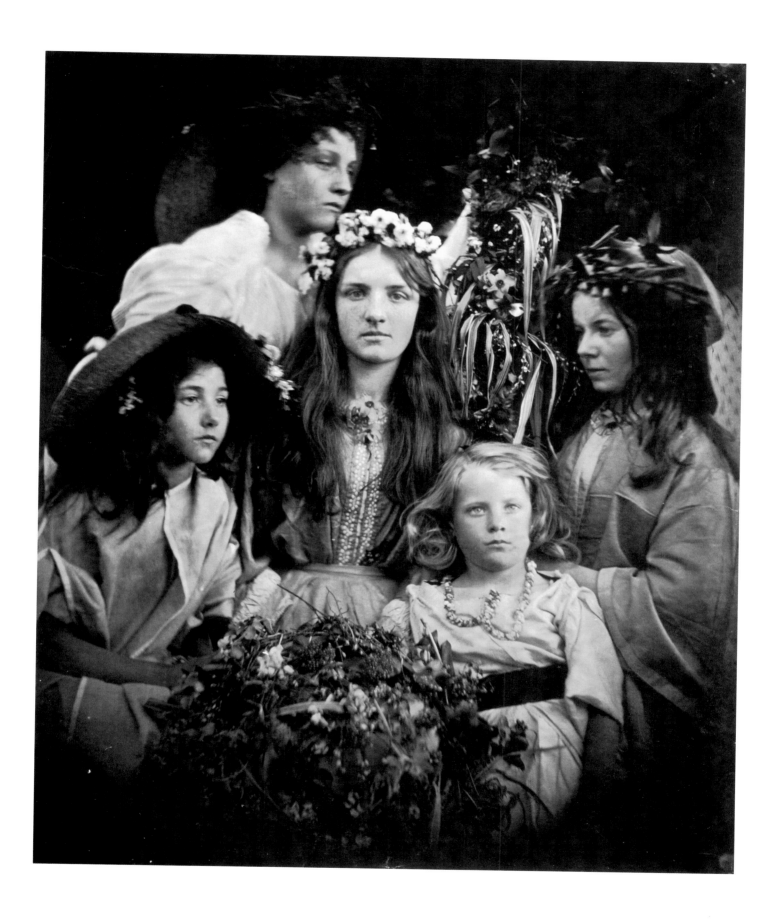

20 Marie Spartali
1870

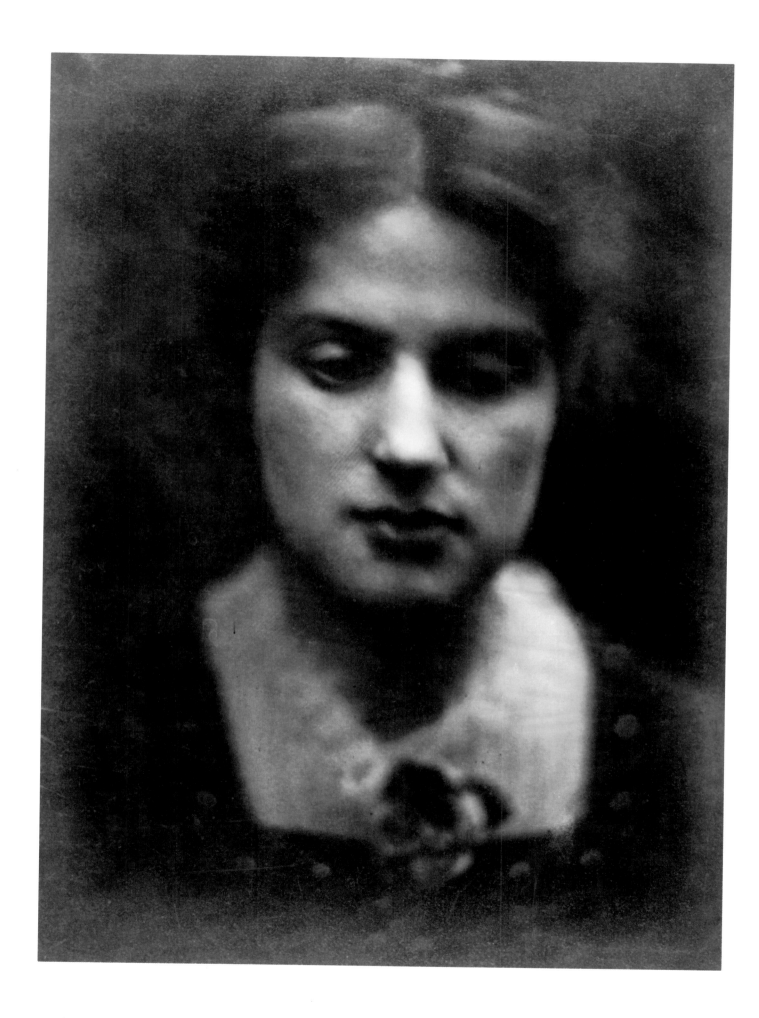

21 Christabel
1866

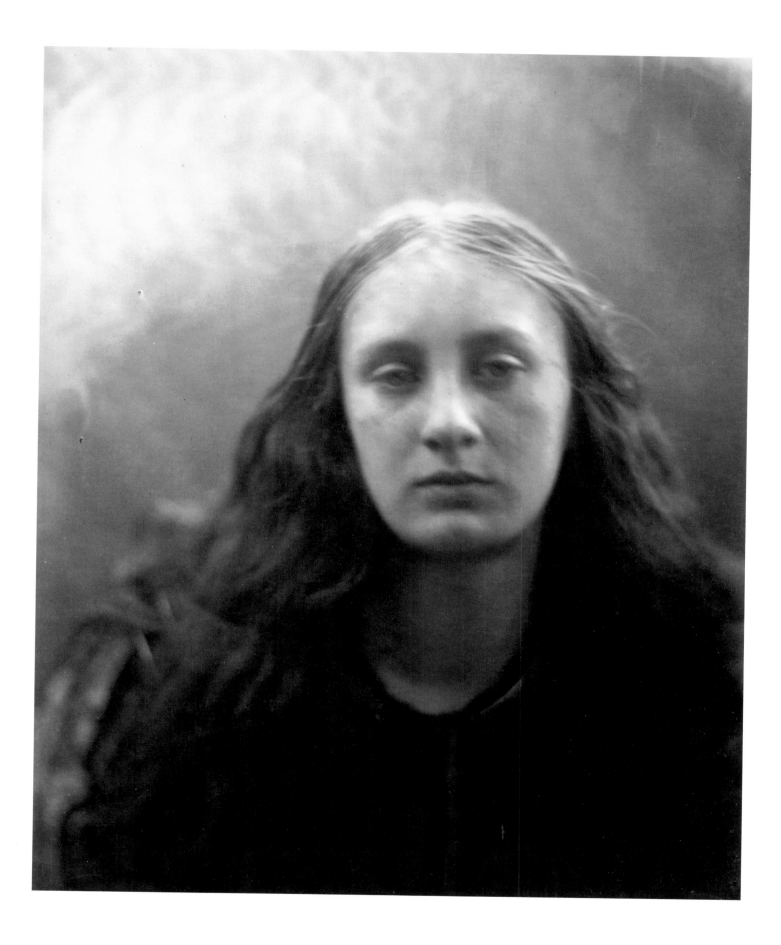

22 The Wild Flower
1867

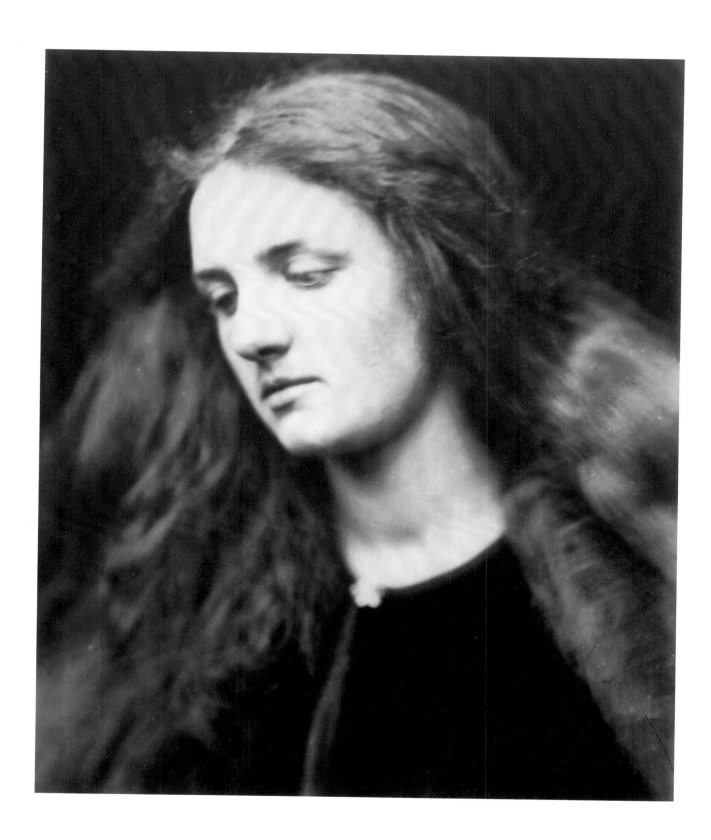

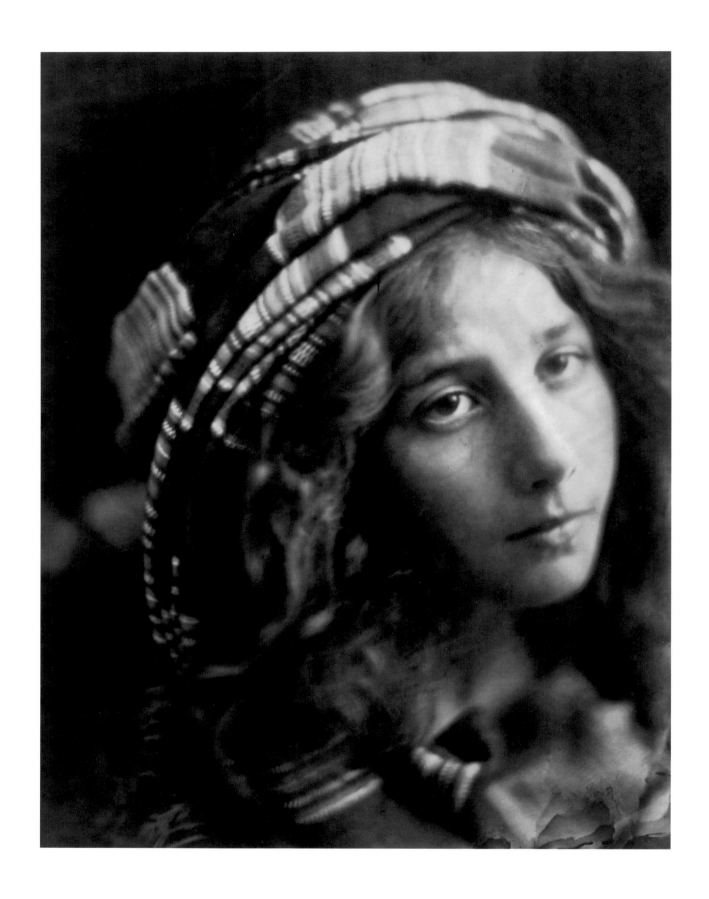

23 A Study of the Cenci

May 1868

24 Beatrice
1866

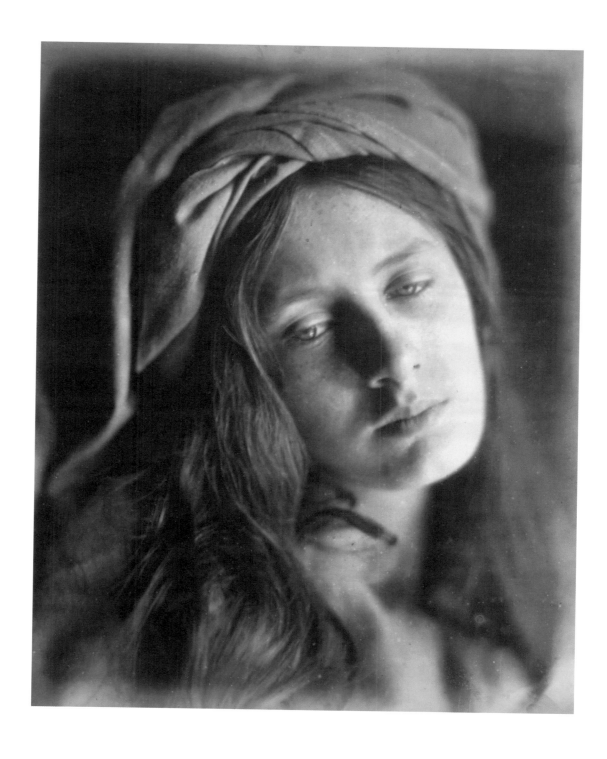

25 Pre-Raphaelite Study

October 1870

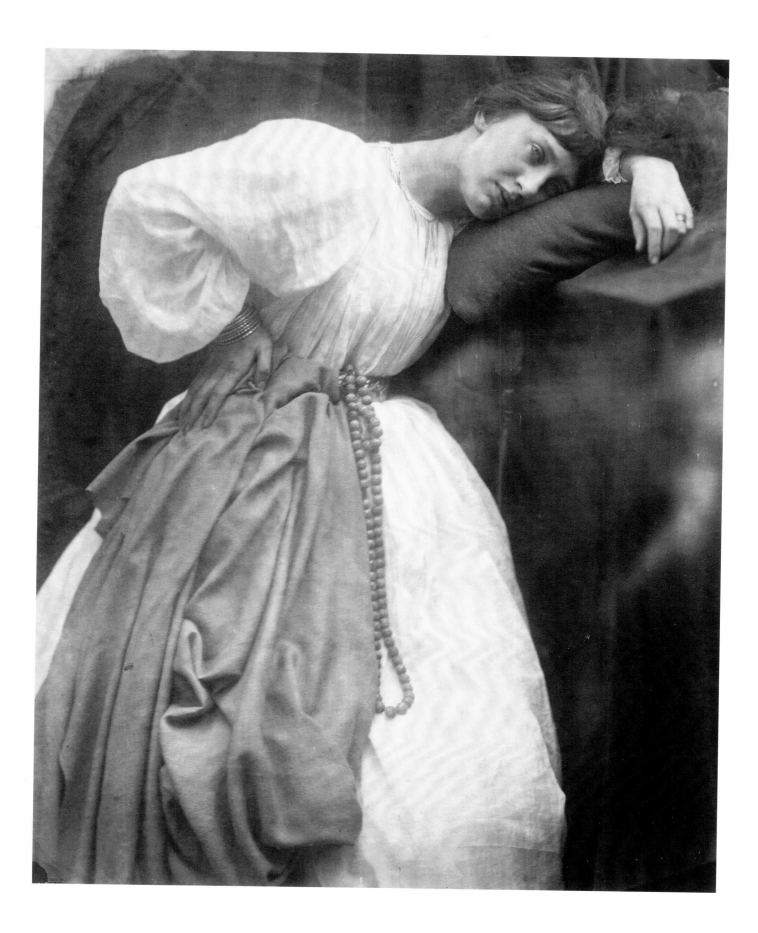

26 Lady Adelaide Talbot

1865

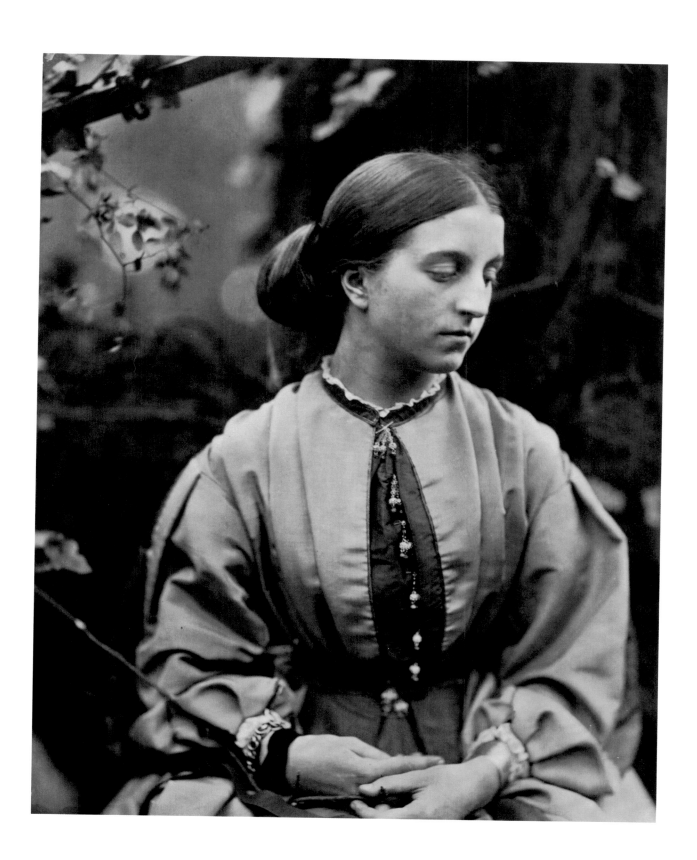

27 Emily Peacock

1874

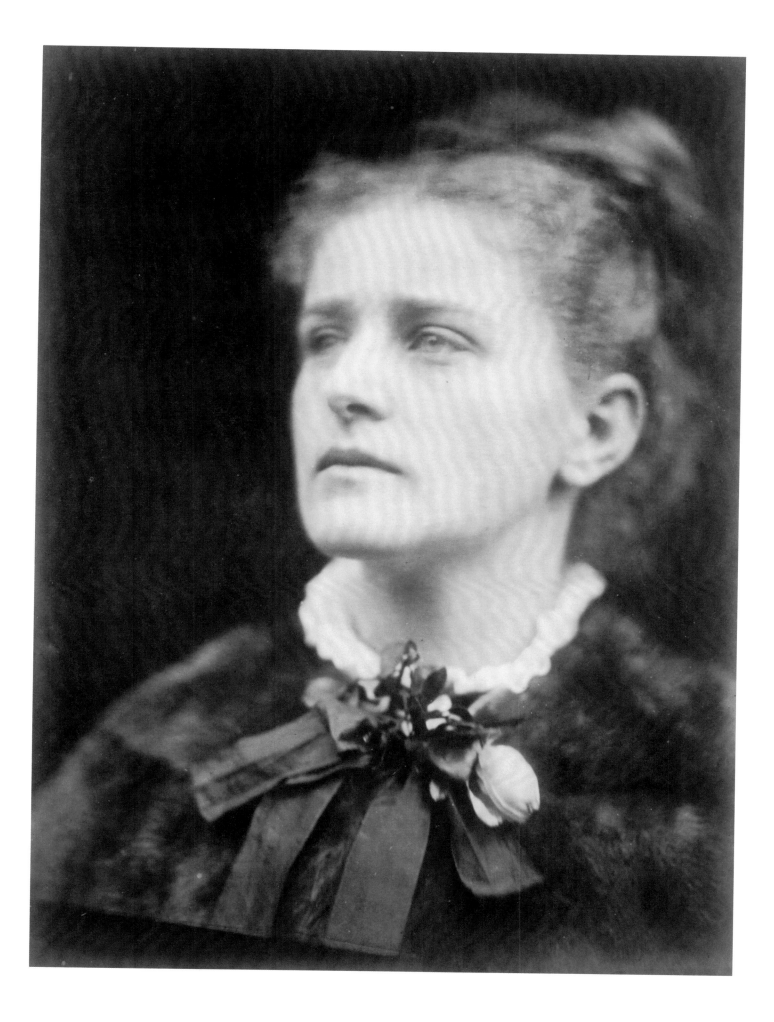

28 The Rosebud Garden of Girls

June 1868

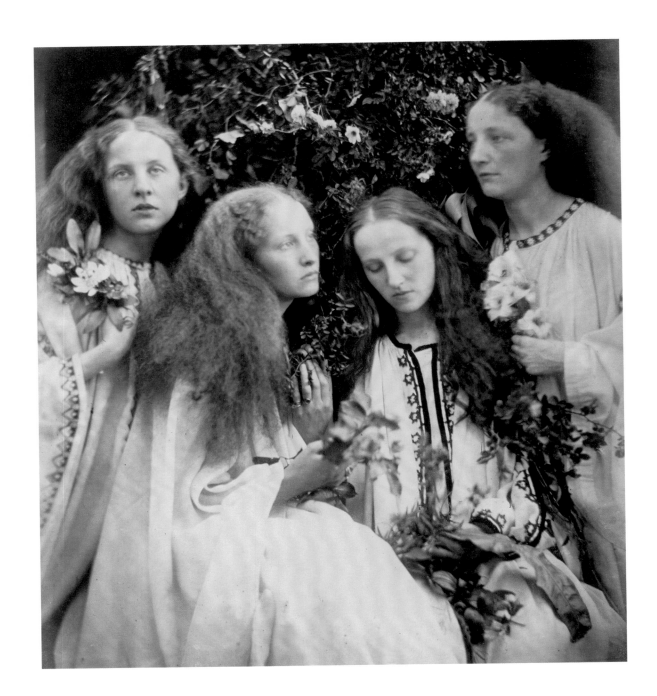

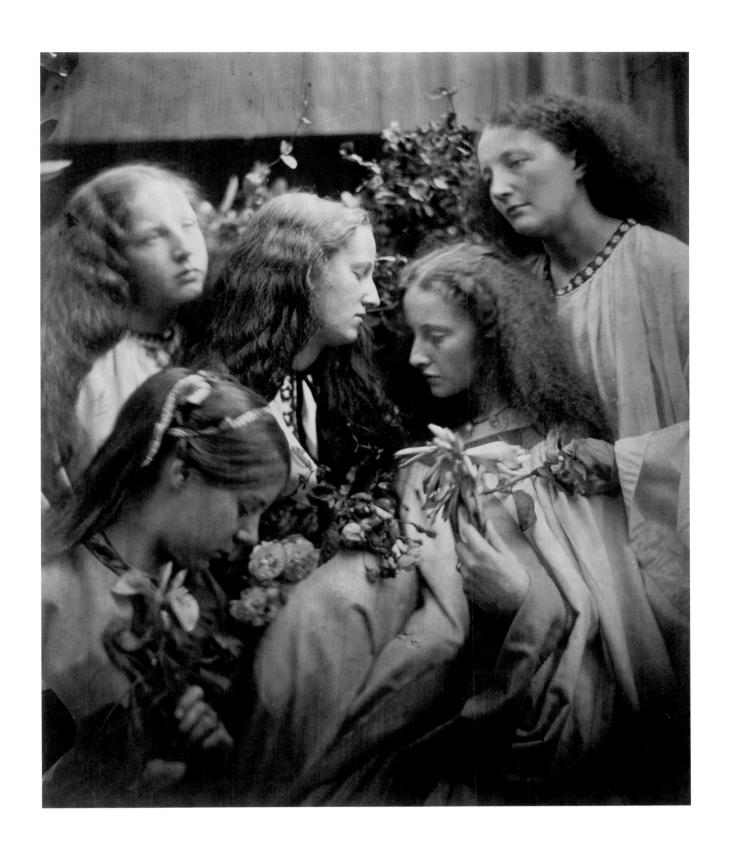

29 The Rosebud Garden of Girls
1868

30 My Ewen's Bride
 (God's Gift to Us)

 November 18, 1869

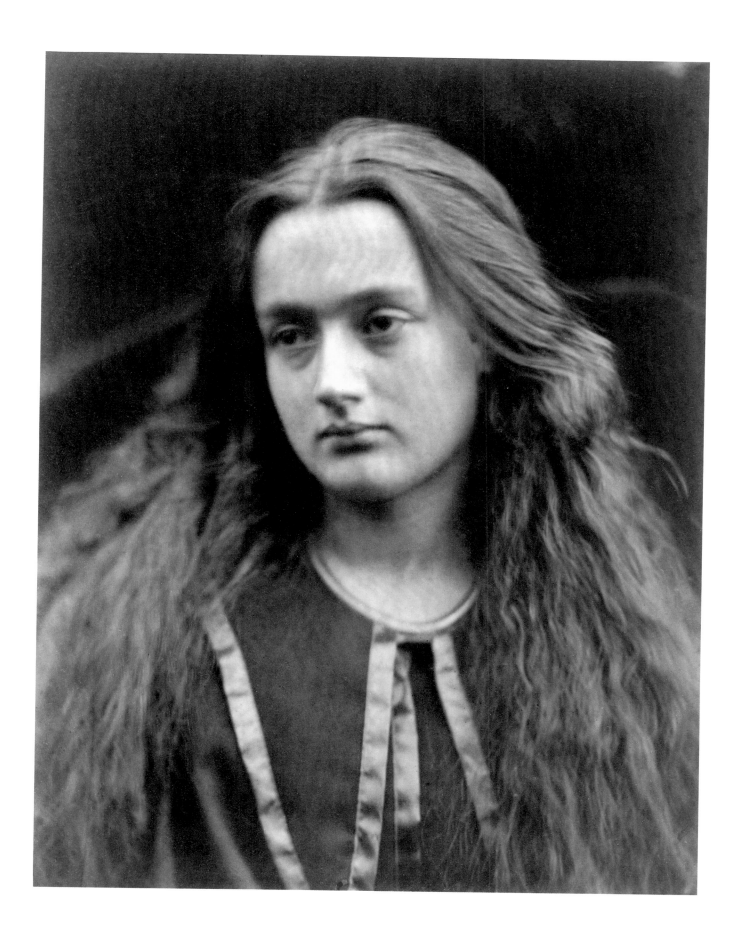

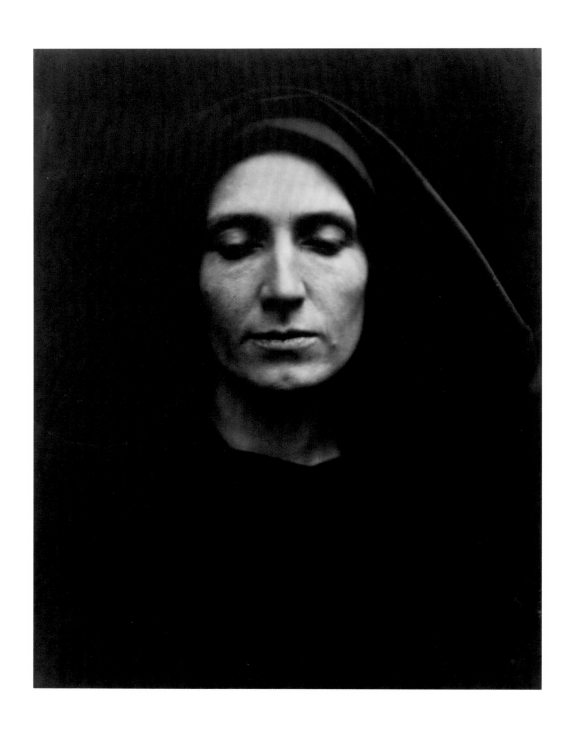

31 Julia Norman

March 1868

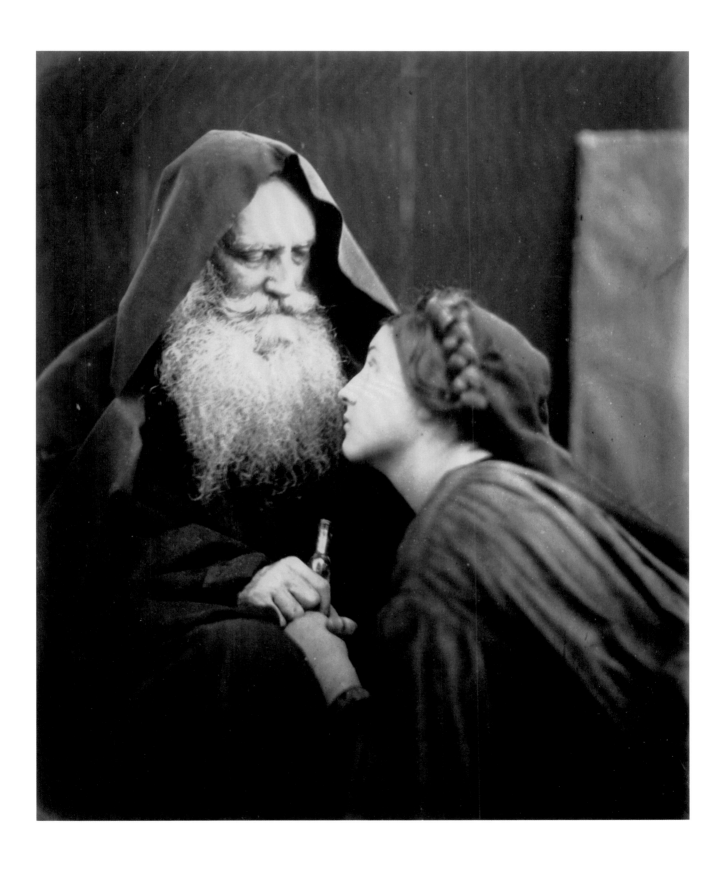

33 The Dream

April 1869

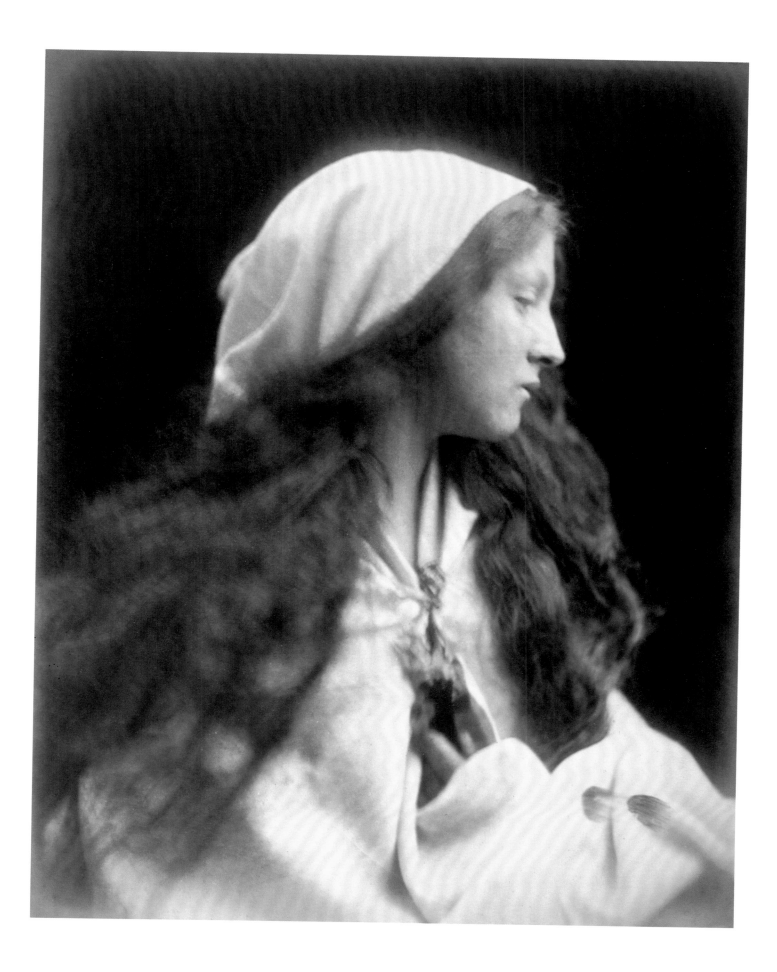

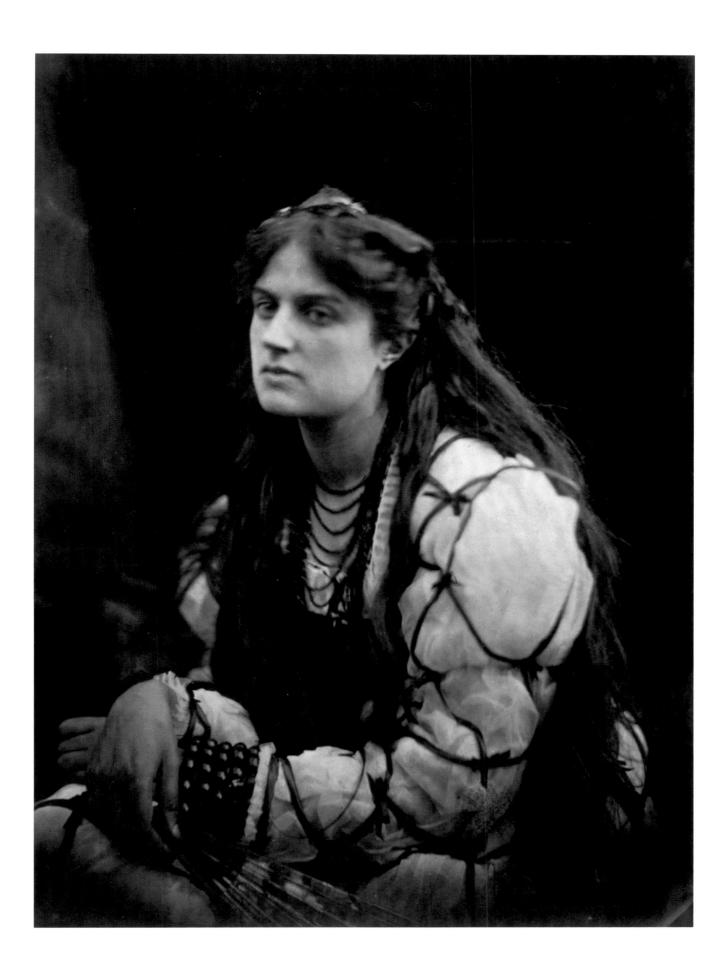

35 Queen Esther before
 King Ahasuerus
 1865

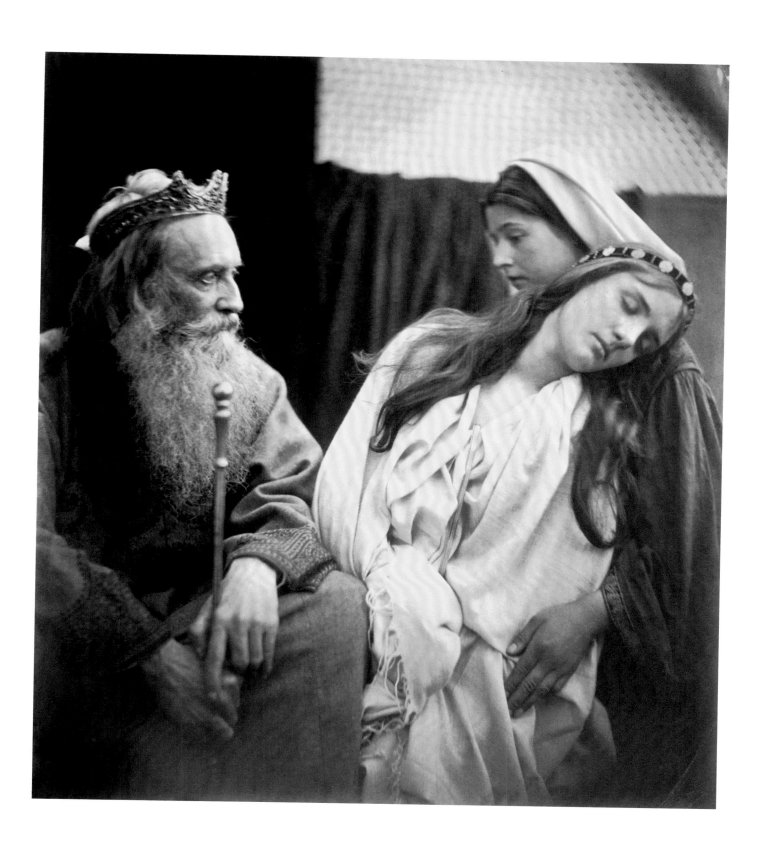

36 Rachel
1867

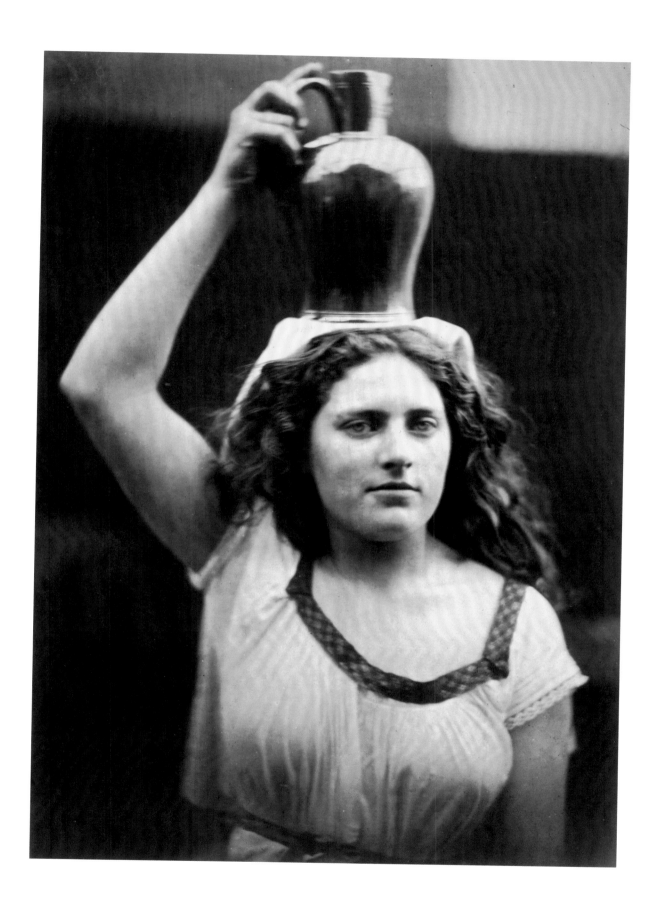

37 A Bacchante

June 20, 1867

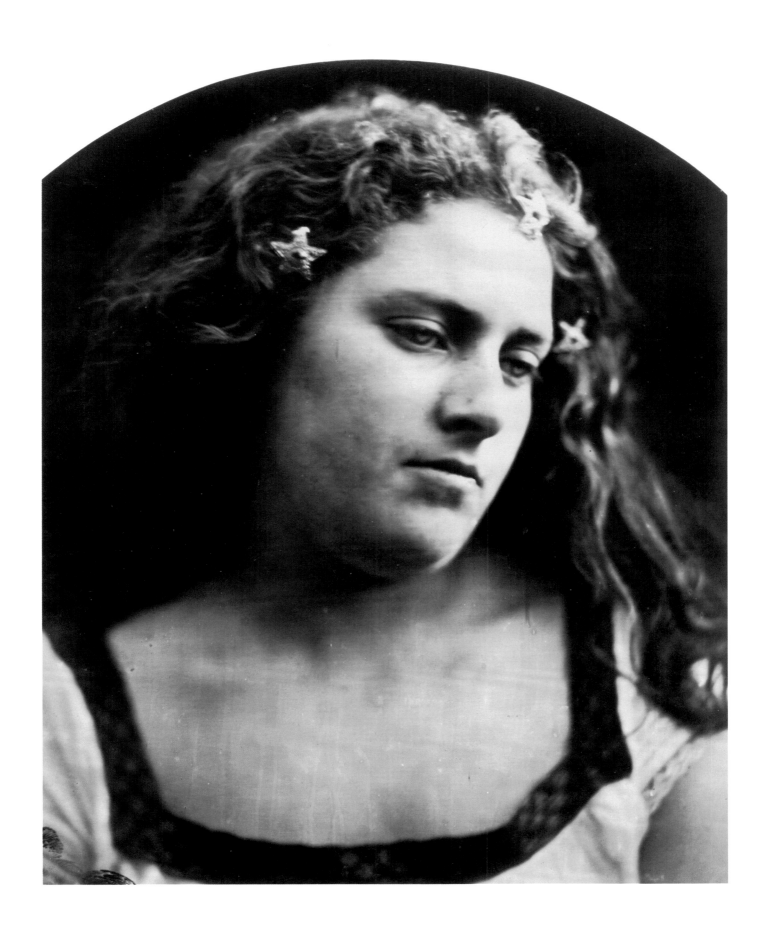

38 May Prinsep
1868

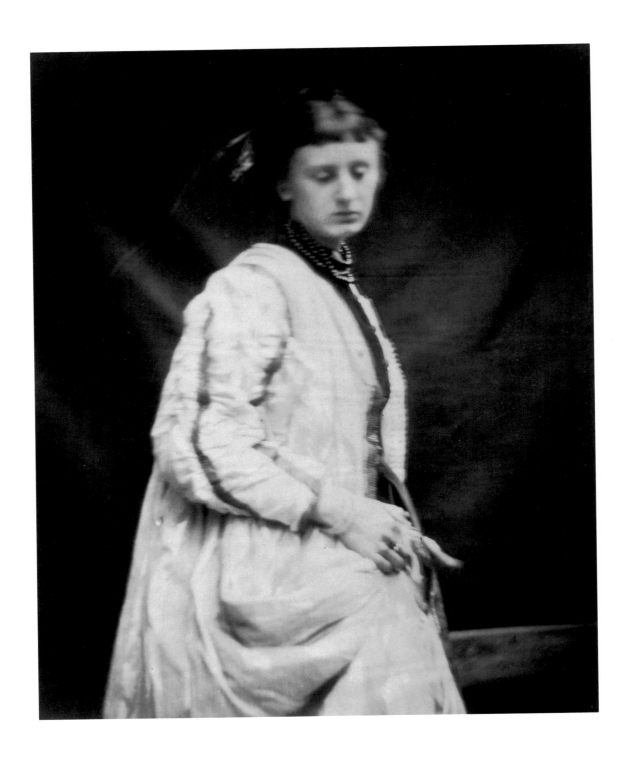

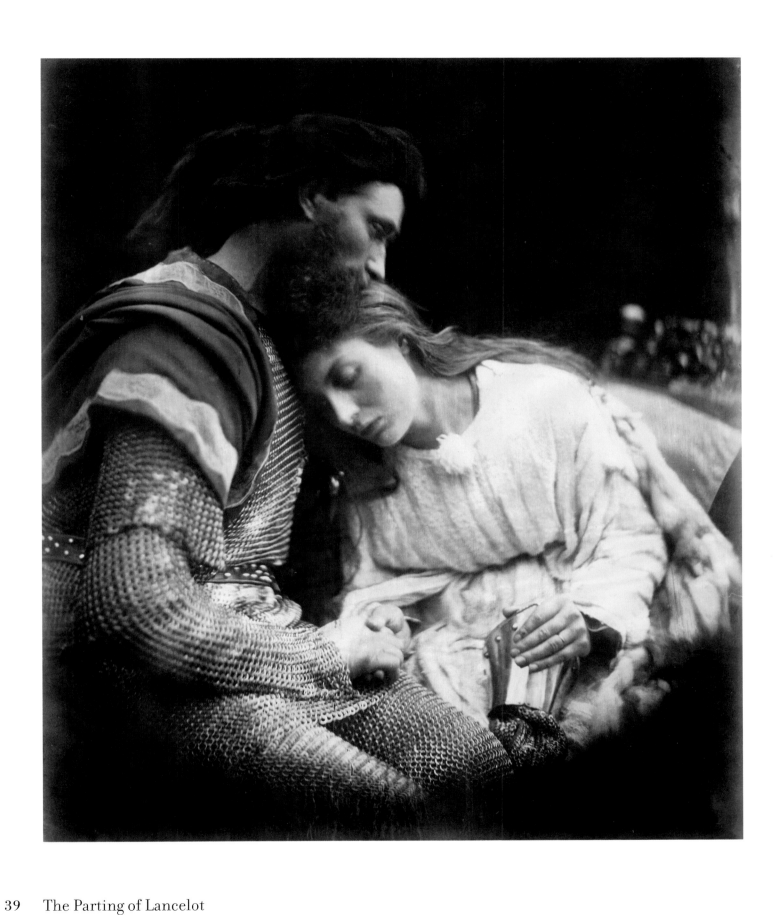

39 The Parting of Lancelot
 and Guinevere

1874

40 The "little Novice" and Queen Guinevere
 in "the Holy House of Almesbury"

October 1874

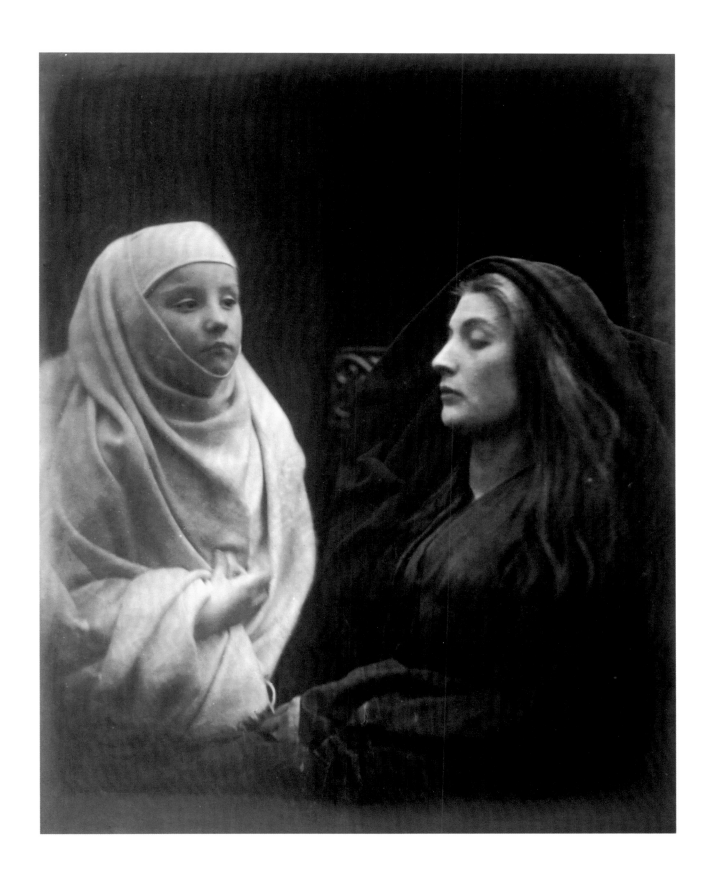

41 The Angel at the
 Sepulchre
 1869

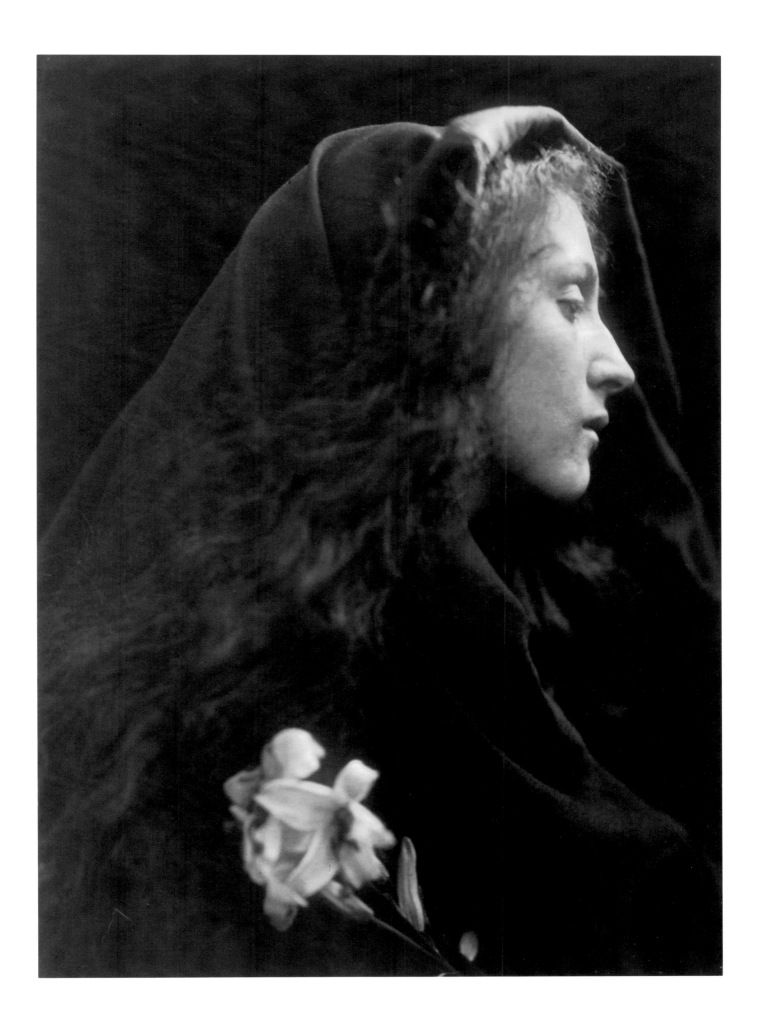

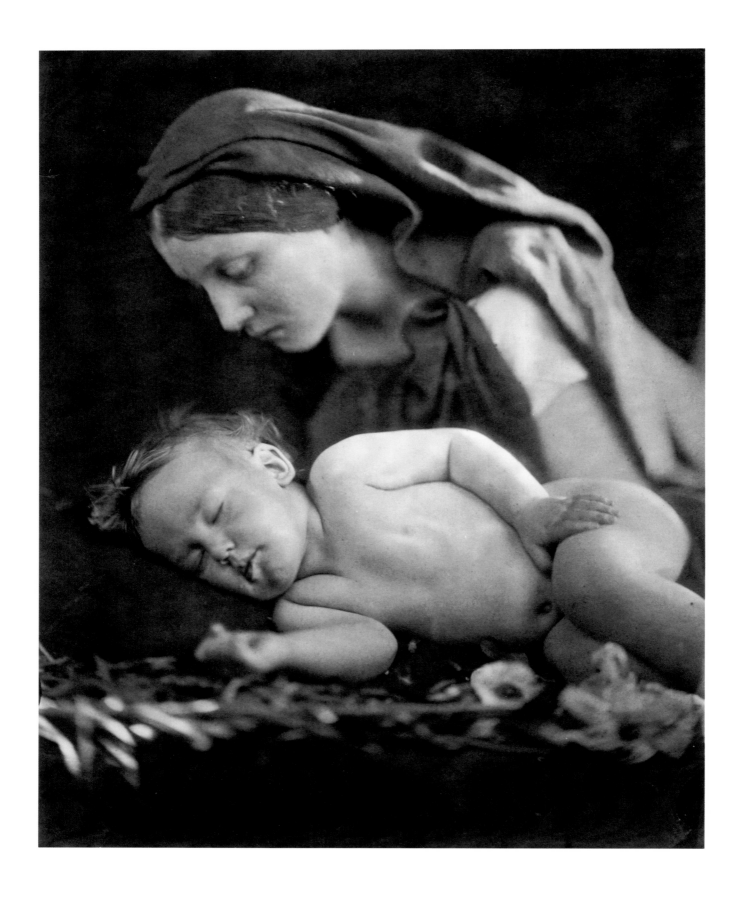

42 The Day Spring

1865

43 Goodness, from the series
 Fruits of the Spirit
 1864

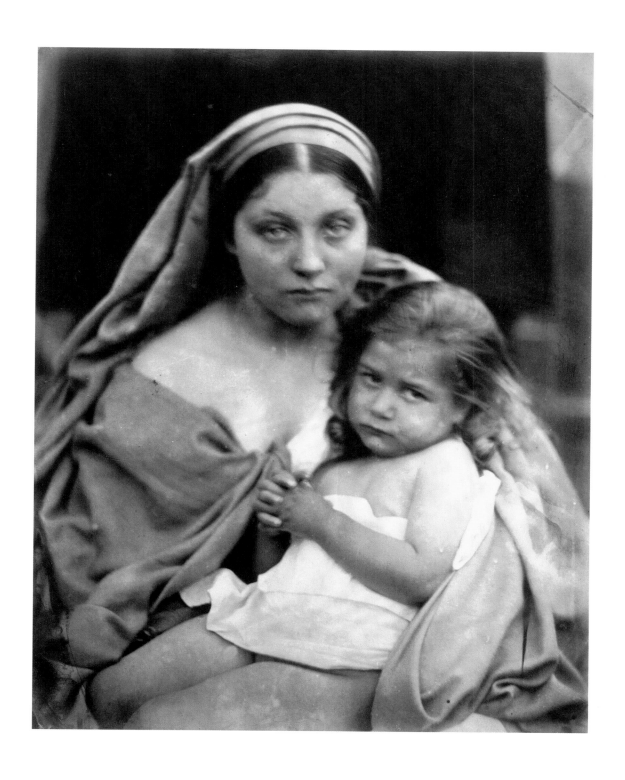

44 Mary Mother
April 1867

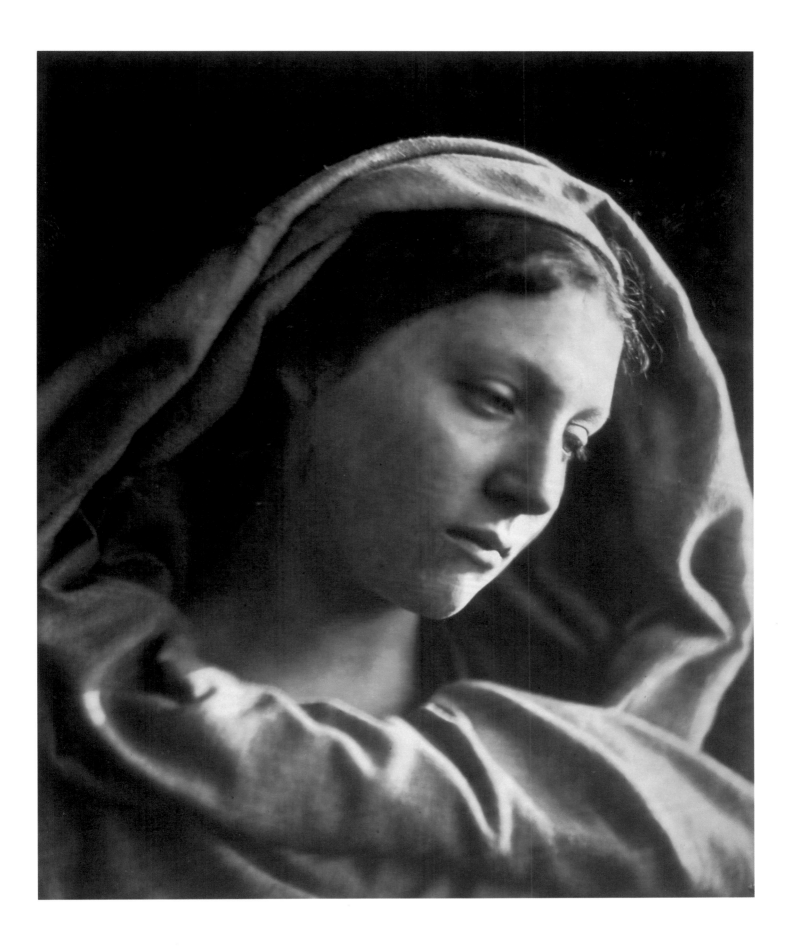

45 The Return after
 Three Days

1865

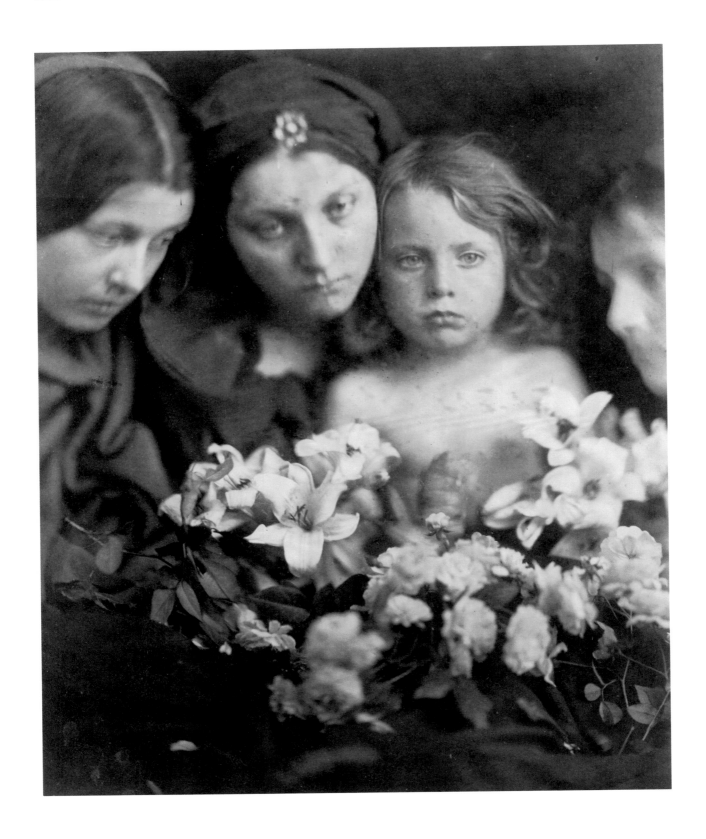

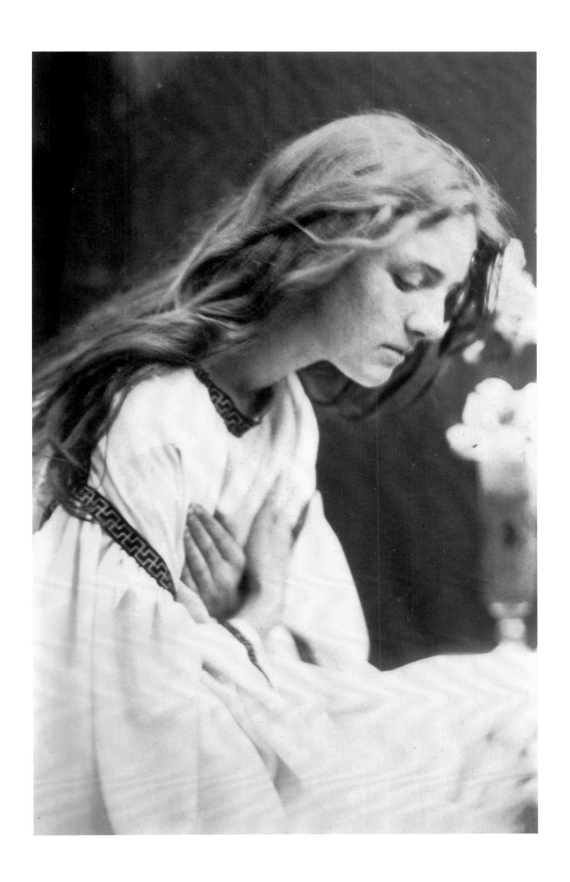

46 After the Manner
of Perugino

1865

47 The Angel at the Tomb
1870

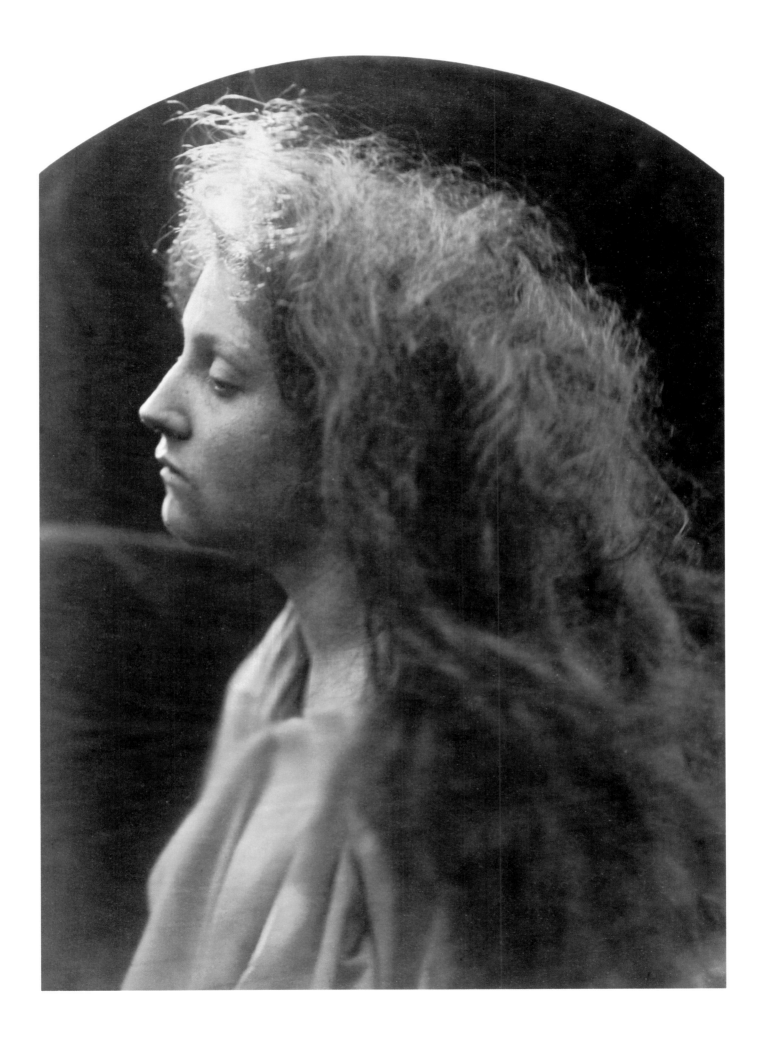

48　　Meekness, from the series
　　　Fruits of the Spirit
　　　1864

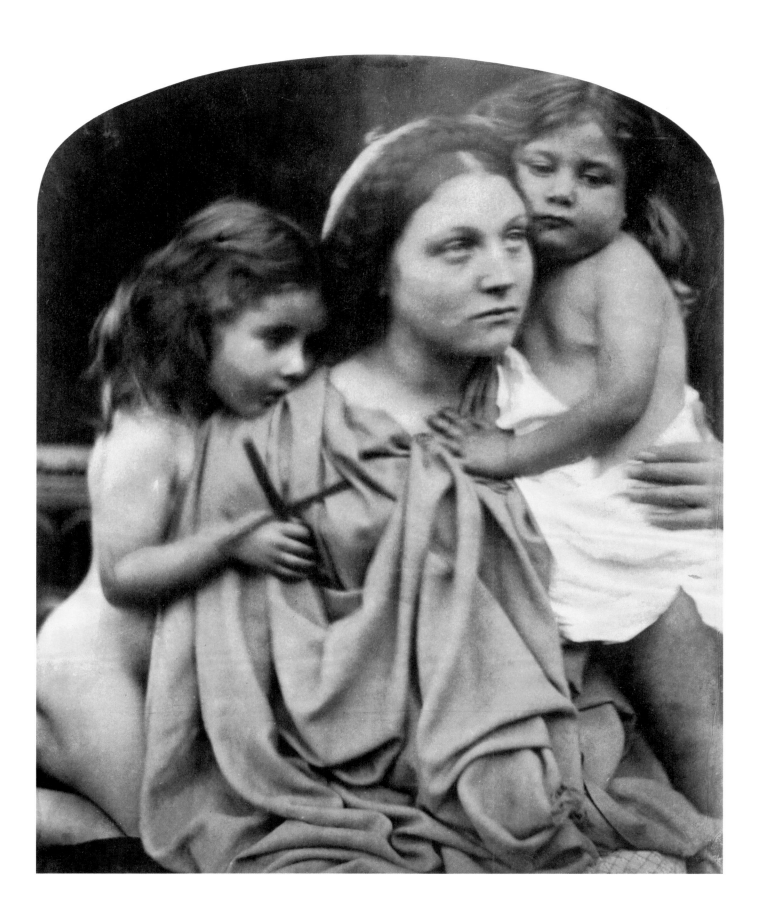

49 The Holy Family
1867

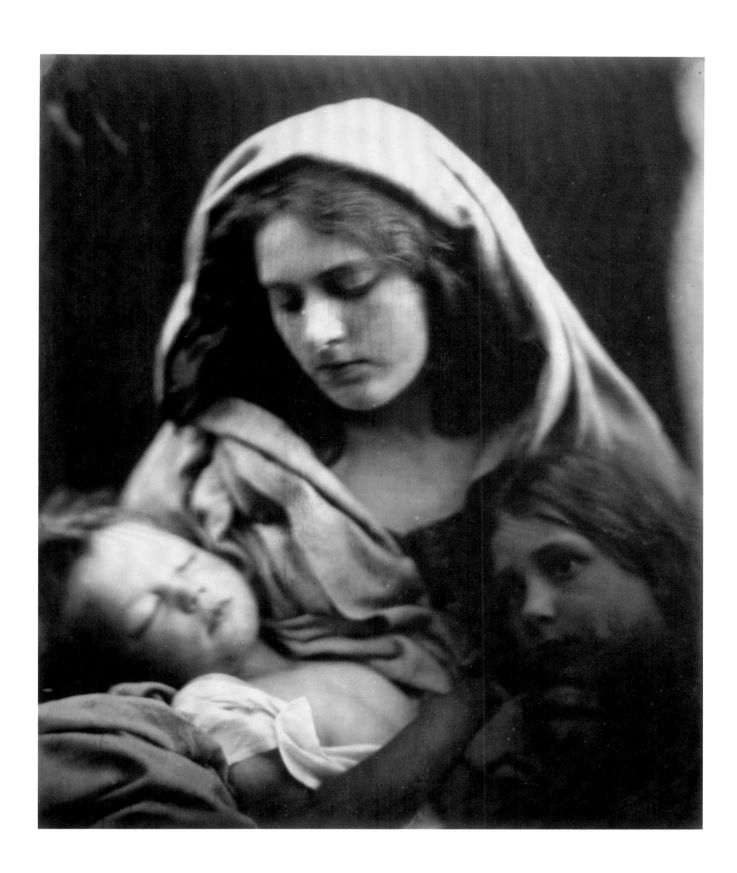

50 Spring
May 1865

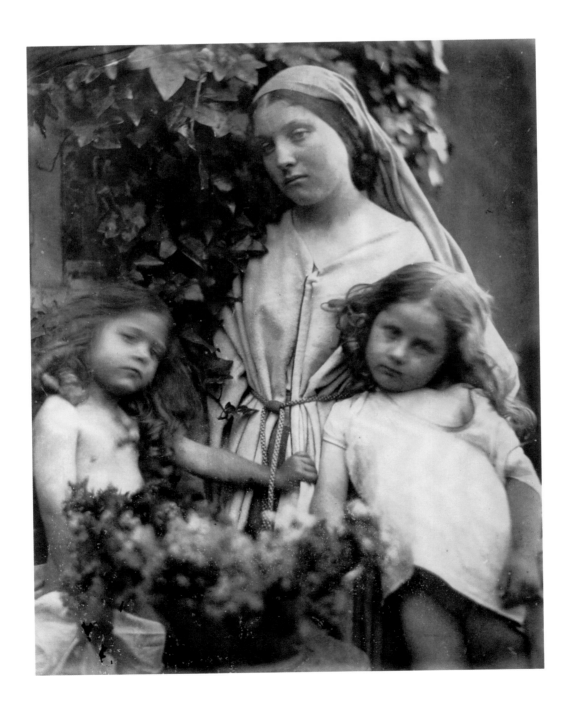

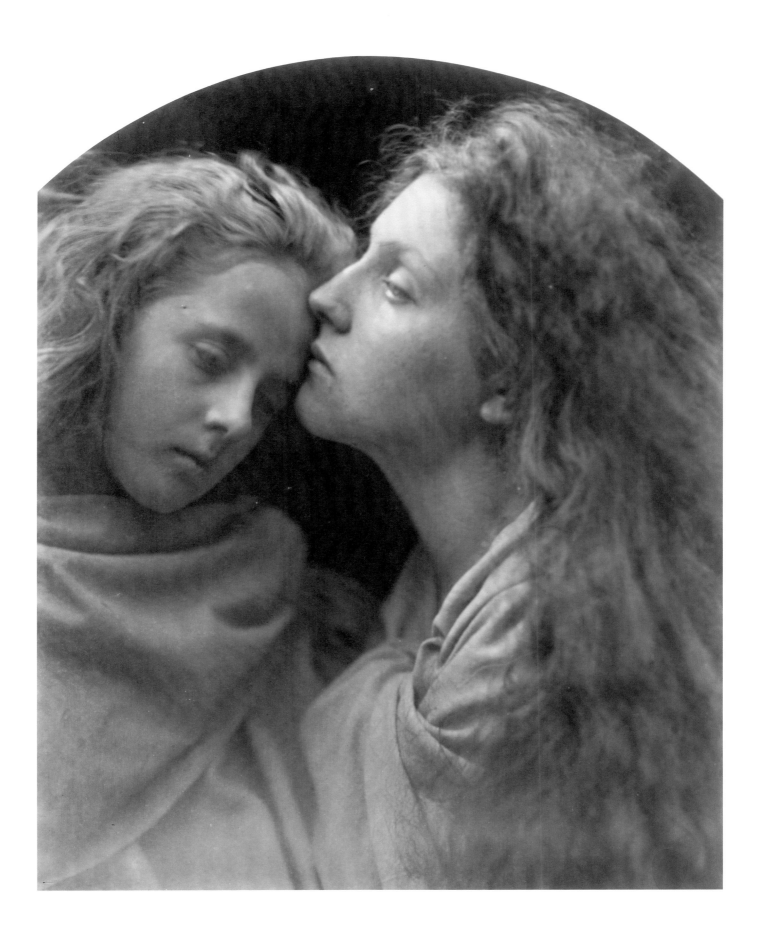

51 The Kiss of Peace
1869

52 Julia Jackson

1864

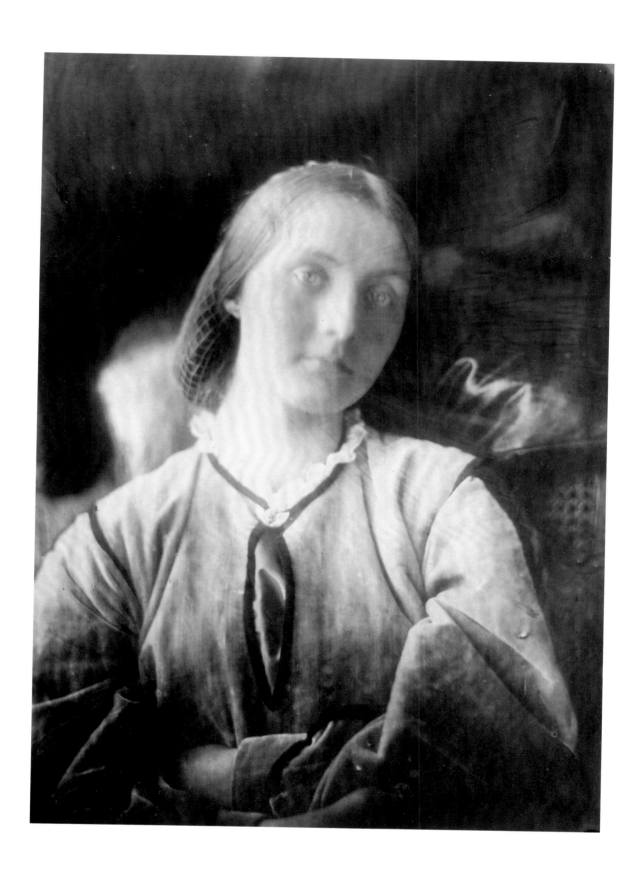

53　Julia Jackson

1864/65

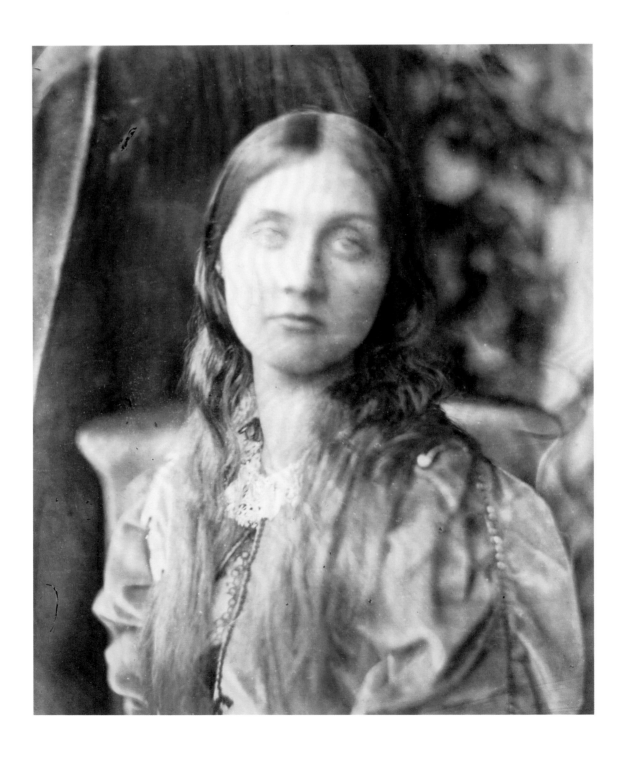

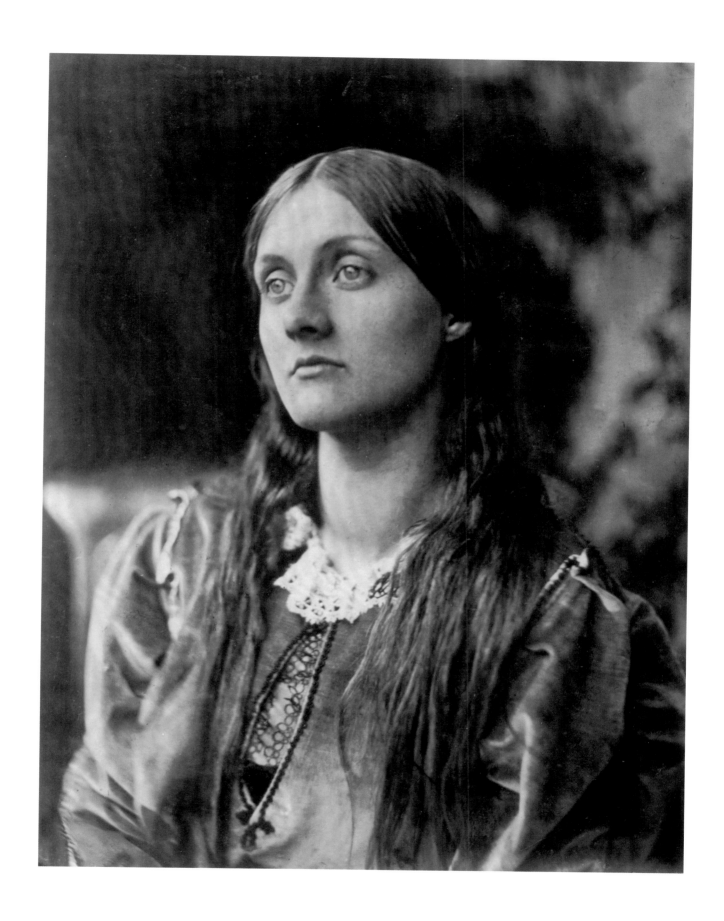

54 Julia Jackson

1864/65

55 Julia Jackson

March 1866

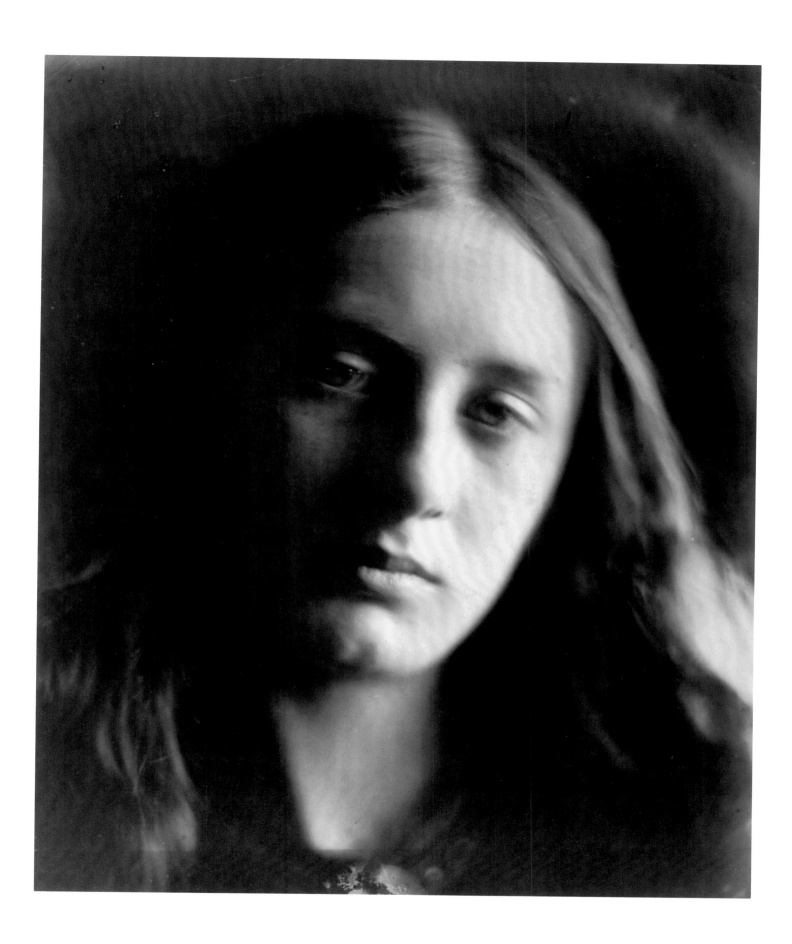

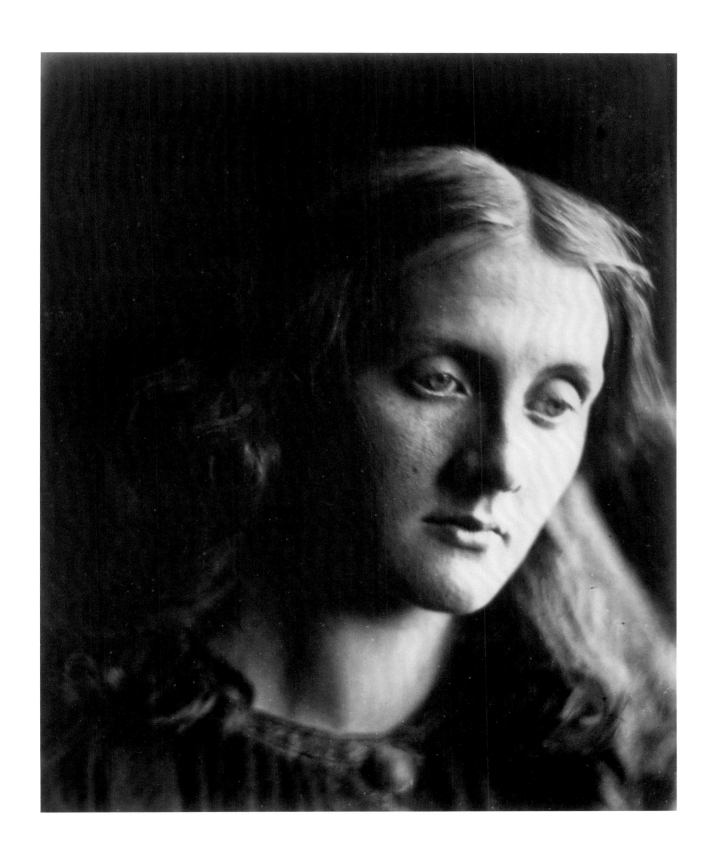

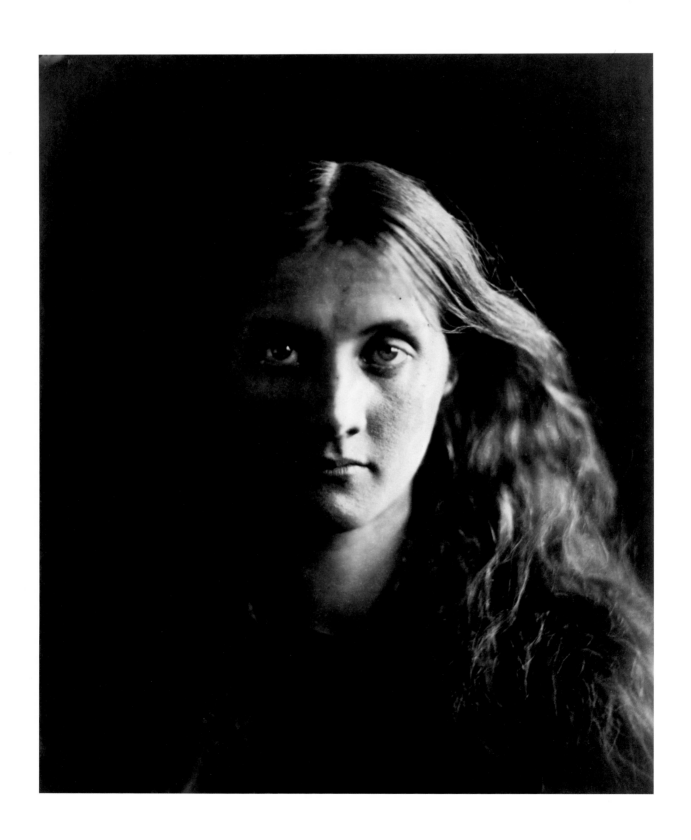

57 Julia Jackson
1867

58 Mrs. Herbert Duckworth

1867

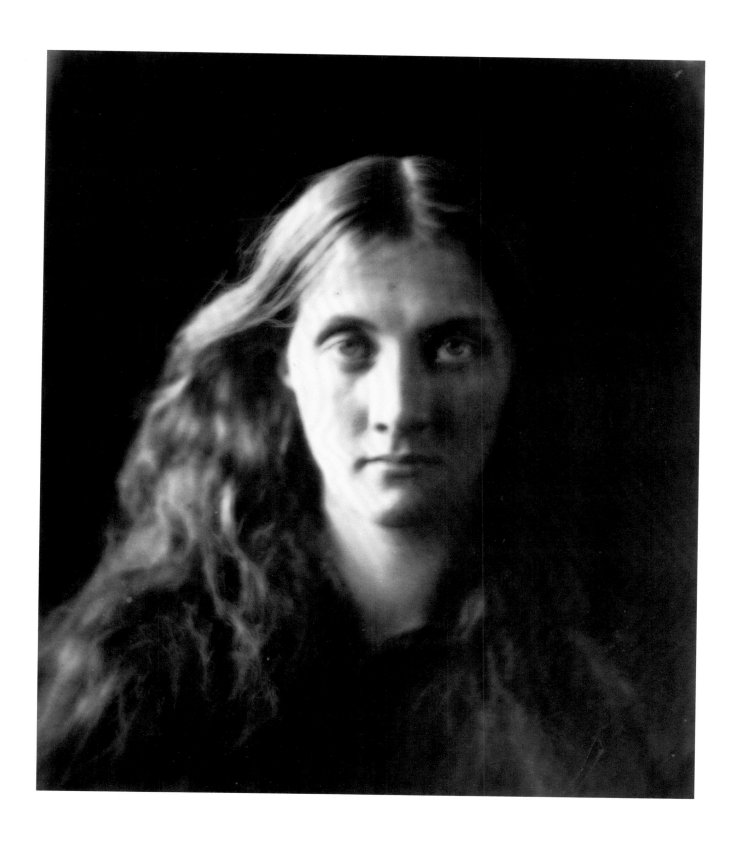

59 Julia Jackson

1867

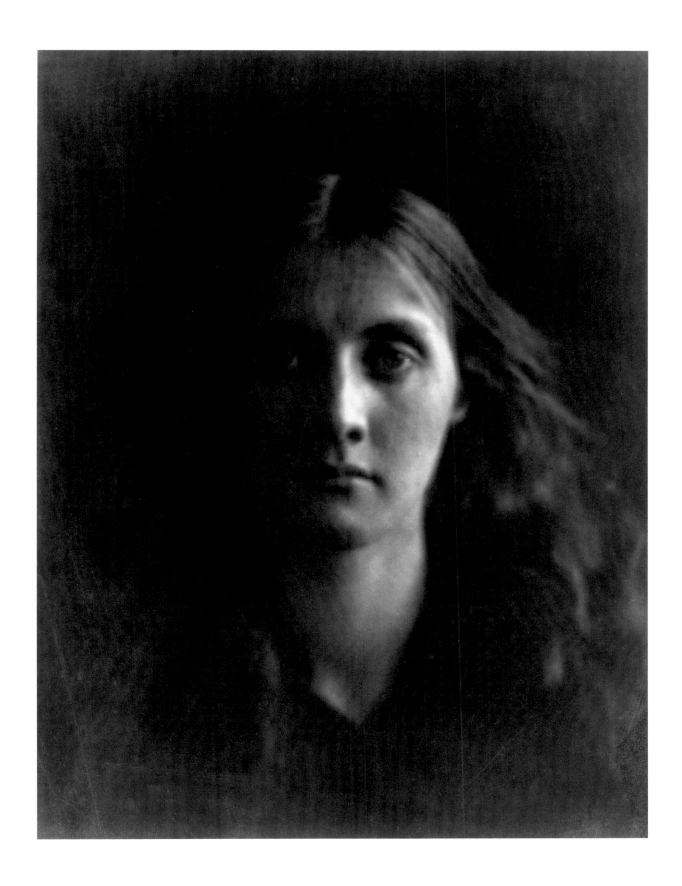

60 Mrs. Herbert Duckworth
1867

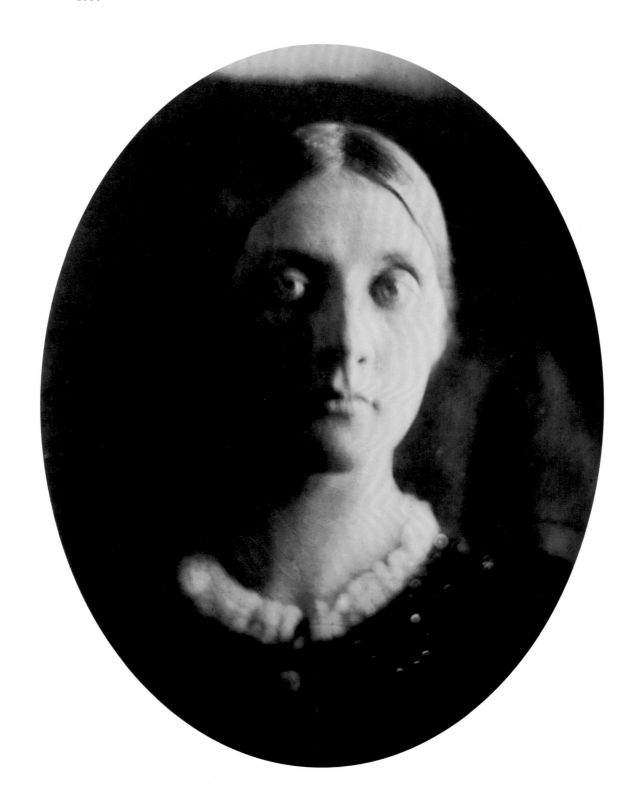

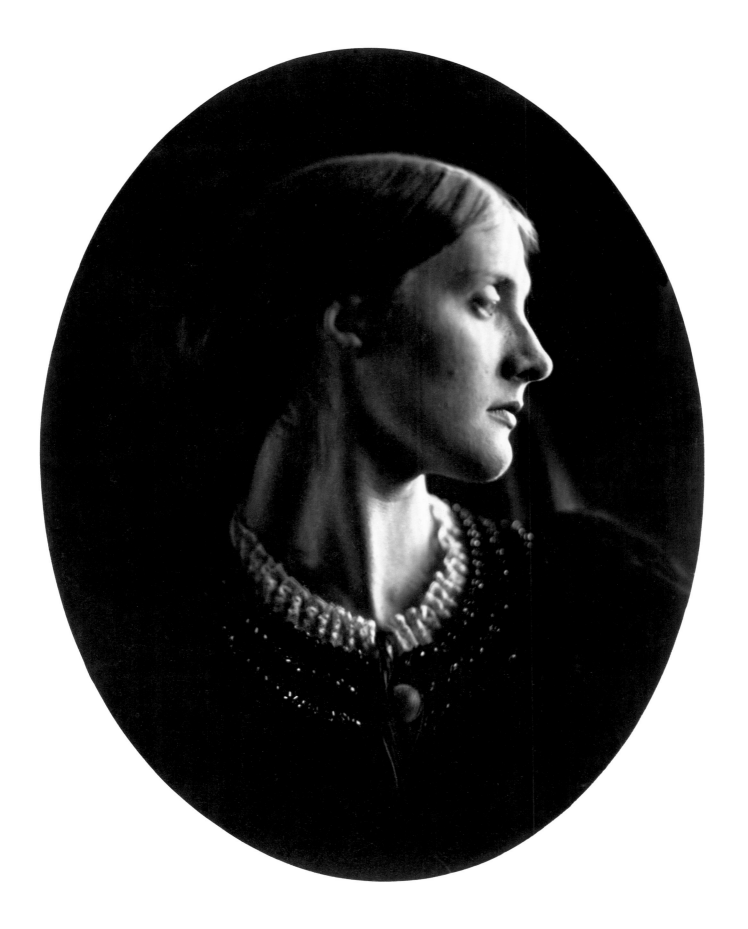

61 Mrs. Herbert Duckworth

April 1867

62 "A beautiful Vision"
 1872

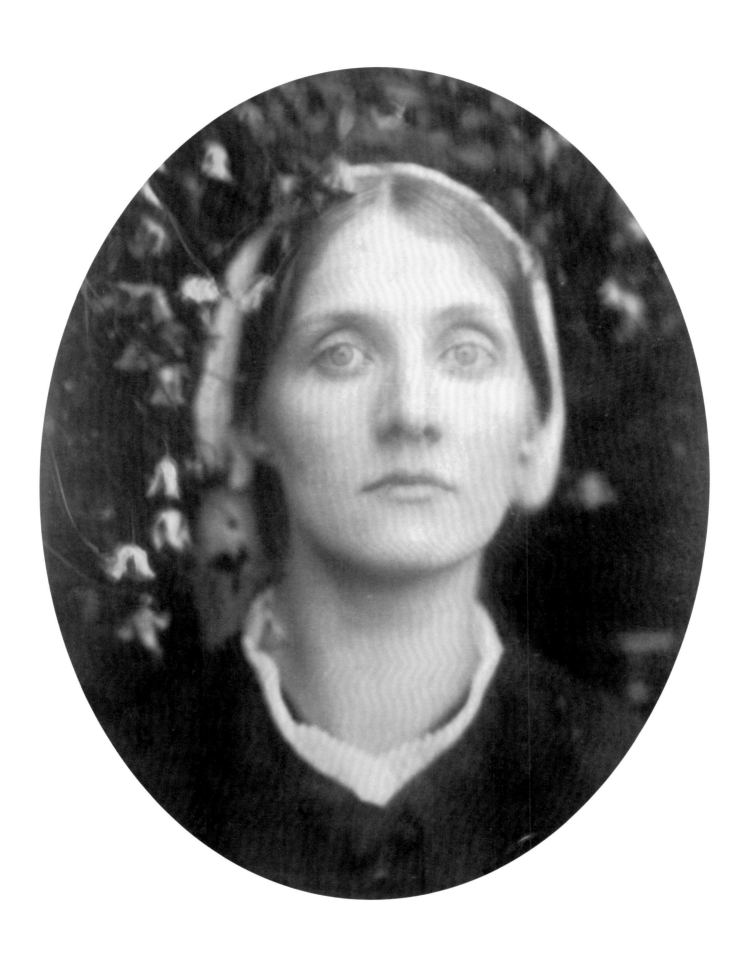

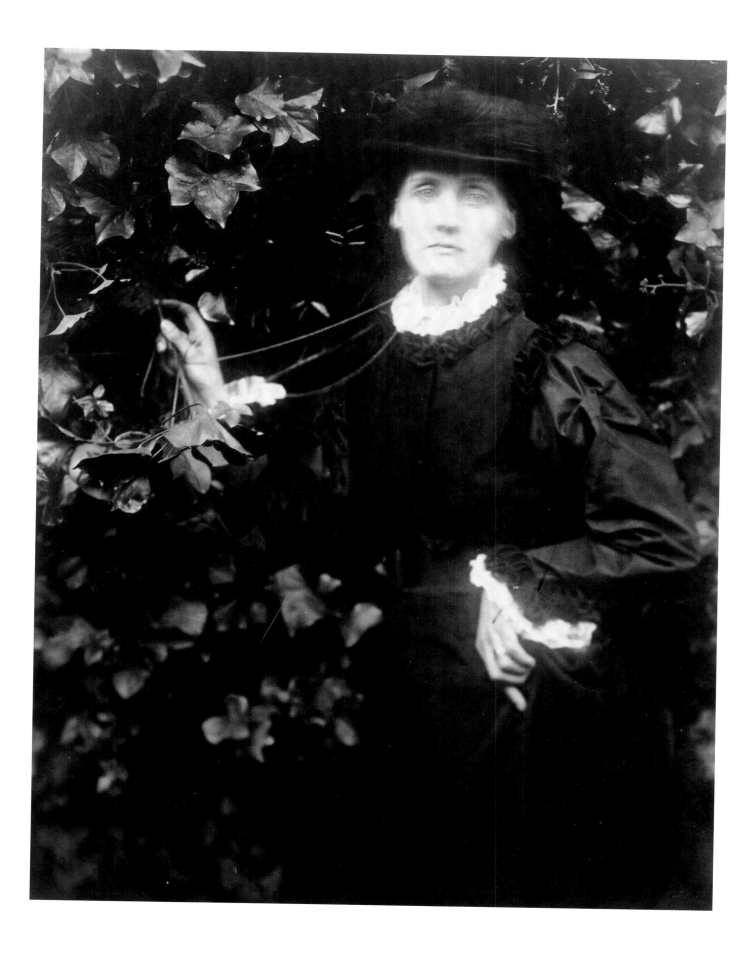

Sylvia Wolf

"Mrs. Cameron's Photographs, Priced Catalogue"
A Note on Her Sales and Process

During research for this exhibition, I had occasion to study an annotated price list of Julia Margaret Cameron's photographs, which is currently in the collection of the National Museum of Photography, Film & Television in Bradford, England.[1] While this price list does not directly address the subject of Cameron's portraits of women, it does provide information about Cameron as a Victorian woman who was commercially active. It makes reference, in two places in particular, to technical aspects of Cameron's production. And it gives clues as to how Cameron valued her pictures at the time of their making. The list also raises some interesting questions. Did a photograph of the astronomer Sir John Herschel, for instance, fetch the same price as one of the poet Alfred Tennyson? Were Cameron's photographs of "famous men and fair women" valued equally? Can we assume that Cameron's prices reflect her aesthetic assessment of her pictures, or are other factors involved? Although a thorough decoding of this price list will require the efforts of additional readers and scholars, some information can be gleaned through simple observation. The following notes, then, are offered not as final answers, but as a point of departure for further inquiry into these aspects of Cameron's art.

Mrs. Cameron's Photographs, Priced Catalogue (figure 1) is pasted inside a portfolio case with three folds that once belonged to the family of the evolutionist Charles Darwin. Research into Cameron's exhibition history confirms that the list was originally part of a publication that accompanied an exhibition of Cameron's work held at the German Gallery, Bond Street, London, in January and February of 1868.[2] At some point, the list was removed from the gallery publication and pasted inside the portfolio. By whom, when, and why are still unknown. The document consists of a printed list of 181 titles and accompanying prices, broken down into the categories "Fancy Subjects" (with a subcategory "Groups"), "Portraits," and "Series of twelve Life-sized heads of fancy Subjects." Another 41 titles and prices — for a total of 222 — are handwritten in the margins in Cameron's recognizable script. The category "Fancy Subjects" takes up the bulk of the *Priced Catalogue*, with 130 listings. The "Portraits" account for 80 titles, and the "Life-sized heads" number 12.

Among the "Fancy Subjects" are photographs with religious, literary, and mythological themes. This is where we find Cameron's tragic heroines, her illustrations of poems and myths, and her Madonna pictures. Over two dozen photographs on biblical themes are listed here. This section also shows us that some of the photographs Cameron included in her *Illustrations to Tennyson's "Idylls of the King" and Other Poems*, published in two volumes in 1874–75, were made in the early 1860s: *King Cophetua and the Beggar Maid*, for example. In the "Portraits" section, roughly three quarters of the photographs are of men (with well-known subjects often represented by several views). The remaining quarter are images of women, all of whom are named. Included are Lady Elcho (see figure 31 in my earlier essay in this book), Lady Adelaide Talbot, and Mrs. Herbert Fisher. This suggests that, contrary to general belief, Cameron made numerous formal portraits of women.

plate 26
plate 8

The titles added in the margins of the *Priced Catalogue* are written in Cameron's hand, but the

plus signs marked next to certain titles could have been written by anyone, leaving their meaning unclear. Do these marks indicate photographs that were sold or ordered? If so, then perhaps this document can be interpreted as a record of Cameron's sales. Or perhaps it is a record of the images that the portfolio once contained. An inscription on the outside of the portfolio reads "268 Photographs Forwarded as per list, Nov. 2d 66." The number of prints and the date are crossed out and replaced with "120" and "Aug 13th 68," respectively (figure 2). Cameron's letters reveal that when she sent prints to patrons and friends, she sometimes asked that the shipping containers be returned.[3] Perhaps Cameron similarly recycled this portfolio case. The inscription does not clarify if the new numbers refer to images subtracted from the original 268, or if they represent a different shipment. It does, however, signal that large numbers of prints were in circulation.

The 268 prints listed here were in fact not the only photographs Cameron placed on the market. Two years before this price list was published, Cameron had entered into a business relationship with P. & D. Colnaghi and Co., a London gallery on Bond Street. For exhibition and sale, she had made multiple prints – her enthusiasm for the new relationship with Colnaghi's evidenced by her consignment of 460 prints to the gallery in December 1865 and January 1866 alone.[4] Paul and Dominic Colnaghi were London's preeminent print dealers, and had been selling popular and historical engravings for years. In the mid 1850s, they took an interest in photography, recognizing it as akin to the print medium they knew so well. In 1855, for example, Colnaghi's purchased and offered prints from the glass negatives taken in Crimea by British photographer Roger Fenton, and in 1857 the gallery opened its own studio for the reproduction of photographic prints.[5] Photographs priced by Colnaghi's or its affiliated photographers may be considered, therefore, in the context of the long- and well-established system of commerce in fine-art prints.

Evidence of Cameron's first price structure does not come from Colnaghi's, however, nor does it come from the Priced Catalogue discussed here. In November of 1865 – a month before she consigned work to Colnaghi's – Cameron had a show at the French Gallery, 120 Pall Mall, London. To accompany it, a price list was printed containing 158

items, costing from five to ten shillings.[6] In the Priced Catalogue of 1868, by contrast, Cameron's prices range between three and twenty-one shillings. The two lists have less than forty titles in common – that alone a sign of Cameron's prolific production – but among these, the photographs of famous men almost doubled in price, while the price of the allegorical studies dropped, changes that may have been made in response to the demands of the marketplace. While a comparative analysis of both these price lists would be fruitful, the focus here is on the 1868 Priced Catalogue, both because it is annotated and because it exhibits an extensive range of material at the peak of Cameron's career. How, though, do we assess the prices listed here, and what do they mean?

While countless factors may enter into an artist's pricing strategy, there were at least three driving forces behind Cameron's decisions in these matters. First and foremost was the popular appeal of a given image. Tennyson, for example, as Poet Laureate, inspired a cult worship that reached heroic proportions. A photograph of him would have been prized by any member of the Victorian middle and upper classes, especially if it was signed by the poet. Cameron fully understood the power and value of an autographed portrait. Sometimes a well-known sitter's signature was lithographed onto a mount. At other times she sent empty mounts to sitters and asked them to sign them and return them to her (she then positioned the sitter's picture on the signed page). In a letter to Herschel, dated March 3, 1868, Cameron wrote, "Am I to be pardoned for sending you blank mounts & trusting to your goodness to sign them *when you can*....The Photograph of you is to my idea doubled in value by *your* genuine autograph."[7]

The second factor influencing Cameron's pricing of a photograph was the cost of the materials that went into its making. Research into the dimensions of prints on this price list showed that large prints – the "Life-sized heads" at sixteen shillings, for example – cost more than the smaller Madonna studies at five shillings. Lastly, the condition of a negative, or any difficulty Cameron might have had in making the print, affected its price. In a letter Cameron wrote to a buyer in 1875, she itemized the prices of two portraits of Herschel: one at sixteen shillings and one with "genuine autograph [at] L1.10 [thirty

Juliet alone 5/
Mary Ryan 5/
Irish Mary 5/
La Penserosa 5/
the Maid of Athens 5/

PRICED CATALOGUE.

Mrs. Cameron's photographs are all taken from the life direct, and are not enlarged.

the Infant Bridal 5/
the Child Samuel 5/
Daisy 3

Fancy Subjects.

	s.	d.		s.	d.
La Contadina	10	0	First sorrow	3	0
The Neapolitan	7	6	Gem	7	6
Adriana	10	0	Joy	5	0
Sappho	10	0	Juliet	5	0
Love in idleness	10	0	Lady Clara Vere de Vere	5	0
Christabel	10	0	Laura	7	6
The anniversary	5	0	Love	7	6
Wild flower	10	0	Suspense	5	0
Maude Clare	5	0	King David	7	6
Acting grandmamma	7	6	Flora	5	0
Beauty of holiness	5	0	Annie my first success	3	0
Innocence	5	0	La santa Julia	21	0
Flos, (from St. Clement's Eve)	10	0	A bacchante	10	0
King Cophetua	7	6	The flower girl	5	0
Gardener's daughter	15	0	Astyanax	7	6
Recording angel	5	0	Ophelia	7	6
Infant Samuel	3	0	Dolores	16	0
Violet	7	6			
Grace	8	0			
Fanny St. John	8	0	GROUPS.		
Beatrice with eyes open	16	0	Friar Lawrence and Juliet	10	0
Do. do. closed	16	0	Prospero and Miranda	10	0
Daphne	16	0	Queen Esther & king Ahasueras	10	0
The morning star	10	0	The orphans	10	0
The mountain nymph, sweet liberty	10	0	Group from Sordello	10	0
The passion flower at the gate	10	0	Summer days	14	0
Mignon	7	6	Cherub and seraph	10	0
The vision	16	0	Minstrel group	16	0
Ophelia	7	6	Red and white roses	7	6
Study of the Holy Family	7	6	Romeo and Juliet by moonlight	16	0
Maud	8	0	The turtle doves	5	0
Rachel	10	0	Flos and Iolande	5	0
Rosalba	10	0	The double star	5	0
Mary mother	16	0	Paul and Virginia	7	6
L'allegro	5	0	The story of the heavens	7	6
Aurora	7	6	Whisper of the muse	7	6
			Teachings from the Elgin marbles	7	6
			The vow	7	6

Cyllena a Study 10
Mary 7-6
Grief 10
La Madonna Puritima 16/
Two Lilies Mary & Paddaddy 10/

Egeria
The Maid of astolat 16
May day — 8
The rose bud garden of girls 16 2 copies
Do Do other Version 1—

La Madonna della...

	s.	d.	
La Madonna riposata — resting in hope	5	0	Robert Browning
			Do. (genuine autograph)
La Madonna adolorata—patient in tribulation	5	0	Henry Taylor (life size)
La Madonna aspettante—yet a little while	5	0	Henry Taylor in Arab dress
La Madonna essaltata — fervent in prayer	5	0	Henry Taylor (first series, 12 various views) (each)
La Madonna della ricordanza— kept in the heart	5	0	Henry Taylor (second series, various views) (each)
La Madonna vigilante—watching always	5	0	Carlyle (life size)
The salutation, after Giotto			Carlyle (profile)
Love and light	5	0	G. F. Watts, R.A., ¾-face
Goodness	5	0	, profile
Faith	5	0	, with hat
My grandchild with Mary (various)	3	0	Professor Jowett
Divine love	5	0	James Spedding
Devotion	7	6	Late Gov. Eyre
Trust	7	6	H. T. Prinsep
Mary	5	0	Valentine Prinsep
Xmas carol			W. M. Rossetti
Maud by moonlight	3	0	Sir John Herschel, life size
St. Agnes	3	0	, with genuine autograph
Astarte, Queen of the heavens	7	6	Sir John Herschel, with cap
Enoch Arden	7	6	Honble. Frank Charteris
Wise virgins	5	0	Honble. G. Howard
Foolish virgins	5	0	Adolphus Liddell
The return after three days	7	6	Anthony Trolloppe
The grandmother, from Tennyson's poem	7	6	Lionel Tennyson
Yes or no	5	0	Harry Cotton
Spring	5	0	Dean of St. Paul's (Milman)
First born	5	0	Dean of Christ Church (Liddell)
First alarm	7	6	Henry Halford Vaughan
Two children in one hamlet born and bred	7	6	Rev. F. Paul
The dialogue	5	0	Lord Morley and Rev. W. Awdry
Queen of the may	8	0	Sir Coutts Lindsay (various, each)
Philippa Wodehouse and Hardinge Hay Cameron	7	6	William Holman Hunt (in eastern dress)
The nativity	16	0	Eugene Cameron, R.A.
The orphans	7	6	Charlie Hay Cameron (various)
The annunciation	16	0	Charles Hay Cameron (senior)

Mary a study with lily 5/
Theaphile of concord
The Offerances 5/

Portraits.

	s.	d.	
Alfred Tennyson, full face	16	0	Ewen Hay Cameron
A. Tennyson, profile	10	0	Hardinge Hay Cameron
A. Tennyson, various (each)	10	0	Henry Herschel Hay Cameron
A. Tennyson (genuine autograph)	21	0	Mrs. Herbert Fisher (various, each)
			Mrs. Herbert Duckworth
			Lady Adelaide Talbot
			Lady Eleho (as dantesque vision)
			Miss Philippa Wodehouse
			Miss Cyllena Wilson (profile)
			Miss Kate du Bois
			Miss May Prinsep
			Miss Frances Hopekirk

A Tennyson Playes 7-6 My gr and Child
Henry Taylor 5 copies oh ye all mounted
Alfred Tennyson with his two Sons 7/6

268 Photographs forwarded as per list
20 — aug 13th 66 Nov. 2d 66

Mrs. Cameron's Photographs.

			Series of twelve Life-sized heads of fancy Subjects.		
Christina Tytler	5	0			
and Honble. Mrs. Lloyd					
...dsay	7	6	No. 1. Freddy	8	0
Minnie Thackeray	7	6	2. Freddy	8	0
Charlotte Norman	7	6	3. Freddy	10	0
Maria Pears	7	6	4. Katie, eyes down	10	0
Alice du Cane	5	0	5. Katie, eyes flashing	10	0
Gladstone	7	6	6. Alice	10	0
Fanny St. John	8	0	7. Alice, larger than life	16	0
...ieur Jacques Blumenthal	7	6	8. Lizzie, hands clasped	8	0
...d Tennyson and his two			9. Beatrice, eyes down	16	0
...s	7	6	10. Beatrice, eyes open	16	0
S. Cotton as king Cophetua	7	6	11. Freddy	10	0
			12. Freddy, god of love	16	0

Any Photograph, of which there is no copy left, will be delivered within a fort-
...from the closing of the gallery, (that is to say, before the 8th of March next),
...rs are now given, and each person ordering is requested to mention whether the
...or the brown toning is preferred.

figure 1 *Mrs. Cameron's Photographs, Priced Catalogue,* 1868 Bradford, England, National Museum of Photography, Film & Television

figure 2 *Inscription on portfolio case* Bradford, England, National Museum of Photography, Film & Television

shillings] as negative is spoilt & copies are scarce."[8] In the late 1860s, Cameron had substantial difficulty with her negatives. As she wrote to Henry Cole on June 12, 1869, "45 of my most precious negatives this year have perished thro [sic] the fault of collodion or varnish supplied & both or either destroy the film that holds the picture."[9] She went on to say she was considering having negatives of her most famous pictures transferred onto a plate for engravings before the negatives deteriorated.[10] Clearly, practical issues as well as aesthetic concerns came into play when Cameron determined her prices. We cannot assume, therefore, that she liked a high-priced picture more than a less expensive one.

With this caveat in mind, a look at the breakdown of prices on this list is revealing. Most of the photographs listed under the heading "Fancy Subjects" cost between five and ten shillings, with the bulk at either five shillings or seven shillings sixpence. The "Portraits" were slightly more expensive, with most at either seven shillings sixpence or ten shillings. One would expect Cameron's photographs of famous men to be in demand and to fetch, therefore, the highest prices. Indeed, the list shows a Tennyson portrait with a "genuine autograph" to be one of the three photographs priced at the list's premium amount of twenty-one shillings. One of the many surprises offered by this list is that the only other two photographs at that price are of Julia Jackson: one as *La Santa Julia* (the alternate title for plate 56) and the other as *Mrs. Herbert Duckworth*. (While we cannot be sure which of the many portraits titled *Mrs. Herbert Duckworth* is the one referred to on this list, I suspect it may be plate 61, Cameron's most famous portrait of her favorite niece.) No significant technical differences distinguish Cameron's portraits of Tennyson from those of Jackson. Consequently, the fact that Cameron valued her pictures of her niece as much as an autographed portrait of the Poet Laureate implies that she was proud of the photographs of Jackson. It also suggests that the legendary beauty of her niece held a commercial as well as aesthetic appeal. (For a discussion of Cameron's portraits of Jackson, see my essay earlier in this book.) Close behind the portraits of Tennyson and Jackson, at

twenty shillings apiece, are autographed portraits of Herschel and the poet Robert Browning. The American poet Henry Wadsworth Longfellow must not have been as well known, for his autographed photograph of equal size is valued at ten shillings – half that of his British colleagues. Cameron's most popular subjects are represented by multiple photographs. This may be because Cameron knew images of these subjects would be in demand, so she made several variations. Or it may be because these sitters were friends who were willing to pose for numerous exposures. On this list there are four separate photographs of Tennyson, three of Herschel, three of the painter George Frederic Watts, and over fifteen of the writer Henry Taylor.

Relative to other expenses of Cameron's day, the prices listed above make it clear that to own one of her photographs was a financial commitment. Those who bought Cameron's photographs were educated, middle- and upper-class Victorians, who appreciated the symbolic subject matter of her works and admired her expressive style. *Cartes-de-visite* photographs, by contrast, were favored by the upper and lower classes alike. A *carte-de-visite* of a famous person – the queen, for instance – cost roughly sixpence (or half a shilling), whereas one of Cameron's autographed photographs of Tennyson, at twenty-one shillings, was considerably more expensive.[11] A Colnaghi invoice dated 1865, now in the Royal Archives, Windsor Castle, provides comparison with other photographs of the day; it shows ten views of the Sinai and Palestine by Francis Bedford to have been sold to the queen for three pounds ten shillings, or seven shillings each.[12]

Looking at Cameron's prices another way, a housemaid in a home the size of the artist's earned between twenty and twenty-five pounds a year, or about eight to ten shillings a week.[13] Many of Cameron's photographs were made with her housemaids as models. Those on this list range in price from five to sixteen shillings. An image of one of her servants, in other words, might sell for more than that servant made in a week.[14] To use yet another term of comparison, the price of Cameron's photographs may be related to that of food items at the time. According to a grocer's advertisement in the *London Times* in 1868, oatmeal cost three pence a pound, a dozen jars of high-quality marmalade cost seven shillings, a pound of tea ranged between two and four shillings depending on its variety, and a good

French Beaujolais ran roughly sixteen shillings per case.[15]

Art critics commenting on Cameron's prices would have used the print market as a point of reference. Compared to the cost of high-quality engravings, the amount Cameron charged for a photograph was quite reasonable.[16] In the "Art Gossip" column of an issue of the *Athenaeum*, dated June 22, 1867, a critic reviewing a show of Cameron's work at Colnaghi's noted that "the very moderate prices of these fine works of art in photography commend them to the general public and the student. Their excellence is supreme."[17] The writer went on to single out one of Cameron's portraits of Thomas Carlyle as "being the most apt and earnest in its expression, [it] will attract those who desire to possess admirable resemblances of the author." By acknowledging the affordability of Cameron's pictures and recognizing the public's attraction to portraits of well-known subjects, the reviewer pointed to the market potential of Cameron's photographs.

Some buyers displayed their "desire to possess" Cameron's images by purchasing prints in large numbers. In 1865, the South Kensington Museum in London (now the Victoria and Albert Museum), which was then under the direction of Henry Cole, bought eighty prints, for which the museum paid twenty-two pounds, four shillings, and four pence (or five-and-a-half shillings a piece). Cameron responded by donating an additional thirty-four prints to the museum little over a month later. In 1868, a man named Dan Gurney ordered twenty-four prints, paying for them with a check for twelve pounds ten shillings (representing a price of roughly ten-and-a-half shillings per print).[18] The father of the artist and model Marie Spartali paid the same price per picture that same year when he ordered multiple copies of one of Cameron's portraits of his daughter. Cameron wrote, "Mr. Spartali was a most glowing and enthusiastic admirer of my works with a very graceful note of thanks he gave me an order for 40 copies of his daughters [*sic*] pictures enclosing 20 guineas."[19]

One patron – a Mr. Fields, who was a friend of the Tennysons – thought highly enough of Cameron's art to send money with no print preferences

attached. In a letter of September 1872, Cameron thanked him for a check she had recently received and wrote: "I hope very much you will be pleased with the selection I have made.... I have endeavoured to send you a large supply [20 prints] for the sum of Ten Pounds as I have let you have all at the rate of ten shillings each & Colnaghi's price for all these is sixteen shillings each.... I like much better that my friends should order direct from me as I would far rather that they should have the benefit of the discount."[20] One might expect an artist to reduce the unit price of prints when negotiating a large sale, but this letter shows that Cameron gave Fields far more for his money than he asked for. The generosity exhibited here and in her earlier gift to the South Kensington Museum indicates that, although Cameron hoped to make money on the sale of her works, she was equally concerned with getting large numbers of photographs into important collections.[21]

In spite of selling numerous pictures, Cameron's profit after expenses must not have been great, for in 1869 she wrote to Cole that "even now after five years of toil I have not yet by One Hundred pounds recovered the money I have spent."[22] This letter also tells us that Cameron was willing to break with social convention to promote her art. To discuss finances with such frankness would have been unusual for a man. For a woman, it was almost unheard of. To begin with, a married woman of the Victorian middle and upper classes rarely made money. Not until 1870, with the passing of the Married Woman's Property Act, was a woman legally entitled to keep any earnings she made, and that legislation was enacted to assist working-class women. That may be why it was assumed, for decades, that Cameron was making photographs for her own amusement. Only in recent years has it become known that Cameron hoped to make a profit from her art.[23] Part of her motivation was her desire to be respected for her artistic achievement, and print sales were a measure of success. The other motivation was a practical one. In the early 1860s, the decline in the Camerons' coffee crops in Ceylon imposed financial stress on the family. This, together with the dramatic rise in the cost of living in the 1850s and 1860s, made Cameron's desire to support her own photographic activities and to supplement the family's income with the sale of her photographs all the more pressing.[24]

Evidence of Cameron's need can be found in her letters. In hopes that praise from her famous friends would increase her sales and raise her public profile, she asked many to send favorable remarks. When she wrote to Herschel on January 26, 1866, Cameron acknowledged that she had already received a measure of attention, but fame as yet eluded her, and she believed renown might bring financial relief:

Since I have acquired *reputation* if not fame in the Photographic world I sell as fast as I can print & as it is of extreme importance for me to sustain the sympathy and high opinion of the Public I do not hesitate dear Sir John to ask you if you do think well of my photographs if you would write if ever so briefly a few observations for the Press – Your approval your name would justly add enormously to my reputation & this greatly quickens the sale of my photographs – which is for me most needful now.[25]

Herschel, though an ardent supporter of Cameron's art, does not appear to have written any observations for the press.

Money must have been tight indeed, for that same week Cameron wrote a similar appeal to William Michael Rossetti, an art critic for the *Athenaeum* and the *Spectator*, and the brother of Pre-Raphaelite painter Dante Gabriel Rossetti. In her letter, Cameron asked him to write a favorable review of her show then on view at Colnaghi's: "Have you no means of introducing any friendly paragraph into any paper that has *good* circulation?"[26] That Cameron asked Rossetti to write for a paper with good distribution shows her to be savvy about the marketplace and about the dissemination of news in the popular press. That she asked him to write anything at all is startling, for even though it was common for men to ask for favors, it was outside the realm of feminine restraint for a Victorian woman to do the same. No review, friendly or otherwise, is on record from Rossetti.

If Cameron had difficulty making a financial profit from her photographs, it may be in part because of her generosity. In the first few years of her career, she gave away hundreds of photographs. Many were presented in album form to friends and family members. Others were given to those who, like William Michael Rossetti, Cameron hoped might advance her career with their influence or praise. She also gave prints to her sitters as a means of sharing her enthusiasm for photography or as

thanks for posing. How Cameron kept up with demand for sales and with her own generous nature is hard for any photographer or historian to imagine. Indeed, some believe Cameron had help in making her prints. But in a letter to Herschel of January 28, 1866, written early in her career, Cameron insisted, "I work without a *single assistant* of any kind."[27] In another letter to Herschel, she reiterated her autonomy in both composing and printing the pictures: "I do all alone without *any* assistance & print also entirely by myself."[28] Even so, it is hard to believe that Cameron could have filled her print orders alone, particularly as she gained notoriety and her sales increased.[29] With or without help, Cameron's production is remarkable – especially given the volatility of her materials and the time-consuming nature of her process.

The technique Cameron used, while common to her era, was tedious and demanding. To make her negatives, she poured wet-collodion emulsion from a bottle onto a glass plate and tilted the plate to spread the emulsion. If she did not spread the collodion evenly, a negative with streaks would result. If, by mistake, she rubbed the plate before the emulsion dried, it would smudge. Any dust or dirt on the glass would show up as spots on the final print (this explains some of the flaws on Cameron's prints). Once a negative had been exposed, processed and dried, it was varnished for protection. The glass-plate negative was then ready for printing.[30]

While it is often assumed that Cameron made her own albumen paper, the fact that she never wrote of the process or any problems she might have had with it (as she did with the wet-collodion negative process) makes us question this assumption.[31] Add to the above the fact that commercially coated albumen paper was readily available by the early 1860s, when Cameron made her first photographic experiments, and it seems unlikely that she would have gone to the extra effort and expense of making her own paper, particularly given the high demand for her work and her impressive production. Whether using commercially made or hand-coated paper, the printing process was the same. To make an albumen print, Cameron placed a negative in a print frame, the emulsion side of the negative in contact with the emulsion side of the paper. She then placed the frame outdoors, negative side up.[32] The light of the sun passed through the negative and darkened the albumen paper, making a positive imprint. Once the image was fully "developed" by the sun, remaining light-sensitive salts were removed in a bath of hypo. The print was then washed, toned, and dried.[33]

Because albumen paper is thin, Cameron often mounted her finished prints on board for stability. But first, she trimmed the albumen paper to the desired proportions. Various croppings of prints made from the same negative suggest that Cameron did not always interpret an image the same way. Indeed, even the title (and sometimes the date) differs from print to print, making it difficult to establish the facts about many of Cameron's photographs. The handwriting of Cameron's name also varies in style, which supports the idea that many hands were at work in the preparation, if not the printing, of Cameron's photographs. When there is an inscription on a mount, it often consists of a signature, a title, a date, and the location of the portrait sitting (usually her hometown of Freshwater). Sometimes the words "From Life," "Not Enlarged," "Registered Photograph," or "Copyright" are on the mount. There might also be an oval Colnaghi stamp, or a horizontal stamp that simply reads "Registered Photograph."[34]

A registered photograph was one recorded at the Copyright Office in London. In 1862 a Copyright Act was passed to give photographers protection over the reproduction of their work. This was particularly important for those who made portraits of famous people, which were of high market value and could easily be pirated and mass-produced as *cartes-de-visite* by some of the unscrupulous photography studios that appeared in the early 1860s. Cameron's awareness of this danger is voiced in a request made to a recipient of her portraits of Tennyson: "I have only one request to make of you which is that you will not allow any one privately or publicly to photograph from my copies and to reproduce impressions."[35] While not all photographs with Cameron's copyright inscription on the mount were officially recorded, 508 of her photographs were registered at the Copyright Office at Stationer's Hall, London, between 1864 and 1875.[36]

In addition to the different croppings and inscriptions, there is a significant range of color among Cameron's photographs. Some of the variation is due to deterioration of her albumen prints over time (therefore not all of the color we now see reflects Cameron's intentions). Newly exposed and developed albumen prints were a brick-red color. Most photographers toned their prints with gold chloride to yield more appealing colors, ranging from sepia, to eggplant, to black. One of the surprises of this *Priced Catalogue* is the text at the very end: "each person ordering is requested to mention whether the grey, or the brown toning is preferred." In no previously known document does Cameron give buyers a choice. Starting in 1867 a toner now referred to as "gold thiocyanate," called "sulphocyanide" in Cameron's day, was discovered. When applied to albumen prints, gold thiocyanate toner could produce a colder tone and a more neutral gray color than previous gold toners. Because this price list was published only months after the introduction of gold thiocyanate, it is a distinct possibility that Cameron was referring to this new toner. If this is the case, the text tells us that Cameron was up to date on the latest chemical innovations in photography. But a cool-toned print could also be achieved by raising the gold content of a toning bath, by toning the print longer than usual, or by using a different gold toning formula altogether. If these were Cameron's means of achieving tonal variety, then the text is an indication of her ability to control subtle toning techniques. In either case, the price list gives evidence that Cameron was both willing to accommodate the preferences of her customers, and was masterful enough at toning to provide them with options.[37]

The *Priced Catalogue* also draws attention to another aspect of her technique. At the bottom of page eight of this price list, Cameron wrote in her distinctive hand, "Sixty in large mounts. Sixty in small mounts in this portfolio." By this, Cameron was most likely referring to the two plate sizes she used in the mid-1860s. During the first two years of her career, Cameron photographed with a French-made Jamin lens of Petzval construction with a focal length of 12 inches. It was mounted on a sliding box camera carrying glass-plate nega-

tives sized 11 by 9 inches. The Jamin lens was an asymmetrical portrait lens that covered roughly half of Cameron's plate. In other words, only 6 inches of Cameron's 11-by-9-inch plate were in sharp focus. The focus on the rest of the plate fell off progressively toward the outer edges of the glass. With this early equipment, Cameron made portraits from close range and the short focal length of the Jamin lens yielded soft, diffused, atmospheric pictures.

In 1866 Cameron shifted to a larger camera, one with 15-by-12-inch plates, and she changed to a Dallmeyer Rapid Rectilinear lens with a focal length of 30 inches. This lens was quite different from Cameron's first. Unlike the Jamin lens, the Rapid Rectilinear was symmetrical, with a focal length that covered nearly all the surface of Cameron's glass negatives. It allowed her literally to fill the frame with the head of her sitter, making nearly life-sized heads and controlling the focus overall. Because it had a long focal length, the lens had a shallow depth of field. Therefore, at its working aperture of F8, exposure times were between three and eight minutes long. This may be why some of Cameron's sitters look somber or a bit dazed. It also explains why in some pictures, a model's minor movement during the exposure created a slightly fuzzy effect.[38]

Cameron's photographs were a dramatic departure from portrait images made by other photographers of her day. In fact, the close-up heads she made were unprecedented in photographic portraiture (for additional discussion of conventional portraits, see my essay earlier in this book). Cameron was proud of this, as evidenced by her notation on the mount under many of her prints, "From Life, Not Enlarged."[39] It was especially unusual for a woman to make big pictures. Most women artists in the late-nineteenth century created works that were modest in scale in keeping with feminine codes of demure behavior.[40] That Cameron saw other artistic possibilities available to her as a woman points to her independent spirit. It also highlights her willingness to take creative risks.

Cameron was equally bold when it came to asserting her place in the world of art. During the mid-nineteenth century, wealthy members of the upper classes had leisure time and money with

which to engage in the amateur study of the arts and sciences. This was considered a noble enterprise, one which expanded an individual's understanding of the physical world and allowed for the passage of idle hours in productive and creative amusement. When Cameron first took up photography, she worked within the context of this kind of amateur endeavor, which is why art journals of the period and modern books on photography frequently refer to her as an amateur. In the oldest sense of the word – which derives from the Latin "amator," meaning "lover," and the Greek "amma," meaning "nurse" – Cameron was indeed an amateur. From her earliest photographic experiments to the last pictures she took in Ceylon, Cameron was a lover of photography who nurtured her career with passion and determination.

Nevertheless, it may sting today to call Cameron an amateur, given the term's current use as a synonym for dilettante or dabbler. And, as we begin to realize the extent of her commercial activity, it becomes all the more tempting to call her a professional – one who made money on her work. One could argue that as soon as Cameron struck up a business relationship with Colnaghi & Co., she was no longer an amateur.[41] But the term "professional" meant more than making money in Cameron's day. In the 1860s, a "professional" was a man of breeding and education who was appointed to a position of some authority: a member of the military, the clergy, or the civil service, for example.[42] In the arts, professionals were distinguished from artisans and amateurs by their contribution to human achievement. The respect professional artists received must have appealed to Cameron, for she sought similar recognition. One of her letters to Cole reflects a belief that she, too, was making an important contribution to humanity with her photographs: "my last portrait of Alfred Tennyson ... I think you will agree with me in feeling is a National Treasure of immense value – next to the living speaking man must ever stand this portrait of him, quite the most faithful & most noble portrait of him existing."[43]

By declaring the greatness of her photographs, Cameron placed herself alongside the professionals she knew – men like Tennyson, Watts, and

Herschel. By engaging in the commercial market and by exercizing her ambition, she stepped beyond the bounds of amateurism and assumed the authority of a respected professional. It is interesting to note that Cameron did all this without publicly declaring herself either an amateur or a professional photographer. Government census reports taken once every ten years reflect no change in Cameron's status even after her reputation as a photographer was well established. In both 1861 and 1871, Cameron is listed as "wife" under the heading of "relation to head of household," with no occupation given under the heading "profession."[44]

That Cameron would assert her identity as a respected professional, but remain registered as "wife" in the national census is in keeping with the paradoxes that permeate her career. Documents like this *Priced Catalogue* help us sort out the issues she faced and better appreciate the complex time in which she lived and worked. This list, for example, points out that Cameron was an entrepreneur. It reflects her energy and prolific production, and it proves her to be well organized and accommodating. As a document that was compiled and annotated by Cameron, this price list is also a relic of sorts – an artifact that reflects the artist's thinking. At the same time, it is a reminder of how much is yet unknown about Cameron's life and art. Many of the questions it raises will have to wait for answers until additional scholars examine its contents, or until other documents emerge from public or private archives. In the meantime, the list may be appreciated, not only for what is in it, but equally for what is not. For in its information and its mysteries, *Mrs. Cameron's Photographs, Priced Catalogue* heightens our curiosity about Cameron's career and urges us to look at her photographs once again.

1 I am grateful to Roger Taylor, former Senior Curator of Photographs at the National Museum of Photography, Film & Television, Bradford, England, for bringing this list to my attention, and for contributing insightful criticism and invaluable references to early drafts of this text.

2 The three pages of the *Priced Catalogue*, pasted together and slightly overlapping, measure 22.4 by 41.8 cm. The portfolio case into which the list is pasted measures 60.5 by 61.5 cm when closed, and 106.5 by 120.6 cm when open. The pages on which the list is printed are numbered 6, 7, and 8, indicating that the *Priced Catalogue* was part of a larger publication. No publication date is indicated, but nearly all of the pictures on the list are dated between 1864 and 1867, which would make 1868 a likely date for the publication of the list. Moreover, at the end of the list, potential buyers are told that "Any Photography, of which there is no copy left, will be delivered within a fortnight from the closing of the gallery, (that is to say, before the 8th of March next)." Since a fortnight lasts two weeks, the close of the show must have been February 25. And indeed, Cameron's exhibition history (see JL, pp. 98–101) shows that she exhibited at the German Gallery in January and February of 1868 (though the exact dates of the show are not known).

3 See, for example, a letter from Cameron to Miss Mosely, dated September 28, 1875: "I will ask you kindly to undertake that the portfolio is returned to me this day week at the latest. I enclose the address to save you trouble" (Bath, England, The Royal Photographic Society).

4 Cameron to Herschel, January 28, 1866 (London, The Royal Society, Herschel Correspondence [hereafter RS:HS], 5.162).

5 Announcement of the purchase of the Fenton negatives was made in the *Athenaeum* 1523 (Jan. 3, 1857), p. 2. Announcement of the "New Photographic Establishment at Messrs. Colnaghi's" was made in the *Art Journal* 3 (June 1857), p. 199. The entry reads: "In addition to the other departments of their extensive and very complete establishment, Messrs. P. & D. Colnaghi have just completed the requisite arrangements for the production of photographs of the largest class and the largest size and also in every possible variety."

6 An original copy of the French Gallery price list of 1865 is in the National Art Library of the Victoria and Albert Museum, London (hereafter NAL), no. 200 B.O. I am grateful to Pam Roberts, Curator of Photography at The Royal Photographic Society, Bath, England, for bringing this price list to my attention.

7 RS:HS, 5.168.

8 Cameron to Miss Mosely, October 10, 1875 (Bath, England, The Royal Photographic Society). On the mount of a portrait of Sir Henry Taylor, which I recently saw in a private collection, Cameron similarly wrote: "L1.10.0 Price raised to thirty shillings as accident has happened to negative." Gernsheim referred to this same inscription in his monograph on Cameron (HG1975, p. 77).

9 Cameron to Cole, June 12, 1869 (NAL, Cole Correspondence, Box 8).

10 Cameron knew that albumen prints were subject to deterioration. Therefore, in 1875 she made arrangements with a commercial printing house, the Autotype Company, to have carbon prints made of her most popular images. Carbon prints are known for their permanence. They were made from positive transparencies generated from Cameron's original glass-plate negatives and retouched to eliminate spots and imperfections. While handsome in their own right, carbon prints do not contain the subtle tonal range and color of Cameron's original albumen prints.

11 The average income of a mid-level civil servant in 1868, the year this list was compiled, was three hundred and fifty British pounds, or a little over six-and-a-half pounds (one hundred thirty-five shillings) a week. Buying one of Cameron's prints would thus have been a substantial purchase. See Alexander Charles Ewald, *A Guide to the Civil Service*, London, 1868. The income of the landed gentry was markedly larger (upwards of one thousand pounds), but so were their expenses.

12 Windsor Castle, The Royal Archives, PP2/102/1044.

13 John Burnett, *A History of the Cost of Living*, n. p., 1969, p. 241; and J. A. Banks, *Prosperity and Parenthood*, London, 1954, pp. 71–72.

14 As compensation to her sitters, Cameron is known to have sometimes given them a photograph. There is no evidence, however, of her paying her servants extra for the labor of posing.

15 Prices were taken from an advertising section for C. D. Harrod, wholesale grocer, in the *London Times*, May 2, 1868, p. 14. Prices for tea and wine ranged widely. A high-quality pearl-leaf gunpowder green tea, for example, cost four shillings a pound, while a second-quality black tea cost two shillings a pound.

16 P. & D. Colnaghi and Co. does not have records of sales before the 1880s, but an invoice from Colnaghi to the queen in 1852 (Windsor Castle, The Royal Archives, PP2/1/2999) shows that engravings of Franz Xaver Winterhalter's immensely popular painting of the royal family, entitled *The First of May* and dated 1851, sold for two pounds, two shillings. An engraving of Winterhalter's *The Queen's Pets* sold for the same price. Although these prices represent the print market sixteen years before the publication of Cameron's *Priced Catalogue*, they are significantly higher than even the highest priced Cameron photograph made over a decade later. For more information on The Royal Archives and the royal family's involvement with photography, see Frances Dimond and Roger Taylor, *Crown and Camera: The Royal Family and Photography, 1842–1910*, Middlesex, England, 1987. A useful study of the print and photographic markets in the mid-nineteenth century is Grace Seiberling's *Amateurs, Photography, and the Mid-Victorian Imagination*, Chicago, 1986.

17 *Athenaeum* 2069 (June 22, 1867), p. 827.

18 Information about the South Kensington Museum's acquisition of Cameron's prints and Gurney's purchase may be found in Mark Haworth-Booth, *Photography: An Independent Art (Photographs from the Victoria and Albert Museum, 1839–1996)*, London, 1997, pp. 80–88.

19 Cameron to Cole, April 7, 1868 (NAL, Cole Correspondence, Box 8). A guinea equals twenty-one shillings, a pound equals twenty shillings, and a shilling equals twelve pence.

20 Cameron to Fields, September 2, 1872 (San Marino, California, The Huntington Library, FI 881).

21 Although Cameron's sales in the hundreds were high in absolute terms, they were modest compared to those of commercial portrait photographers who boasted *cartes-de-visite* sales in the thousands each year. See William C. Darrah, *Cartes de Visite in Nineteenth-Century Photography*, Gettysburg, Penn., 1981.

22 Cameron to Cole, June 12, 1869 (NAL, Cole Correspondence, Box 8).

23 The idea that Cameron tried to supplement her family's income with the sale of her work was first proposed by Mike Weaver in 1986 (MW1986). With the emergence of a list of expenditures and outstanding bills, Weaver revealed Cameron's efforts to make a commercial success of her photography.

24 Between 1850 and 1873, prices rose by 48 percent; see Burnett (note 13), p. 203.

25 Cameron to Herschel, January 28, 1866 (RS:HS, 5.162).

26 Cameron to William Michael Rossetti, January 23, 1866 (University of Texas at Austin, Harry Ransom Humanities Research Center [hereafter HRHRC], Gernsheim Collection Letters). My thanks go to Debra N. Mancoff for pointing out the degree to which this request was unusual.

27 Cameron to Herschel (RS:HS, 5.162).

28 Cameron to Herschel, undated (RS:HS, 5.174).

29 Gernsheim, among others, has speculated that Colnaghi's might have printed and mounted some of Cameron's more popular images (HG1975, p. 76). Though Colnaghi's is still in operation, its staff reports that no records of sales or printing activities remain from Cameron's time.

30 This description of the wet-collodion negative process is drawn from Douglas Severson's "Glossary of Selected Photographic Processes," a brochure produced in conjunction with the Art Institute's exhibition *Out of a Dark Room: Photographic Variations from the Permanent Collection* (1995).

31 In a letter to Herschel, Cameron wrote at length about her difficulties in making wet-collodion negatives and in processing her albumen prints (Cameron to Herschel, March 20, 1864, RS:HS, 5.158).

32 One print in the Victoria and Albert Museum's permanent collection (*Julia Jackson*, 1867, London, Victoria and Albert Museum, 361-1981) shows the edge of what looks like the glass-plate negative. The paper outside the edge is equally exposed, which introduces the possibility that Cameron did not always use a closed wooden print frame.

33 For an in-depth discussion of albumen prints, see James M. Reilly, *The Albumen and Salted Paper Book: The History and Practice of Photographic Printing, 1840–1895*, Rochester, N.Y., 1980. For a clear and insightful discussion of Cameron's photographic process and the effect of time on her prints, see Grant B. Romer, "The Albumen Print and Cameron's Work," in JL, pp. 82–83. Another detailed analysis of Cameron's photographic process may be found in HG1975, pp. 69–76. I am grateful to James M. Reilly for reviewing this text and for enlarging my knowledge of the albumen printing process with his response. My thanks also go to Douglas Severson, Grant B. Romer, Doug Munson, and Sylvie Penichon for lending their observations and expertise to this study of Cameron's prints.

34 The Colnaghi stamp reads, "Registered Photograph/Sold by/Messrs. Colnaghi/14 Pall Mall East/London."

35 Cameron to Fields, October 22, 1869 (San Marino, California, The Huntington Library, FI 880).

36 For an itemized list of Cameron's registered photographs, see RDW.

37 For a detailed description of gold toning, see Reilly (note 33), pp. 76–81. I am grateful to Violet Hamilton and to Sandra and Stephen Norman for the opportunity to examine the Norman family album, which, in its tonal variation within the controlled environment of a single album, added greatly to my understanding and appreciation of Cameron's toning practices.

38 I am indebted to Rudolf Kingslake for clarifying, in conversation and through his book, how Cameron's lenses worked and their effect on the way her pictures look. See Rudolf Kingslake, *Lenses in Photography*, Garden City, N.J., 1951, pp. 122–23. Also see HG1975, pp. 69–76, and note 35 of my essay "Julia Margaret Cameron's Women" in this book.

39 Though a solar enlarger was available, it was rarely used. Albumen prints were most often made using a contact-printing process in which the photographic paper is placed in direct contact with the negative during exposure – the result is an image that has a one-to-one relationship to the negative.

40 Jan Marsh and Pamela Gerrish Nunn, *Pre-Raphaelite Women Artists*, exh. cat., Manchester City Art Galleries, 1997, p. 27.

41 While it was common for amateur photographers to sell pictures, the degree to which Cameron engaged in the commercial marketplace and the volume of prints she sold set her apart.

42 Recent publications on Victorian women's access, or lack of access, to formal art education and professional opportunities include Clarissa Campbell Orr, ed., *Women in the Victorian Art World*, Manchester, 1995; and Marsh and Nunn (note 40).

43 Cameron to Cole, June 12, 1869 (NAL, Cole Correspondence, Box 8).

44 Census information was found at the Family Records Centre on Myddleton Street in Finsbury, East Central London. I owe thanks to Will Stapp and Stephanie Lipscomb for their research on Cameron's census status.

Stephanie Lipscomb

From our perspective in the late twentieth century, Victorian women seem to dwell in the shadows of their time. Hidden behind the identities of their fathers and husbands, they have seldom been invited to step out into the light of their own lives. In photography, Julia Margaret Cameron granted a few of them a kind of immortality. Like Cameron's male subjects, these women took their place in prints and albums Cameron gave away as gifts; and their likenesses were sold through Cameron's gallery, Colnaghi. Their portraits have been assured reproduction in numerous publications, as interest in Cameron's work continues to grow. Even so, Cameron's women have retained an aura of mystery compared to the famous men she portrayed, both because of their anonymity and the symbolic role they played in her photographs. It is hoped that these biographies, while by no means exhaustive, will begin to satisfy our interest to know as mortals the women Cameron so eloquently rendered as myths.

Exploring the lives of Cameron's female sitters fulfills a basic curiosity to know who these women were and how they were revealed or transformed through Cameron's vision. This information also helps us understand how Cameron worked, her attitudes toward women, and how, through photography, she sought to represent an ideal of femininity consistent with her time, while still pushing accepted boundaries.

Cameron photographed women for different reasons than she photographed men. Her male sitters — Darwin, Herschel, Tennyson, Watts — were figures of intellectual and cultural import, who made significant contributions to the history of science, literature, and the arts. Authoritative and compelling, they were recognized by Cameron as the great minds of the Victorian age. Her women, by contrast, inhabited a poetic world in the guise of legendary or literary figures, such as Sappho or Ophelia. With the notable exception of her niece Julia Jackson, they were rarely identified by their actual names. Unlike the men Cameron photographed, her female models met no special qualifications for achievement or intellect. Although they were for the most part young and beautiful, they were chosen in a surprisingly democratic manner from a variety of backgrounds: ladies and servants, intimate friends and distant acquaintances.

Cameron did not have to go far to find the models for her pictures. Almost all of them lived at or visited Dimbola Lodge, the Camerons' home in Freshwater, on the Isle of Wight. Some, like Marie Spartali, made Cameron's acquaintance through her large circle of friends. Others, like Julia Jackson and May Prinsep, were part of her extended family. Still others, notably her parlor maid Mary Hillier, were members of her household staff.

Much of the previous research on Cameron's life and work, begun in large part by photo-historians Colin Ford, Helmut Gernsheim, Amanda Hopkinson, and Mike Weaver, has been invaluable in creating the biographical portraits of Cameron's sitters that follow. In addition, a number of her female sitters possessed a degree of social standing, so information about them is available through a variety of published sources: biographies, encyclopedias, and obituaries. The remaining information has been the result of a process of comparison and cross-reference, which has led me to identify physiognomic characteristics from one image to another, search for leads through diaries and memoirs, and dissect peerage and census records for marriage years and family history. But for many of these women, very little documented information exists, so their stories remain by necessity largely anecdotal in nature.

In compiling the following entries, I have sought to report the pertinent details of the sitters' lives, down to the month and day of birth and death, when possible. If this information could not be determined, I have taken the liberty of conservative speculation. The peerage records, for example, do not give the date of birth for women who married into nobility, and so Lady Adelaide Talbot's year of birth remains, for now, an estimation.

The following entries are in alphabetical order according to the sitter's last name. The sources used are abbreviated at the end of each entry and cited in full in the catalogue's Bibliographic Abbreviations. The photograph accompanying each biography corresponds to a full-page reproduction in the plate section of the book. The relevant plate number, which is given beneath each image, is also keyed to information in the Checklist of the Exhibition. For other photographs of a particular sitter reproduced in this book, the reader should consult this checklist.

Hatty Campbell

born c. 1852

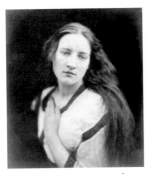

plate 6

Very little is known about Hatty Campbell, who was the sitter for a series of photographs entitled *The Echo*, all apparently made in 1868. Like other young women who modeled for Cameron, Campbell may have been one of the local residents of the Isle of Wight. On September 7, 1868, Emily Tennyson wrote of seeing "the wonderful photographs of the Miss Campbells," which Cameron had brought to show her, suggesting that Hatty Campbell may have also had a sister who posed for Cameron. Campbell's youthful innocence and soft gaze aptly mirror the classic myth of the maiden nymph Echo, who, according to Ovid's *Metamorphoses*, distracted Hera from Zeus's philanderings with idle chatter. When Hera realized the deception, she punished Echo by taking away her voice. (For other versions of this myth, see the Appendix.) In Cameron's portrayal, Echo holds her hand to her chest as if to give expression to this loss. (Hatty Campbell's name is spelled two ways in the literature on Cameron. Ford [CF] and Gernsheim [HG1975] referred to her as "Hattie," whereas Cameron inscribed her name as "Hatty." In any case, it was probably a shortened version of Harriet. For the sake of consistency, we have chosen to spell her name as Cameron did.)

LTJ

Annie Chinery

born c. 1851

plate 30

Annie Chinery married Cameron's second son and third child, Ewen Wrottesley Cameron (born India, 1844), in November 1869. Known also by her nicknames "Topsy" and "Birdie," Chinery was the daughter of Edward Chinery, the town doctor of Lymington, Hampshire. Cameron adored her son's bride, her first daughter-in-law, and sang praises to her beauty and charm in letters to friends and relatives. To Sir John Herschel she wrote: "Never was one's own offspring dearer to a Mother than this darling daughter is to me" (CF, p. 136). And in another letter, Cameron added: "She was perfectly unconscious of her beauty – only 18 – naive ingenuous and stedfast [*sic*], strong and utterly true and reliable. She adored her own father Dr. Chinery and he had nothing in life he loves so well as this Ewe Lamb of his flock – but yet she surrendered herself to Ewen and started with him for his mountain solitude without a misgiving tho [*sic*], of course it was a severe trial to leave her home" (London, The Royal Society, Herschel Correspondence, 5.170). Cameron's intense expressions of affection for Annie apparently went unrequited: in a letter of October 19, 1871, to her eldest son, Hardinge, Cameron described Annie's response to her mother-in-law as "very temperate" (Los Angeles, Getty Research Institute, Research Library, Cameron Family Papers, no. 850858).

Assisted by his parents, Ewen and Annie purchased a coffee estate in Ceylon and moved there shortly after they were married. Although Ewen Cameron resided in Ceylon exclusively for the next twenty years, Annie appears to have returned frequently to England, often for extended periods. In fact, she was residing in England with their two children, Ewen Hay and Julia Hay, when her husband died in Ceylon in January 1889.

BH, CF, VH

Mrs. Herbert Fisher, née Jackson

1841–1916

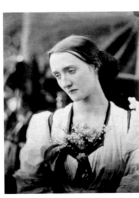

plate 8

Mary Louisa Fisher posed for her aunt a number of times and, like her sister Julia Jackson (see entry), always as herself. She and her cousin Arthur Prinsep also posed for George Frederic Watts's painting *Una and the Red Cross Knight* in 1862 (Port Sunlight, England, Lady Lever Art Gallery). Born in Calcutta on December 30, 1841, Mary was the second of three daughters born to Cameron's younger sister Maria (Mia) Pattle and John Jackson, a highly respected physician. Mary returned to England with her mother and sisters in 1848. In 1862 she married Herbert William Fisher, a scholar and barrister, who was a tutor and private secretary (from 1860 to 1870) to Albert Edward, Prince of Wales, son of Queen Victoria and Prince Albert. The Fishers raised their eleven children in Brockenhurst, Hampshire. Their eldest son, Herbert, became a distinguished member of the House of Commons, initiating reforms in the British educational system. Their eldest daughter, Florence, became a talented violinist and, as a child, assumed a number of allegorical roles in front of Cameron's camera, including that of Saint John the Baptist in 1872. Mary Jackson Fisher died during World War I, on August 24, 1916, after being struck by a car while crossing a street in London.

BH, CF, DNB (SUPPL. 4), EPR, HF, JC

Nellie, Christina, Mary, and Ethel Fraser-Tytler

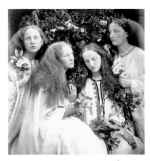

plate 28

In *The Rosebud Garden of Girls* of 1868 (plate 28), Mary Fraser-Tytler and her sisters – Nellie, Christina, and Ethel – enacted a verse from Alfred Tennyson's *Maud* (1855):

*Queen rose of the rosebud
garden of girls
Come hither, the dances are done,
In gloss and satin and glimmer
of pearls,
Queen lily and rose in one.*

(See Appendix for more on *Rosebud Garden of Girls*.)

The sisters were daughters of Charles Edward Fraser-Tytler, a Scottish landowner and former Indian Civil Servant. They had come to pose for Cameron by way of their father's professional association with her

brother-in-law Thoby Prinsep. Nellie, pictured first from left, married a Mr. McCullom, according to Cameron's notation in an album she gave to her daughter and son-in-law. Christina Catherine Fraser-Tytler (d. 1927), pictured second from left, married Rev. Edward Thomas Liddell (1845–1914), honorable Canon of Durham and Vicar of Welton St. Martins (from 1894 to 1902) in 1871. Mary Seton Fraser-Tytler (1849–1938), pictured third from left, fell in love with the acclaimed painter George Frederic Watts, whom she met at Little Holland House, the Prinseps' estate in Kensington, London, around

1870. Watts had lived there since 1851 and was married at the time to Ellen Terry, one of England's most celebrated Shakespearean actresses. (Terry and Watts were separated within a year after their 1864 wedding and were formally divorced in 1877.) Mary aspired to become a painter herself and greatly revered Watts, thirty years her senior, whom she called "the painter of painters for me." They were married in November 1886 and after 1891 resided in both London and Compton, Surrey. After Watts's death in 1904, Mary wrote a three-volume biography of her late husband, *The Annals of an Artist's Life*, published in 1912. She died in 1938.

BPBK, JC, MB, MSW, RC, WB

Mrs. Hardinge

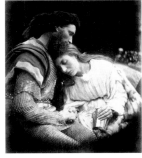

plate 39

In copyright documents of December 8, 1874, the models for Julia Margaret Cameron's photograph *The Parting of Lancelot and Guinevere* (plate 39) are identified as Mr. Read and Mrs. Hardinge. No information has yet surfaced to indicate who Mrs. Hardinge was, although she may have been a relative (through marriage) of Sir Henry Hardinge, first Viscount Hardinge of Lahore (1785–1856). Cameron had been the equivalent of

Hardinge's social secretary during his tenure as Governor General of India (from 1844 to 1848), and it is possible she may have associated with members of his family after moving to England in 1848.

If Mrs. Hardinge was indeed married by the time Cameron's photograph was made in 1874 (as the copyright record and the wedding ring on the sitter's finger suggest), then we can rule out several candidates for her identity. Presumably, she would not have been married to any of Sir Henry

Hardinge's grandsons, since the four that did marry did so after 1890, sixteen years after *The Parting of Lancelot and Guinevere*. However, two of Sir Hardinge's younger brothers, Richard and Frederick, had sons who married women before 1874. Richard Hardinge's son Bradford (1833–1871) married Caroline Edwards in 1864. Frederick Hardinge's son Henry Charles (1832–1870) married Eleanor Lord in 1868.

BPBK, DNB (VOL. 8)

Mary Ann Hillier

1847–1936

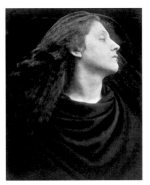

plate 1

In *Annals of My Glass House* (1874), Cameron described her maid and photographic model Mary Hillier as "one of the most beautiful and constant of my models, and in every manner of form has her face been reproduced, yet never has it been felt that the grace of the fashion of it has perished" (HG1975, p. 182). Born in Freshwater, on the Isle of Wight (in Lea Cottage, Pound Green) on November 19, 1847, Mary was the daughter of John Hillier, a shoemaker, and his wife Martha. Her brother George and sister Sophia

were both servants at Farringford, the Tennyson estate next door to the Camerons. Hillier began working as Cameron's parlor maid in 1861, at age fourteen. She remained Cameron's maid and favorite model until 1875, when the Camerons moved back to Ceylon. In many of Cameron's photographs, Hillier is posed as the Madonna. Her refined beauty appealed to other artists as well, including the painter George Frederic Watts, for whom she also modeled. On December 5, 1877, Hillier married Thomas Gilbert, an official for the

railways. Gilbert was the son of a gardener in London and had himself worked as a gardener for Watts at his Briary estate in Freshwater. They had eight children in all, five boys and three girls, one of whom was named Julia. Mary Hillier Gilbert died on April 11, 1936.

CEW1861, CEW1871, CF, HG1975, JC

Julia Prinsep Jackson

1846–1895

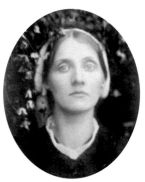

plate 62

One of Cameron's favorite models was her niece and godchild Julia Prinsep Jackson, whom she photographed repeatedly over the years. Yet, unlike most of her other female subjects, whom Cameron portrayed as characters from biblical, classical, or literary sources, Julia was almost always represented as herself, simply and eloquently, without pretense.

Born in Calcutta on February 7, 1846, she was the third and youngest daughter of Cameron's younger sister Maria (Mia) Pattle and John Jackson, a highly respected physician who practiced in Calcutta for twenty-five years. Julia lived in India until she was two years old, when she returned to England with her mother and two older sisters, Adeline Maria (born 1837) and Mary Louisa (born 1841; see entry on Mrs. Herbert Fisher). John Jackson joined his family in 1855 and, until 1866, they all lived in Hendon,

near London, where he practiced medicine. In 1866 the family settled at Saxonbury Lodge, a country house in Kent, near Tunbridge Wells.

During most of her adult life, Julia acted as the primary caretaker of her invalid mother. In 1883 she published a popular essay on the subject of nursing, *Notes from Sick Rooms*. Her compassion was matched by her beauty. She modeled for several leading artists of the day, including the painters George Frederic Watts and Edward Burne-Jones; the latter used her as the model for the Virgin in his *Annunciation* of 1876–79 (see figure 32 in Sylvia Wolf's essay "Julia Margaret Cameron's Women"). She refused proposals to marry from several suitors (including the sculptor

Thomas Woolner and the painter William Holman Hunt) until May 1867, when she married a barrister, Herbert Duckworth, who died three years later, shortly before the birth of their third child. Widowed at the age of twenty-four, with young children, Jackson fell into a long grieving period. In March 1878, she married the Victorian intellectual and author of the *Dictionary of National Biography*, Sir Leslie Stephen. They had four children, two of whom would become famous by their own talent: Vanessa Bell, as a gifted painter, and Virginia Woolf, as one of the most highly regarded authors of the twentieth century. Woolf portrayed her mother in the character of Mrs. Ramsay in her novel *To the Lighthouse* (1927). Julia died of rheumatic fever on May 5, 1895, at age forty-nine.

DG/ES, EPR, LS

Mrs. Keene

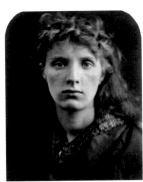

plate 4

Mrs. Keene is identified as the sitter for Cameron's photograph *The Mountain Nymph Sweet Liberty* of 1866 (plate 4) on the contents page of an album Cameron gave to her daughter and son-in-law, Julia and Charles Norman. There, the name "Mrs. Keene" (or perhaps Keane) is written in Cameron's hand beside the title "The Mountain Nymph." Information about Mrs. Keene and her relationship to Cameron has yet to be discovered, however. The title of the photograph comes from John Milton's poem "L'Allegro" of 1632, which reads:

Haste thee Nymph, and bring with thee
Jest and Youthful Jollity,
Quips and Cranks, and Wanton Wiles,
Nods and Becks, and Wreathed Smiles,
Sport that wrinkled Care derides
And Laughter holding both his sides.
Come, and trip it as you go
On the light phantastic toe;
And in thy right hand lead with thee
The mountain nymph, sweet Liberty.

An inscription on a variant of the pose in the Gernsheim Collection at the University of Texas at Austin reads "Lady Clara Vere de Vere," which is the title of a much less cheerful poem published in 1842 by Alfred Tennyson. In this poem, which is thought to have been inspired by Tennyson's personal experience, a young man

bitterly describes a lady's refusal of his love because of his social class:

Lady Clara Vere de Vere
I know you proud to bear your name,
Your pride is yet no mate for mine,
Too proud to care from whence I came.
Nor would I break for your sweet sake
A heart that doats on truer charms.
A simple maiden in her flower
Is worth a hundred coats-of-arms.

AT, HG1975, LKH, VH

Mary Kellaway

born c. 1847

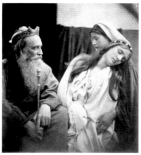

plate 35

Mary Kellaway is thought to have been a maid at Dimbola Lodge, the Cameron estate in Freshwater, on the Isle of Wight. The April 1861 census record for the Isle of Wight, however, lists Mary Kellaway, age fourteen, as a dressmaker. Born in Pound Green, Freshwater, she was the only daughter and third child of Barnaby Kellaway, a sailor, and his wife Hannah. Like Mary Ryan, whom she supports in Cameron's *Queen Esther before King Ahasuerus* of 1865 (plate 35), Kellaway was part of the large circle of family, neighbors, and household staff frequently called upon to model for Cameron's photographs.

CEW1861

Kate Keown

born 1858

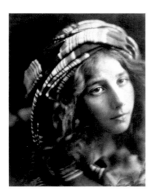

plate 23

Kate Keown appears frequently in Cameron's photographs. She was born and raised in Freshwater, on the Isle of Wight, the oldest child of Thomas and Sarah Keown. According to Colin Ford, Thomas Keown was a Master Gunner (second Class) in the Royal Artillery, which he had joined as a driver shortly before his seventeenth birthday. He fought as sergeant in the Crimean War and was wounded in the battle of Sebastopol. He married in 1856 and was made a Master Gunner the same year, manning the coastal forts of Britain for the Artillery's Coast Brigade. He was promoted to Freshwater Redoubt, a hilltop fort less than half a mile from Dimbola Lodge, the Camerons' Freshwater estate. He and his family are listed in the 1861 census record for the Isle of Wight. Keown retained his post until 1870 and raised his six children on the island. Kate's two younger sisters, Elizabeth ("Lizzie," born 1859) and Alice (born 1861), also sat for Cameron.

Beginning with what she called *Annie "My First Success,"* a portrait of a Freshwater orphan named Annie Philpot taken in 1864, Cameron called upon numerous children to pose for her camera. In some instances, Cameron posed the children as themselves, but she more often used them to embody childhood innocence. The Keown sisters, like Freddy Gould and Alice du Cane, were among the local children who donned gowns or angel wings to play the part of Cupid or the Infant Christ in Cameron's photographs. At ten years of age, Kate Keown also sat for a more mature role. In *A Study of the Cenci* of 1868 (plate 23), she portrayed the sixteen-year-old Beatrice Cenci, a young woman of the sixteenth century, who, by the time of Cameron's interpretation, had come to represent both feminine suffering and the irrepressible capacity of the human spirit for transcendence (see Sylvia Wolf's essay "Julia Margaret Cameron's Women" and the Appendix for more on Beatrice Cenci).

CEW1861, CF

Alice Pleasance Liddell

1852–1934

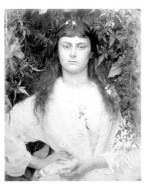

plate 18

Perhaps best known as the little girl for whom Lewis Carroll (Charles Dodgson) wrote the book *Alice's Adventures in Wonderland* (1865), Alice Pleasance Liddell grew up in Oxford, the fourth child of Lorina Hannah Reeve and Henry George Liddell, dean of Christ Church. She was born on May 4, 1852, in Westminster, while her father was serving as headmaster of Westminster School. In 1855 the family moved to Oxford, where Henry Liddell took the distinguished post he would hold for the next thirty-six years. Alice and her siblings grew up in an environment enriched by academic and cultural pursuits. She studied art with John Ruskin, who had become Slade Professor of Fine Arts at Oxford in 1869.

In the early 1870s, the Liddell family began renting a house on the Isle of Wight, not far from Dimbola Lodge, the Camerons' home in Freshwater. Because of their connections at Oxford, the Liddells mingled easily with the intellectual coterie at Freshwater, which included the poets Alfred Tennyson and Henry Taylor.

Alice's cousins Adolphus and Augustus Liddell lived nearby and also sat for Cameron. As a child, Alice had posed numerous times for Lewis Carroll's camera. When she posed for Cameron as *Pomona* (plate 18) and *Alethea* (plate 9) in 1872, she was twenty years old. In 1878 Liddell married Reginald Gervis Hargreaves (1852–1926) and moved with him to his estate in Hampshire. They had three sons: Alan, Leopold, and Caryl. Alice Liddell Hargreaves died in Westerham, Kent, on November 15, 1934.

AC, AL, DNB (VOL. 22), MNC

Agnes Mangles

c. 1850–1906

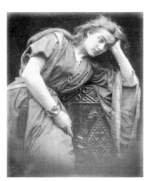

plate 11

An inscription in Cameron's hand in a volume of her *Illustrations to Tennyson's "Idylls of the King"* (once owned by Cameron's daughter, Julia Norman) identifies the sitter in the photograph *Mariana* of 1875 (plate 11) as "Miss Agnes Mangles now Mrs. Arthur Chapman." According to *Who Was Who* (1916–1928, vol. 2), Mangles was the daughter of "the late Captain Mangles" of Poyle Park, Tongham, Surrey. In 1876 she married Sir Arthur Wakefield Chapman (1849–1926) who was a partner in Pigott, Chapman and Company, Calcutta (from 1875 to 1902), and Chairman of the Surrey City Council (from 1911 to 1917). Agnes Mangles Chapman died in 1906.

Mangles also portrayed Vivien in several photographs entitled *Vivien and Merlin* of 1874 (see figures 8 and 9 in Debra N. Mancoff's essay), which Cameron created as illustrations to Alfred Tennyson's *Idylls of the King*. Cameron's husband, Charles Hay Cameron, played the bearded magician Merlin. In a short essay written for the January 1, 1886, issue of the *Photographic News*, Mangles, identified only as "A Lady Amateur," described her experience posing for Cameron: "And so Mrs. Cameron had determined that I was to be Vivien. I very much objected to this, because Vivien did not seem to me to be a very nice character to assume. In addition to my having to portray the objectionable Vivien, I discovered, to my dismay that Mrs. Cameron had designed her husband for Merlin – for Mr. Cameron was given to fits of hilarity which always came in the wrong places. As to Mr. Cameron being an admirable representation of the patriarch there could not be a shadow of a doubt – but would he laugh? The point was soon settled; laugh he did, and that most heartily. He was to be sitting in the oak, and for this purpose a hollow fragment of a tree was brought into the studio, arranged with ivy leaves by Mary and the gardener, who spent quite half a day over it, and Merlin was seated inside. I was posed in due time, and the exposure commenced. But it was more than a mortal could stand to see the oak beginning gently to vibrate, and know that the extraordinary phenomenon was produced by the suppressed chuckling of Merlin."

JC, JL, WWW2

Julia Hay Norman, née Cameron

1839–1873

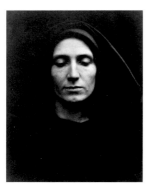

plate 31

Julia Hay Norman was the Camerons' first child and only daughter. On January 18, 1859, she married Charles Lloyd Norman (1833–1889), the son of George Warde Norman (1793–1882), a director of the Bank of England (from 1821 to 1872) and a wealthy landowner who had studied at Eton College with her father, Charles Hay Cameron. It was Julia Norman who, with her husband, provided the catalyst for Cameron's career in photography. In late 1863 they gave Cameron her first camera, accompanied by the words: "It may amuse you, Mother, to try to photograph during your solitude at Freshwater" (Julia Margaret Cameron, *Annals of My Glass House*, 1874).

Julia rarely posed for her mother. Cameron nevertheless adored her daughter, who was described by Henry Taylor in his autobiography as follows: "An entire simplicity, and unconscious honesty of mind… strength of understanding and clearness of purpose, with a composure small disturbances could never ruffle, a liveliness of the inner mind… having been born of parents who were no more ordinary in their ways than in their gifts and faculties and powers, there occurred in the case of the daughter that sort of resilience which is so often observed that it may almost be regarded as a provision of Nature, and her originality took, along with other forms, the form of a determination to be commonplace. Commonplace otherwise than externally she could never be" (HT, p. 46).

The Normans had six children before Julia's death in childbirth in 1873. That year, not surprisingly, marked a decline in Cameron's production – she registered only two photographs for copyright in 1873. Sometime after her daughter's death, Cameron encouraged her niece Julia Jackson to consider marrying the widowed Charles Norman. Jackson, who had been widowed herself three years earlier, refused Norman's hand, but nevertheless remained a loyal friend to him and his family.

AVM, CEW1871, DNB (VOL. 14), HT, LS, VH

Emily Peacock

born c. 1855

plate 2

Emily Peacock and her sister Mary may have been visitors of the Camerons in Freshwater, on the Isle of Wight, or perhaps neighbors of theirs (although the 1871 census records do not reveal a family named Peacock in Freshwater). Emily appears in many of Cameron's photographs of 1873 and 1874, and is a model in five of her illustrations to Alfred Tennyson's *Idylls of the King* (1874–75). In the photograph *The Sisters* of 1871, believed to have been made by Cameron with her son Henry

Herschel Hay Cameron (Virginia Woolf and Roger Fry, *Victorian Photographs of Famous Men and Fair Women by Julia Margaret Cameron*, London, 1926; rev. and ed. by Tristram Powell, Boston, 1973, plate 14), Mary and Emily Peacock appear in identical clothing – dark dresses with white fur collars – with their heads together and a book opened before them. Emily appears alone in three-quarter profile in another photograph, *The Angel in the House* (plate 2), which, judging by the similarity of her costume and hairstyle,

was probably made at the same time as *The Sisters*. The title of the photograph alludes to Coventry Patmore's popular poem "The Angel in the House," a celebration of married love, published in four installments from 1854 to 1862. (For more information on this subject, see Sylvia Wolf's essay "Julia Margaret Cameron's Women" and the Appendix.)

BH, MW1984

Mary Pinnock

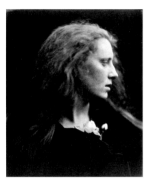

plate 16

For a long time, the sitter in both *Ophelia* (1867; plate 16) and *Ophelia, Study No. 2* (1867; plate 15) was inconsistently identified in the Cameron literature. Helmut Gernsheim identified her as Mrs. Halford Vaughan (née Adeline Jackson, sister of Julia and Mary Jackson) in the first edition of his monograph on Cameron (HG1948), but changed this identification to Cyllene [*sic*] Wilson in the book's second edition (HG1975). That the woman pictured was Wilson, as Gernsheim claimed, is doubtful since Cameron herself identified a very

different woman as Wilson in several other photographs, such as *Rosalba* of 1867 (plate 12).

In Julia Margaret Cameron's copyright entry forms at the Public Records Office, London, the sitter in *Ophelia* is identified as Mary Pinnock. No information about Mary Pinnock has been found, except that Cameron identified her in a private album as the model for *The Passion Flower at the Gate* of c. 1865–70 (see figure 12 in Sylvia Wolf's essay "Julia Margaret Cameron's Women"). The name "Pinnock" also appears twice in some outstanding bills in Cameron's papers (Los Angeles, Getty Research

Institute, Research Library, Cameron Family Papers, no. 850858), suggesting that there might have been a merchant or laborer by this name in Freshwater and that Cameron's model was related to him. Because the model in *The Passion Flower at the Gate* wears a wedding ring, it is possible that Pinnock was the sitter's married name. Mary Pinnock also posed as the Greek nymph *Daphne* (1866/68; plate 7).

HG1948, HG1975, RDW

Mary Emily (May) Prinsep

1853–1931

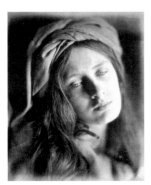

plate 24

Mary Emily (May) Prinsep was the daughter of Charles Robert Prinsep, Advocate-General of Calcutta and the elder brother of Cameron's brother-in-law Thoby Prinsep. Orphaned by the time she was eleven years old (her father died in 1864 and her mother had presumably died earlier), May was adopted by Thoby and Sarah (christened Sarah, but later known as Sara) Prinsep and lived with them at Little Holland House, their home in London. Over the next ten years, May spent several holidays at the Cameron estate in Freshwater, on the Isle of

Wight. Cameron apparently considered May's classical beauty well suited to the portrayal of "Italian" characters, as in *Beatrice* (plate 24) and *The Neopolitan*, both photographs dating to 1866. Prinsep also posed for the painter George Frederic Watts, who lived at Little Holland House from 1851 to 1875. Her cousin Valentine Prinsep was a painter in the Pre-Raphaelite circle too.

In 1874 May Prinsep married Andrew Kinsman Hichens, a London stockbroker. The couple moved to Monk's Hatch, near Guildford, in Surrey. In

1890 Hichens built a second house in the area and rented it to Watts and his wife Mary, who also posed for Cameron (see entry under Fraser-Tytler). On July 27, 1918, after Hichens's death earlier that year, May married Hallam Tennyson (1852–1928), son of the Poet Laureate Alfred Tennyson. They lived at Farringford, the Tennyson estate on the Isle of Wight. May died on July 20, 1931.

BB, BH, MSW, WB

Mary Ryan

1848–1914

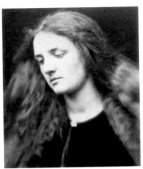

plate 22

Mary Ryan was a maid at Dimbola Lodge, the Camerons' home in Freshwater, on the Isle of Wight. Born on October 29, 1848, Mary was the daughter of James Ryan from Limerick, Ireland. She and her mother were beggars who had approached Cameron on Putney Heath, near London, sometime around 1859. Cameron, struck by the girl's beauty, took them home with her and gave the mother employment. When the Camerons moved to the Isle of Wight in 1860, they took Mary Ryan with them – the mother remained behind – and had her educated by the family governess. Ryan became the Cameron's house maid and, like Mary Hillier, posed for numerous pictures.

Through a romantic sequence of events, Mary Ryan rose out of servitude and into a position of social standing through her marriage to Henry John Stedman Cotton (1845–1915), who was a member of the Indian Civil Service. Upon seeing her portrayed in one of Cameron's photographs, hanging at the Colnaghi Gallery in London, Cotton became enamored of Ryan and pursued her. In a photograph Cameron registered for copyright in July 1867, she posed the couple for an interpretation of Robert Browning's narrative poem *Sordello* (CF, plate 80). They were married a month later, on the first of August, at All Saints Parish Church in Freshwater. Julia Margaret and her husband, Charles, acted as witnesses. Cotton, whose grandfather and great

grandfather had been directors of the East India Company, was knighted in 1902 and Mary Ryan became Lady Cotton. They had three sons, one of whom was also knighted for a distinguished career in the Indian Civil Service. They lived alternately in England and India during Sir Cotton's thirty-five-year tenure with the Indian Civil Service and subsequent four-year membership in the House of Commons. Mary Ryan died in England in 1914, one year before her husband's death.

BH, CF, HC, HG1975, WWW1

Marie Spartali

1843–1927

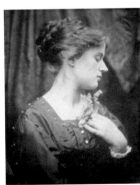

plate 10

As a painter and artist's model, Marie Spartali was well connected to the Pre-Raphaelite movement and was herself a prominent exponent of the style in the 1870s and 1880s. Like many of the artists with whom she was associated, she painted in watercolor, favoring allegorical subjects drawn from early Italian poetry and Arthurian legend. Spartali was admired for her exotic beauty and was sought after as a model; she posed for several important painters of her day, including Dante Gabriel Rossetti, Edward Burne-Jones, and Cameron's nephew Valentine Prinsep.

Spartali was born in Tottenham, Middlesex, on March 10, 1843, the elder daughter of the Greek-born businessman and Greek Consul-General Michael Spartali and his wife, Euphrosyne Varsini. A disciplined

artist since childhood, Spartali became a pupil of the Pre-Raphaelite painter Ford Madox Brown in 1864 and made her exhibition debut at the Dudley Gallery, London, in 1867. Although the Pre-Raphaelite Brotherhood had officially dissolved by 1853, Spartali was welcomed into its ranks in 1871 by William Rossetti, who praised Spartali's "keen perception of the poetry which resides in beauty and the means of art for embodying beauty" (JM/PGN, p. 99). That same year, Spartali married William James Stillman, the American journalist and painter, who was an early follower of John Ruskin. She exhibited widely around England, including at the Royal Academy, London (from 1870), for the next three decades. She died on March 6, 1927, in Kensington, London.

Between 1867 and 1870, Spartali posed extensively for Cameron in a

number of symbolic roles alluding to her Greek heritage: as *The Spirit of the Vine* (1868; Los Angeles, University of California, University Research Library, Department of Special Collections, 98.49); as *Hypatia* (1867; plate 34), the Alexandrian Neoplatonist philosopher, who was martyred by Christian zealots (see the Appendix for more on this subject); and as *Mnemosyne* (1868; Michael Bartram, *The Pre-Raphaelite Camera: Aspects of Victorian Photography*, Boston, 1985, figure 164), the Greek goddess of memory and mother of the nine Muses. In a number of portraits, Cameron also photographed Spartali as herself, in contemporary dress and wearing her hair in a coiled braid (plates 10 and 20).

FM, JM1985, JM1987, JM/PGN

Lady Adelaide Talbot

c. 1849–1917

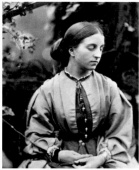

plate 26

Lady Adelaide Talbot was the fourth daughter and the youngest of eight children of Sir Henry John Chetwynd Talbot (1803–1868), eighteenth earl of Shrewsbury. On June 22, 1868, she married Sir Adelbert Wellington (1844–1921), third earl of Brownlow, who served in the British government as Parliamentary Secretary and as Undersecretary of State for War. In 1897 Brownlow was appointed a trustee of the National Gallery, London. Lady Talbot's brother Sir Reginald Arthur James Talbot (1841–1929) served the British military in Africa, becoming a general, and was the governor of Victoria, Australia, from 1904 to 1908.

In addition to sitting for Cameron, Lady Talbot also posed for the painter George Frederic Watts around 1862. In her biography of her husband, Mary Watts wrote that the painter was working at this time on "a portrait group of the three sisters, Lady Lothian, Lady Gertrude, and Lady Adelaide Talbot" (MSW, vol. 1, p. 211). After she married, Lady Talbot continued as Watts's friend and patron. She had no children and died on March 16, 1917.

BPBK, DNB (VOL. 19), HC, MSW, WWW2

Cyllena Margaret Wilson

1851–1883

plate 37

Cyllena Margaret Wilson was the daughter of the Reverend Samuel Sheridan Wilson, a missionary, translator of the New Testament into modern Greek, and Congregational Minister at Shepton Mallet, Somerset. When Wilson, her sister Melita Emily (born 1857), and brother Sheridan William (born 1853) were orphaned in 1866, they were adopted by Cameron, who was a friend of the family. According to Helmut Gernsheim, Wilson was "good looking but hated being photographed by Mrs. Cameron" (HG1975, p. 193). Her broad facial features and dark hair seem to have inspired Cameron to portray her in roles drawn from Greek and Roman mythology, including *A Bacchante* (1867; plate 37). She also modeled for Cameron in a pair of photographs based on the Elgin Marbles, sculptures from the Parthenon frieze in Athens, which were first put on public display at the British Museum in 1816. Wilson's role as *Rosalba* (1867; plate 12) was drawn from a play by Cameron's friend Henry Taylor (see Appendix for more on this subject).

Wilson must have been of an independent mind, for despite the strict Protestant teachings of her father and the charming, active life to be found in her new home with the Camerons, she ran away from their home in Freshwater, on the Isle of Wight, in 1870. Little is known of her subsequent life, except that it was adventurous. She eloped with the first engineer on an Atlantic liner and became a stewardess. After her first husband died, Wilson married and was widowed two more times before her own death of yellow fever in Argentina in her early thirties.

(Wilson's first name, Cyllena, is inconsistently spelled in the Cameron literature. Gernsheim [HG1975] spelled it "Cyllene," whereas Ford [CF] used "Cyllina." In the documents of the Copyright Office, London, the spellings "Selina" and "Cyllena" also appear. For this book, we have chosen "Cyllena," the spelling given in Cameron's own hand in the *Priced Catalogue* discussed in this book by Sylvia Wolf.)

AH, CF, HG1975

Debra N.
Mancoff
with contributions
by Sylvia Wolf

Appendix: Cameron's Literary and Mythological Subjects

The following entries focus on the less familiar narrative and allegorical subjects treated by Julia Margaret Cameron in the photographs in this exhibition. (Entries written by Sylvia Wolf are followed by her initials.) Of Cameron's many titles derived from poetry, only the most notable are treated below; others are explained more briefly in the essays in this book and are readily accessible through the book's index. The interpretations offered, as well as the sources specified in this appendix, reflect the cultural view of Victorian England and may be at odds with more contemporary analyses. This choice was deliberate, in the hope of better understanding the interpretive habits of Cameron's day.

Alethea

From the ancient Greek; the word means "true" or "truthful."

In the Victorian era, educated members of society would have recognized the Greek word "alethea" and known that it meant "true" or "truthful." Henry George Liddell, father of Alice Liddell, the model for Cameron's photograph *Alethea*, contributed to the Victorians' understanding of ancient Greek with his publication in 1843 of a Greek-English lexicon. "Alethea" is listed in his lexicon as "true, sincere, truthful, frank, honest, real, and actual." The term does not appear to have been personified in art and literature, however, except in the writings of the Greek philosopher Parmenedes (born c. 515 B.C.), one of the earliest theorists about the cosmos. SW

The Angel in the House

From a poem by Coventry Patmore (1823–1896); the ideal wife.

Patmore celebrated the rewards of matrimony in his poem "The Angel in the House." Released in four installments – "The Betrothal" (1854), "The Espousals" (1856), "Faithful for Ever" (1860), and "Victories of Love" (1862) – the complete poem charts the progress of an ideal marriage. The "angel" of the poem is Honoria, a clerical dean's daughter, who possesses a perfect balance of the qualities associated by the Victorians with feminine nature: innocence, devotion, and an infinite capacity for nurturing. Honoria and her husband Felix share a life of modest domestic fulfillment, which Patmore presented as the epitome of love, possible only within the bond of marriage.

Bacchante

From classical mythology; female follower of the god of wine.

Also known as Maenads, Bacchantes formed a cult around Bacchus, the Roman god of wine, and demonstrated their devotions in spasmodic dancing at the rites of the Bacchanal. Euripides's tragedy *The Bacchae* is the major Greek source on this cult, while Livy's *The History of Rome (Ab urbe condita libri)* is the major Roman source. The Bacchantes' unrestrained behavior, attributed to their hot blood, often led to their madness or death. Once roused to a state of frenzy, they could not be controlled; their passion led them to tear men, including Orpheus, to pieces. In the Victorian era, Bacchantes represented what was thought of as the wild, uncontrolled side of feminine nature, an aspect reflected at the time in descriptions of female hysteria.

Beatrice Cenci

From Percy Bysshe Shelley's play *The Cenci* (1819); a young woman convicted of patricide.

Shelley based this play on a murder and trial that took place in Rome in the late sixteenth century. After years of abuse at the hands of her cruel aristocratic father, Beatrice Cenci joined her brothers and stepmother in a plot to kill him. They contracted assassins to carry out the murder, but when these hired killers were later caught, they led the authorities to Beatrice and her family. In the ensuing trial, the details of the elder Cenci's treatment of his daughter were made public, and the Roman populace gave Beatrice their sympathy. Pope Clement VIII, however, remained unmoved and refused to grant her a pardon. She was hanged on September 11, 1599. Shelley's play enhanced her image as a romantic figure. A portrait of her, attributed to Guido Reni, hung in the Palazzo Barberini in Rome; this picture was a popular attraction for nineteenth-century tourists, and it was featured in the writings of Charles Dickens, Nathaniel Hawthorne, and Herman Melville.

Christabel

From Samuel Taylor Coleridge's poem "Christabel" (1816); a young woman corrupted by evil sorcery.

Coleridge (1772–1834) completed only a fragment of his poem "Christabel," but what survives is a chilling tale. Christabel, a young and innocent girl on the verge of womanhood, encounters a mysterious woman in the woods near her house. The woman appears ill, and Christabel persuades her to take shelter in her home and rest in her bed. Christabel is unaware that she has given refuge to an insidious snake demon known as Lady Geraldine. In the dark of night, Geraldine abandons her disguise and reveals her true, repellent, reptilian form. Although she recoils in horror, Christabel cannot escape Geraldine's powers of transformation, and by morning, she is turned into a hissing monstrosity. Lady Geraldine resumes her human disguise, petitioning Christabel's father for help and setting him against his daughter. At this point the poem abruptly ends, so Christabel's final fate remains unknown. Such tales of hideous transformation were popular throughout the Romantic era, and the loss of innocence to corruption certainly appealed to the Victorian moral sensibility.

Daphne

From classical mythology; nymph pursued by the god Apollo.

According to the classical legend, the mountain nymph Daphne, daughter of the river god Peneus, served as a priestess to Mother Earth. Although Daphne had sworn an oath of perpetual virginity, Apollo desired her. To maintain her oath, Daphne fled, and before Apollo could capture her, her father (in alternate versions, Zeus) came to her aid and transformed her into a laurel tree. Only then did Apollo relent, and breaking off a small branch of the tree, he twined it in his hair and declared that the laurel be sacred to all his followers. Like all evergreens, the laurel symbolizes immortality, and the Apollonian association linked immortality to victory, as seen in the laurel wreath that crowned the heads of warriors and athletes.

Echo

From classical mythology; the nymph who loved Narcissus.

Echo, a nymph of the trees and of spring, became infatuated with Narcissus at first sight. When he spurned her, as he did all others, she pined for his love, fading from life until nothing remained but her voice. But she could not speak independently; she could only repeat the final syllables of words spoken near her. Other versions of Echo's story exist. In one, Hera grew weary of her constant babbling and took away her speech. In another, Echo refused Pan's advances, and furious for revenge, he pushed his shepherds to such madness that they tore her apart. The first version of Echo's tale appealed to the Victorians as an illustration of one of the era's favorite subjects: the tragic results of unrequited love.

Esther

From the Old Testament; Queen of Persia.

When Queen Vashti refused to accompany her husband, King Ahasuerus of Persia, to a feast, he disavowed her and married a young Jewish woman named Esther. To protect herself and her family, Esther kept her religious beliefs secret, but when the king's advisor Haman tried to incite a massacre of the Jews, she petitioned her husband for mercy and justice. Ahasuerus, horrified at Haman's deceit, sentenced him to death by hanging on the same gallows that Haman had prepared for Esther's uncle Mordecai. To Christian commentators, Esther prefigured the Virgin Mary, interceding for her people with her son on the Day of Judgment.

Guinevere

From the Arthurian legend; wife of King Arthur and lover of Sir Lancelot.

Throughout the Arthurian tradition, the failed marriage of Arthur and Guinevere gave a human dimension to the collapse of the kingdom of Camelot. In the *Historia Regum Britanniae* of Geoffrey of Monmouth (c. 1138), Arthur's nephew Modred forced Guinevere to commit polygamy by marrying her while Arthur was away in battle; but in the French romance by Chrétien de Troyes, *Chevalier de la charrete* (c. 1178), she was willingly paired with Sir Lancelot, a lover worthy of her attention. In Sir Thomas Malory's *La Morte Darthur* (1469–70), Lancelot's enemies entrapped the lovers and forced Arthur to accuse her of treason. Alfred Tennyson followed this narrative in "Guinevere," one of the poems included in his *Idylls of the King* (1859), but allowed Arthur to vent his anger and forgive his wife. Tennyson then had Guinevere redeem her sin by recognizing the superiority of her husband over her lover, thus reconciling the medieval queen, who chose desire over duty, with the Victorian ideal of the submissive wife.

Hypatia

From Charles Kingsley's novel *Hypatia* (1851–53); a pagan martyr.

Kingsley's *Hypatia; or New Foes with an Old Face* appeared in serial installments in *Fraser's Magazine* in 1851. It was published as a novel two years later. Set in fifth-century Alexandria, this romance tells of Hypatia's tragic life. The daughter of Theon, a respected mathematician, Hypatia was a brilliant lecturer on Neoplatonist philosophy. Endowed with a rare spiritual charm, she fascinated her listeners, but she also angered the Christian community who feared her influence. A mob rose against her, and she was murdered, a senseless loss to the world of ideas. Also known as the "Divine Pagan," her combination of wisdom and beauty, as well as her martyrdom, stirred the sympathy of Victorian readers.

Juliet

From William Shakespeare's drama *Romeo and Juliet* (1595);
star-crossed lover of Romeo.

Shakespeare based *Romeo and Juliet*, a tragedy of feuding families and youthful passion, on an Italian drama. Juliet, daughter of the prominent Capulet family of Verona, fell in love with Romeo, son of her father's enemy Montague. Although only a girl, Juliet felt a woman's desire. When she confessed her love, believing she was alone on her balcony, Romeo, who was hiding beneath her window, declared he loved her in return. With little persuasion, the sheltered girl defied her family, rejected the man they had chosen for her, and wed Romeo in secret with the aid of Friar Laurence. But their joy was short-lived; Friar Laurence's plan, that Juliet drink a sleeping potion and Romeo convey her to Mantua for safety, went awry when Romeo received misinformation that Juliet was dead. He bought poison and committed suicide next to her seemingly lifeless form. When she awoke to find her dead lover, she drank the dregs in the vial and joined him. Anna Jameson, in her *Characteristics of Women* (1832), observed, "All Shakespeare's women ...either love or have loved...but Juliet is love itself."

Mariana

From Alfred Tennyson's poem "Mariana" (1842);
the rejected fiancée of Angelo.

Tennyson drew inspiration for this poem from William Shakespeare's play *Measure for Measure*. In the play, Mariana's wicked fiancé, Angelo, an aid to the Duke of Vienna, refuses to wed her. She spends five lonely years in a tower room in a moated country manor, waiting for her faithless suitor. Shakespeare offered a happy ending, but Tennyson featured only Mariana's isolation and despair, watching and waiting and longing for death. The image of the patient, suffering woman touched Victorian sympathies. Mariana in the moated grange was also a popular subject for painting, best known in the version by John Everett Millais (1850–51; England, Makins collection).

The Mountain Nymph Sweet Liberty

From John Milton's poem "L'Allegro" (1632);
the spirit of freedom.

The Italian title of this poem may be translated as "The Cheerful Man." In contrast to the somber mood of Milton's pendant work, "Il Penseroso" (The Thoughtful Man), "L'Allegro" presents the poet's plea to the goddess of Mirth to take him as a companion in a life of merriment. In this idyll, the pleasures of happy living know no restrictions; they can be found in tranquil rural meadows or among the towers of the city in the "busy hum of men." Nature is a major source of joy, and Milton invoked his guide through the world of natural delights with these words:

Come, and trip it as you go
On the light phantastic toe;
And in thy right hand lead with thee
The mountain nymph, sweet Liberty.

Rather than a character, the mountain nymph is a spirit, the personification of freedom as it engenders joy.

Ophelia

From William Shakespeare's drama *Hamlet* (1603);
rejected and doomed lover of Hamlet.

Ophelia was the victim of tragic circumstances in Shakespeare's drama. She did not understand her lover's unpredictable – and often violent – behavior, as he carried out his plot to expose his uncle's role in his own father's death. Fearing Hamlet had lost his mind, Ophelia allowed her father Polonius to spy upon him. Enraged, Hamlet killed Polonius, and with no one to turn to, Ophelia descended into madness. In her erratic wanderings, picking bouquets of flowers and singing childish rhymes, she fell into a river and drowned. Victorian audiences regarded Ophelia as one of the most pitiable characters in literature, whose sweet and gentle innocence ventured unprotected in a dangerous world, only to be crushed out of existence. Ophelia's delusions and death offered a popular and poignant subject in the visual arts, as seen in John Everett Millais's painting *Ophelia* (1851–52; London, Tate Gallery).

Pomona

From classical mythology; the Roman divinity of trees.

As the goddess of trees, Pomona's name is linked with the growth cycles of the earth and with other female divinities who represent fertility, such as Ceres and Flora. According to Ovid, she was wooed and won by the god Vertumnus, who presided over the seasons. Just as Zeus transformed his appearance to seduce the beautiful women of the earth, Vertumnus courted Pomona in many disguises. As his partner, Pomona also guaranteed seasonal changes and the fertility of the earth. Most often, she was represented by fruit-bearing trees, and she was depicted with an armful of fruit held to her bosom and a pruning knife held in her hand.

Rachel

From the Old Testament; the wife of Jacob and mother
of Joseph and Benjamin.

Jacob, who was deeply in love with the beautiful Rachel, was promised her hand in marriage in exchange for seven years of work for her father. When Jacob had paid his debt, however, Rachel's father used the cover of night to trick Jacob into the bed of Rachel's older sister Leah. Jacob discovered the trick in the morning and protested strongly. He was ultimately granted marriage to Rachel, but only in exchange for another seven-years labor. Rachel was childless for many years while her sister bore Jacob six sons and a daughter. Rachel finally conceived and bore Joseph, but she died giving birth to her second son, Benjamin. As a woman who loved, longed for motherhood, and died in childbirth, Rachel was the kind of tragic heroine that aroused the sympathy of the Victorians. SW

The Return after Three Days

From the New Testament; the young Jesus is missing
and then reunited with his parents after three days.

The following story is recounted in Luke 2.41–50. Every year Mary and Joseph went to Jerusalem during the feast of Passover. When Jesus was twelve years old, they took the boy with them. At the end of the feast, Mary and Joseph departed with a group of people, believing their son to be among them, but Jesus had remained behind. Mary and Joseph soon discovered he was missing and hastily returned to Jerusalem. Three days later, they found him in the Temple of Jerusalem sitting among the teachers, whom Jesus had amazed with his precocious ability to engage in theological discussion. This story is often cited as evidence of the boy's passage from childhood to adult understanding. It is also symbolic of Christ's awareness of his separation from his worldly family, for he responded to Mary and Joseph's anguish at his absence with surprise, "Did you not know that I must be in my Father's house?" To a parent of any era, this poignant story marks a moment of loss, when a child pulls away from home. For the Victorians, a story about a lost son carried with it the added implication of death, a very real subject at a time of high child mortality. SW

Rosalba

From Henry Taylor's play *The Virgin Widow* (1849); a bride torn between duty and desire.

Sir Henry Taylor (1800–1886), known for his illustrious career in the Colonial Office, published his first play *Philip van Artevelde* to excellent reviews in 1834. (It was not staged until 1847 and then its run was abruptly cut after six performances.) In 1849, inspired by a year-long rest cure in Italy, he wrote *The Virgin Widow, or A Sicilian Summer*. The play, set at an unspecified time in Palermo, revolves around Rosalba, a young and beautiful countess, whose mercenary father has arranged for her marriage with the aged, but vastly wealthy Count Ugo. When Rosalba arrives in Palermo, she meets Silisco, the

handsome, but destitute Lord of Malespino. Entranced by her saintly beauty, Silisco falls in love with her at first sight. Rosalba rejects him, however, explaining that she loves him too, but has vowed to obey her father at her mother's deathbed. Silisco then disappears from Palermo. The rest of the plot turns on Ugo's discovery on the night of the wedding that Rosalba does not love him. He leaves her to undertake a pilgrimage to see the Holy Sepulchre, where he dies in the company of a mysterious wanderer. When the news of his death

reaches Palermo, his will holds a surprising clause: if Rosalba does not wed, she inherits his wealth; if she does, everything goes to his anonymous last companion. When it is revealed that Silisco tended Ugo in his final hours, Rosalba's father relents, allowing his daughter to marry for love, now that the man she loves has riches as well as her heart. *The Virgin Widow* was not well reviewed and was never performed, but the character of Rosalba, in her willingness to sacrifice her hopes for her own future to obey her father and honor her mother's dying wish, embodies in extreme form Victorian ideals of feminine virtue.

Rosebud Garden of Girls

From Alfred Tennyson's poem "Maud" (1855).

In this lengthy poem about a man who loves the daughter of his dire enemy, Maud is described as a woman whose beauty surpasses all others:

Queen rose of the rosebud
 garden of girls
Come hither, the dances are done,
In gloss and satin and glimmer
 of pearls,
Queen lily and rose in one.

Here Maud's suitor pines for her in her rose garden, while she and other young women perform dances at a dinner party for politicians and other men from the region. The suitor was not invited, but he knows that all eyes will be on Maud, for her beauty

reigns supreme. Victorian artists and writers often used flowers as metaphors for feminine characteristics, and Tennyson's use here of this imagery would have been readily understood by Victorian audiences. The lily, for example, symbolized purity, the rose stood for beauty, and the rosebud signaled youth. SW

Zoe

From modern Greek history; a heroine of the Greek War of Independence.

After almost four centuries of subjugation by the Turks, the people of Greece rose up in revolt in 1821. The Greek War of Independence lasted for more than a decade. The Greek cause found tremendous sympathy among the more liberal minds in Europe, including the poet Byron, who went to Greece in 1823 to lend his support.

Zoe's father was one of many men killed in the Turkish attack on her homeland. The loss transformed her from a timid young girl into an articulate orator, advocating resistance and revenge. She was credited for urging the exhausted insurgents to continue their struggle, and she helped to persuade the senate to approve the dispatch of manned and

armed ships, which led to routing the Turks. She became an iconic image, like the personification of Greece in Eugène Delacroix's *Greece Expiring on the Ruins of Missalonghi* (1827; Bordeaux, Musée des Beaux-Arts).

233

Checklist of the Exhibition

The numbering of the images in this checklist follows that of the plates. The title and date of each image is based on Julia Margaret Cameron's own inscription on this print or, if it bears no inscription, on another print from the same negative located elsewhere. When an original inscription could not be found for a given image, we have suggested an identifying title, which is distinguished from the others by being typeset in roman rather than italics. The names of Cameron's sitters are provided in parentheses whenever the work's title does not identify them. Further information on Cameron's female models may be found in the section of this book entitled "Sitters' Biographies." Every attempt has been made to be accurate, but because thousands of Cameron's prints exist in countless public and private collections worldwide, and because Cameron herself occasionally inscribed two prints from the same negative with different titles or dates, there remains by necessity a margin of error.

Frontispiece. Julia Jackson, 1867
Albumen silver print from wet-collodion glass negative, 24.8 x 19.8 cm
The Art Institute of Chicago, Mary and Leigh Block Endowment, 1998.301

1 *"Call, I follow, I follow, let me die!,"* 1867
(Mary Hillier)
Carbon print, 35 x 26.8 cm
The Board of Trustees of the Victoria and Albert Museum, London, 15-1939

2 With Henry Herschel Hay Cameron (1852–1911)
The Angel in the House, 1871
(Emily Peacock)
Carbon print, 34.5 x 25.3 cm
The Board of Trustees of the Victoria and Albert Museum, London, 2309-1997

3 *Zoe, Maid of Athens,* 1866/70
(May Prinsep)
Albumen silver print from wet-collodion glass negative, 30.1 x 24.5 cm
The Metropolitan Museum of Art, New York, The Rubel Collection, Purchase, Lila Acheson Wallace, Ann Tenenbaum and Thomas H. Lee, and Muriel Kallis Newman Gifts, 1997 (1997.382.38)

4 *The Mountain Nymph Sweet Liberty,* 1866
(Mrs. Keene)
Albumen silver print from wet-collodion glass negative, 36.3 x 28 cm
Michael and Jane Wilson Collection, London, 93:4917

5 *The Echo,* 1868
(Hatty Campbell)
Albumen silver print from wet-collodion glass negative, 32.9 x 24.4 cm
Marjorie and Leonard Vernon, Los Angeles

6 *The Echo,* 1868
(Hatty Campbell)
Albumen silver print from wet-collodion glass negative, 27 x 22.6 cm
The J. Paul Getty Museum, Los Angeles, 84.XM.443.64

7 *Daphne,* 1866/68
(Mary Pinnock)
Albumen silver print from wet-collodion glass negative, 35.7 x 27.1 cm
Gernsheim Collection, Harry Ransom Humanities Research Center, The University of Texas at Austin, 964:0037:0110

8 Mrs. Herbert Fisher, 1864
Albumen silver print from wet-collodion glass negative, 34.3 x 25.3 cm
Michael and Jane Wilson Collection, London, 90:4143

9 *Alethea,* 1872
(Alice Liddell)
Albumen silver print from wet-collodion glass negative, 32.5 x 23.7 cm
The J. Paul Getty Museum, Los Angeles, 84.XM.443.18

10 Marie Spartali, 1868
Albumen silver print from wet-collodion glass negative, 33.2 x 25 cm
Gernsheim Collection, Harry Ransom Humanities Research Center, The University of Texas at Austin, 964:0037:0047

11 *Mariana, "She said I am aweary aweary, I would that I were dead,"* 1875
(Agnes Mangles)
Albumen silver print from wet-collodion glass negative, 35.5 x 28 cm
From *Illustrations to Tennyson's "Idylls of the King,"* vol. 2, May 1875,
The J. Paul Getty Museum, Los Angeles, 84.XO.732.1.2.8

12 *Rosalba,* 1867
(Cyllena Wilson)
Albumen silver print from wet-collodion glass negative, 35.4 x 27.9 cm
International Museum of Photography and Film, George Eastman House, Rochester, New York, 81:1121:0025

13 *Summer Days,* April 1866
(Clockwise from left: May Prinsep, Mary Ryan, Elizabeth Keown, and Freddy Gould)
Albumen silver print from wet-collodion glass negative, 35 x 27.2 cm
The Board of Trustees of the Victoria and Albert Museum, London, 934-1913

14 *"For I'm to be Queen of the May, Mother,*
 I'm to be Queen of the May,"
 May 1, 1875
 (Emily Peacock)
 Albumen silver print from wet-
 collodion glass negative, 35.2 x 27.3 cm
 From *Illustrations to Tennyson's "Idylls*
 of the King," vol. 2, May 1875,
 The J. Paul Getty Museum, Los Angeles,
 84.XO.732.1.2.2

15 *Ophelia, Study No. 2*, 1867
 (Mary Pinnock)
 Albumen silver print from wet-
 collodion glass negative, 33 x 27.1 cm
 International Museum of Photography
 and Film, George Eastman House,
 Rochester, New York, 81:1121:0012

16 *Ophelia*, 1867
 (Mary Pinnock)
 Albumen silver print from wet-
 collodion glass negative, 35 x 27.8 cm
 Gernsheim Collection, Harry Ransom
 Humanities Research Center,
 The University of Texas at Austin,
 964:0037:0111

17 *The Gardener's Daughter*, 1867
 (Mary Ryan)
 Albumen silver print from wet-
 collodion glass negative, 29.2 x 23.4 cm
 National Museum of Photography, Film
 & Television, Bradford, England (by
 courtesy of the Board of Trustees of the
 Science Museum), Herschel Album,
 pl. 66

18 *Pomona*, 1872
 (Alice Liddell)
 Albumen silver print from wet-
 collodion glass negative, 34.6 x 26.9 cm
 The Royal Photographic Society,
 Bath, England, 2286/1

19 *May Day*, 1866
 (Left to right: Kate Keown, Mary
 Hillier, Mary Ryan, Freddy Gould, and
 unknown sitter)
 Albumen silver print from wet-
 collodion glass negative, 33.8 x 28.5 cm
 The Board of Trustees of the Victoria
 and Albert Museum, London, 933-1913

20 Marie Spartali, 1870
 Albumen silver print from wet-
 collodion glass negative, 36.2 x 26.6 cm
 The J. Paul Getty Museum, Los Angeles,
 84.XM.349.2

21 *Christabel*, 1866
 (May Prinsep)
 Albumen silver print from wet-
 collodion glass negative, 33.7 x 27.6 cm
 The Board of Trustees of the Victoria
 and Albert Museum, London, 946-1913

22 *The Wild Flower*, 1867
 (Mary Ryan)
 Albumen silver print from wet-
 collodion glass negative, 27.6 x 23 cm
 National Museum of Photography,
 Film & Television, Bradford, England (by
 courtesy of the Board of Trustees of the
 Science Museum), Herschel Album,
 pl. 78

23 *A Study of the Cenci*, May 1868
 (Kate Keown)
 Albumen silver print from wet-
 collodion glass negative, 35.2 x 27 cm
 Michael and Jane Wilson Collection,
 London, 93:4853

24 *Beatrice*, 1866
 (May Prinsep)
 Albumen silver print from wet-
 collodion glass negative, 33.2 x 26.7 cm
 National Museum of Photography, Film
 & Television, Bradford, England (by
 courtesy of the Board of Trustees of the
 Science Museum), Herschel Album,
 pl. 83

25 *Pre-Raphaelite Study*, October 1870
 (May Prinsep)
 Albumen silver print from wet-
 collodion glass negative, 39.4 x 31.8 cm
 Paul F. Walter, New York, 76.357

26 *Lady Adelaide Talbot*, 1865
 Albumen silver print from wet-
 collodion glass negative, 26.1 x 21 cm
 The Board of Trustees of the Victoria
 and Albert Museum, London, 45.142

27 Emily Peacock, 1874
 Albumen silver print from wet-
 collodion glass negative, 35.2 x 26.2 cm
 The Royal Photographic Society,
 Bath, England, 2293

28 *The Rosebud Garden of Girls*, June 1868
 (Left to right: Nellie, Christina, Mary,
 and Ethel Fraser-Tytler)
 Albumen silver print from wet-
 collodion glass negative, 29.4 x 26.8 cm
 The J. Paul Getty Museum, Los Angeles,
 84.XM.443.66

29 *The Rosebud Garden of Girls*, 1868
 (Left to right: Nellie Fraser-Tytler,
 unknown sitter, Christina, Mary, and
 Ethel Fraser-Tytler)
 Albumen silver print from wet-
 collodion glass negative, 34.9 x 29.1 cm
 The Royal Photographic Society,
 Bath, England, 2191

30 *My Ewen's Bride (God's Gift to Us)*,
 November 18, 1869
 (Annie Chinery)
 Albumen silver print from wet-
 collodion glass negative, 31.2 x 24 cm
 The J. Paul Getty Museum, Los Angeles,
 84.XM.349.8

31 Julia Norman, March 1868
 Albumen silver print from wet-
 collodion glass negative, 34.4 x 26.3 cm
 Michael and Jane Wilson Collection,
 London, 93:4921

32 *Other Version of Friar Laurence and*
 Juliet, 1865
 (Henry Taylor and Mary Hillier)
 Albumen silver print from wet-
 collodion glass negative, 28 x 23 cm
 National Museum of Photography, Film
 & Television, Bradford, England (by
 courtesy of the Board of Trustees of the
 Science Museum), Herschel Album,
 pl. 62

33 *The Dream*, April 1869
 (Mary Hillier)
 Albumen silver print from wet-
 collodion glass negative, 30.5 x 24 cm
 Michael and Jane Wilson Collection,
 London, 97:5636

34 *Hypatia*, 1867
 (Marie Spartali)
 Albumen silver print from wet-
 collodion glass negative, 33.5 x 24.6 cm
 The J. Paul Getty Museum, Los Angeles,
 84.XM.443.69

35 *Queen Esther before King Ahasuerus*,
 1865
 (Left to right: Henry Taylor, Mary Ryan,
 and Mary Kellaway)
 Albumen silver print from wet-
 collodion glass negative, 32.5 x 28.8 cm
 The Royal Photographic Society,
 Bath, England, 2212/1

36 *Rachel*, 1867
 (Cyllena Wilson)
 Albumen silver print from wet-
 collodion glass negative, 34.8 x 24.5 cm
 Gernsheim Collection, Harry Ransom
 Humanities Research Center,
 The University of Texas at Austin,
 964:0037:0118

37 *A Bacchante*, June 20, 1867
 (Cyllena Wilson)
 Albumen silver print from wet-
 collodion glass negative, 32.3 x 26.5 cm
 The J. Paul Getty Museum, Los Angeles,
 84.XM.443.40

38 *May Prinsep*, 1868
 Albumen silver print from wet-
 collodion glass negative, 26.5 x 21.6 cm
 The J. Paul Getty Museum, Los Angeles,
 84.XM.443.59

39 *The Parting of Lancelot and Guinevere*, 1874
(Mr. Read and Mrs. Hardinge)
Albumen silver print from wet-collodion glass negative, 32.2 x 28.8 cm
From *Illustrations to Tennyson's "Idylls of the King,"* vol. 1, Dec. 1874–Jan. 1875, The Metropolitan Museum of Art, New York, David Hunter McAlpin Fund, 1952 (52.524.3.10)

40 *The "little Novice" and Queen Guinevere in "the Holy House of Almesbury,"* October 1874
(Mrs. Hardinge at right and possibly Elizabeth Keown at left)
Albumen silver print from wet-collodion glass negative, 34.4 x 27.1 cm
From *Illustrations to Tennyson's "Idylls of the King,"* vol. 1, Dec. 1874–Jan. 1875, Marjorie and Leonard Vernon, Los Angeles

41 *The Angel at the Sepulchre*, 1869
(Mary Hillier)
Albumen silver print from wet-collodion glass negative, 35.6 x 25.4 cm
Charles Isaacs Photographs, Pennsylvania, K1038

42 *The Day Spring*, 1865
(Mary Hillier and possibly Percy Keown)
Albumen silver print from wet-collodion glass negative, 29 x 23.5 cm
International Museum of Photography and Film, George Eastman House, Rochester, New York, 81:1121:0034

43 *Goodness*, from the series *Fruits of the Spirit*, 1864
(Mary Hillier and Alice Keown)
Albumen silver print from wet-collodion glass negative, 25.3 x 20 cm
National Museum of Photography, Film & Television, Bradford, England (by courtesy of the Board of Trustees of the Science Museum), Herschel Album, pl. 44

44 *Mary Mother*, April 1867
(Mary Hillier)
Albumen silver print from wet-collodion glass negative, 33.2 x 26.6 cm
International Museum of Photography and Film, George Eastman House, Rochester, New York, 81:1121:0006

45 *The Return after Three Days*, 1865
(Left to right: Mary Kellaway, Mary Hillier, Freddy Gould, and Mary Ryan)
Albumen silver print from wet-collodion glass negative, 28 x 22.9 cm
Michael and Jane Wilson Collection, London, 85:2339

46 *After the Manner of Perugino*, 1865
(Mary Ryan)
Albumen silver print from wet-collodion glass negative, 20.8 x 13 cm
National Museum of Photography, Film & Television, Bradford, England (by courtesy of the Board of Trustees of the Science Museum), Herschel Album, pl. 48

47 *The Angel at the Tomb*, 1870
(Mary Hillier)
Albumen silver print from wet-collodion glass negative, 34.5 x 25.3 cm
The J. Paul Getty Museum, Los Angeles, 84.XM.443.6

48 *Meekness*, from the series *Fruits of the Spirit*, 1864
(Left to right: Elizabeth Keown, Mary Hillier, and Alice Keown)
Albumen silver print from wet-collodion glass negative, 25.3 x 20.6 cm
Adam Fuss, New York

49 *The Holy Family*, 1867
(Cyllena Wilson, possibly Percy Keown, and Alice Keown)
Albumen silver print from wet-collodion glass negative, 27.5 x 22.9 cm
National Museum of Photography, Film & Television, Bradford, England (by courtesy of the Board of Trustees of the Science Museum), Herschel Album, pl. 57

50 *Spring*, May 1865
(Left to right: Alice Keown, Mary Hillier, and Elizabeth Keown)
Albumen silver print from wet-collodion glass negative, 25.4 x 20 cm
The J. Paul Getty Museum, Los Angeles, 84.XZ.186.42

51 *The Kiss of Peace*, 1869
(Mary Hillier at right and possibly Florence Anson at left)
Albumen silver print from wet-collodion glass negative, 35.1 x 28.2 cm
Gernsheim Collection, Harry Ransom Humanities Research Center, The University of Texas at Austin, 964:0037:0091

52 Julia Jackson, 1864
Albumen silver print from wet-collodion glass negative, 25 x 18.2 cm
The Art Institute of Chicago, Harriott A. Fox Endowment, 1968.226

53 Julia Jackson, 1864/65
Albumen silver print from wet-collodion glass negative, 23.3 x 18.8 cm
The Art Institute of Chicago, Mary and Leigh Block Endowment, 1998.263

54 Julia Jackson, 1864/65
Albumen silver print from wet-collodion glass negative, 25.7 x 20 cm
Michael and Jane Wilson Collection, London, 96:5408

55 Julia Jackson, March 1866
Albumen silver print from wet-collodion glass negative, 33.8 x 28 cm
Gernsheim Collection, Harry Ransom Humanities Research Center, The University of Texas at Austin, 964:0037:0079

56 *My Favorite Picture of All My Works. My Niece Julia*, April 1867
(Julia Jackson)
Albumen silver print from wet-collodion glass negative, 28 x 22.6 cm
National Museum of Photography, Film & Television, Bradford, England (by courtesy of the Board of Trustees of the Science Museum), Herschel Album, pl. 67

57 Julia Jackson, 1867
Albumen silver print from wet-collodion glass negative, 27.6 x 22 cm
The Art Institute of Chicago, Harriott A. Fox Endowment, 1968.227

58 *Mrs. Herbert Duckworth*, 1867
(Julia Jackson)
Albumen silver print from wet-collodion glass negative, 27.6 x 23.8 cm
International Museum of Photography and Film, George Eastman House, Rochester, New York, 81:1124:0007

59 Julia Jackson, 1867
Albumen silver print from wet-collodion glass negative, 27.4 x 20.6 cm
The Metropolitan Museum of Art, New York, Purchase, Joseph Pulitzer Bequest, 1996 (1996.99.2)

60 *Mrs. Herbert Duckworth*, 1867
(Julia Jackson)
Albumen silver print from wet-collodion glass negative, 35.3 x 27.1 cm
National Gallery of Art, Washington, D.C., Patrons' Permanent Fund, 1995.36.66

61 *Mrs. Herbert Duckworth*, April 1867
(Julia Jackson)
Albumen silver print from wet-collodion glass negative, 34 x 26 cm
The Beaumont and Nancy Newhall Estate, courtesy of Scheinbaum & Russek Ltd., Santa Fe

62 *"A beautiful Vision,"* 1872
(Julia Jackson)
Albumen silver print from wet-collodion glass negative, 34 x 26.8 cm
The Art Institute of Chicago, Harriott A. Fox Endowment, 1970.834

63 *"She walks in beauty,"* September 1874
(Julia Jackson)
Albumen silver print from wet-collodion glass negative, 35.1 x 27.3 cm
The Art Institute of Chicago, Harriott A. Fox Endowment, 1968.222

Bibliographic Abbreviations

The following list includes published and unpublished sources frequently cited throughout the book. For additional bibliography on Julia Margaret Cameron, the reader is encouraged to consult the notes to Sylvia Wolf's and Debra N. Mancoff's essays.

AC Anne Clark, *The Real Alice*, London, 1981.

AH Amanda Hopkinson, *Julia Margaret Cameron*, London, 1986.

AL A.G.C. Liddell, *Notes from the Life of an Ordinary Mortal*, London, 1911.

AT Alfred Tennyson, *A Dream of Fair Women and Other Poems*, selected and illustrated by Edmund J. Sullivan, London, 1900.

AVM Anita Ventura Mozley, *Mrs. Cameron's Photographs from the Life*, exh. cat., Stanford University, Museum of Art, Stanford, Calif., 1974.

BB Sir Bernard Burke, *Burke's Genealogical and Heraldic History of the Landed Gentry*, 18th ed., London, 1965.

BH Brian Hill, *Julia Margaret Cameron: A Victorian Family Portrait*, New York, 1973.

BPBK *Burke's Genealogical and Heraldic History of the Peerage, Baronetage and Knightage*, ed. by Peter Townsend, 105th ed., London, 1970.

CEW1861 Census of England and Wales, 1861 (RG 9/662), Public Record Office, Richmond, England.

CEW1871 Census of England and Wales, 1871 (RG 10/1172), Public Record Office, Richmond, England.

CF Colin Ford, *The Cameron Collection: An Album of Photographs by Julia Margaret Cameron Presented to Sir John Herschel*, London, 1975.

DG/ES Diane F. Gillespie and Elizabeth Steele, eds., *Julia Duckworth Stephen: Stories for Children, Essays for Adults*, New York, 1987.

DNB Leslie Stephen and Sidney Lee, eds., *The Dictionary of National Biography*, 22 vols., 11 suppls., London and New York, 1885–1993.

EPR Elizabeth P. Richardson, *A Bloomsbury Iconography*, Winchester, England, 1989.

FM Frances Miller, *Catalogue of the William James Stillman Collection*, Schenectady, N.Y., 1974.

HC Henry Cotton, *Indian and Home Memories*, London, 1911.

HF H. A. L. Fisher, *An Unfinished Autobiography*, London, 1940.

HG1948 Helmut Gernsheim, *Julia Margaret Cameron: Her Life and Photographic Work*, London, 1948.

HG1975 Helmut Gernsheim, *Julia Margaret Cameron: Her Life and Photographic Work*, New York, 1975.

HT Sir Henry Taylor, *Autobiography of Henry Taylor*, 2 vols., London, 1885.

JC Julian Cox, *In Focus: Julia Margaret Cameron, Photographs from The J. Paul Getty Museum*, Weston Naef, general editor, Los Angeles, 1996.

JH Jeremy Howard, *Whisper of the Muse: The World of Julia Margaret Cameron*, London, 1990.

JL Joanne Lukitsh, *Cameron: Her Work and Career*, exh. cat., Rochester, N.Y., International Museum of Photography at George Eastman House, 1986.

JM1985 Jan Marsh, *The Pre-Raphaelite Sisterhood*, New York, 1985.

JM1987 Jan Marsh, *Pre-Raphaelite Women: Images of Femininity in Pre-Raphaelite Art*, London, 1987.

JM/PGN Jan Marsh and Pamela Gerrish Nunn, *Women Artists and the Pre-Raphaelite Movement*, London, 1989.

LKH Linda K. Hughes, *The Manyfac'ed Glass: Tennyson's Dramatic Monologues*, Athens, Ohio, 1987.

LS Leslie Stephen, *Sir Leslie Stephen's Mausoleum Book*, Oxford, 1977.

LTJ Emily Tennyson, *Lady Tennyson's Journal*, Charlottesville, Va., 1981.

MB Marilynn Anacker Board, "G. F. Watts, a Soldier in the Battle for an Art of Ideas," Ph.D. diss., University of Illinois at Urbana-Champaign, 1982.

MNC Morton N. Cohen, *Lewis Carroll*, New York, 1995.

MSW Mary S. Fraser-Tytler Watts, *George Frederic Watts*, London, 1912, 3 vols.; vols. 1–2, "The Annals of an Artist's Life," by M.S. Watts; vol. 3, "His Writings."

MW1984 Mike Weaver, *Julia Margaret Cameron, 1815–1879*, London, 1984.

MW1986 Mike Weaver, *Whisper of the Muse: The Overstone Album and Other Photographs by Julia Margaret Cameron*, exh. cat., Malibu, Calif., The J. Paul Getty Museum, 1986.

NA Nina Auerbach, *Ellen Terry, Player in Her Time*, New York, 1987.

PH1983 Phyllis Hartnoll, ed., *The Oxford Companion to the Theatre*, 4th ed., Oxford, 1983.

PH1985 Phyllis Hartnoll, *The Theatre: A Concise History*, London, 1985.

RC Ronald Chapman, *The Laurel and the Thorn: A Study of G. F. Watts*, London, 1945.

RDW R. Derek Wood, ed., "Julia Margaret Cameron's Copyrighted Photographs," unpubl. booklet compiled from the records at the Public Record Office, London, 1996 (copy on deposit at The Royal Photographic Society, Bath, England).

VH Violet Hamilton, *Annals of My Glass House: Photographs by Julia Margaret Cameron*, exh. cat., Claremont, Calif., Scripps College, Ruth Chandler Williamson Gallery, and Santa Barbara Museum of Art, Calif., 1996–97.

WB Wilfrid Blunt, *England's Michelangelo*, London, 1975.

WWW1 *Who Was Who, Vol. I, 1897–1915*, London, 1966.

WWW2 *Who Was Who, Vol. II, 1916–1928*, London, 1967.

Index

The index covers all parts of the book except such supplementary apparatus as the preface, introduction, notes, checklist, and list of bibliographic abbreviations. Numbers in **bold type** refer to pages with illustrations. Plate numbers for works by Julia Margaret Cameron included in the present exhibition appear in parentheses.

Photography Credits

Photographs of works of art reproduced as plates and comparative figures in this volume have been provided in most cases through the courtesy of the owners or custodians of the work, who are credited in the captions accompanying the images or in the Checklist of the Exhibition. The following photo credits, which are arranged alphabetically by the institution's or individual's name, apply to all images for which separate or additional credit is due.

© The British Museum, London (fig. 20, p. 56)

Christie's Images, London (fig. 4, p. 95)

Courtesy George Eastman House, Rochester, New York (plates 12, 15, 42, 44, 58 [also reproduced as fig. 37, p. 72]; fig. 2, p. 15; fig. 7, p. 34)

Photograph © 1998 by The Metropolitan Museum of Art, New York (plates 3, 39, 59 [also reproduced as fig. 40, p. 73])

All rights reserved, The Metropolitan Museum of Art, New York (fig. 1, p. 86; fig. 3, p. 94; fig. 8, p. 98; fig. 10, p. 100)

© Photothèque des Musées de la Ville de Paris, Cliché: Degraces-Khoshpanjeh (fig. 39, p. 72)

© Photothèque des Musées de la Ville de Paris, Cliché: Lyliane Degraces (fig. 26, p. 59)

Courtesy, Museum of Fine Arts, Boston (plates 31, 54; fig. 12, p. 45; fig. 18, p. 55)

Photograph © 1998 Board of Trustees, National Gallery of Art, Washington, D.C. (plate 60)

Board of Trustees, National Museum and Galleries on Merseyside (Lady Lever Art Gallery, Port Sunlight, England) (fig. 32, p. 69; fig. 6, p. 97)

National Museum of Photography, Film & Television/Science & Society Picture Library, Bradford, England (fig. 1, p. 12; fig. 1, p. 22; figs. 21–22, p. 56; fig. 28, p. 61)

By courtesy of the Picture Library, National Portrait Gallery, London (fig. 2, p. 27)

Photo courtesy of The Newberry Library, Chicago (fig. 2, p. 93; fig. 5, p. 95; fig. 7, p. 97; fig. 13, p. 102)

Copyright © 1974 by Irving Penn. Courtesy Vogue (fig. 4, p. 17)

The Royal Archives, Windsor Castle, England © 1998 Her Majesty Queen Elizabeth II (fig. 6, p. 32)

Miki Slingsby Fine Art Photography, London (plates 4, 23; fig. 9, p. 37)

Tate Gallery, London/Art Resource, NY (fig. 14, p. 50)

V&A Picture Library, London (plates 1, 2, 13, 19, 21, 26; fig. 19, p. 55; fig. 24, p. 58; fig. 29, p. 65; fig. 31, p. 67; fig. 38, p. 72)

Gregory A. Williams, Photographer, The Art Institute of Chicago, Department of Imaging and Technical Services, Alan B. Newman, Executive Director (frontispiece; plates 5, 17, 22, 24, 25, 32, 40, 41, 43, 46, 48, 49, 52, 53, 56, 57, 62, 63)

Donald Woodman Photographer, Belen, New Mexico (plate 61)